Los Angeles is a city on the Pacific Rim where things appear on edge, for they lack a permanent footing even while occupying a specific locale. The city's *genius loci* produces this dual vision of fixed place in a state of constant dislocation.

It is only appropriate for the edge-bound Getty Center to initiate a series of publications that aim to expose the historical study of artifacts to the oscillation of rigorous debate. Each of these books proceeds from a specific body of historical material, not because that material is in itself inherently imbued with controversy but because its exposure to different disciplinary approaches raises new questions of interpretation. In the realm of historical studies, issues often emerge at the intersection of the various perspectives scholars have constructed for the examination of their subjects. As their debate refracts and refocuses the material under scrutiny, it also invites reflection upon itself and thereby exposes the assumptions and tendencies of scholarship to no less assiduous criticism than it does the underpinnings of its subjects.

Volumes in the series ISSUES & DEBATES will result from symposia and lecture series, as well as from commissioned writings. Their scholarly editors are invited to frame highly focused essays with introductions, commentaries, and/or sources, documents, and illustrations that further contribute to their usefulness.

ISSUES & DEBATES
A Series of the Getty Center Publication Programs
Julia Bloomfield, Kurt W. Forster, Thomas F. Reese, Editors

Art in history
History in art

The Getty Center for the History of Art and the Humanities

Distributed by the University of Chicago Press

ISSUES & DEBATES

Art in history
History in art

Studies in seventeenth-century Dutch culture

Edited by David Freedberg and Jan de Vries

Art in History/History in Art
Studies in Seventeenth-Century Dutch Culture

Edited by David Freedberg and Jan de Vries

This volume, the first title in the series ISSUES & DEBATES, evolved from
the symposium entitled "Art in History: History in Art," which was held at
the Getty Center for the History of Art and the Humanities, Santa Monica,
California, 30 April–2 May 1987.

The Getty Center Publication Programs
Julia Bloomfield, Kurt W. Forster, Thomas F. Reese, Editors
Lynne Hockman, Michelle Ghaffari, Hadley Soutter, Manuscript Editors

Copy Editor, Lois Nesbitt

Consultant for Dutch Language, Anne-Mieke Halbrook

Translators for essays by Eric J. Sluijter and Lyckle de Vries,
Kist Kilian Communications

Cover: Rembrandt Harmensz. van Rijn, Danae, 1636.
Leningrad, State Hermitage Museum.

Published by the Getty Center for the History of Art and the Humanities,
Santa Monica, CA 90401-1455
© 1991 by The Getty Center for the History of Art and the Humanities
All rights reserved. Published 1991
Printed in the United States of America

97 96 95 94 93 92 91 7 6 5 4 3 2 1

Library of Congress Cataloging-in-Publication Data

Art in history/history in art : studies in seventeenth-century Dutch culture /
edited by David Freedberg and Jan de Vries.
 p. cm. – (Issues & debates)
 Includes bibliographical references and index.
 ISBN 0-89236-201-4 : $55.00. – ISBN 0-89236-200-6 (pbk.) : $29.95
 1. Art and society–Netherlands. 2. Realism in art–Netherlands.
3. Painting, Dutch. 4. Painting, Modern–17th–18th centuries–Netherlands.
5. Netherlands–Civilization–17th century. 6. Netherlands–Intellectual
life–17th century. I. Freedberg, David. II. De Vries, Jan, 1943 Nov. 14–
III. Title: Art in history. IV. Title: History in art. V. Series.
N72.S6A746 1991
701'.03'0949209032–dc20 91-13351
 CIP

Contents

CONCLUSION

Jan de Vries

Introduction

This volume is dedicated to advancing the dialogue between two academic disciplines, art history and history. Their names alone suggest a close association — that one is in fact a branch of the other. But this is not the case, and the points of contact between them are now explored less than they once were when historians aspired to a universalism rare in our age of specialization.

One of the last and greatest of these historians of broad vision was Johan Huizinga, whose name is frequently invoked in this volume. It is therefore fitting to note that Huizinga, who did incorporate the fine arts in his cultural studies, harbored considerable reservations about the use of "visual data" as a source of historical knowledge. He introduced his celebrated *Dutch Civilization in the Seventeenth Century* with this observation, "Were we to test the average Dutchman's knowledge of life in the Netherlands during the seventeenth century, we should probably find that it is largely confined to odd stray notions gleaned from paintings."[1] He went on to contrast this state of affairs with the far greater, and very different, historical knowledge of an earlier generation, which relied almost entirely on written sources.

This issue occupied Huizinga throughout his career. In his earlier masterpiece, *The Waning of the Middle Ages*, he observed that the Burgundian culture of the late Middle Ages was best known to his contemporaries through its art, while earlier generations were familiar with it primarily through literary and historical works. With the change in medium, he asserted, there came a shift in the mental images that people formed of that culture, a shift from somber and pessimistic to serene and uplifting.

1

Huizinga then asked, "On what does this fundamental difference between the vision of an epoch derived from art and that derived from history, writing, and literature rest?"[2] Is it a peculiarity of late medieval art? Or, he continued, "Is it a general phenomenon that plastic art leaves a brighter image of a period than does the word of the poet or historian?"[3] Without hesitation, he answered his own question. The phenomenon was general, "Indeed, our picture of all earlier cultures has become more serene than previously as we have turned increasingly from reading to viewing, and the historical 'sensory organ' (*zintuig*) has become more visual."[4] Huizinga warned of the dangers of this development. Reliance on visual sources of historical information inevitably imparts a bias; it yields valuable new insights, but its larger effect is to impoverish and limit historical understanding.

Considering that he wrote *The Waning of the Middle Ages* in 1919, when visual culture could hardly be said to have saturated society as it now does, Huizinga's sensitivity to this phenomenon can only be described as acute — acute, but not really surprising. A Calvinist culture teaches one to reject graven images but also to be skeptical of visual images more generally. The primacy of the word in Reformed thought derives not simply from the existence of sacred texts — as the Iconoclasm so vividly demonstrated, there are no sacred images — but also from a belief in the intellectual superiority of words as a means of communication. By comparison, images can only address basic emotions and convey simple or ambiguous messages.

It is no small irony that the seventeenth-century Dutch culture, which Calvinism labored so mightily to shape, has left visual images — paintings — as its most enduring and influential legacy. Most seventeenth-century Dutch art attracts our attention not only by means of its beauty but also by means of its compelling social content. The very culture whose spirit Huizinga breathed as he worried about the impoverishing biases of visual impressions has left a visual legacy capable of seducing us into believing that it offers a unique entrée to the Dutch Republic of the seventeenth century.

Today's historian, child of a visual culture, is receptive to this seduction. General historical study, integrating cultural, social, and political history in a unified interpretation, is now all but extinct, whereas illustrated history is ubiquitous. The educated layperson of our era receives most of his or her historical knowledge from museum exhibitions. Whether trained for the task or not, today's historian, regardless of specialization, is called upon to deal with visual sources and is generally eager to do so.

Dutch paintings invite the "historian's gaze," and the viewer, overruling his better judgment, treats a painting as a framed view of reality and, as it were, peers into seventeenth-century Dutch society. The temptation is great because Dutch paintings seem to provide evidence concerning just those historical issues that fascinate us today and about which traditional archival sources say so little, for example, the everyday life of ordinary people, relations between the sexes, and material culture. Contemporaries often praised seventeenth-century Dutch painters for their skill in *stofuitdrukking* (the projection of materiality through the convincing presentation of textures and surfaces). Our own needs and values cause us to praise them for their talent in what might be called *maatschappijuitdrukking* (the projection of a vanished society through the convincing presentation of physical and social reality).

Fixing the historian's gaze on Dutch paintings is understandable. After all, Dutch painters aspired to dazzle the viewer with their creation of the *schijn zonder zijn* (semblance without being).[5] This perspective is not, however, intellectually valid. Art historians in their exploration of artists' didactic and moral intentions have placed Dutch art in an interpretative framework of considerable sophistication. The recovery of the complex and often high-minded messages communicated by Dutch art is only complicated by its typically artisanal origins; this has given rise to much debate about how the recovery of intention should proceed. In this debate historical contextualization, the re-creation of the social and cultural contexts in which the artists created and the viewers "consumed" works of art, has emerged as a major methodological contender. Rather than being the uncomplicated *source* of historical knowledge, the painting is for art historians the challenging *object* of interpretations; historical contextualization allows them to make a distinctive contribution, which Josua Bruyn defined as the ability "to get to the bottom of seventeenth-century pictorial matter in its determinants and to read it as one might read a text."[6]

Is this goal attainable? The historian must wonder whether this quest to possess works of art by reducing them to words will not inevitably be frustrated, no matter how complete the historical contextualization. Just as the historian's temptation to possess works of art by converting them to archival documents must yield to the recognition of art as a subjective creation, "shaped by imagination as well as by tradition and purpose,"[7] so the art historian's quest must at some point confront the fact that visual

3

rhetoric is not fully reducible to expository prose.[8]

What historians and art historians share, it would seem, is frustration experienced in their efforts to use one another's intellectual resources. This is surely an odd, if not a perverse, way to introduce a book that seeks to reconnoiter the common ground and the points of contact between history and art history as both disciplines contribute to an understanding of seventeenth-century Dutch culture. This volume is in fact the indirect product of the interaction of historians and art historians who gathered for a year at the Getty Center for the History of Art and the Humanities. Their frequent discussions were uncommonly fruitful and stimulating; art historians proved exceptionally willing to explore the social and economic aspects of Dutch art, while some historians, exploiting the prerogative of their naïveté about conventions of visual representation, were willing to ask basic questions.

There was very little frustration in evidence as our discussions led to an enthusiastic exploration of the materiality of Dutch art (vegetables, ships, clouds, etc.), to a freewheeling exploration of Dutch art as an economic activity, and to a reconsideration by the art historians of such basic issues as the claims of emblematic interpretation, the periodization of style, and the meaning of such hoary terms as "realism." In time our discussions also led to a conference at which additional representatives of the two disciplines gathered on the shores of the Pacific to address the visual culture of the distant polders and towns of the seventeenth-century Dutch Republic.[9] The present volume was inspired by that conference, but it is not a report of it; some of the papers published here were not presented at the conference, others were presented but are not published here, and still others were delivered in a form quite different from that in which they now appear. Our aim has been to encourage what diplomats call a "frank and open exchange of views," for, however agreeable and mutually beneficial to its contributors the path leading to this volume has been, its underlying motivation remains the frustration and even mutual suspicion of historians who see visual art as granting access to an underlying history and art historians who use history to read meaning into art.

The editors are acutely aware that not all of the important issues have been addressed or given the extended treatment that they deserve, but what we concede in comprehensiveness, we hope to compensate for with fresh perspectives on those topics selected for discussion. The introductory essays by Gary Schwartz and J. W. Smit offer tales that are both encouraging and

cautionary concerning the pursuit of interdisciplinary approaches to cultural studies. The material contents of Dutch art are explored *in concreto* in the essays of Linda Stone-Ferrier, Willem A. Brandenburg, Richard W. Unger, and John Walsh, while the strengths and limitations of the iconographic approach are addressed by E. de Jongh, Jochen Becker, and Eric J. Sluijter. The more general questions of realism, style, and connoisseurship are raised by Lyckle de Vries, while economic and quantitative dimensions of Dutch art production, sale, and possession are analyzed in the essays of Jan de Vries, Ad van der Woude, and John Michael Montias. David Freedberg's concluding essay emphasizes both new and neglected areas of exploration in an attempt to redeem the skepticism expressed here about the limits of the art historian's quest.

The frustration experienced by historians and art historians who use one another's disciplinary resources derives from the fact that they are driving in opposite directions on a common street. The essays in this volume suggest, however, that the street is a broad one, and with some good will, the two vehicles should be able to share it without fear of collision.

NOTES

1. Johan Huizinga, *Dutch Civilization in the Seventeenth Century* (Haarlem: H. D. Tjeenk Willink & Zoon, 1941; London: Collins, 1968), 9.

2. Johan Huizinga, *Herfsttij der Middeleeuwen* (Haarlem, 1919). Quotations are from *Verzamelde werken* (Haarlem: H. D. Tjeenk Willink & Zoon, 1949), 3: 305. I have not used the English translation, *The Waning of the Middle Ages* (London: E. Arnold & Co., 1924), but have translated from the original Dutch. The quoted passages cannot be found in anything like their original form in the published translation.

3. Ibid., 305–6.

4. Ibid., 306.

5. This expression is used by the painter Philips Angel in his *Lof der schilder-konst* (Leiden: Willem Christiaens, 1642), 24–26. For further discussion, see Eric J. Sluijter's essay in this volume.

6. Josua Bruyn, "Het probleem van het realisme in de zeventiende-eeuwse Hollandse kunst van Huizinga tot heden," *Theoretische geschiedenis* 13 (1986): 216. This quotation is discussed more extensively in E. de Jongh's essay in this volume.

7. Theodore K. Rabb and Jonathan Brown, "The Evidence of Art: Images and Meaning in History," *Journal of Interdisciplinary History*, n.s., 17, no. 1 (Summer 1986): 6. Note that the

authors' assessment of the ability of art to function as a class of historical evidence is different than mine.

8. At this point art historians skeptical of the historicizing movement might call attention to the intellectual resources covered by the term "connoisseurship," arguing that this talent both does justice to the uniquely subjective quality of art and identifies art history as a discipline methodologically distinct from history. Recent trends in history — the so-called "return to narrative" and the fashion of precious "micro-histories" — suggest that the post-Modern historian is developing a talent analogous to connoisseurship that might be called "raconteurship."

9. The conference, which bore the same title as the present volume, was held at the Getty Center for the History of Art and the Humanities, Santa Monica, California, 30 April–2 May 1987. The following participants delivered papers or comments: Jochen Becker, Albert Blankert, Willem A. Brandenburg, S. Dudok van Heel, Reindert Falkenburg, David Freedberg, Egbert Haverkamp-Begemann, E. de Jongh, J. Richard Judson, John Michael Montias, Simon Schama, Gary Schwartz, J. W. Smit, Marijke Spies, Linda Stone-Ferrier, Richard W. Unger, Jan de Vries, Lyckle de Vries, John Walsh, and Ad van der Woude.

Gary Schwartz

Art in History

Despite the difficulties of drawing art and history together,
there is perhaps no enterprise more deserving of major and
united effort.... If the need seems particularly urgent at
present, it is because of the current crisis in the two fields.[1]
　　　　　　　— Theodore K. Rabb and Jonathan Brown, 1986

Et quel autre peuple a ainsi écrit son histoire dans ses arts?[2]
　　　　　　　— W. Bürger, on the Dutch, 1858

The impulse to draw art and history together has characterized the study
of Dutch art from its beginnings. This is hardly surprising, considering
the major role of art in Dutch society and the importance of history to the
origins of the Dutch nation. Whereas other European states attributed their
sovereignty to divine right, imperial charter, or contracts between rulers
and the ruled, the Dutch derived their claim to self-rule from the interpre-
tation of the historical events leading to the revolt against Spain. The actual
events were not frequently depicted in the seventeenth century, but this is
not the only measure of their influence on art. The history of the revolt was
imprinted on religious iconography, creating what Simon Schama has called
"patriotic Scripture"; on depictions of the Batavian past, as Henri van de
Waal has shown; and, through countless allusions, on still life, genre paint-
ing, portraiture, and townscape.[3]

Other, more general attributes of Dutch art have had a more profound
effect on its perception in the nineteenth and twentieth centuries. Georg
Wilhelm Friedrich Hegel's lectures on aesthetics,[4] given in Heidelberg and

7

Berlin between 1817 and 1829 for steadily growing audiences and published in 1835, were a powerful influence in this regard. For Hegel, the link between the subjects of Dutch genre painting and the fortunes and character of the Dutch people was a cornerstone of European history. He saw the realism of genre painting as a function of the liberation of Western man from the grip of religion. This immense achievement could only have been attained by "a national state that fought for its own freedom, a country that reformed the church by itself, that wrested itself from the sea on its own; a country without aristocrats, with few peasants...inhabited largely by burghers, [who nurture] the bourgeois spirit, entrepreneurial drive and pride in business, concern for [the] welfare [of their fellow burghers], cleanliness, pleasure in the small [things of life]."[5] Hegel finds a way to accommodate Dutch religion as well in his vision of a perfectly material art. "By faith – this aspect is of great importance – the Dutch were Protestants, and Protestantism alone enjoys the distinction of...infiltrating the prose of life, validating it entirely on its own, independently of any relations to religion, allowing it to develop in unbounded freedom."[6] In the paintings they made and collected, the Dutch enjoyed for a second time "the cleanliness of their cities, houses, and furnishings, their domestic tranquility, their riches, the respectable attire of their women and children, the splendor of their political town celebrations, the daring of their seamen, the fame of their trade and their ships, which sail the ocean the world over."[7]

Strands of commonsense criticism spun in the course of the eighteenth and early nineteenth centuries are here tied into a mighty knot. Hegel's analysis provided a causal link between features of old Holland that commanded increasing respect in post-Napoleonic Europe: republicanism in politics and realism in art, rooted in a spirit of national and intellectual independence. Thus, his analysis fed into the deepest currents of his time. Seen through Hegel's eyes, the specific values embodied in Dutch painting spoke directly to the spirit of 1848. Here were products of a major European civilization – the very best products of that civilization – created by burghers for burghers. The existence of these works and their quality proved that no social elite was required for the creation of great art. The aristocracy was superfluous, the church irrelevant. Bourgeois artists attuned to the basic conditions of life around them, trusting their sensibilities and powers of observation alone, were capable of capturing the ultimate meaning of their culture. If artists in Italy, France, and England were unable to bypass

metaphysics, allegory, and aggrandizement, that was their problem and that of their patrons, not a condition of art and society. Dutch art provided the iconography for a nineteenth-century religion of humanity.

In Hegel's first and second lecture series, this momentous breakthrough is credited to the Dutch alone, based on the particularities of their culture and history. "No other people, under other circumstances, would have conceived of turning the subjects visualized for us by Dutch painting into the main contents of a work of art.... The Dutch derived the content of their depictions from themselves, chosen from the actualities of their own life."[8] This assertion underwent a stunning change, however, in Hegel's third series. Here the corresponding section, entitled "Netherlandish and German Painting," begins, "As for painting in Germany...proper, we can combine it with that of the Netherlands,"[9] and the following text does just that. The same arguments concerning Dutch history and culture are repeated, but the "total immersion [of art] into the secular and everyday" is now attributed jointly to Dutch *and* German painting, despite the utterly different circumstances of German history.[10] This inconsistency opened the door to the co-optation of Dutch culture by German culture, leading eventually to such excesses as the cult of the *Rembrandtdeutsche*, Julius Langbehn. It made Golden Age Holland available as a historical model for a variety of nineteenth-century German and French movements in politics and art.

The contours of cultural "Dutchness" drawn by Hegel corresponded to the severely limited image of Dutch art being projected in the museums of Amsterdam and The Hague. This image was derived from a canon of what were seen as secular, descriptive easel paintings of genre, still life, portrait, local landscape, and seascape.[11] The biblical subjects of Rembrandt and his school were included but were qualified as expressions of universal human faith rather than Christian sectarian images. Absent from the canon, as from Hegel's purview, were many subjects, styles, and modes of Dutch art that failed to fit the picture. Generations of twentieth-century art historians (it took an entire generation in each case) fought to rehabilitate, often with apologies and special pleas, the art of "Romanists" like Maarten van Heemskerck and Jan van Scorel; "pre-Rembrandtists" like Pieter Lastman and Jan Pynas; "classicists" like Cesar van Everdingen and Pieter Bor; "Caravaggists" like Hendrick ter Brugghen and Matthias Stomer; "Italianates" like Jan Baptist Weenix and Jan Asselijn; and the history paintings of these masters and others. Still awaiting rehabilitation — the term itself sug-

gests moral insufficiency — are Catholic subjects and allegories, which continue to be under- and misrepresented in the literature and in museums, not to mention the unsigned paintings by Dutch artists mistaken for Italian works and vice versa. A treatment of Dutch painting placing these disjected members in proper perspective has yet to be written.

Just as the expansion of the canon with imaginary landscapes, theatrical fantasies, and hankerings after ancient Rome and the Catholic past has diluted the image of Dutch painting as a realistic mirror of a sober Protestant society, the earlier picture of that society itself has been changing. The stereotype of the bourgeois Calvinist republic that constituted the other member of Hegel's equation of life and art is no longer accepted. Skeptical historians mitigate the distinction between the Dutch Republic and other nations of the ancien régime. "If in fact [the revolt] was at times revolutionary and produced in some areas a form of society and government which might be called modern in comparison with those of such states as the Southern Netherlands or Spain, this was a result of economic and social forces not controlled, nor even clearly distinguished by the opposition."[12] The groups for whom expensive paintings were made are no longer necessarily regarded as burghers. The eminent importance of the patrician class, whose autocratic airs could rival those of the nobility of France and England, is now seen as a determining factor in Dutch cultural and political life.[13] The class from which the artists themselves came has been creeping up the social scale from the lower middle class to the upper and, possibly, even to the patrician.[14] Finally, the "Calvinism" of Dutch society has been questioned as more serious account is taken of the country's religious pluralism. A recent study of church and society in Haarlem during the early republic concludes: "The case of Haarlem confirms the [opinion of those who] reject [the thesis that the formation of the Dutch state went hand in hand with] Protestantizing. The Reformed church was not the dominant church in Haarlem. It was not able to dictate official policy with regard to religion. It did not encompass a majority of the population. It did not establish the norm for society at large."[15] To this we may add that it was probably underrepresented among painters and their patrons.

Despite these facts and despite the frequency with which it is said that the sophisticated twentieth-century art historian has seen through the fallacies of nineteenth-century positivism, Hegel's model has never been replaced and its power to persuade is still largely undiminished. The Peli-

can *History of Art* volume on Dutch art states in its introduction: "In Holland alone was to be found the phenomenon of an all-embracing realism which was unparalleled in both comprehensiveness and intimacy. The Dutch described their life and their environment, their country and their city sights so thoroughly that their paintings provide a nearly complete pictorial record of their culture."[16] Piecemeal revisions of this statement, even if they lead in aggregate to a complete demolition of its assumptions and claims, somehow leave its commonsense credibility intact. Like the Cheshire cat, Hegel's theorem continues to beam at us without a body.

One recent attempt in art history to demur at a more fundamental level is E. de Jongh's proposed redefinition of the nature of realism in Dutch painting. In a stream of articles and exhibition catalogs following the publication of *Zinne- en minnebeelden* in 1967, De Jongh has demonstrated that many seemingly descriptive Dutch paintings are informed by a pervasive quality that one might call moral cognition.[17] De Jongh has reinterpreted hundreds of Dutch genre paintings, still lifes, and portraits, showing how painters reconciled verisimilitude with moral messages that mattered more in the eyes of their contemporaries. His arguments have appealed to scholars and the public alike, and his method has inspired widespread emulation. His work supplies museum docents with interesting things to tell audiences about Dutch pictures, which while always popular were considered a little dull. If the implications of this approach were to percolate into general consciousness, the psychology of the viewer would undergo a radical change. Dutch paintings would cease to look like mirrors of nature and society and instead begin to resemble visual sermons.

Whether this will happen is a moot point at present. De Jongh's ideas have encountered strenuous opposition. Svetlana Alpers devoted an appendix of *The Art of Describing* to a rebuttal of the link that De Jongh draws between emblems and paintings.[18] Her own book, however, can be read as an attempt to bestow new intellectual legitimacy on Hegel's exhausted platitudes. She writes:

> My argument [in chapter 3, "The Craft of Representation"] will move back and forth between the intellectual and social circumstances and the images themselves in an attempt to suggest the manner in which these phenomena were interwoven at the time.... Hegel, in a short passage in his lectures on aesthetics, already characterized Dutch painting in terms close to these. He

argued that the Dutch replaced an interest in significant subject matter with an interest in the means of representation as an end in itself (*"die Mittel der Darstellung werden für sich selber Zweck"*).... My purpose in this chapter is to try to relate such pictorial phenomena to notions of knowledge current in the seventeenth century.[19]

In appealing to such things as "the images themselves," "the look of art," and "what is present to the eyes," Alpers leaves her readers and herself at the mercy of appearances and the distorted ideas that we receive from them.[20] This is bound to be the case, I fear, with any approach beginning with "the images," including iconographic methods like De Jongh's and the anti-iconographic ones of his newest, most radical critics, Peter Hecht and Jan Baptist Bedaux. These younger associates of De Jongh have now taken sharp issue with him and with their own former ideas concerning the interpretation of genre painting and portraiture, respectively.[21] Where they once exerted their wits to puzzle out subtle meanings lurking between the brushstrokes of everyday scenes, they now deny flatly that such meanings exist at all. This has precipitated a crisis in Dutch art history. (A newspaper story on Bedaux's degree defense — a public event in the Netherlands — bore the headline "Art Historian Commits Patricide in Auditorium.") The insufficiency of the methodological underpinning for the interpretation of Dutch painting — with dire implications for hermeneutics at large — has come to the surface.

Is there a way to dispel the optical illusion — or at least make it visible as such — that Dutch painting is "a nearly complete pictorial record" of a Calvinist republican culture? If there is, it will have to be done from a vantage point that offers clear views of the artistic and historical elements concerned on their own terms, not as functions of each other. Such a middle ground between art and history in fact exists but has been largely avoided or ignored in the past. It can be described as the historical study of art — not a survey of existing works or a guide to a *musée imaginaire* (of these we have plenty) but a history of the activity and its products. This approach deals with the origins of painting and printmaking as trades and their development as crafts; the status of art in comparison with other activities; the way in which artists and their work functioned on an economical and intellectual level;[22] the areas of politics and society with which they interacted and how they did so;[23] the relation of the visual arts to poetry, theater, and

art theory;[24] the varieties, numbers, and quality levels of art seen in relation to the aforementioned concerns, to regional differences, and to art in other countries, especially the Southern Netherlands;[25] and visual imagery as propaganda or projection of religious, ethnic, scientific, national, or psychological values.[26] If there is a quality of "Dutchness" to be discovered in the art or history of the Northern Netherlands, one wants to learn about it in the conclusion of a solid comparative study, not in prefaces reiterating the same old clichés.

Some recent contributions of this new kind are cited in the notes to this essay. On the whole, however, the historical study of art is still unpopular among art historians and historians alike. Most art historians, trained in the examination and comparison of existing objects, grow fidgety dealing with non-visual material and aggressive when the idea is challenged that quality, style, and iconography are all that matters about art. The historical establishment has traditionally considered art too marginal and subjective to merit serious treatment. As a result, the libraries of art history groan under catalogs and monographs, while no one has tried to improve upon Hans Floerke's study of 1905 — insufficient even at the time — on the trade, production, and collecting of art in Holland.

Conventionality still stands in the way of the construction of a new cultural model needed to replace Hegel's intoxicating simplification. If we want something better in its place, we have a lot of imaginative interdisciplinary work to do.

NOTES

1. Theodore K. Rabb and Jonathan Brown, "The Evidence of Art: Images and Meaning in History," *Journal of Interdisciplinary History*, n.s., 17, no. 1 (Summer 1986): 1–6 (introductory essay to a collection of edited lectures delivered at a 1985 conference at the Rockefeller Foundation's Villa Serbelloni, Bellagio, Italy; the conference was devoted to the relationship between history and art history).

2. W. Bürger [T. E. J. Thoré], *Musées de la Hollande* (Paris: V^e Jules Renouard), vol. 1, *Amsterdam et La Haye*, 324. Quoted in Dedalo Carasso's "Beeldmateriaal als bron voor de historicus" (an unpublished lecture held in the Rijksmuseum, Amsterdam, 26 May 1982).

3. Simon Schama, *The Embarrassment of Riches: An Interpretation of Dutch Culture of the Golden Age* (New York: Alfred A. Knopf, 1987), 51–125; Henri van de Waal, *Drie eeuwen*

vaderlandsche geschied-uitbeelding, 1500–1800: Een iconologische studie, 2 vols. (The Hague: Martinus Nijhoff, 1952).

4. This was called to my attention by Dedalo Carasso. The quotations are from Georg Wilhelm Friedrich Hegel, *Ästhetik*, ed. Friedrich Bassenge (Berlin: Aufbau-Verlag, 1955). To Carasso I also owe references to two further studies dealing with Hegel and Dutch art: Peter Demetz, "Defenses of Dutch Painting and the Theory of Realism," *Comparative Literature* 15, no. 2 (Spring 1963): 97–115; Jan Białostocki, "Einfache Nachahmung der Natur oder symbolische Weltschau: Zu den Deutungsproblemen der holländischen Malerei des 17. Jhdt.," *Zeitschrift für Kunstgeschichte* 47 (1984): 421–38.

5. Carasso (see note 2); this quotation is a reliable paraphrase of passages in Hegel (see note 4), 194–95, 561–64, 800–805.

6. Hegel (see note 4), 562: *"Ihrer Religion nach waren die Holländer, was eine wichtige Seite ausmacht, Protestanten, und dem Protestantismus allein kommt es zu, sich auch ganz in die Prosa des Lebens einzunisten und sie für sich, unabhängig von religiösen Beziehungen, vollständig gelten und sich in unbeschränkter Freiheit ausbilden zu lassen."*

7. Ibid., 803: *"Diese sinnige, kunstbegabte Völkerschaft…will in ihren Bildern noch einmal in allen möglichen Situationen die Reinlichkeit ihrer Städte, Häuser, Hausgeräte, ihren häuslichen Frieden, ihren Reichtum, den ehrbaren Putz ihrer Weiber und Kinder, den Glanz ihrer politischen Stadtfeste, die Kühnheit ihrer Seemänner, den Ruhm ihres Handels und ihrer Schiffe genießen, die durch die ganze Welt des Ozeans hinfahren."*

8. Ibid., 562: *"Keinem anderen Volke wäre es unter anderen Verhältnissen eingefallen, Gegenstände, wie die holländische Malerei sie uns vor Augen bringt, zum vornehmlichsten Inhalt von Kunstwerken zu machen."* Ibid., 194: *"Die Holländer haben den Inhalt ihrer Darstellungen aus sich selbst, aus der Gegenwart ihres eigenen Lebens erwählt."*

9. Ibid., 800: *"Die niederländische und deutsche Malerei. Was nun* drittens *die deutsche Malerei angeht, so können wir die eigentlich deutsche mit der niederländischen zusammenstellen."* The first and second eras were the Byzantine and Italian.

10. Ibid., 302: *"Das letzte nun, wozu es die deutsche und niederländische Kunst bringt, ist das gänzliche Sicheinleben ins* Weltliche *und* Tägliche."

11. Gary Schwartz, " 'The Family Album': Dutch Paintings in the Museums of Holland," *Dutch Heights* (September 1990): 20–25. An abridgment of a lecture, the complete text of which is forthcoming in a Dutch translation, which will be included in *Kunstzaken: Particulier en overheidsinitiatief in de wereld van de beeldende kunsten*, ed. H. Dagevos.

12. E. H. Kossmann and A. F. Mellink, *Texts Concerning the Revolt of the Netherlands* (Cambridge: Cambridge Univ. Press, 1974), 2.

13. Joop de Jong, *Een deftig bestaan: Het dagelijks leven van regenten in de 17de en 18de eeuw* (Utrecht: Uitgeverij Kosmos, 1978).

14. Marten Jan Bok, "Artisans or Gentleman Painters? The Social Background of Utrecht Painters in the Early Seventeenth Century" (lecture delivered at the College Art Association annual meeting, Boston, 1987).

15. *"Haarlem bevestigt de onjuistheid van de protestantiseringsthese. De gereformeerde kerk was in Haarlem niet de heersende kerk. Zij was niet in staat de godsdienstpolitiek van de overheid te bepalen. Zij omvatte niet de meerderheid van de bevolking. Zij stelde niet de norm voor heel de gemeenschap"* (Joke Spaans, *Haarlem na de Reformatie: Stedelijke cultuur en kerkelijk leven, 1577–1620* [The Hague: Hollandse Historische Reeks 11, 1989], 232).

16. Jakob Rosenberg et al., *Dutch Art and Architecture, 1600 to 1800* (Harmondsworth: Penguin, 1966), 3.

17. E. de Jongh, *Zinne- en minnebeelden in de schilderkunst van de zeventiende eeuw* (Amsterdam: Nederlandse Stichting Openbaar Kunstbezit en Openbaar Kunstbezit in Vlaanderen, 1967).

18. Svetlana Alpers, *The Art of Describing: Dutch Art in the Seventeenth Century* (Chicago: Univ. of Chicago Press, 1983), 229–33.

19. Ibid., 73, and the note on that passage, 249.

20. Ibid., 228–29. These are unquestionably nineteenth-century ideas, and Alpers is being less than candid when she writes: "De Jongh offers the emblematic connection as a challenge to what *he takes to be the nineteenth-century view* of Dutch art as a realistic mirroring of the world," 229 (italics mine).

21. Peter Hecht, *De Hollandse fijnschilders: Van Gerard Dou tot Adriaen van der Werff*, exh. cat. (Maarssen: Gary Schwartz/SDU; Amsterdam: Rijksmuseum, 1989). Hecht argues that genre paintings were primarily vehicles for the demonstration of the artist's skills or what Hegel, quoted by Alpers, called "the means of representation." Jan Baptist Bedaux in *The Reality of Symbols: Studies in the Iconology of Netherlandish Art, 1400–1800* (Maarssen: Gary Schwartz/SDU, 1990) disputes the notion that Dutch painting was infused with disguised symbolism in Erwin Panofsky's or De Jongh's terms.

22. An impressive start for the study of the economics of the Dutch art world was provided by economist John Michael Montias in *Artists and Artisans in Delft: A Socio-Economic Study of the Seventeenth Century* (Princeton: Princeton Univ. Press, 1982). Many of the intellectual parameters of Dutch artistic life were charted by Jan A. Emmens. See the four volumes of the *Verzameld werk* (Amsterdam: G. A. van Oorschot, 1981).

23. See the sketch by the present author in *The Dutch World of Painting*, exh. cat. (Vancouver: Vancouver Art Museum, 1986).

24. A pioneering study is M. M. Tóth-Ubbens, "De barbier van Amsterdam," *Antiek* 10 (1975–1976): 381–411.

25. See W. Brulez, *Cultuur en getal: Aspecten van de relatie economie-maatschappij-cultuur*

in Europa tussen 1400 en 1800 (Amsterdam: Nederlandse Vereniging tot Beoefening van de Sociale Geschiedenis, 1986); and the review by Marten Jan Bok in *Simiolus* 18 (1988): 63–88. One suspects that Brulez's statistical method was guided to an uncontrollable degree by cultural prejudice. In his hierarchy of European cultural centers, he put his native Belgium — a country which did not exist between 1400 and 1800 — at level one for art and music.

26. Schama (see note 3). For nineteenth-century French and English historiography of Dutch culture, see Simon Schama, "De ark van Noach of 'de onrijpe nectarine'? Visies op Nederland in de 19de eeuw," brochure with translated text of the Seventh Van der Leeuw Lecture, held in Groningen on 18 November 1989. The brochure, published by the Amsterdam daily *De Volkskrant*, includes an interview with Schama by Paul Brill and a commentary on his lecture by E. H. Kossmann. The latter deals as well with the antipathy toward the Dutch Golden Age in the Young Germany Movement of the 1830s.

J. W. Smit

History in Art

A symposium dedicated to the relations between history and art history should begin with an attempt to define clearly the nature of these two disciplines. The frequent calls for a closer collaboration between the two seem to suggest that they are clear and distinct enterprises, each with a well-defined methodology and field of investigation. This belief easily leads to the assumptions that history can illuminate art and that the study of art can somehow help one understand history — convictions that seem particularly to have taken hold over the last few decades. The "historical" approach has come to be seen as one of the avenues leading toward a renewal of art history, a discipline allegedly exhausted when iconology lost its attraction. At the same time, so-called "pure" or "mere" historians like Georges Duby have drifted into studies of art and architecture after careers devoted to social history. For traditional historians, however, this is not new. Johan Huizinga's *Waning of the Middle Ages* grew out of a desire to understand the world of Jan van Eyck, and Huizinga started his professorial career with an inaugural oration on the aesthetic components of the historical imagination. The names of many other historians — prominent, like Jakob Burckhardt, or half-forgotten, like Karl Lamprecht — also come to mind.

In the art-historical camp, history was not always so welcome. The more or less Marxist approaches to the study of art by Frederick Antal or Arnold Hauser got a polite, but generally cool, reception and, more importantly, did not inspire many young academics to follow their lead.[1] It is only over the last two decades that interest in the social, political, or cultural history of art has produced a great number of articles, books, and exhibition catalogs. This brings us back to our original question: What is the exact nature

17

of history and art history? Further, are they distinct disciplines? Are they disciplines at all? What, if anything, do they have to offer each other?

Let us begin with history. At the Getty Center for the History of Art and the Humanities in Santa Monica, California, where "historians" and "art historians" lived peacefully together for one year, one of the most frequently asked questions was: What does "The Historian" think of this, that, or the other? It is a difficult type of question, one for which I never knew the answer. The embarrassing truth is that as an academically certified historian, occupied with the study of what reasonably might be expected to be history, I do not have much of an idea of what the discipline really is. So-called historians are very much in search of an identity and have great difficulty defining a field that since the beginning of this century has progressively split into a variety of activities that seem to have little to do with each other. The obvious answer — that all of these specialities deal with the past — is of little help; the same claim can be made for geology, evolutionary biology, or astrophysics. The heart of the matter is that history, long considered a substantial field of study, is nothing more than a term denoting the temporal aspect of everything that can be spoken of in the past tense. The "history" of academic departments and curricula, the presumed discipline and methodology, and the historians themselves are to a large extent creations of the eighteenth and nineteenth centuries, invented to make sense of and give coherence to a secularized and incomprehensible present. History became a substitute for religion (as would happen to art somewhat later), and the historian became its high priest. Leopold von Ranke, the presumed father of modern history, wrote celebrated maxims about the methodology of his craft that were eagerly accepted as proof that history had become a science. In reality, however, Ranke's insistence that he only wanted to find out *"wie es eigentlich gewesen"* (how things had really been) could not obscure the fact that his work is, in the first place, an elaborate theodicy of German existence. In other nineteenth-century theories, history is personified: it becomes at once the theater and the vehicle of progress; in Hegel it can play tricks, and in Comte and Marx it knows the only path to the future. Fustel de Coulanges, Ranke's French counterpart, assured his students that in his lectures they heard history itself speaking through his mouth. It was the ultimate deification of history and elevation of the historian to the rank of interpreter of the meaning of life.

This is not the place to analyze how the methodological battles of the late

18

nineteenth and early twentieth centuries ended in the epistemological bank-ruptcy of history. The German neo-Rankeans fell back on an obscurantist elevation of intuition as the way toward historical understanding; Max Weber, on the other hand, proposed that all comprehension of the past rested ultimately on mental constructions that only attempted to arrange and understand data and events in certain ways. As a result, history ceased to be a coherent subject of study, nor did it, as a discipline, preserve its own methodology. The methodologies developed in other "properly defined" disciplines became tools for specialized students of the past (economics for the economic historian, sociology for the social historian, etc.), all of them epistemologically predestined to produce only ideal types. History *wie es eigentlich gewesen* was dead, the historian *tout court* was dead — epistemologi-cally speaking, that is, for up to the present day few historians seem to have noticed, and most are quite content with being at least academically and institutionally alive.

Historians of art now found themselves on equal footing with other stu-dents of the past, no more different from the economic historian than the latter was from the historian of science. Art historians had remained bliss-fully aloof from the epistemological battles that had been going on in the world of so-called historians. They had, in fact, been among the first to separate themselves from the historical herd by clearly, if simply, defining the object of their interest. More correctly stated, they had not so much separated themselves as they had emerged from a background entirely dif-ferent from that of history. The history of art first blossomed in the world of aesthetes, collectors, amateurs, connoisseurs, and "gentleman" scholars. It assumed in the first place the ability to express the allegedly notable and beautiful feelings evoked by the work of art. It also required, however, the systematic hard work of dealing with the artifact and analyzing and classi-fying elements of style — in short, the activities of the connoisseur, now so despised. It was probably this consciousness of exercising an esoteric craft that made early art historians rather uninterested in the broader cul-tural ramifications of their discipline. Alternatively, it might have been the nineteenth-century canonization of art as the highest achievement of human endeavor that prevented them from extending their curiosity to the vulgar goings-on in society. Indeed, for a long time the history of art remained — and in some contexts still remains — a socially rarified luxury business. Even when Aby Warburg and Erwin Panofsky broke through the limitations

of aesthetic, stylistic art history, their confrontation with other aspects of the past resulted in a highly esoteric history of ideas.

What, one may ask, does all of this have to do with the relations between art history and a history now declared defunct? It is to be hoped that this lengthy elucubration has shown that in identifying the distinctions and possible alliances between disciplines, the usual arguments from epistemology or *Wissenschaftslehre* are not particularly helpful. In order to define a discipline, one must study what scholars actually do rather than what philosophers suppose they do. This is especially true in our case, where art historians and historians of all kinds converge on a particular field of study. And though a moment ago we declared the historian *tout court* dead by epistemological standards, it may well be that in their daily practice, historians reveal certain characteristics that distinguish them from art historians.

This hypothesis is supported by the work of the most influential historical school in recent decades, that of the *Annales*. The fathers, or perhaps grandfathers, of that school, Marc Bloch and Lucien Febvre, bitterly attacked the narrowness of the traditional historian's specialization. They conceived the ideal of the "total" historian, an ideal that still hovers over their offspring like a menacing and oppressive superego. The total historians had to be generalists, sensitive to the idea of the whole yet expert in all areas relevant to their concerns. Even a cursory glance at the variety of articles in Febvre's *Pour une histoire à part entière* is a dizzying experience.

One can doubt the feasibility of the *Annales* program, but it did lay bare a glaring weakness of the specialization model of historical science. Specialization tears apart a web of relations that may not be seamless but nevertheless represents a connectedness of human endeavors, the inseparability of the social, the economic, the religious, and the artistic. To recapture that totality may prove an illusion, but even the most specialized historians need to think that they are part of the larger enterprise of recovering a complete past.

Is the upshot of theoretical investigation then that there are no differences between historians of art and those of other fields of investigation? Philosophically, this is probably true, but it would be unwise to leave it at that. As I said before, disciplines should be defined by what their practitioners *do*. It does not take much reflection to see that in practice all specialists live in different worlds. We see this every time an art historian moves into other areas of history or historians of whatever stripe hold forth on art. When, for example, Hessel Miedema and Svetlana Alpers polemicized about agrar-

ian history in order to define the meaning of the peasant in art, the debate must have struck social historians as excessively primitive.[2] On the other hand, Duby's *Age of the Cathedrals* was favorably reviewed by Nathalie Davis, a fellow social historian, while Michael Davis in the *Journal of Architectural Historians* virtually annihilated the book.[3] Somehow Miedema and Alpers on the one hand and Duby and Davis on the other must have missed handfuls of clues about neighboring, but nevertheless still alien, historical disciplines.

Is there then an essential difference between the history of art and that of other subjects? An epistemological approach to this question, as we saw before, will not get us very far. The important difference is not that of theory but of the everyday practice of our trades, the material with which we work and the questions that we ask. Familiarity with certain kinds of sources and problems creates a sort of connoisseurship and a communal language that excludes others, even those in fields close to our own. The literary forms in which we present our findings can only be fully understood by fellow specialists. The outsider misses the undertones and overtones and lacks the interpretative flexibility to fully understand the text.

This is by no means only true in the humanities or social sciences. The discovery of the double-helix structure of the DNA molecule by Francis Crick and James D. Watson provides an example. Watson, a geneticist, relates that he was initially frustrated in his attempts to build a model of the double helix. Lacking sufficient familiarity with biochemistry, he had copied the formula from a textbook. It was not until he showed his work to a biochemist that he found his mistake. The specialist admitted "that organic chemistry textbooks are littered with those forms: but all his chemical intuition told him that in this case the structures would appear in another form."[4] What matters, and what is instructive for our purpose, is that Watson's familiarity with the language of his own discipline limited his understanding of a field close to his own. He could learn that language superficially; he could not acquire what he himself calls the "right intuition."

If this is true in science, in the work of one of the great researchers of our time, we can understand Miedema, Alpers, and Duby: they did their homework and studied the appropriate secondary literature, but they derived formulas from it, not the feeling for a distant reality.

In many ways Watson's story casts a somber light on the usefulness of printed media. Without the personal interchange with the biochemist at the Cavendish Laboratory, he would never have made his discovery. On

the other hand, the story contains an encouraging moral and illustrates the enormous importance of bringing together scholars who can explain *orally* to each other what otherwise would have remained uncomprehended.

In sum, if cooperation between historians and art historians is to succeed, we must start from the assumption that different connoisseurship gives us different judgments of the same event or object. I would like to demonstrate this with my one personal experience in this area. In the course of writing a paper on soldiers in Dutch art, I tried to interpret Hendrick ter Brugghen's so-called *Sleeping Mars*. I found an excellent scholarly article on the painting by Erik de Jong, an article with which I viscerally disagreed from the beginning. In his study De Jong points out that the title of the painting (which is dated by specialists somewhere between 1623 and 1629) does not appear in written records until approximately twenty-five years later. Through a careful argument he attempts to prove that the title is nevertheless correct and that despite the absence of *all'antica* costume and other allegorical elements, we are dealing with a mythological-allegorical depiction of the Greco-Roman god of war.[5]

What is of interest now is not whether De Jong's or my interpretation is right but the difference in our ways of looking and in the signals picked up by our antennae. De Jong, who is accustomed to thinking that paintings are symbolic constructions, not direct mirrors of reality, brings to bear extensive knowledge of mythological representation. My eyes, however, were immediately drawn toward the drum in the painting. The drum is a conventional metonym for war. Given my experience with military sources, including diaries and eyewitness accounts of war, however, I could not imagine that the drum — whose roll was heard on a daily basis by the citizen in the town and the soldier in the field, where it relayed officers' commands — could have evoked a mere metonymical or metaphorical response in contemporary viewers. It was too concrete a part of their daily experience, I thought, to evoke such a mediated response. And there was more. The way the soldier (probably an officer) is dressed, as De Jong points out, is antiquated, and he argues that this sets the representation apart from concrete time. It is, however, not as antiquated as he thinks and shortly before 1600 remained the gala dress of the Spanish officer. In contemporary Dutch illustrations of war scenes, it is the costume that often distinguishes the Spanish military from the Dutch. My conclusion was, in short, that Ter Brugghen's soldier could not be a Mars to his contemporaries and that a complicated

allegorical interpretation was out of place because the image would have struck too many *immediate* experiential chords. Twenty-five years after the fact some learned antiquarians might have invented such an interpretation but not someone who lived the reality of war on a daily basis. What interests me here, I repeat, is not who is right but the difference in thinking, which has been developed in the course of very different ways of doing things and feeling things, different ways of converting intuitions into arguable propositions. And, if I am not mistaken, we social or sociocultural historians are more concerned with the range of audience responses and the lived realities that form these responses than historians of art. Obviously, one could test different pairs of historians and art historians, but I think that one would come more or less to the same conclusion. Historians would tend, often wrongly, to interpret images as reflections of reality, while art historians would be apt to recognize convention, imitation, creative and symbolic transformations of reality, or a mere product of the life of artistic forms.

If we are to find a useful basis for cooperation with historians of art, we must identify the sources of the confusion that historians experience in their confrontation with art, as well as the limited points of view or practices that emerge. This will be a tedious task, which is perhaps better left to philosophers after all. Although I realize that in writing I have gradually transformed the historian into the social historian, that is, a practitioner of my own speciality, I may, however, be able to speak in the name of historians of all persuasions about what we would like to gain from cooperation with historians of art.

Rudolf Wittkower in his "Interpretation of Visual Symbols" distinguishes usefully between four levels of meaning: the literal representational, the literal thematic, the multiple meaning, and the expressive meaning.[6] The last, Wittkower states, is obviously the central problem of art and the history of art. Historians, however, are no less interested in all four levels of meaning. They do not limit themselves to using art to document fact but want to understand art on the other three levels as well, above all on the level of expressive meaning, which encompasses the whole mysterious complex of taste and the aesthetic impulse in artists and their audience.

This area is fraught with interpretative dangers. Since art began to replace religion in the nineteenth century as a signpost to the meaning of life, an army of quacks has risen to explain the deep revelations of art to a pious, museum-going public. The problems of expressive meaning, of

aesthetics of forms as well as of style and of taste, are, however, of prime importance to all historians. This information is as vital to them as understanding biochemical formulas was to Watson. But the uninitiated historian can rarely enter this field without becoming a quack, and it is precisely here that partnership with an art historian is required.

Unfortunately, in the art-historical world the current trend is toward so-called "historical" interpretation, a reaction against the "ahistorical" practices of connoisseurship and formal, stylistic interest in art; this shift parallels the New Historicism in literary studies. Frankly, it is not a trend I observe with much sympathy. I do not doubt that our understanding of all forms of history can contribute to the understanding of art, but I think that historians per se are better at that than their colleagues in art history. More importantly, in my opinion, art historians are turning away from the central problems of their craft. The business of art history is *art*, and the intrinsic character of art is in its aesthetic urgencies — the mystery of man's need to imitate, transcend, abuse, or glorify the existing world in a configuration of spaces, forms, gestures, and colors. Lomenie de Brienne tells a moving story about Cardinal Mazarin shuffling around in his painting gallery a few weeks before his death. He hears Mazarin talking to himself plaintively, saying: "I must leave all this" and "I will no longer see these where I am going." Then again, when Brienne joins him, "Oh, my poor friend, one must leave all of this!" He mentions his *Venus* by Titian and a *Deluge* by Antonio Carracci and continues: "Farewell, my paintings which I have loved so much," adding with a touch so Mazarinesque that it alone validates the story, "and which have cost me so much."[7]

The art historian who, confronted with this story, decides to figure out how much Mazarin paid for his pictures makes, I think, the wrong decision. But to know what Mazarin had in mind — what made him so conscious of the bleakness of a heaven without art — to understand *that* should be the ambition of art historians. And only if they return to those essentials of the craft will there be a creative cooperation with other sorts of historians leading to a fuller understanding of history.

NOTES

1. Frederick Antal, *Florentine Painting and Its Social Background* (Boston: Boston Book & Art Shop, 1965); Arnold Hauser, *The Social History of Art* (New York: Alfred A. Knopf, 1951).

2. Svetlana Alpers, "Realism as a Comic Mode," *Simiolus* 8 (1975–1976); Hessel Miedema, "Realism and Comic Mode," *Simiolus* 9 (1977).

3. Michael Davis, "Georges Duby, *The Age of Cathedrals: Art and Society, 980-1420*," Journal of the Society of Architectural Historians 61, no. 2 (May 1982): 156–58.

4. James D. Watson, *The Double Helix* (New York and London: W. W. Norton, 1980), 110.

5. Erik de Jong, *Een schilderij centraal: De Slapende Mars van Hendrick ter Brugghen* (Utrecht: Centraal Museum, 1980).

6. Rudolf Wittkower, "Interpretation of Visual Symbols" in *Allegory and the Migration of Symbols* (Boulder, Co.: Westview, 1977).

7. Quoted in Francis Haskell, *Patrons and Painters*, 2nd ed. (New Haven and London: Yale Univ. Press, 1980), 186.

PART I: ART AND REALITY

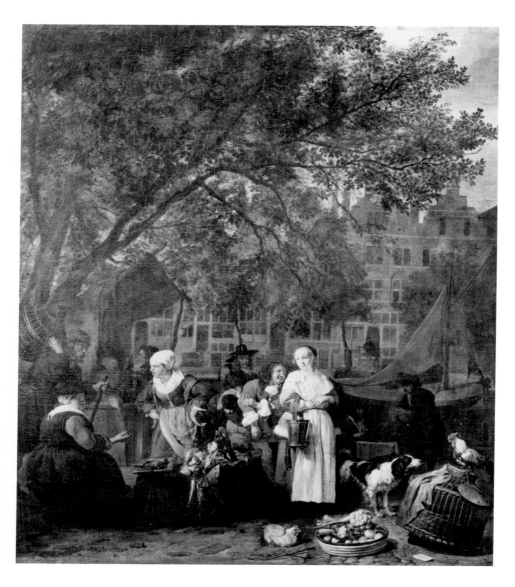

1. Gabriel Metsu,
 Vegetable Market at Amsterdam, ca. 1661–1662,
 oil on canvas, 97 x 83 cm.
 Paris, Musée du Louvre, no. 1460.
 Photo: Courtesy Réunion des musées
 nationaux, Paris.

Linda Stone-Ferrier

Market Scenes As Viewed
by an Art Historian

A large group of Dutch marketplace paintings appeared rather suddenly
after the mid-seventeenth century, and they raise a number of provocative
questions about the role of certain kinds of historical information in our
understanding of the meaning and function of these images and of seven-
teenth-century Dutch paintings in general.[1] Specific paintings in the group
have previously been discussed by art historians who have attempted to
understand individual marketplace paintings in one of two ways: either the
work was felt to contain a moral based on a biblical or emblematic text, or
it was of interest because of the particular stage that it represented in the
artist's stylistic development.

Although both types of inquiry into individual marketplace paintings
are undoubtedly relevant, they are limited. The relationship of the individ-
ual work to the whole group is at least as important to consider. Furthermore,
the relationship of the paintings to the specific historical circumstances or
contexts in which they were produced must be examined in order to under-
stand fully their meaning and function. Historians of Dutch art have too
often defined that historical context in terms of the world of contemporary
literature, and they have, as a result, only searched for sources of meaning
in texts.

Economic and social circumstances should be vigorously investigated
by students of marketplace paintings in particular and of seventeenth-
century Dutch art in general. Careful visual analysis of an image or group
of images — including their stylistic and iconographic characteristics — must,
however, precede the determination of the aspects of history that may be
relevant to interpretation.

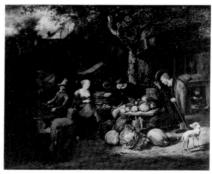

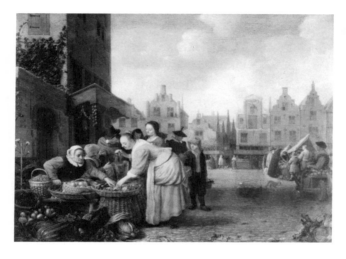

2. Hendrik Martensz. Sorgh,
 *The View of the Grote Markt with
 Vegetable Stall*, 1654,
 oil on panel, 30.5 x 40 cm.
 Rotterdam, Museum Boymans-van
 Beuningen, no. 1818.

3. In the manner of Jan Steen,
 Market Scene, mid-seventeenth century,
 oil on panel, 42 x 50 cm.
 Sold Sotheby's, New York, 15 January
 1987, lot 42.
 Photo: Courtesy Sotheby's, Inc., ©1987.

The large group of Dutch marketplace paintings in question may be subdivided according to the type of market depicted. This paper examines exclusively images of vegetable markets because the interpretative questions that they raise are distinct from those pertinent to other market painting types (for example, fish market paintings). The differences result not only from the various ways in which each market type is depicted but also from their respective historical circumstances.

The characteristics shared by the vegetable market images are unprecedented. These paintings show vendors and customers in front of contemporary buildings, as in Hendrik Martensz. Sorgh's painting *The View of the Grote Markt with Vegetable Stall*, 1654 (fig. 2). The foodstuffs are very carefully described and prominently displayed in the foreground, as they are in a mid-seventeenth century painting by Nicolaes Maes and his studio, *Vegetable Market* (Amsterdam, Rijksmuseum), a contemporary work by a follower of Jan Steen, *Market Scene* (Boston, private collection), and a mid-seventeenth century painting in the manner of Steen sold recently at Sotheby's (fig. 3). The figures in such works are depicted full-length and appear rather small in relation to the size of the composition, as in a painting by Sorgh, *Vegetable Market*, circa 1662 (Amsterdam, Rijksmuseum). What interaction there is seems anecdotal rather than narrative.

Gabriel Metsu's *Vegetable Market at Amsterdam*, circa 1661–1662 (figs. 1, 12, 13), shows the vegetable vendors and their goods prominently positioned in the foreground. Other vendors are also shown behind the vegetable sellers: a fisherman walking in from the left; a woman selling a hare; and a woman selling some kind of liquid in a flask to a gentleman on the right who wears a turban. Behind them is a small boat on the canal that separates the vendors from a figure standing on a stoop looking out of the picture.

Such subjects were popular, as the large number of surviving paintings suggests. During the 1650s prototypes were made by artists of the Leiden school, the community where Metsu lived and studied.[2] The pictorial tradition was continued in Amsterdam, Rotterdam, and Delft, communities that figured prominently in the history of Dutch horticulture.[3] In Holland vegetables were first and most extensively grown in Leiden. Subsequently, Amsterdam, Rotterdam, and Delft became important horticultural growing and marketing centers. The increasing importance of horticulture in these towns paralleled the production of the marketplace paintings during the second half of the seventeenth century, and the vegetables in these

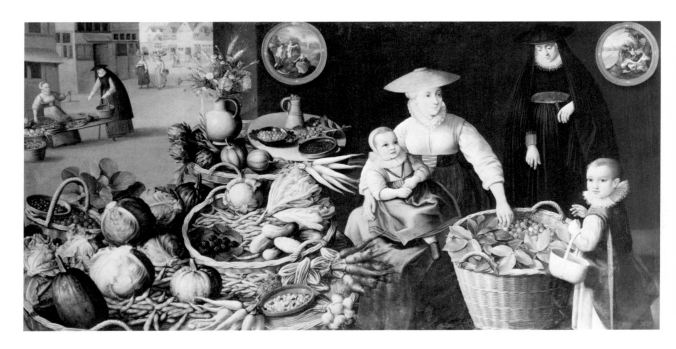

4. Circle of Lucas van Valckenborch
 and Georg Flegel,
 Vegetable Market (July-August),
 late sixteenth century,
 oil on canvas, 109 x 220 cm.
 Vienna, Kunsthistorisches Museum, no. 7626.

paintings were often those produced or traded in the places depicted.

This suggests a relationship between the importance of Dutch horticulture in certain cities and the vegetable marketplace paintings produced in precisely the same locales. Before examining this connection, however, it is advisable to consider some of the possible pictorial precedents for the marketplace paintings. If the seventeenth-century paintings did not evolve from earlier depictions of vegetables or marketplaces, then the influence of certain historical factors — namely the development of Dutch horticulture and the growth of markets — on these paintings would appear to have been a strong one.

It is well known that so-called market scenes or kitchen paintings were produced by Pieter Aertsen and Joachim Beuckelaer in the mid-sixteenth century. Paintings such as Aertsen's *Christ in the House of Martha and Mary*, 1553 (see p. 67), share an interest in the careful depiction of various foods, including vegetables, with the mid-seventeenth-century marketplace paintings. The similarity is not strong enough, however, to conclude that the seventeenth-century Dutch marketplace paintings evolved from the sixteenth-century kitchen paintings. The two groups of paintings differ visually in ways that significantly distinguish their meanings and functions. Many of the earlier works feature monumental, encyclopedic displays of food in the immediate foreground, as opposed to portraying an anecdotal marketplace. The background scenes in many of the Aertsen and Beuckelaer paintings have been identified as biblical narratives that represent spiritual food and, therefore, a contrast with the real food in the foreground.[4] The seventeenth-century Dutch marketplace paintings do not have the sharp contrast between foreground and background scenes, and none of the later paintings depict biblical subjects.

There are other earlier groups of paintings to which the seventeenth-century Dutch marketplace paintings may be compared and which suggest a possible evolutionary progression. Market goods are found in the late sixteenth-century series of the seasons and months by Lucas van Valckenborch or by his circle in collaboration with Georg Flegel, for example the *Vegetable Market (July-August)* (fig. 4).[5] Two painted roundels with the words *Julius* and *Augustus* inscribed on them show other scenes associated with the time of year. In another painting by a member of Van Valckenborch's circle and Flegel, *Fruit Marketplace (September and October)* (Vienna, Kunsthistorisches Museum, no. 2204), the fruit marketplace represents

the produce associated with the fall season.

The descriptive and compositional emphasis Van Valckenborch placed on vegetables and other foodstuffs suggests that the pictures have much in common with paintings like Metsu's *Vegetable Market at Amsterdam*. Ultimately, however, the Van Valckenborch paintings are fundamentally different. They were conceived as part of a series symbolizing seasons or months, whereas the seventeenth-century Dutch paintings function as individual works of art.[6]

The structure of the earlier series, in contrast with the seventeenth-century paintings, suggests religious associations such as those that had once appeared in medieval church sculptural programs and in illuminated manuscripts — in short, the "calendar tradition." The longevity and popularity of the convention of cyclical imagery would have made the religious associations of the subsequent cycles generally self-evident.[7] The seventeenth-century marketplace paintings are significantly different in conception and structure from the Van Valckenborch paintings and, thus, cannot have evolved from them.

Although they prominently display foodstuffs, including vegetables, neither of the earlier groups of images appears to be directly or even closely related to the later paintings. It is possible, however, that other distinguishing characteristics of the later paintings, for example, the site of the marketplace itself, may have had roots in earlier imagery. Painted cityscapes and topographical views in city histories and maps provide both a precedent and a contemporary parallel for the way in which the marketplace is shown as a distinctive locale in the group of paintings under consideration. The demand for painted cityscapes evolved at the same time as the market paintings by Metsu and others.[8] It is therefore important to investigate whether they resulted from the same patronage demands, served the same function, and carried the same meaning.

Painted cityscapes — which included aspects of civic life such as markets — are exemplified by Gerrit Adriaensz. Berckheyde's *Flower Market in Amsterdam*, circa 1670–1675 (fig. 5).[9] Cityscapes evolved from late sixteenth- and early seventeenth-century topographical drawings and prints of city views, such as Gerard ter Borch's drawing of the *Vegetable Market on the Grote Markt in Haarlem*, circa 1635–1640 (Haarlem, Teylers Museum).[10] Claes Jansz. Visscher's *Profile of Amsterdam with Description*, 1611, exemplifies cartographic views of a city that combine either a bird's-eye profile or

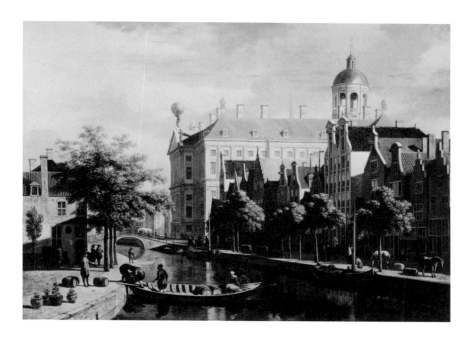

5. Gerrit Adriaensz. Berckheyde,
Flower Market in Amsterdam, ca. 1670–1675,
oil on canvas, 45 x 61 cm.
Amsterdam, Amsterdams Historisch
Museum, no. A 7455.

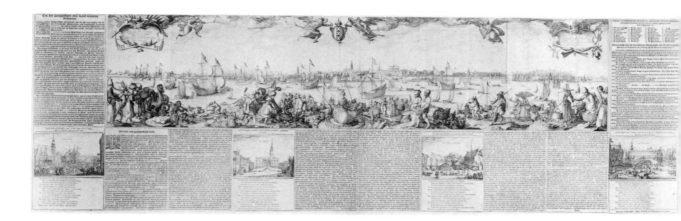

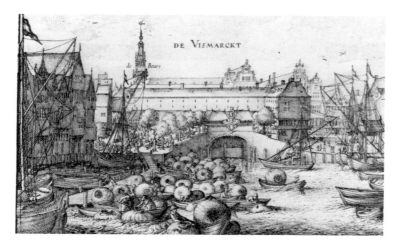

6. Claes Jansz. Visscher,
 Profile of Amsterdam with Description, 1611,
 engraving and etching, 26 x 112 cm.
 Rotterdam, Historisch Museum, Stichting
 Atlas van Stolk.

7. Detail of fig. 6,
 De Vismarckt.

plan with smaller topographical prints depicting close-up views of particularly important buildings or markets, such as the fish market (figs. 6, 7).[11] The importance of the buildings or markets was extolled in accompanying chauvinistic texts. Visscher's print is inscribed, *"tot een eeuwighe Memorie, lof van deze voortreffelijcke stadt"* (in the eternal memory, in praise of this excellent city).[12]

The cityscape paintings share with Metsu's *Vegetable Market at Amsterdam* and the other marketplace paintings a celebration and commemoration of a small-scale economic enterprise associated with a particular community. In this limited sense, the marketplace paintings and cityscapes in paintings and maps have a similar function, meaning, and perhaps origin. The cityscapes, however, sacrifice the close-up description of food or flowers and vendors for the careful depiction of recognizable buildings and landmarks of the community with which they are identified. In contrast, the vegetables described in the marketplace paintings are as central to the meaning and function of the images as is the description of place.

Depictions of marketplaces as landmarks also appeared in seventeenth-century city histories and descriptions. These publications date from nearly the same time as Metsu's *Vegetable Market at Amsterdam*. Between 1662 and 1665, a half century after the first city history of Amsterdam was published, eleven histories of Amsterdam were issued to satisfy a seemingly insatiable market.[13] Both the history publications and Metsu's painting pay special attention to the community's economic prosperity, as well as to local color. Amsterdam's celebrated marketplaces received more attention with each new edition of the histories.

In Tobias van Domselaer's *Beschrijvinge van Amsterdam*, 1665, which drew heavily on earlier publications,[14] a new, separate section was provided on the vegetable and carrot market. He explained where the market was previously located and where it was currently situated.[15] Two eighteenth-century prints of the Amsterdam vegetable market show its seventeenth-century location, as well as its later expansion. A print by Jan Schenk, *Prinsengracht Seen from Reesluis toward Westerkerk*, first half of the eighteenth century (fig. 8), shows that the market ultimately extended on the west side of the Prinsengracht north to the Eglantiersgracht and south to the Looiersgracht. In a print by Johannes Pieter Visser Bender after a drawing by Jacob Cats, *The Strawberry Market, Amsterdam*, end of the eighteenth century (fig. 9), the vegetable market is shown on the east side of the Prinsengracht. There

37

8. Jan Schenk after Abraham Rademaker,
 *Prinsengracht Seen from Reesluis
 toward Westerkerk*,
 first half of the eighteenth century,
 etching and engraving, 56.6 x 98.5 cm.
 Amsterdam, Gemeentearchief.

9. Johannes Pieter Visser Bender after
 a drawing by Jacob Cats,
 The Strawberry Market, Amsterdam,
 end of the eighteenth century,
 engraving, 55 x 85 cm.
 Amsterdam, Gemeentearchief.

the market eventually extended as far north as the Westermarkt and as far south as the Berenstraat. The descriptions of the vegetable market in city histories acknowledged the increasingly colorful aspect of street commerce, which is also reflected in Metsu's painting.

The physical expansion of Amsterdam's vegetable and carrot market in the 1650s, which the histories were quick to describe, revealed the city's increasingly vital role in vegetable marketing. At the same time the cultivation of vegetables in the Netherlands expanded and increased in reputation due to growth in demand. In the early seventeenth century the areas around Leiden and Delft were especially known for the cultivation of "coarse" vegetables, including cabbages, carrots, turnips, parsnips, and onions; in the second half of the seventeenth century they were known for "fine," or leafy vegetables, including lettuce, spinach, and cauliflower.[16] Metsu depicted both types in *Vegetable Market at Amsterdam*.

During the first half of the century, the coarse vegetables were in demand because they were inexpensive and because of their association with a moderate life-style — one that did not include fancy foods. Govaert Flinck's painting *Marcus Curius Dentatus Who Scorned His Enemy's Gold and Chose a Meal of Turnips Instead*, 1656 (fig. 10), commissioned for the new Amsterdam Town Hall, extolled such a virtue. The painting hung in the burgomasters' assembly chamber and was inscribed: "So the city was built through Moderation and Loyalty."[17]

By mid-century Dutch participation in horticultural innovation as well as marketing was exemplified by the development of the "Horn" carrot — the short, bright orange variety.[18] The Horn carrot was depicted for the first time in Gerrit Dou's painting *The Quacksalver*, 1652 (see p. 71). The carrots may be seen on the wheelbarrow to the left and in the basket on the ground to the right. Metsu's painting also shows the new vegetable; this reflects the artist's desire to depict the most recent Dutch horticultural innovations rather than to adhere to outmoded artistic conventions.[19] Metsu's accurate depiction of the Horn carrot is significant because other artists exercised artistic license in treating this and similar subjects. Some painters, for example, depicted vegetables that did not grow at the same time of the year, may never have existed, or are not recognizable.[20] Metsu chose to honor developments in contemporary Dutch horticulture with a realistic depiction rather than to resort to artistic license.

The accurate depiction of other vegetables in Metsu's painting also

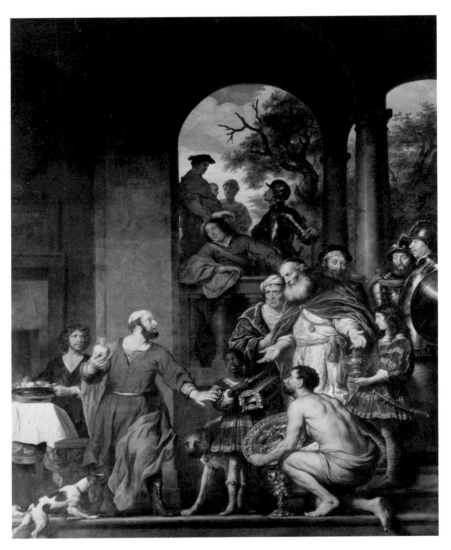

10. Govaert Flinck,
*Marcus Curius Dentatus Who Scorned His
Enemy's Gold and Chose a Meal of Turnips
Instead*, 1656,
oil on canvas, 485 x 377 cm.
Amsterdam, Koninklijk Paleis op de Dam.

testifies to the artist's decision to conform to reality. One of the new, so-called "fine" vegetables, cauliflower, rests in the basket in the lower right-hand corner of Metsu's painting. Expensive, fine vegetables supplemented the market for cabbages, onions, and carrots and met a demand created by the improved economic status of the Dutch population as a whole.

Many vegetable growers, especially in Leiden, became rich by intensely cultivating the soil in an effort to meet the growing market for both coarse and fine vegetables.[21] This expansion was enabled to a great degree by the fact that cultivation was no longer limited to the areas immediately surrounding large cities. During the sixteenth century the growth of a network of local markets established to meet rural needs and a good system of transportation that linked rural production to urban markets, especially along waterways, permitted large-scale cultivation to take place in the most conducive areas.[22]

At this time many small villages requested market privileges to meet their growing needs and to compete with the services and goods offered by the urban marketplaces. The cities' vehement protests and the subsequent legislation designed to suppress rural markets testify to the economic importance of the marketplace — both urban and rural — and to the extent of a community's identification with its marketplace.[23] The depiction of the market in Metsu's painting thus had more than casual associations for the artist and his contemporary viewers. The marketplace was patronized and governed by the community, not owned or operated by private individuals. Its depiction would have strongly appealed to a wide spectrum of citizens, who would have felt civic pride on seeing (or owning) such paintings.

The high value placed on the right to hold a market can be demonstrated more specifically by the now-famous Alkmaar cheese market, depicted in Romeyn de Hooghe's etching, *The Waagplein with the Weigh House in Alkmaar*, 1674. In 1581 the States-General granted the city permission to establish the cheese market in appreciation of Alkmaar's role in 1573 as the first Dutch city to thwart an attempted Spanish invasion.[24] Subsequently, the Heilige Geestkapel was transformed into the cheese weigh house (it still functions as such today). The reward for bravery in defending the northern provinces — a valiant and celebrated military effort — was the right to establish this local market. The value placed on a city's market and its associations with the community's economic, social, and political well-being are also reflected in Cornelis Beelt's painting *The Proclamation of the Treaty*

of Münster on the Grote Markt, Haarlem, date unknown (Amsterdam, Rijksmuseum, no. c93), in which the announcement of the end of the Eighty Years' War in 1648 fittingly takes place in the city's marketplace instead of, for example, in the town hall.

In spite of competition, the well-established urban marketplaces continued to dominate the rural ones. Amsterdam became the marketing center for the coarse and fine vegetables sent from communities all over North and South Holland.[25] In order to protect local interests, the Amsterdam city government passed extensive regulations controlling the quality and trade of such vegetables.[26] A regulation in 1664, for example, forbade the sale of "rotten, spoiled, or defective spinach, cucumbers, and carrots, ears of corn, radishes or other 'fruits' [that is, vegetables] because pride could not be taken in or from such things."[27]

Metsu's painting and others like it were produced in a society in which the right to hold a market was necessary but difficult to obtain. In view of this and the fact that the market was regulated by civic codes insuring quality and protecting the community's reputation, marketplace paintings must have evoked political and economic pride. They cannot simply be taken to represent a casual and arbitrary slice of Dutch life.

Pride in the community market was paralleled by the great contemporary achievements in Dutch horticulture. Foreigners who traveled through the provinces to study Dutch agriculture testified to the international fame that it enjoyed. Already in the sixteenth century Lodovico Guicciardini praised the flavor of Netherlandish vegetables over those grown in Italy.[28] English writers such as John Parkinson and Samuel Hartlib described the introduction and substantial importation of Dutch vegetables to England. In his *Legacy of Husbandry*, 1651, for example, Hartlib commented that cabbages, cauliflowers, turnips, carrots, parsnips, rape, and peas were "few or none in England but what came from Holland and Flanders."[29]

Needless to say, the Dutch themselves showed great interest in the variety and uses of plants and vegetables, some of which were only developed in the seventeenth century. From as early as the mid-sixteenth century, for example, such interest was manifested in illustrated herbals, which offered considerable information in the form of lengthy texts and copious images. In a page from Rembert Dodoens's *Cruyde-boeck*, 1554, for example, beets are illustrated and discussed (fig. 11).

Dodoens's *Cruyde-boeck*, the first herbal published in the Netherlands,

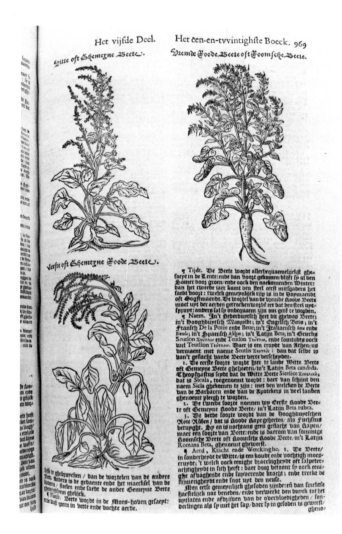

11. *Beets* from Rembert Dodoens's
Cruyde-boeck (Antwerp, 1554).
Wageningen, Special Collections,
Agricultural University Library.

was written in Dutch rather than Latin. On the title page the author urges that the information in the herbal be as accessible to laymen, who were increasingly interested in such books, as to scholars.[30] Dodoens's wish makes clear the widespread interest in plants and vegetables among all literate social strata from the middle of the sixteenth century onward, and herbals continued to be published in Dutch throughout the seventeenth century. Reprints of Dodoens's book were published by Francoys van Ravelingen (Leiden, 1608 and 1618) and Balthasar Moretus (Antwerp, 1644).[31] The illustrations for such herbals provide reliable visual information about scientific interest in the description of herbs, plants, and vegetables. Some of the accompanying texts, however, provide confusing or conflicting information, referring to different images of plants or herbs by the same names. Carrot (*Daucus carota* L.) and parsnip (*Pastinaca sativa* L.), for example, were often mistaken for each other, and both were referred to as *peen*.[32]

It has already been noted that Metsu included accurately rendered vegetables in his *Vegetable Market at Amsterdam*. His depiction of the Horn carrot, for example, reflected a recent Dutch horticultural innovation. Accurately rendered beets, as in Dodoens's herbal, can also be seen in Metsu's painting (fig. 12). Since Metsu's knowledge of vegetables was shared by the large number of readers of herbals, the painter's interest was not unique or accidental. Presumably, readers of herbals were often viewers of marketplace paintings, and at least some of the interest in the accurate description of a plant or vegetable was satisfied both by pictures and books. The art, therefore, should be considered in the larger context of contemporary interest in horticultural achievements.

Another form of publication that demonstrates both the fame of and interest in Dutch horticulture is the practical garden book. Although examples were published throughout Europe, including the Netherlands, well before mid-century, their publication flowered soon thereafter in the Netherlands. Indeed, these books reflected Dutch horticulture's international prominence.[33] For example, Jan van den Groen's *De Nederlandse hovenier*, first published in 1669, was quickly followed by seven more editions.[34] The great interest in such books in the second half of the century was presumably due to the increased production of coarse and fine horticultural crops for marketing and to the increased interest in having one's own country home and accompanying private garden.

The impact of Dutch horticulture spread far beyond the particular com-

12. Detail of fig. 1, Gabriel Metsu,
 Vegetable Market at Amsterdam.

13. Detail of fig. 1, Gabriel Metsu,
 Vegetable Market at Amsterdam.

munity in which the produce was grown and attained international importance as a result of exports and widely disseminated horticultural writings. Curiously, however, the subject of horticultural gardening and the cultivation of Holland's famous tulips were not depicted by Dutch painters. Only paintings of domestic gardens by Pieter de Hooch, such as *A Girl with a Basket in a Garden*, circa 1661 (Basel, Kunstmuseum), even remotely allude to contemporary Dutch interests in horticulture.[35] Instead, it can be argued that a community's proud identification with a locally produced or marketed crop found its visual expression in scenes of specific marketplaces on city maps, in topographical prints, and ultimately in the marketplace paintings.

But such broad historical trends cannot explain every art historical phenomenon. When we return to Metsu's *Vegetable Market at Amsterdam*, we find curious aspects of the painting that distinguish it from the group and that cannot be understood in terms of the historical context as discussed so far. The painting's idiosyncratic aspects derive not from the history of seventeenth-century Dutch markets and horticulture but from Dutch drama.

Metsu's painting is distinguished by a number of theatrical qualities, including several pairings of figures, who interact with exaggerated gestures. The figures and the background buildings are placed parallel to the picture plane, as if on a stage. A canopy of leaves from the trees on the left functions like a stage coulisse. Two of the figures look directly out at the viewer as if they are addressing an audience. The costume worn by the figure in the center is not contemporary in either color or style but is instead associated with a certain Dutch theatrical stock character, Capitano, from the *commedia del l'arte*, who is dressed as a fashionable dandy.

A study of seventeenth-century Dutch drama reveals that significant aspects of Metsu's painting may be compared to the famous description of Amsterdam's markets in the popular play *Moortje* by Amsterdam's beloved playwright Gerbrand Adriaensz. Bredero.[36] Throughout Bredero's farce, the seedy, sycophantic Frenchman *Moncksuer Kackerlack* (Monsieur Cockroach) — a servant — is a pivotal character who manipulates and exploits situations to his own advantage.[37] In a lengthy description of a walk through Amsterdam's markets, Kackerlack explains his ability to flatter and fawn on the wealthy and powerful by exaggerating their intelligence and good manners. The account of the walk through Amsterdam's markets is remarkable for its extraordinarily colorful language and detail.[38]

46

Many elements in Monsieur Kackerlack's description of the markets find visual correspondence in *Vegetable Market at Amsterdam*, resulting in a rich and complex relationship between the play and the painting. Metsu's painting, however, does not replicate Kackerlack's description of the city's markets; Metsu singles out and depicts most prominently the vegetable market vendors and their goods. On the other hand, the similarities are numerous. First, it appears that Metsu has actually depicted Kackerlack in the center of his painting (fig. 13). The figure wears a bright red, sixteenth-century Burgundian costume with slashed sleeves, breeches, and feathered hat. The bright color was associated with the extravagance of the French,[39] and it was therefore appropriate for Kackerlack, the flatterer, who liked to greet those whom he exploited *"à la mode de Fransche"* and who was referred to as *"monsuer."*[40] The style of the costume worn by the bowing figure in Metsu's painting is similar to that worn by Capitano, who like Kackerlack was a servant.[41] The same costume appears on the servant in Metsu's *Brothel Scene*, early to mid-1650s (Leningrad, State Hermitage Museum). The costume is also worn by the servant in *Lazarus and the Rich Man*, 1650s (Strasbourg, Musées de la Ville), formerly attributed to Metsu but now tentatively attributed to Jan Steen.[42]

During Kackerlack's walk through Amsterdam's markets he tells of meeting a neighbor's maid who had bought a basket of mussels for two *stuivers*. Kackerlack describes her as a *"parlde pop,"* which literally means a "doll with pearls" but metaphorically refers to an elegantly dressed and made-up woman.[43] The young woman to whom Kackerlack bows in Metsu's painting is also dressed elegantly in fur and yellow satin, wears — like the *"parlde pop"* — pearl earrings, and carries a pail (fig. 13). There are other similarities between Bredero's play and Metsu's painting. Kackerlack describes his experience at the Amsterdam market, which includes an exchange with an earthy vegetable woman. She tries to sell Kackerlack precisely those vegetables displayed so prominently in the foreground of Metsu's painting: parsnips, beets, cabbage, cauliflower, Horn carrots, and turnips.[44]

Although written early in the seventeenth century, Bredero's *Moortje* was reprinted three times before mid-century, appeared in three editions of his complete works before 1645, and surpassed his other plays in popularity after 1650.[45] It was performed twenty-two times between 1646 and 1666 in the Amsterdam theater, including a command performance in 1662 — the approximate date of Metsu's painting. It was played before the city's

14. Pieter van de Berge,
"Junius"/View North from the Berenstraat
from a series of twelve drawings of the
seasons, ca. 1690,
pen, ink, and wash on paper.
Amsterdam, Gemeentearchief.

magistrates, to whom the performance was dedicated.[46] Significantly, the general popularity of the play was derived in large part from Kackerlack's description of the markets. The market adventure was so well known that in the 1650s it was imitated in plays by two other Dutch playwrights, M. Waltes and J. van Paffenrode.[47]

By incorporating elements from Bredero's famous description of Amsterdam's markets into the established conventions of marketplace paintings, Metsu created an image that celebrated not only the Dutch pride in horticultural innovation and Amsterdam's important role as a market center but also the colorful and lively exchange of goods and banter associated with the street life of the marketplace. The civic pride in Amsterdam's commerce evoked by the painting was enriched by the pleasure viewers could take in the allusion to the famous play by Bredero, their beloved native son.

A final piece of the interpretative puzzle remains, however. Why did Metsu choose to focus on the vegetable market rather than on any of the other Amsterdam markets described in Bredero's farce? The choice suggests that the vegetable market was most meaningful or most familiar to Metsu. This leads us to ask several questions: What actual contact, if any, did he have with Amsterdam's vegetable market? Was he involved himself in horticultural production or sales? Did he have any firsthand experience with the vegetable marketplace? In actuality, Metsu's contact with the Amsterdam vegetable market was uncomplicated but significant. He lived on the Prinsengracht in Amsterdam, precisely where the vegetable market took place. Two documents from the 1650s in the Amsterdam archives reveal that Metsu lived in the alley near the Crowned Stag brewery, also referred to as the Red Stag.[48] The brewery was located at Prinsengracht 353–57 on the east side of the canal just south of the Rheestraat Bridge. A drawing (circa 1690) by Pieter van de Berge in the Amsterdam city archives shows a view, looking north, of the east side of the Prinsengracht and the brewery with the sign of the stag (fig. 14). A late nineteenth-century atlas depicts the location of the seventeenth-century buildings; we can see the brewery and the alley in which Metsu must have lived, just a few doors away at Prinsengracht 363–71 (figs. 15, 16). The Crowned Stag medallions are still visible today at the same location on the Prinsengracht, as is the alley where Metsu presumably lived. Metsu's view across the Prinsengracht, looking from east to west, is most likely the view in *Vegetable Market at Amsterdam*. Regardless of the exact location of Metsu's house, he would have had first-

15. Amsterdam atlas, plate 46, 1876,
chromolithograph, 46 x 57.5 cm.
Amsterdam, Gemeentearchief.

16. Amsterdam atlas, plate 51, 1876,
 chromolithograph, 46 x 57.5 cm.
 Amsterdam, Gemeentearchief.

51

hand knowledge of the Amsterdam vegetable market; it took place, almost literally, in his front yard.

Although circumstances in the lives of artists do not always account for the artistic choices that they make, the visual evidence of *Vegetable Market at Amsterdam* coincides precisely with at least one aspect of the artist's biography, his Amsterdam address. Therefore, contrary to the claim that Metsu's paintings show little awareness of the contemporary scene in Amsterdam,[49] the painter seems to have been deeply engaged with several aspects of the city's life. Metsu combined his knowledge of his neighborhood market with pictorial conventions of contemporary market paintings; he evoked the pleasure taken in Bredero's staged verbal portraits of Amsterdam's markets; and he displayed a certain familiarity with the horticultural developments and trade that brought economic success and fame to Amsterdam. All this is no more and no less than the background to Amsterdam's outdoor markets today.

NOTES

Expanded versions of this essay may be found in the following publications: "Gabriel Metsu's *Vegetable Market at Amsterdam:* Seventeenth-Century Dutch Market Paintings and Horticulture," *Art Bulletin* 71, no. 3 (September 1989): 428–52; "Gabriel Metsu's *Vegetable Market at Amsterdam* and Its Relationship to a Bredero Farce," *Artibus et Historiae* (forthcoming).

1. I found nineteen examples of vegetable marketplace paintings in the Rijksbureau voor Kunsthistorische Documentatie in The Hague. Contributing artists include Quirijn van Brekelenkam, Nicolaes Maes, Gabriel Metsu, Michiel van Musscher, Hendrik Martensz. Sorgh, and Jan Steen.

2. Franklin W. Robinson, *Gabriel Metsu (1629-1667): A Study of His Place in Dutch Genre Painting of the Golden Age* (New York: A. Schram, 1974), 15.

3. Ibid., 45.

4. Kenneth Craig, *"Pars Ergo Marthae Transit*: Pieter Aertsen's 'Inverted' Paintings of Christ in the House of Martha and Mary," *Oud Holland* 97, no. 1 (1983): 25–39; idem, "Pieter Aertsen and the Meat Stall," *Oud Holland* 96, no. 1 (1982): 1–15; Ardis Grosjean, "Toward an Interpretation of Pieter Aertsen's Profane Iconography," *Konsthistorisk tidskrift* 43, nos. 3–4 (December 1974): 121–43; and others.

5. The paintings are discussed by A. Wied, "Lucas van Valckenborch," *Jahrbuch der kunsthistorischen Sammlungen in Wien* 67, no. 31 (1971): 175–81. Other examples include Arnout

de Muyser's *Market with Vegetables, Fruit and Fowl* and *Market with Flowers, Fruit and Vegetables*, late sixteenth century (Naples, Museo e Gallerie Nazionali di Capodimonte). Although only these two paintings by De Muyser are extant, it is probable that others originally existed or were planned to complete the season series. The De Muyser paintings resemble Van Valckenborch's *Fruit and Fowl Market*, 1594 (The Hague, collection of H. Jochems) in particular, which suggests that the two artists may have known of each other's work. Wied discusses still other examples of the market genre possibly by Frederik van Valckenborch (a nephew of Lucas), Martin II van Valckenborch (the son of Lucas I), Van Valckenborch's workshop assistants, and Dirck de Vries (ibid., 177–80).

6. Series of the elements also frequently depicted vegetables or vegetable markets to symbolize the earth, as in the engravings of the four elements *Perspective corporum regularium* of 1568 by Jost Amman after Wentzel Jamnitzer (Wolfenbüttel, Herzog August Bibliothek), see Gerhard Langemeyer and Hans-Albert Peters, *Stilleben in Europa*, exh. cat. (Münster: Westfälisches Landesmuseum für Kunst und Kulturgeschichte; Baden-Baden: Staatliche Kunsthalle, 1979–1980), 143–44; the engravings of four elements by Nicolas de Bruyn after Maerten de Vos (Braunschweig, Herzog Anton Ulrich-Museum), ibid., 145-46; and two mid-seventeenth-century paintings by Quirijn van Brekelenkam of the elements water and earth, personified by a fisherman and a vegetable woman, Herzog Anton Ulrich-Museum, Braunschweig, *Die Sprache der Bilder: Realität und Bedeutung in der niederländischen Malerei des 17. Jahrhunderts*, exh. cat. (Braunschweig: Herzog Anton Ulrich-Museum, 1978), 54–56.

7. By the sixteenth century, the calendar tradition was adopted and adapted to various functions and media — paintings and prints, such as Pieter Bruegel the Elder's series of five paintings of the *Seasons*, 1565 (Vienna, Kunsthistorisches Museum; Prague, National Museum; New York, The Metropolitan Museum of Art), in which overt religious and astrological signs were omitted, and Crispijn de Passe's *Twelve Months*, circa 1590, in which each of the twelve etchings depicted the appropriate sign of the zodiac, an inscription, and scenes in the foreground and background. See Bob Haak et al., *Opkomst en bloei van het Noordnederlandse stadsgezicht in de 17de eeuw (The Dutch Cityscape in the Seventeenth Century and Its Sources)*, exh. cat. (Amsterdam: Amsterdams Historisch Museum; Toronto: Art Gallery of Ontario, 1977), 80–81. The particular labor considered appropriate to a given month or season became traditional. It is not surprising, therefore, to find that the late summer and early autumn were represented by Bruegel as fruit harvesting in a landscape, by De Passe as a fruit seller offering her goods at a market stall, and by the member of Lucas van Valckenborch's circle and by Georg Flegel as a fruit marketplace.

8. Ibid., 194.

9. Ibid., 206-7.

10. Ibid., 150. Ter Borch's drawing belongs to the artist's larger group of such views of

Haarlem's markets, which date from 1634 to 1640.

11. Ibid., 116–17. A painted version of such a bird's-eye profile of an entire city with smaller topographical views is exemplified by Jacob van der Croos's *View of the Hague with Twenty Scenes in the Neighborhood*, 1663 (The Hague, Haags Gemeentemuseum). See Bob Haak, *The Golden Age: Dutch Painters of the Seventeenth Century*, ed. and trans. Elizabeth Willems-Treeman (New York: Harry N. Abrams, 1984), 330.

12. Renée Kistemaker and Roelof de Gelder, *Amsterdam: The Golden Age, 1275–1795* (New York: Abbeville, 1982), 69; Haak et al. (see note 7), 116.

13. I. H. van Eeghen, "Illustraties van de 17de eeuwse beschrijvingen en plaatwerken van Amsterdam," *Amstelodamum*, Zesenzestigste jaarboek van het genootschap (1974): 98–198. In 1611 the first publication of Amsterdam's history, *Rerum et urbis Amstelodamensium historia*, was written by Johannes Pontanus and published by Judocus Hondius. This is the earliest book on Amsterdam mentioned in Wouter Nijhoff's *Bibliographie van Noord-nederlandsche plaats-beschrijvingen tot het einde der 18de eeuw*, 2nd ed. (The Hague: Martinus Nijhoff, 1953). In 1614, two years after Pontanus's death, a Dutch translation of the book, *Historische beschrijvinge der seer wijt beroemde coopstadt Amsterdam*, was published. The 1611 edition contained seven large illustrations and fifty smaller ones, forty-seven of which dealt with discovery trips and only three of which depicted scenes in Amsterdam. The 1614 publication consisted of only one additional small illustration of Amsterdam, Van Eeghen (see above), 96–97. In contrast with the fruit market, Pontanus did not describe the vegetable market in any detail, probably because the vegetable sellers were not guild members whereas the fruit sellers were (Jos van Assendelft, Renée Kistemaker, Michiel Wagenaar, *Amsterdam: Marktstad* [Amsterdam: Dienst van het Marktwezen, 1984], 45).

14. Van Eeghen (see note 13), 104. In addition to Van Domselaer, three other authors were responsible for the eleven publications of city histories between 1662 and 1665: Olfert Dapper, Melchior Fokkens, and Filips von Zesen.

15. The author explains that originally the market had been on the west side of the Oudezijdsvoorburgwal, to the south of the Varke-sluys, in front of the S. Pieterskerkhof (Saint Peter's graveyard), and behind the Vleyshal (Meat Hall). In the fourteenth and fifteenth centuries there possibly existed a vegetable market in the northern part of the Warmoesstraat; this street received its name, which refers to vegetables grown for the market, in the second half of the fourteenth century. In the sixteenth century a vegetable market existed on the Nieuwezijds-voorburgwal from the top of the Vogelsteeg past the medieval town hall on the Dam (Van Assendelft et al. [see note 13], 45).

16. Jan de Vries, *The Dutch Rural Economy in the Golden Age: 1500–1700* (New Haven and London: Yale Univ. Press, 1974), 72, 153–54; W. J. Sangers, *De ontwikkeling van de Nederlandse tuinbouw tot het jaar 1930* (Zwolle: W. E. J. Tjeenk Willink, 1952), 23–46, 58, 112, 117–18; Amster-

dams Historisch Museum, *Het land van Holland: Ontwikkelingen in het Noord-en Zuidhollandse landschap*, exh. cat. (Amsterdam: Amsterdams Historisch Museum, 1978), 118–21; Van Assendelft et al. (see note 13), 47.

17. Haak (see note 11), 359–61; Albert Blankert, *Kunst als regeringszaak in Amsterdam in de 17de eeuw: Rondom schilderijen van Ferdinand Bol*, exh. cat. (Lochem: De Tijdstroom, 1975), 14–16; Albert Blankert et. al., *Gods, Saints and Heroes: Dutch Painting in the Age of Rembrandt*, exh. cat. (Washington, D.C.: National Gallery of Art, 1980), 68.

18. Otto Banga, "Origin of the European Cultivated Carrot: The Development of the Original European Carrot Material," *Euphytica* 6 (1957): 72, 75. I am grateful to Anton C. Zeven, Institute of Plant Breeding, Agricultural University, Wageningen, the Netherlands, for calling Banga's article to my attention.

19. Willem A. Brandenburg, Department of Plant Taxonomy, Agricultural University, Wageningen, the Netherlands, in conversation. See also Banga (see note 18), 72; Anton C. Zeven and Willem A. Brandenburg, "Historie van tuinbouwgewassen aan de hand van afbeeldingen," *Bedrijfsontwikkeling* 15 (1984): 536; and Joos van Ommeren, "Plotseling zie je orange worteltjes verschijnen," *Boerderij* 67, no. 48 (1 September 1982): 25. For a discussion of Dou's influence on Metsu, see Robinson (see note 2), 43–46, 48–49, and elsewhere.

20. Zeven and Brandenburg (see note 19), 536.

21. Sangers (see note 16), 123–24, 127.

22. De Vries (see note 16), 154–55.

23. Ibid., 155–57.

24. Haak et al. (see note 7), 130–31. De Hooghe's print includes the escutcheons and names of Alkmaar's four burgomasters and the bailiff who probably commissioned the print. The single image is one of few cityscapes that were produced separately as opposed to being a part of an album or city history.

25. De Vries (see note 16), 157.

26. Van Assendelft et al. (see note 13), 48.

27. Sangers (see note 16), 59.

28. Cited in Paul Lindemans, *Geschiedenis van de landbouw in Belgie* (Antwerp: De Sikkel, 1952), 174.

29. Samuel Hartlib, *Legacy of Husbandry* (London: Richard Wodenothe, 1651); and John Parkinson, *Paradisi in sole: Paradisus terrestris* (London: H. Lownes & R. Young, 1629), cited in Ellen C. Eyler, *Early English Gardens and Garden Books*, Folger Booklets on Tudor and Stuart Civilization Published for the Folger Shakespeare Library (Virginia: Univ. of Virginia, 1974), 46–52.

30. I am grateful to Carla Oldenburger, Special Collections Library, Agricultural University, Wageningen, the Netherlands, for calling Dodoens's preface to my attention.

31. These reprints may be found in the Special Collections Library, Agricultural University, Wageningen, the Netherlands. For a bibliography of herbals, see Agnes Arber, *Herbals: Their Origin and Evolution, a Chapter in the History of Botany 1470–1670*, 2nd ed. (Cambridge: Cambridge Univ. Press, 1938; reprint, 1953).

32. Anton C. Zeven and Willem A. Brandenburg, "Use of Paintings from the Sixteenth to Nineteenth Centuries to Study the History of Domesticated Plants," *Economic Botany* 40, no. 4 (1986): 405–6.

33. De Vries (see note 16), 154.

34. Ibid.; Carla Oldenburger, in conversation.

35. See Peter C. Sutton, *Pieter de Hooch: Complete Edition with a Catalogue Raisonné* (Ithaca: Cornell Univ. Press, A Phaidon Book, 1980), cat. no. 45.

36. Bredero's *Moortje* is a farce based on a sixteenth-century French translation of Terence's *Eunuchus*. I am grateful to E. K. Grootes, Dutch Literature Institute, Universiteit van Amsterdam, for referring me to the description of Amsterdam's markets in *Moortje*. *Moortje* was performed in 1615 in the Eglantier, published in 1617, and enjoyed great popularity during the rest of the century (Amsterdams Historisch Museum, *'T kan verkeeren Gerbrand Adriaensz. Bredero 1585–1618*, exh. cat. [Amsterdam: Amsterdams Historisch Museum, 1968], 31). The popularity of the play was revived when it was performed in 1957 in The Hague as part of the Holland festival.

37. In the *dramatis personae* Bredero described Kackerlack as a flatterer or sponger. Pieter van Thiel, "Moeyaert and Bredero: A Curious Case of Dutch Theatre as Depicted in Art," *Simiolus* 1 (1972–1973): 41.

38. Gerbrand Adriaensz. Bredero, *G. A. Bredero's Moortje*, annotated by F. A. Stoett (Zutphen: Stoett; Thieme, 1931), 29–33, lines 639–754. See also the more recently annotated edition of the play: P. Minderaa, et al. *G. A. Bredero's "Moortje"* (Leiden: Martinus Nijhoff, 1984), 167–75.

39. Linda Stone-Ferrier, *Images of Textiles: The Weave of Seventeenth-Century Dutch Art and Society* (Ann Arbor: UMI Research Press, 1985), 219–20; Constance Wibaut, Lecturer, History of Style and Costume, Rijksakademie van Beeldende Kunst, in correspondence.

40. Van Thiel (see note 37), 42; Bredero, 1931 (see note 38), 34; Minderaa et al. (see note 38), 176–77, lines 768 and 771.

41. S. J. Gudlaugsson, *The Comedians in the Work of Jan Steen and His Contemporaries*, trans. James Brockway (Soest: Davaco, 1975), 40, 44. In Renaissance comedy certain aspects of the Roman slave and parasite survived in the role of the servant (Brian Jeffery, *French Renaissance Comedy, 1552–1630* [Oxford: Clarendon Press, 1969], 145). Kackerlack is both a servant and a social parasite.

42. Robinson noticed the similarity between the servants' costumes in the Leningrad and Strasbourg paintings (Robinson [see note 2], 22).

56

43. Bredero, 1931 (see note 38), 32; Minderaa and Zaalberg (see note 38), 173, line 713.

44. Bredero, 1931 (see note 38), 31; Minderaa and Zaalberg (see note 38), 170–71, lines 675–78.

45. Van Thiel (see note 37), 46.

46. E. Oey-de Vita et al., *Academie en schouwburg: Amsterdams toneelrepertoire 1617–1665* (Amsterdam: Huis aan de Drie Grachten, 1983), 184. I am grateful to E. K. Grootes for referring me to this publication.

47. The two plays were M. Waltes's *Klucht van de bedrooge gierigaart* (1654) and J. van Paffenrode's *Sr. Filibout, genaemt Oud-Mal* (1657). See Jan Paulus Naeff, *De waardering van Gerbrand Adriaenszoon Bredero* (Gorinchem: Noorduijn, 1960), 32; G. Kalff, *Geschiedenis der Nederlandsche letterkunde* (Groningen: Wolters, 1910), 5: 188. I am grateful to E. K. Grootes for drawing these two plays and references to my attention.

48. The first of the two documents relates that a woman who lived on the Prinsengracht near the brewery Het Rode Hert testified as a witness for her neighbor, Gabriel Metsu, living at the same place, that he was missing some chickens and that another neighbor was stealing them early in the morning (Notary Public, H. Westfrisius, Not. Arch. Amsterdam no. 2801: 307, 19-7-1657). Part of this document was published in Abraham Bredius, "Iets over de jeugd van Gabriel Metsu," *Oud Holland* 25 (1907): 197–203. The second document explains that Gabriel Metsu, twenty-seven years old and living on the Prinsengracht *"in de gangh van de gecroonde Hert"* (in the alley of the brewery The Crowned Stag), continued to have trouble with his neighbors (Notary Public, C. Touw, Not. Arch. Amsterdam no. 1447: 1403: 16-10-1657). I am grateful to S. A. C. Dudok van Heel of the Municipal Archives of Amsterdam for making the contents of these documents known to me.

49. "His development in the early Amsterdam years, from the middle fifties to about 1662, is documented by five dated paintings, and almost seventy others can be assigned to this period, which shows a distinct shift from his formative years in Leiden.... Interestingly enough, Metsu's work at this time shows little awareness of contemporary events around him in Amsterdam" (Robinson [see note 2], 24).

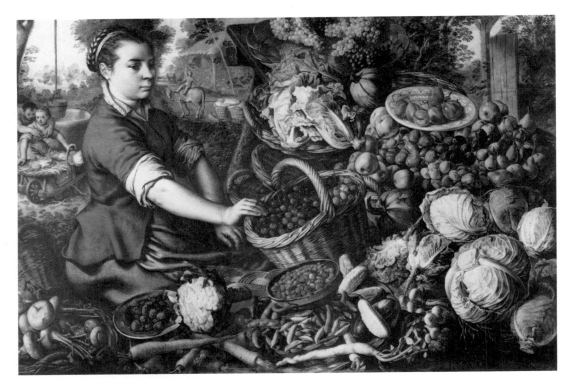

1. Joachim Beuckelaer,
 Woman Selling Vegetables, 1563,
 oil on panel, 112 x 163 cm.
 Valenciennes, Musée des Beaux-Arts de
 Valenciennes, no. P.65.5.1.

Willem A. Brandenburg

Market Scenes As Viewed
by a Plant Biologist

Plant evolution — the development of new plants and the disappearance of others — is one of botany's main concerns, and a knowledge of its workings is essential to understanding the relations between living organisms. Evolutionary processes have taken place since the origin of life on earth and continue to do so. Theories of descendance, ancestry, etc., remain largely hypothetical, however, due to the lack of data and processes that can be tested. Although the general order of the origin of the main plant groups — algae, mosses, ferns, and flowering plants — is known, their descendance cannot be determined in a way that can be experimentally repeated. The question as to whether evolution proceeds continuously, by radical changes, or by both means remains itself the subject of divergent opinions, although most evidence seems to support the last theory.

Cultivated plants, adapted to human habitats and/or objectives, are, like any other type of plant, the result of evolutionary processes. The process of development from a wild or weedy plant to a cultivated plant is called domestication. Depending on the crop concerned and the objectives for which it is cultivated, domestication may have taken place in prehistoric times and been unwittingly enforced over centuries by humans who simply made use of the best plants for their needs. Some evidence from prehistoric settlements suggests the early domestication of cereals. In parts of the world today, this kind of domestication remains the only factor in the development and maintenance of cultivated plants.

For the period of recorded history, descriptions and illustrations revealing the development of domesticates are available. Evidence from botanical experiments exists beginning in the sixteenth century. Consequently, the

domestication of some cultivated plants can be investigated by studying historical illustrations such as woodcuts in herbals and ornamentation in breviaries and paintings.[1] Such illustrations are even more valuable as sources if they can be linked to references from agricultural or botanical literature.

Domestication has resulted in the range of cultivated plants presently at our disposal. The time span in which domestication has taken place from the origin of agriculture until the present does not exceed ten-thousand years. During this period, structural changes occurred in wild and weedy plants that led to their developing into cultivated plants, as exemplified by the evolution of teosinte into maize. Even in historical times, new crop plants have arisen and sometimes disappeared. The variation in cole crops, many of which still exist and others of which have disappeared (for example, various cabbage forms as opposed to various stem kale forms), is one such case.

Fruits and Vegetables Depicted in Paintings

In the Netherlands during the sixteenth century, painters or their patrons became interested in depicting profane subjects as opposed to biblical allegories. In addition to ornamentals, which frequently appear in still lifes, fruits and vegetables were often used in kitchen and market scenes. Comparing the range of fruits and vegetables represented with descriptions in herbals, such as those of Leonhard Fuchs (1543) and Rembert Dodoens (1554), we may conclude that only a selection of the available fruits and vegetables has been depicted.[2] One must thus inquire as to which criteria — conscious or unconscious — determined this selection.

Symbolic significance is one possible explanation.[3] The European wild strawberry (*Fragaria vesca* L.) was frequently used as a Christian symbol in illustrations found in fourteenth- and fifteenth-century breviaries and altarpieces. The tripartite leaves were used to refer to the Holy Trinity, the five petals to the five wounds of Christ, the white flower to purity, the low habit to humbleness, and the fruit to the drops of Christ's blood.[4] In sixteenth-century kitchen and market scenes strawberries were still frequently depicted, whereas more common fruits such as red currants (*Ribes rubrum* L.) appeared less often. A beautiful exception, however, is a painting assigned to Floris Claesz. van Dijck, *Still Life with Vegetables and Fruits*, date unknown (fig. 2).

60

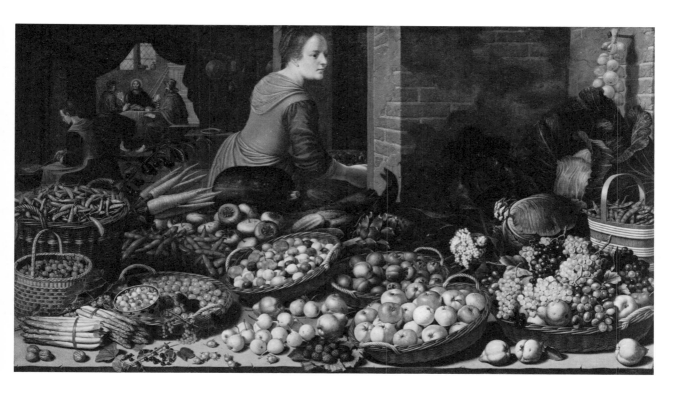

2. Assigned to Floris Claesz. van Dijck,
 Still Life with Vegetables and Fruits,
 date unknown,
 oil on canvas, 113 x 200 cm.
 Amsterdam, Rijksmuseum, no. A2058.

Several types of cabbage (*Brassica oleracea* L.) occur in most kitchen and market scenes. The English word *cabbage* and the old Dutch word *cabuys* are supposedly derived from the Latin word *caput*, which means head. According to herbals, cabbage is a symbol of life in general and of female fertility in particular.

We should not, however, overemphasize the symbolic meaning of plants with respect to their appearance in sixteenth-century Dutch paintings.[5] An interest in everyday human surroundings had been awakened. Furthermore, the scope of human awareness had been enlarged by recent discoveries of new continents. These discoveries introduced new plants to Europe; some of which were accepted with surprising rapidity and used as vegetables. For example, the common bean (*Phaseolus vulgaris* L.) and runner bean (*Phaseolus coccineus* L.) were being cultivated fifty years after the discovery of America and shortly thereafter replaced the garden type of broad bean (*Vicia faba* L.). In some paintings (for example, Lucas van Valckenborch's *Vegetable Market (July–August)*, circa 1590 (see page 32), both *Phaseolus* and *Vicia* beans are depicted.

Despite theories that the pumpkin (*Cucurbita* spp.) originated in Turkey,[6] it is native to the Americas and was probably introduced to Europe in the first half of the sixteenth century. From that time on, pumpkins frequently appear in paintings, for example, Joachim Beuckelaer's *Market Scene*, 1566 (fig. 3). Different types of pumpkins were depicted, supposedly as exhibitions of wealth rather than for their traditional meanings as symbols of female fertility.

Symbolic meanings were transferred to new crops as can be seen in old botanical literature, and authors like Dodoens assigned the emotional and medicinal characteristics of familiar crops to new ones that were in some way similar. Symbolism and the demonstration of wealth together best explain the occurrence of fruits and vegetables in paintings.

Paintings as Sources in Historical Studies of Crops

For historical studies of crops, and for historical studies in general, the choice of sources determines the validity of the results. In this respect, the use of illustrations, particularly paintings, remains controversial. It is sometimes possible to determine indirectly whether a plant was depicted after

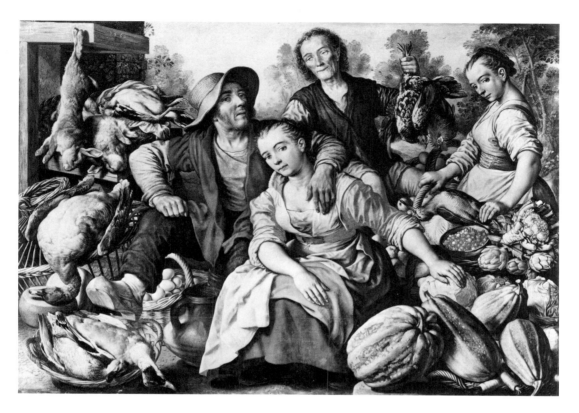

3. Joachim Beuckelaer,
Market Scene, 1566,
oil on canvas, 136 x 166.7 cm.
Naples, Museo e Gallerie Nazionali di
Capodimonte, no. 26571.
Photo: Courtesy Alinari/Art Resource.

63

consulting botanical or agricultural references by comparing illustrations in such texts with a particular painting. Preserved specimens, however, must have been used frequently, as is borne out by legacy statements and by the fact that fruits and vegetables characteristic of different seasons are often depicted in the same painting.[7] The similar arrangement of various types of fruits and vegetables across paintings is a further indication of this, as in Joachim Beuckelaer's *Woman Selling Vegetables*, 1563 (fig. 1).

Paintings may serve as important sources if dated by the painters themselves or if they can be reliably dated by other means. This is essential for research in historical studies of crops, as it may affect plant introduction dates. Knowledge of the particular region in which a painter lived and worked or traveled may also provide information about the choice of plants concerned.

The practice of working with models means that the real provenance of depicted plants has to be questioned. It is especially doubtful that recently introduced plants were as readily available as the paintings suggest. Other sources can corroborate their availability, though the authenticity of such sources must also be checked. In addition to original accounts, sixteenth- and seventeenth-century herbals contain material partly or wholly copied from other herbals; references to original sources are often missing or are given indirectly in prefaces. Any plant material depicted in a herbal should be traced by way of illustrations to the original account.

Lighting and color were applied in paintings to stress certain characteristics, to achieve a certain mood, or to focus attention on an image in the background, which often represents a biblical allegory. Color in particular may hamper a sound interpretation of changes in plants resulting from domestication. Here the cross-reference with botanical and agricultural literature is absolutely necessary.

Paintings should only be considered to be *positive* evidence of the existence of the plants depicted. Conclusions cannot be drawn from the absence of certain plants in paintings. Cereals were cultivated for foodstuffs but were so common and devoid of symbolic content that they were not depicted. One exception is the appearance of wheat spikes (*Triticum aestivum* L.) in *vanitas* still lifes. Whereas several types of cabbage were frequently depicted, leafy and stem kales (assigned to the same species, *Brassica oleracea* L.) are not seen in paintings at all.

Although the above remarks may seem self-evident, agronomists have

sometimes erred in equating the absence of specific plants in illustrations with their actual absence. Such conclusions have long confused thinking about the history of crops.

A Historical Case Study of a Crop: *Daucus carota* L.

Otto Banga has shown that a combined study of paintings and literature (mainly herbals) may yield new information on the history of the carrot (*Daucus carota* L.).[8] Before his study the general assumption was that the carrot was known to the Greeks and the Romans (Δαυκοσ–Greek; *Carota*–Latin), but this could never be confirmed. The carrot and the parsnip (*Pastinaca sativa* L.) are often confused in herbals, and in vernacular Dutch both were referred to as *pee* or *peen*, the latter being originally and linguistically the plural of *pee* and later the common vernacular name for carrot. Based on biosystematic data in herbals and on evidence from sixteenth- and seventeenth-century paintings, Banga concluded that Moors and Arabs introduced carrots with purple and yellow roots from Afghanistan to Spain in the twelfth century.[9] From there, these plants were distributed all over Europe. The purple carrot roots were colored by anthocyanins, as they produced a red color when boiled, which was described by several herbal writers. In the mid-eighteenth century Johann Hermann Knoop described orange carrots, which he suggested had been derived from yellow ones in the Netherlands.[10] These orange carrots were initially long in shape and were referred to as "Long Orange"; later on, they became shorter with heavy shoulders, so-called "forcing types." These "forcing" or "Horn types" were selected for growing underneath *warmoes* (a mixture of soil and horse manure) and were harvested in springtime. In several Dutch cities, Amsterdam among them, a Warmoesstraat at the periphery of the old city is testimony to the original purpose of the place, namely the intensive and forced growing of vegetables.

Carrots in paintings complement the data in literature very well. Paintings from the sixteenth and seventeenth centuries, like Pieter Aertsen's *Fruit and Vegetable Stand*, 1555 (fig. 4), and Nicolaes Maes's *A Market Scene at Dordrecht*, date unknown (fig. 5), show parsnips and clearly distinguish purple/red from yellow/orange carrot roots. Aertsen's *Christ in the House of Martha and Mary*, 1553 (fig. 6), shows the long carrot forms. The change

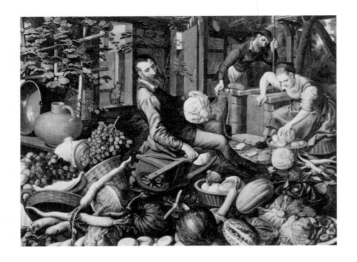

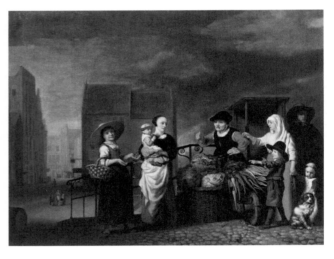

4. Pieter Aertsen,
 Fruit and Vegetable Stand, 1555,
 oil on panel, 103 x 135 cm.
 Rotterdam, Museum Boymans-van
 Beuningen.

5. Nicolaes Maes,
 A Market Scene at Dordrecht, date unknown,
 oil on canvas, 71 x 91 cm.
 Amsterdam, Rijksmuseum, no. A3254.

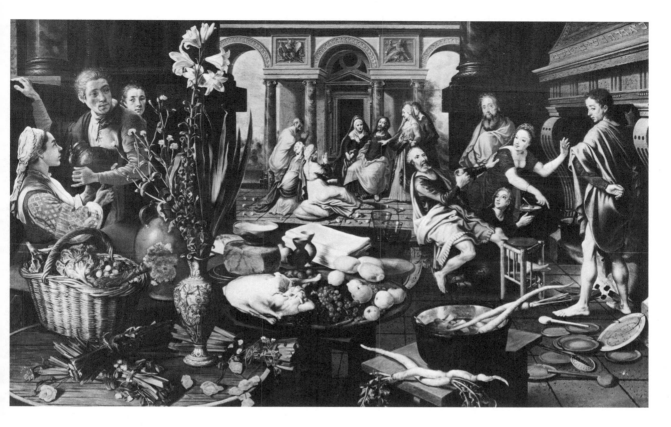

6. Pieter Aertsen,
 Christ in the House of Martha and Mary, 1553,
 oil on panel, 126 x 200 cm.
 Rotterdam, Museum Boymans-van
 Beuningen.

7. (Next page)
 Joachim Wttewael,
 Woman Selling Vegetables, 1618,
 oil on panel, 116.5 x 160 cm.
 Utrecht, Centraal Museum, no. 2262.

67

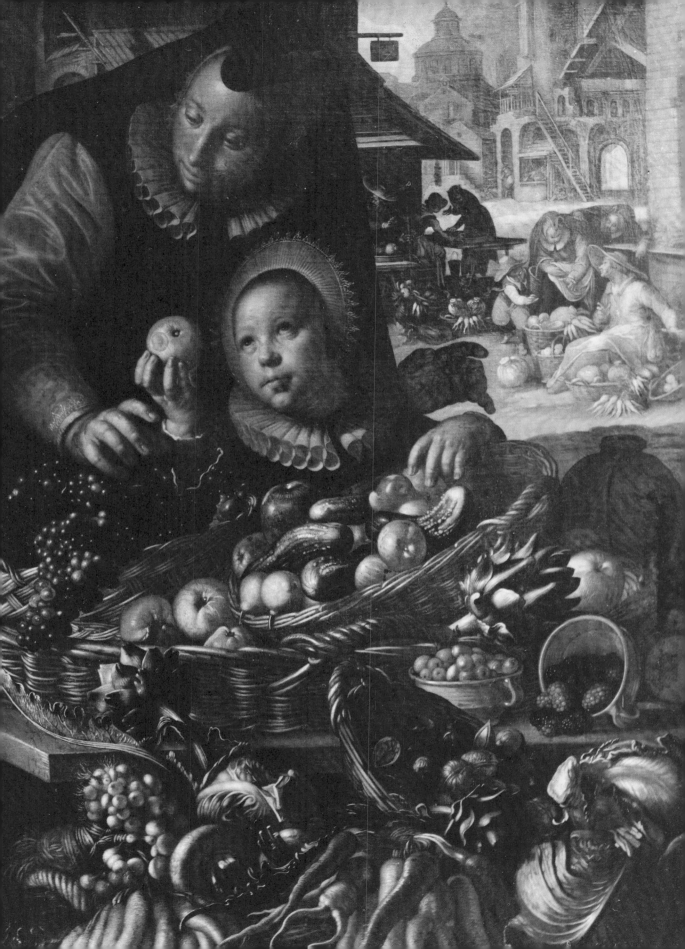

from yellow to orange carrot roots, however, is difficult to see, as is shown by Joachim Wttewael's *Woman Selling Vegetables*, 1618 (fig. 7).[11] Coloration effects seem to result from artistic decisions rather than from the actual differences between types of carrots. The first modern orange carrots are to be seen in paintings from the seventeenth century, for example, Gerrit Dou's, *The Quacksalver*, 1652 (figs. 8, 9). Recent studies have shown that fodder carrots still appear in the whole range of colors, inclusive of the true white fleshy form;[12] in Afghanistan the whole range exists to this very day.[13]

Whether the native European carrot with its inedible, white, branched roots, known as a medicinal plant,[14] was the genitor of the modern cultivated version remains to be proven.[15] For this, a further study of herbals and cookbooks is necessary.

In addition to evidence from the literature, paintings from the sixteenth and seventeenth centuries, especially kitchen and market scenes, contain valuable domestication data. Since the paintings are widely dispersed and their documentation value has not yet been systematically described, an international system or network would facilitate exploration and interpretation of this material. Art historians and museums are requested to cooperate with plant biologists to their mutual benefit. Paintings will gain in documentation value, and museums, like libraries, will act as centers for scientific documentation.

NOTES

The author wishes to express his thanks to Dr. Anton C. Zeven for discussing many details concerning domestication of cultivated plants and paintings and to Mr. J. G. van de Vooren and Mrs. A. van der Neut for critically reading the manuscript.

1. Anton C. Zeven and Willem A. Brandenburg, "Use of Paintings from the Sixteenth to Nineteenth Centuries to Study the History of Domesticated Plants," *Economic Botany* 40, no. 4 (1986): 397–408.

2. Leonhard Fuchs, *New Kreüterbuch* (Basel: M. Isingrin, 1543); Rembert Dodoens, *Cruydeboeck* (Antwerp: Jan vander Loe, 1554).

3. Jan A. Emmens, "Eins aber ist nötig: Zu Inhalt und Bedeutung von Markt- und Küchenstücken des 16. Jahrhunderts," in *Album Amicorum J. G. van Gelder* (The Hague: Martinus Nijhoff, 1973), 93–101; Ardis Grosjean, "Toward an Interpretation of Pieter Aertsen's Profane Iconography," *Konsthistorisk tidskrift* 43, nos. 3–4 (December 1974): 121–42; E. M. Kavaler,

8. Gerrit Dou,
 The Quacksalver, 1652,
 oil on panel, 112 x 83 cm.
 Rotterdam, Museum Boymans-van
 Beuningen.

9. Detail of fig. 8.

71

"Erotische elementen in de markttaferelen van Beuckelaer: Aertsen en hun tijdgenoten," in *Joachim Beuckelaer: Het markt- en keukenstuk in de Nederlanden, 1550-1650* (Ghent: Gemeente-krediet, 1986), 118–26.

4. Zeven and Brandenburg (see note 1).

5. Keith P. F. Moxey, "The Humanist Market Scenes of Joachim Beuckelaer: Moralizing Example or 'Slices of Life'?" *Jaarboek van het Koninklijk Museum voor Schone Kunsten Antwerpen* (1976): 109–89; idem, *Pieter Aertsen, Joachim Beuckelaer and the Rise of Secular Painting in the Context of the Reformation* (New York: Garland, 1977).

6. Dodoens (see note 2).

7. L. Wuyts, "Joachim Beuckelaers groentemarkt van 1567: Een iconologische bijdrage," in *Joachim Beuckelaer: Het markt- en keukenstuk in de Nederlanden, 1550-1650* (Ghent: Gemeente-krediet, 1986).

8. Otto Banga, "Origin of the European Cultivated Carrot: The Development of the Original European Carrot Material," *Euphytica* 6 (1957): 64–76; idem., "Main Types of the Western Carotene Carrot and Their Origin," *Zwolle* (1963).

9. V. I. Mackević, "The Carrot of Afghanistan," *Bulletin of Applied Botany* 20 (1929): 517–62; idem., *Ovośćnye rastenija Turcii* (Leningrad, 1932); A. Thellung, "Daucus," in *Illustrierte Flora von Mittel-Europa*, ed. G. Hegi (Munich: Lehmann, 1926), 1501–26; idem, "Die Abstammung der Gartenmöhre und des Gartenrettichs," *Feddes repertorium specierum novarum regni vegetabilis* 46 (1927): 1–7; P. Zagorodskich, "New Data on the Origin and Taxonomy on the Cultivated Carrot," *Comptes Rendues (Doklady) Academie des Sciences URSS* 25, no. 16 (1939): 520–23.

10. Johann Hermann Knoop, *De beknopte huishoudelijke hovenier* (Leeuwarden, 1752), 1: 309–10; idem., *Beschryving van de moes- en keuken-tuin* (Leeuwarden: A. Ferwerda & G. Tresling, 1769).

11. Willem A. Brandenburg, "Possible Relationships between Wild and Cultivated Carrots (*Daucus carota* L.) in the Netherlands," *Kulturpflanze* 29 (1981): 369–75.

12. W. Scheygrond, "Voederwortelen II: De teelt, de waardebepalende hoedanigheden en enkele voor de veredeling belangrijke correlaties," *Euphytica* 2 (1953): 157–60; J. R. Wijbrans, "Voederwortelen I: De indeling en de beschrijving van het in Nederland geteelde sortiment," *Euphytica* 2 (1953): 149–56.

13. E. Small, "A Numerical Taxonomic Analysis of the *Daucus carota* Complex," *Canadian Journal of Botany* 56 (1978): 248–76.

14. P. Nijlandt, *De Nederlandtse herbarius of kruidt-boeck* (Amsterdam: Michiel de Groot, 1682).

15. Brandenburg (see note 11).

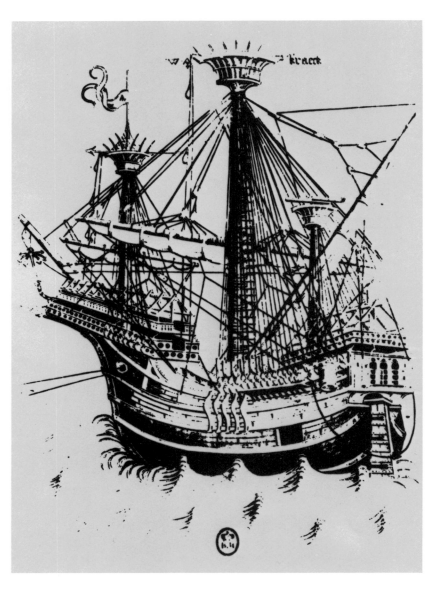

1. Master WA,
 A Carrack, ca. 1480,
 engraving.
 Paris, Bibliothèque Nationale.

74

Richard W. Unger

Marine Paintings and the History of Shipbuilding

Studying works of art as sources of information for the history of technology — in this case the history of shipbuilding — means evaluating artists' reliability rather than their skill. Paintings are immediately denuded of any value for style. The worth of the work, its documentation value, depends on the type of ship or boat illustrated and how precisely that job is done — nothing more. So historians of technology seek in art the lowest level of meaning. Dutch artists in the seventeenth century were highly accurate in their treatment of ships. Virtually all painters took the time to make their pictures reflect precisely what ships looked like and how they worked. It is remarkable that not only marine artists but landscape painters, and indeed all painters, typically chose to make ships look exactly like ships. Their works are the earliest in European history that are completely reliable and that can be used as a source for the study of the history of ship design and construction. This is even more remarkable since in the sixteenth century, painters working in the Low Countries produced some pictures of vessels that certainly could never have sailed. Art in the Netherlands went through a phase during which painters did not show ships accurately, in deviation from previous practice.

In the late Middle Ages the symbolic value of an object in a work of art was still most important. Artists, harkening back to early Christian thought, typically believed that there was much more to a ship than ropes, sails, and planks. It could bear a number of meanings. To carry symbolic meaning, the object had to be recognizable, to look real even if not exactly correct. The simplest thing to do was to create a reasonable facsimile of the object. Throughout the fifteenth century Low Countries' artists made their sym-

75

bolic ships look like real ships. In the seventeenth century Dutch artists, striving for realism, made their ships look precisely like the ships they saw around them. In the intervening period, struggling with a new style not yet fully understood, artists created images that give some hints of the nature of real ships but obscure some contemporary technological developments. That period fell, unfortunately, at a time of critical and even revolutionary advance in Dutch shipbuilding.

Despite variations in representational strategies, works of art are one of the, if not the most important, sources for the study of sixteenth-century shipbuilding. Paintings provide the most numerous contemporary depictions of ships. Maps such as Cornelis Anthonisz.'s *Caerte van Oostlant* (1543) usually show vessels on the seas.[1] This is especially true of the more accurate and less expensive sea charts that appeared toward the end of the century. Lucas Waghenaer's *Spiegel der zeevaerdt* offered accurate charts with a great deal of information, all at much below the usual cost. Waghenaer's book was widely available, translated into English as *The Mariner's Mirror* and sold throughout northern Europe. "Wagonner" became a generic term for such works in English. The ships shown on the charts remained the same throughout the many reprints and translations, still reflecting accurately the types in use at the time of the original publication, 1584–1585.[2] Town seals are a critical source for the study of thirteenth- and fourteenth-century shipbuilding but they had ossified by the sixteenth century.[3] Towns left seals intact for centuries; the seals even gained in authority by having obsolete ships depicted on them. Town views and topographical views of all sorts became increasingly popular in the sixteenth century, and views of ports included pictures of ships as well. Ship and boat archaeology and written records of shipbuilding (which only begin to appear in the sixteenth century) serve to confirm, at least to some extent, what artists chose to depict. A few shipbuilding contracts, mostly from the latter years of the century, have survived. Books on shipbuilding began to appear in Italy as early as the fifteenth century. Originally, they were extremely simple, giving a few dimensions and short descriptions. By the sixteenth century they had become more sophisticated, but the Netherlands would have to wait until the mid-seventeenth century for such books.[4]

Evaluating the accuracy of an artist's illustration of a ship is difficult, not only because of the medium but also because of the basis of such evaluation: the measure of accuracy must often be consistency with the work of

76

another artist. Hence, assessment of works of art risks becoming relative only to other works of art. Fortunately, there are some highly reliable alternative sources against which to gauge paintings and drawings. The large number of wrecks uncovered on the bottom of the former Zuider Zee in the IJsselmeerpolders since the 1930s gives a new and highly accurate way of assessing the depiction of hull construction. Since the rigging is not preserved in such wrecks, masts, spars, sails, and ropes must be checked by a combination of written sources, experimental archaeology, investigation of earlier and later practices, and common sense. Once the accuracy of a work or works has been confirmed with these sources, it is possible to evaluate additional works by the same artist or other artists with some confidence. When a class of attributes or even a class of ship types is established by a combination of sources, even works that contain obvious inaccuracies, such as some sixteenth-century paintings, can serve as sources for at least certain specific information.

Reliable and informative sources are a serious matter because Dutch shipbuilders made great strides in the sixteenth century, moving from being technically backward to being the leaders in the field in Europe. In the fourteenth and fifteenth centuries Mediterranean shipbuilders had made technical advances, developing a new type of vessel, the full-rigged ship, which incorporated the advantages of southern construction methods and the triangular lateen sail with the hull form and the square sail of northern European types. These full-rigged ships proved capable of long trips in unknown waters, making possible the voyages of discovery. In a different form, they also made possible much greater commerce between the Mediterranean and northern Europe. The carrack (fig. 1) was a large ship able to carry bulk goods economically between Iberia and the Low Countries and between Iberia and India. Shipwrights built the hull in the Mediterranean style. The ribs were set up first and exterior planks were then tacked to them. This form of skeletal building was more efficient in terms of wood and more flexible than traditional northern European methods of building hulls, in which strength came from exterior planks. Shipwrights in the Low Countries learned the new method from craftsmen who were brought in to build in the new design, for example, in Brussels, where Portuguese built a ship in 1439 in the new style, and in Zierikzee, where Bretons came to show Zeeland ship carpenters how to proceed in about 1460.[5]

Dutch shipbuilders learned quickly and well. They adopted the new

method but modified it to make it more consistent with what they had done in the past.[6] Using the new method, they created designs specifically suited to their own needs. By the end of the sixteenth century they developed the *fluit* for bulk trades to the Baltic. In a print from the middle of the seventeenth century, Reiner Nooms, also called "Zeeman" because of his experience as a sailor, shows two examples of this type: one designed for use in trade to the Baltic and the other for use in the Norwegian timber trade (fig. 2). But even by the middle of the sixteenth century, vessels in Dutch yards began to take on many of the features of that type. The tiered and tapering stern, shown by Pieter Bruegel the Elder in a print of 1555 (fig. 3), was a hallmark of the seventeenth-century *fluit*. The *fluit* was typically five or six times as long as it was wide, about double the ratio of the carrack. The lengthening of cargo ships may have come from experience with *busses* (boats used in the herring fishery). *Busses* had to be relatively long to control their large drag nets. Virtually defenseless, they traveled together in convoy during wartime. That practice was carried over to cargo ships. So too was design differentiation between fighting vessels and the ships they were to protect, such as the *fluit*. Dutch builders concentrated on efficiency and on specialization in design. They also made many improvements in small craft.[7] Unfortunately, the evolution of the design of types used on rivers, canals, and lakes has gone largely unrecognized, in part because it was seldom recorded by painters. But the changes in small craft proved valuable not only for the internal economy of the Netherlands but also as a source for innovations in larger seagoing vessels.

Despite the improvements going on around them and the changes, which were already having significant effects on the economy and politics, few artists appear to have noticed, or to have cared to notice, the technical advances in ship design that were taking place in the sixteenth century. None of these artists, apparently, had direct knowledge of ships or shipbuilding. While they were not purposefully unfaithful in their depictions of vessels, they typically did not place great value on technical accuracy. There were, however, significant and fortunate exceptions.

In 1520 Lucas van Leyden drew a highly accurate picture of a contemporary ship perfectly consistent with other sources (fig. 4). The depiction harkens back to the earlier tradition of incidental accuracy. The Van Leyden vessel even has four masts and is therefore one of the earliest works to show what would be a common feature of large ships by the end of the century.

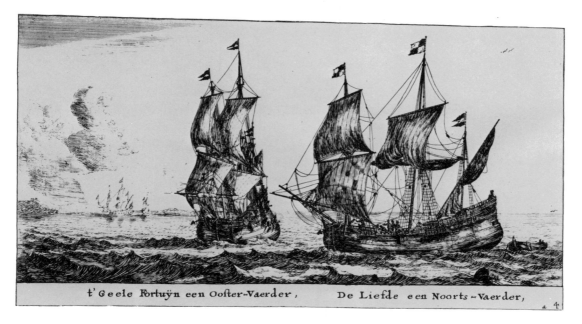

t'Geele Fortüyn een Ooster-Vaerder, De Liefde een Noorts-Vaerder,

2. Reiner Nooms called "Zeeman,"
 *T'Geele Fortüyn een ooster-vaerder, De
 Liefde een noorts-vaerder* (two specialized
 cargo carriers), mid-seventeenth century,
 engraving, 13.2 x 24.7 cm.
 Amsterdam, Rijksprentenkabinet,
 Rijksmuseum.

79

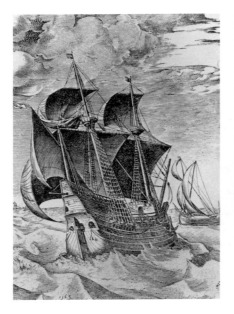
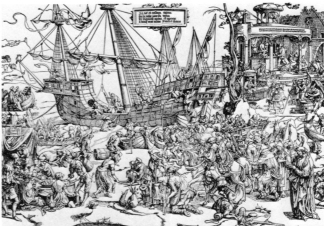

3. Frans Huys after Pieter Bruegel the Elder,
 Nef de bande ou de haut bord (a large cargo
 ship with a stern typical of the *fluit* and a
 very efficient smaller cargo vessel, a boyer,
 to the right), 1564–1565,
 engraving, 24 x 19.4 cm.
 Brussels, Bibliothèque Royale Albert 1er
 (Cabinet des Estampes).

4. Lucas van Leyden,
 *La nef de Saint-Reynuyt ou la nef de la
 mauvaise gestation*, 1520,
 woodcut, 74 x 116 cm.
 Amsterdam, Rijksmuseum.

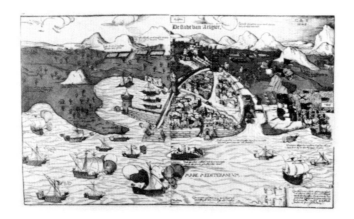

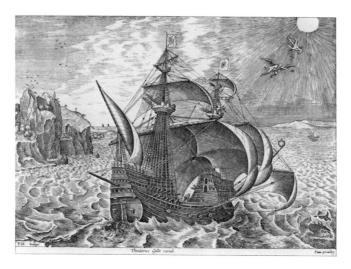

5. Cornelis Anthonisz.,
 The Siege of Algiers, 1542,
 woodcut, 37.4 x 58.3 cm.
 Amsterdam, Rijksprentenkabinet,
 Rijksmuseum.

6. Pieter Bruegel the Elder,
 *Nef de bande vue de trois quarts à droite
 par-derrière, armée de canons*, 1564–1565,
 engraving, 25 x 28.7 cm.
 Brussels, Bibliothèque Royale Albert 1er
 (Cabinet des Estampes).

81

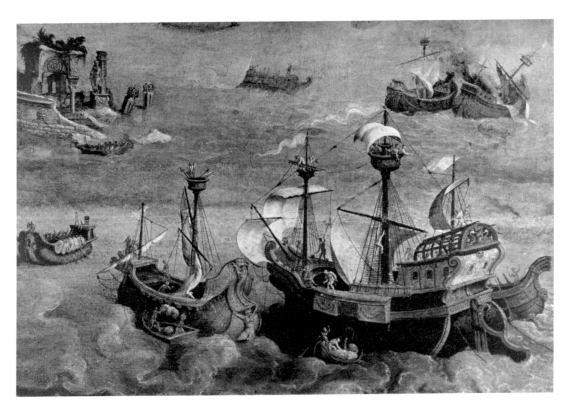

7. Maarten van Heemskerck,
 *Panoramic Landscape with the Abduction of
 Helen* (detail), 1536,
 oil on canvas, 147 x 383.5 cm.
 Baltimore, Walters Art Gallery, no. 37.656.

Many of the details are undoubtedly correct, such as the shrouds, though there might be some confusion in the way the main yard was fixed to the mainmast. In any case, there was no effort to make this vessel look like anything other than a sixteenth-century Dutch ship. In the middle of the century, Cornelis Anthonisz. did much the same, producing pictures of contemporary ships that, though lacking a great deal of technical detail, still resemble the vessels that the Dutch sailed. In a drawing of the town and port of Algiers from 1542 (fig. 5), the artist even went so far as to show ships like those used in northern Europe in Mediterranean surroundings. It is possible, however, that a ship like the one in the lower right corner of this work, which has all the characteristics of a ship from the North Sea, actually did sit in the Algerian harbor at that time.

Bruegel took the most care of any sixteenth-century artist to represent ships accurately. In 1564 and 1565 he did a series of ship prints. Since ships were the subject of the works and in most cases formed the only focus, Bruegel seems to have taken time to show the vessels as they actually were. That he could create such works and expect to find buyers for them in the Antwerp of his day suggests that already by the mid-sixteenth century a market for ship illustrations was emerging. Bruegel depicted different types of vessels — cargo ships and warships, sailing ships and oared ships. The galleys in his prints were typical of the Mediterranean, but navies used them in the early phases of the Eighty Years' War in the Low Countries, so these vessels were not strangers to local waters. He also depicted sixteenth-century northern ships in works showing mythological events such as the fall of Phaëthon and several versions of the fall of Icarus (fig. 6). He might choose a Mediterranean landscape but did nothing to make the ships look like anything other than the Low Countries' vessels of his day. Bruegel seems to have had more of a functional than a symbolic interest in ships. That was not true for many others.

In his large painting *Landscape with the Abduction of Helen*, 1536 (fig. 7) Maarten van Heemskerck showed ships as idealized and classicized, so much so that the vessels would not have been seaworthy. The painting records a classical event. The ships are also classical, or were at least given what the artist thought was a classical appearance. The vessels themselves are strange combinations with contemporary features corrupted by scrollwork and decoration that would never have been found on any ship. The rudders are much too large, the bows and sterns are decorated with carved faces, and the prows

are squared off to carry dramatically curved and flowing timbers. The sails, yards, and masts often lack lines to hold them in place.

For the early church fathers, Noah's ark symbolized the Church, carrying, caring for, and protecting souls. The whole story of Noah proved a rich inspiration for medieval artists. Renaissance artists in Italy made Noah an even grander, more impressive figure, something of a creator. It was exactly this Noah that Van Heemskerck had in mind in his drawing of 1558 (fig. 8), one of a series on the story of the patriarch. The artist changed not only Noah but also the character of the ark. A drawing depicting the Flood, executed a year later, has a ship that simply could not have sailed and might not have been able to float with any stability. It, too, is classicized to the extent that it is no longer seaworthy. Lambert van Noort, working in Antwerp at about the same time as Van Heemskerck, produced a picture of the animals leaving the ark in which the vessel owes more to Roman reliefs or mosaics than to sixteenth-century shipbuilding practice. Noah's ark was beginning to be seen as a vessel that did not have to be able to sail: writers were beginning to wonder if the measurements of the ark could be known or if they mattered.[8] But artists gave a classical appearance to many different ships in many different works, not only to Noah's ark.

Italian art, of course, had a deep and extensive influence on the sixteenth-century Netherlands but not one leading to greater interest in technology, accuracy, or precision in depicting ships. Though the Italian Renaissance would, over the long term, generate a new and more precise realism, in the sixteenth century "classicizing" had the greatest influence on artists' treatment of ships. The interest in the classical past led to an effort to understand and depict vessels of ancient Greece and Rome. The ships were idealized — borrowing from classical texts and Roman artworks — and mixed with some knowledge of contemporary shipbuilding and with pure guesswork. Roman ships were a feature of Baroque art, and descriptions of them were typically included in the opening chapters of shipbuilding manuals through the Enlightenment.[9] Dutch artists on trips to Italy seem to have picked up the interest in classical ships and as a result tried to make their ships look Roman. But the artists knew much more about contemporary ships and therefore borrowed features from them. The results were the strange hybrid vessels that appear in biblical and classical scenes. Artists virtually dressed the ships of their own time in classical garb. Though the treatment of ships may reveal the artists' intentions, as a source of information about six-

8. Maarten van Heemskerck,
*Noah Receiving Direction from God and
Construction of the Ark*, 1558,
brown ink and black chalk on yellow paper,
201 x 253 cm.
Copenhagen, Statens Museum for Kunst,
Den kongelige Kobberstiksamling.

teenth-century shipbuilding they are of very limited value and must be used with much greater care than the works that preceded them in the late Middle Ages.

Jan van Scorel's handling of the story of Saint Ursula from the 1540s (fig. 9) shows the change in style when it is compared to Hans Memling's handling of the same topic on a reliquary in Bruges from the 1480s (fig. 10). The "medieval" artist gives a more accurate picture of a ship. The vessels in Memling's work have highly rounded hull forms, a feature of the ships of his time. Van Scorel, on the other hand, includes scrolled bows, which shipbuilders would never have added to a contemporary ship.

The practice of depicting contemporary ships with some accuracy did not, however, entirely disappear in the sixteenth century. Pieter Bruegel the Elder, as noted, is the best, but not the only, example of a continuing concern for accuracy. Jan Sadeler in a print after Dirck Barendsz. dated 1582 (fig. 11) shows Jonah being thrown to the whale in a highly dramatic way from a ship with curves that owe more to stylistic considerations than to shipbuilding practice. The depiction of the same scene from about twenty years earlier, possibly by Pieter Pourbus, shows a much more realistic ship (fig. 12).[10]

In everyday works like charts and city views, Dutch artists tended to show ships accurately. When it came to depicting boats, Italian influence and related classicism in Holland seem to have been stronger than, for example, in Flanders. At the same time, the influence from the south was not strong enough to destroy completely the established tradition among Dutch painters and other artists of showing vessels much as they were. That older tradition may have grown out of lack of interest in ships as technical objects and was typified by inattention to detail and some resistance to novelty. Even so, it was the base from which Dutch artists started, and that tradition was eroded but never completely eradicated by the first incursions of Renaissance style into the Low Countries.

The classical garb of sixteenth-century ships in Dutch paintings seriously undermines the documentary value of such works for historians of technology. Still, there is a great deal to be learned about shipbuilding from those images. Many contemporary features were hidden beneath the artists' additions — some general and some specific — and the depiction of ships can still be of help to corroborate information from other sources. In general, archaeology confirms, as does art, that many advances and changes

9. Jan van Scorel,
 Ursula and the 11,000 Maidens, 1540–1550,
 brown ink and wash drawing on paper,
 26.9 x 36.5 cm.
 Amsterdam, Rijksprentenkabinet,
 Rijksmuseum, no. 11:108.

10. Hans Memling,
 The Departure from Basel from *The Shrine
 of Saint Ursula*, before 1489,
 oil on panel, 87 x 33 x 91 cm (entire shrine).
 Bruges, Memling Museum, OCMW-
 museums.

Ionas puppe cadens, Ceto forbente voratus,
In pelago non fenfit aquas, vitale fepulcrum

Ne moreretur habens, tandemq̃, e ventre ferino
Venit ad ignotas tutus fine remige terras.

11. Jan Sadeler after Dirck Barendsz.,
Jonah Thrown to the Whale, 1582,
engraving, 24.2 x 20 cm.
Amsterdam, Rijksmuseum.

12. Pieter Pourbus (?),
Jonah Cast over the Side, early 1560s,
drawing, 21.5 x 13.5 cm.
Rotterdam, Museum Boymans-van
Beuningen.

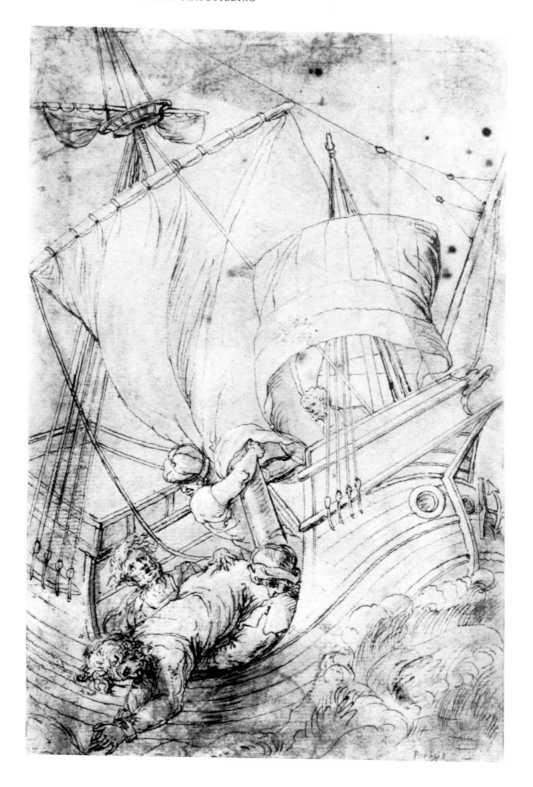

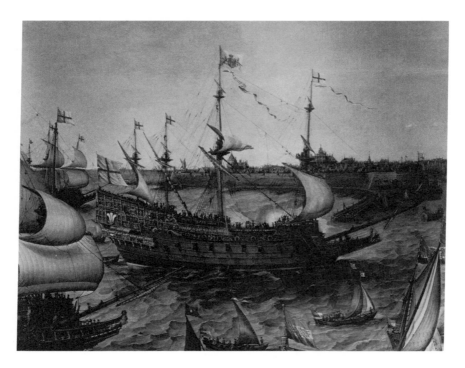

13. Hendrik Vroom,
The Arrival of Frederik V, Elector Palatine,
and Elisabeth Stuart at Vlissingen (Flushing)
(detail of the largest warship), 1623,
oil on canvas, 203 x 409 cm.
Haarlem, Frans Halsmuseum, no. 300.

in shipbuilding practice came earlier than has been indicated in written sources. The work of artists suggests that by the mid-sixteenth century, if not earlier, Dutch shipbuilders had closed any technological gap that may have existed between them and masters in Italy, Spain, France, and Portugal. By that time they had joined the leaders in their field in Europe. The work of artists also implies that Dutch builders made many improvements in the sixteenth century, successfully exploiting the earlier great breakthrough in ship design when the best of northern and southern practices were combined in the full-rigged ship. By the mid-sixteenth century Dutch builders seemed to be technically equal to Iberian builders, a fact typically obscured by the great sixteenth-century navigational success of captains in the service of Spain and Portugal and by Dutch artists' interest in classical rather than contemporary Dutch vessels.

Holland had a close association with the sea. Certainly, by the sixteenth century her prosperity depended heavily on seafaring. The sea as a threat and an avenue for exchange and travel was already an important part of Dutch life. In the seventeenth century the association with the sea generated a school of artists who painted seascapes and pictures of ships. Hendrik Vroom has been called the father of marine painting. His ships look like the warships of Bruegel but have much greater detail and as great or greater accuracy (fig. 13). Reiner Nooms was a former sailor, and as a result, his lines and rigging are absolutely accurate. Through much of the seventeenth century the Willem van de Veldes, Elder and Younger, produced pictures of ships and sea battles so highly prized that the artists enjoyed government and royal patronage.[11] Their massive sketches of sea battles and their paintings of warships in action or sitting in harbors extolled naval power and success. Their works are valuable as sources of highly precise information about the ships themselves. But the Van de Veldes were only the most highly esteemed, widely recognized, and well paid of a large school of marine artists. In addition, landscape painters often felt obliged to include boats in their scenes, and they, too, showed the vessels as they were. The works of all of these artists attain a realism beyond that of late medieval works. Their own personal experience with ships was one reason; another was a desire to produce realistic work. The incidental realism of the later Middle Ages gives historians of technology basic information about changes in ships, but the works of art are neither extensive enough nor precise enough to rival the knowledge that can be gleaned from the seventeenth

century. As the work of painters changed in the closing years of the six-teenth century, the role of art as a source for the history of technology changed. It is difficult, if not impossible, to explain exactly why artists altered their ways of thinking and painting, but more of them began con-centrating on seascapes and landscapes. The development and growth of interest in the two types was closely related. In both cases artists painted from nature. They tried to make their works more consistent with life.[12] Certainly, neither the changing character of the art market nor the naval and maritime success of the Dutch Republic detracted from the value of seascapes. Such explanations, however, only begin to supply an understand-ing of what happened.

During the 1500s the artists' approach combined with influence from the south severely limited the value of their paintings as a source for under-standing the great technological strides made by Dutch shipbuilders. The Low Countries were deeply influenced by the Mediterranean, first in the fifteenth century in shipbuilding practice and then in the sixteenth cen-tury in artistic practice. The former led to major improvements in ship design while the latter led to greater classicism. The seventeenth century witnessed greater realism but also a conscious effort to show the world ships exactly as they were and exactly as sailors handled them. It may be that part of the explanation for the high degree of reliability both in general outline and in detail of Dutch marine art in the later period is to be found in the older tradition of incidental accuracy, as in the pre-1520 practice of artists not bothering to change what they saw around them. Fortunately for the study of technology, after 1600 classicism was relegated to the introduc-tory chapters of practical manuals on how to build ships, and artists no longer bothered to dress their vessels in the style of the Romans.

NOTES

1. F. J. Dubiez, *Cornelis Anthoniszoon van Amsterdam 1507–1550* (Amsterdam: H. D. Pfann, 1969), 16–21.

2. Cornelis Koeman et al., *Lucas Jansz. Waghenaer van Enckhuysen: De maritieme cartografie in de Nederlanden in de zestiende en het begin van de zeventiende eeuw* (Enkhuizen: Vrienden van het Zuiderzeemuseum, 1984).

3. Herbert Ewe, *Schiffe auf Siegeln* (Berlin: Delius, Klasing & Co., 1972).

4. Richard W. Unger, *Shipbuilding in Holland and Zeeland Before 1800* (Assen: Van Gorcum, 1978), 42.

5. Ibid., 24–40, 189.

6. Richard W. Unger, "Dutch Design Specialization and Building Methods in the Seventeenth Century," in *Postmedieval Boat and Ship Archaeology*, ed. Carl Olof Cederlund (Oxford: B.A.R., 1985), 153–64.

7. Richard W. Unger, "Warships and Cargo Ships in Medieval Europe," *Technology and Culture* 22, no. 2 (April 1981): 233–36, 247–51.

8. Don Cameron Allen, *The Legend of Noah: Renaissance Rationalism in Art, Science and Letters* (Urbana: Univ. of Illinois Press, 1963), 60–91.

9. For example, Nicolaes Witsen, *Architectura Navalis et Regimen Nauticum ofte Aaloude en Hedendaagsche Scheeps-Bouw en Bestier* (Amsterdam: Joan Blaeu, 1690), 19–44.

10. J. Richard Judson, *Dirck Barendsz. 1534–1592* (Amsterdam: Van Gendt, 1970), 38.

11. W. Voorbeytel Cannenburg, "The Van de Veldes," *The Mariner's Mirror* 36 (1950): 185–204; David Cordingly, *The Art of the Van de Veldes: Paintings and Drawings by the Great Dutch Marine Artists and Their English Followers*, exh. cat. (London: National Maritime Museum, 1982).

12. Margarita Russell, "Seascape into Landscape," in *Dutch Landscape: The Early Years, Haarlem and Amsterdam 1590-1650*, ed. Christopher Brown (London: National Gallery Publications, 1986), 63–71; John Michael Montias, *Artists and Artisans in Delft: A Socio-Economic Study of the Seventeenth Century* (Princeton: Princeton Univ. Press, 1982), 141–48.

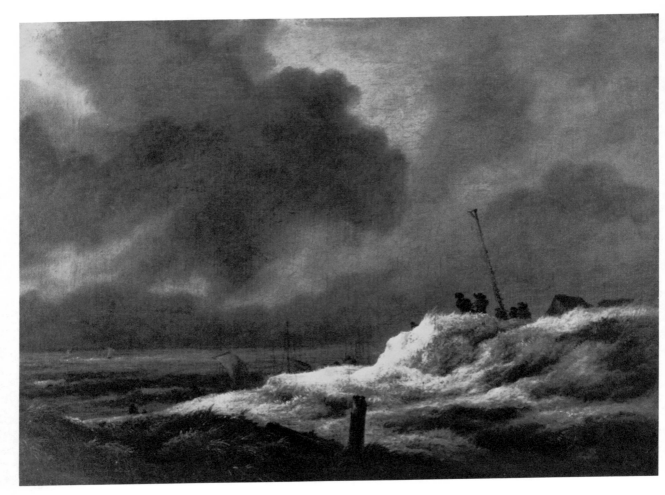

1. Jacob van Ruisdael,
View from the Dunes to the Sea, ca. 1655,
oil on canvas, 26 x 35.2 cm.
Zurich, Kunsthaus, Stiftung Prof.
Dr. L. Ruzicka, no. R.31.

John Walsh

Skies and Reality in
Dutch Landscape

Skies in Dutch landscape, considering their powerful presence, have been treated vividly and fervently but without much curiosity by writers on Dutch landscape. I should like to pose two questions about clouds in Dutch landscapes and seascapes that seem not to have been asked before: Are they rendered true to life? If not, what might this signify? In examining a broad range of pictures with these issues in mind, I was fortunate to have the help of a meteorologist, George Siscoe. My purpose here is to convey the results and suggest directions that a fuller study of clouds and their uses in landscape might take.

How true to nature are the skies in Dutch paintings? The answer has several parts. First, painters did not represent the Dutch climate in a way that was faithful to prevailing conditions or that represented its actual variety. While Dutch artists portrayed a greater spectrum of weather than ever before in history and did so in a generally convincing way, the atmospheric conditions in paintings nevertheless belong to surprisingly few types. Artists generally showed the good or the bad, seldom the mediocre. In most paintings it is summer and the weather is fine. There are sometimes threatening clouds in the distance but not often.

Storms occur in landscapes — again, not often — and make up a special category of seascapes. Stormy landscapes typically represent either the approach or the retreat of a tempest. The little beach scene by Jacob van Ruisdael in Zurich, for instance, shows an imminent threat (fig. 1). In the beach scene by Jan Porcellis in the Mauritshuis, on the other hand, the storm has passed, leaving a ship foundering in the distance (fig. 4). A rescue is underway as sunlight streams through the clouds, unmistakably reinforcing

the human action.[1] (Rembrandt's use of the receding storm in such paintings as *The Stone Bridge* is well known.) In winter scenes it is the rewards of the season and seldom the penalties that are shown. Although winters were indeed colder in the seventeenth century than today, the waterways were certainly not frozen all the time, as we might suppose if these paintings were our only evidence.[2] In winter landscapes by Van Ruisdael and a few others, the weather is sometimes threatening, but in most pictures it is fine.

The most common kinds of Dutch weather — a heavy deck of clouds, intermittent drizzle and heavy rain, and a veil of fog — are hardly ever represented in paintings. For that matter, painters never show a day without clouds, a pure blue sky of the kind that Karel van Mander urged young artists to try and which nobody I know of ever painted.[3] This confining of weather to a few conventional types, however subtly rendered, is consistent with the approach to reality taken by Dutch artists in general. Dutch landscapes fall readily into categories, as has often been pointed out — rivers, dunes, panoramas, nocturnes, etc. — all codified long ago for scholars by the organization of C. Hofstede de Groot's photographs at the Rijksbureau voor Kunsthistorische Documentatie in The Hague and adopted by Wolfgang Stechow for his fundamental survey.[4] The highly selective approach taken by landscape painters to the climate suggests that they were not trying to make a complete and accurate record of the varieties of weather any more than they were trying to map the country. Their intention was not so much to describe nature as to exemplify it, and for that purpose a relatively narrow choice of situations was in order.[5]

As regards the relation of the skies in individual paintings to the reality, writers on Dutch landscape have tacitly assumed that the resemblance is close. Recently, this was explicitly claimed by Marek Rostworowski and Margarita Russell.[6] For Rostworowski, the skies in Dutch landscapes viewed as a whole make up the equivalent of a cloud atlas, a corpus of photographs of every type classified by meteorology. It is true that Dutch skies are far closer to nature than ever before in art, but this will surprise nobody. It may be surprising, however, to see how often Dutch painters, far from contributing to a complete and accurate atlas of cloud observations, were content to leave most weather conditions unrepresented and even to distort cloud forms in order to serve their purposes.

As an example, let us look at a ubiquitous kind of cloud in landscapes and seascapes, one that appears frequently in pictures by Salomon van

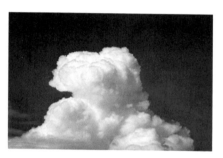

2. Salomon van Ruysdael,
 View of the Valkhof, Nijmegen, 1648,
 oil on canvas, 103.5 x 144 cm.
 San Francisco, The Fine Arts Museums of
 San Francisco, Gift of the Samuel H. Kress
 Foundation, no. 66.44.36.

3. Cumulus.
 Photo: Courtesy G. W. Th. M. de Bont and
 B. Zwart, *De wolken en het weer*
 (Zutphen: Uitgeverij Terra, 1985).

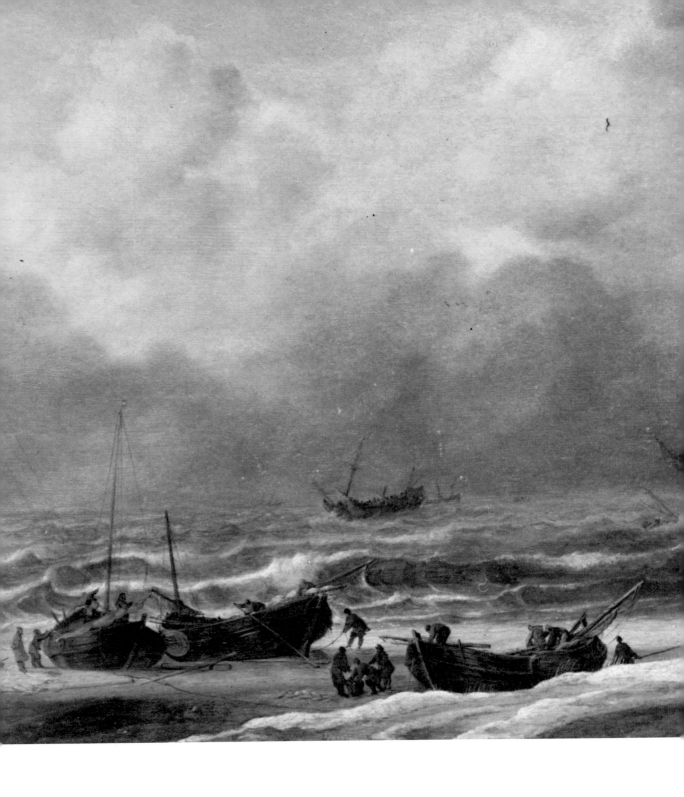

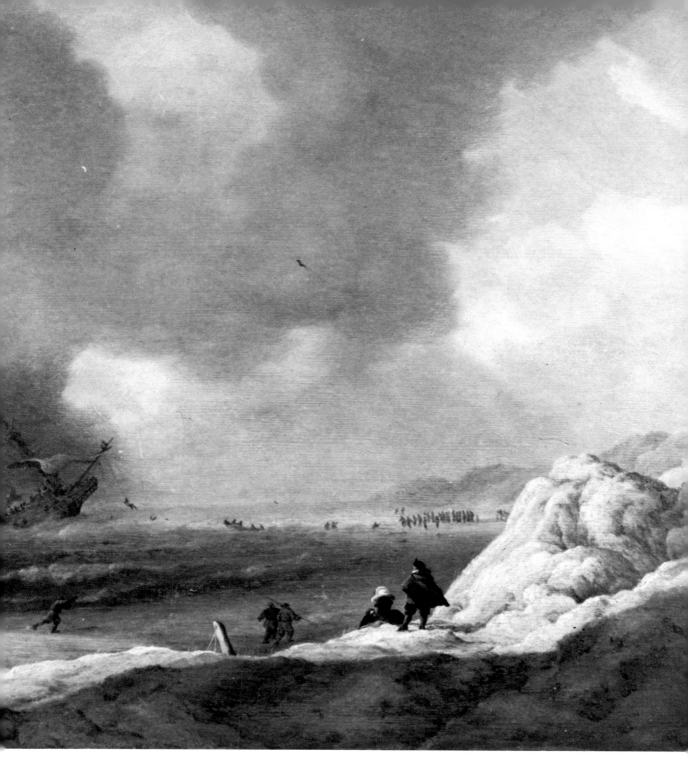

4. Jan Porcellis,
Shipwreck on a Beach, 1631,
oil on panel, 35.5 x 66 cm.
The Hague, Mauritshuis, no. 969.

Ruysdael (fig. 2). The brilliant blue sky is full of long, trailing cloud formations with upswept heads. Propelled by a strong breeze from right to left, the clouds make a pattern that dominates the painting. Clouds something like this exist in real life but not as painted here. Van Ruysdael shows flat layers, or stratus clouds, attached to puffy heaps, or cumulus clouds — an attachment that defies meteorology and thermodynamics. Puffs of cumulus are formed by updrafts of vapor-laden warm air that condenses in the cooler upper air to form a mass of expanding cells (fig. 3); layers of stratus, on the other hand, are formed by the settling and spreading out of clouds in calm air. The two processes do not happen near one another. For flat layers to grow cumulus heads involves a grafting of two different species, possible in the orchard of the artist's imagination but not in nature.

Van Ruysdael's clouds seem to have been stimulated both by nature and by other artists' pictures. Clouds with long tails do occur in nature but at a much greater height: high-altitude cirrus clouds composed of ice crystals bent by the wind into graceful curves (fig. 5). Van Ruysdael, having observed these shapes in the upper air, seems to have brought them down and attached them to the normal growth of summer clouds. Among the images that would have helped him to visualize a sky full of grand, curving clouds are prints after Peter Paul Rubens's landscapes (fig. 6). Readily accessible, these engravings carried great power and authority for Dutch landscape painters. Seldom had such ambitious skies been seen in art and seldom had the clouds played such an essential role in animating and binding compositions.

Distortion of clouds for one artistic purpose or another was accomplished in various ways. This distortion was not unusual but routine in sky painting, even among artists with the greatest reputations as realists. Distortions were not necessarily arbitrary but could be based on the deceptive effect of foreshortening that is observable in nature.[7] Van Ruysdael's bending clouds may well reflect his recollection of such effects of perspective. Flat clouds, when seen from below, can appear to curve or shoot off at an angle (fig. 7). This probably accounts for the tremendous towers of clouds in the pioneering seascapes of the 1620s, for example, which do not occur in this form in real life. Jan Porcellis's model in *A Hoeker in a Fresh Breeze* (fig. 8), might have been cumulus castellanus, but these have flat bases and his do not; it is more likely that he recalled horizontal layers (cumulostratus) that in foreshortened view might actually appear to be vertical. Pushed down to

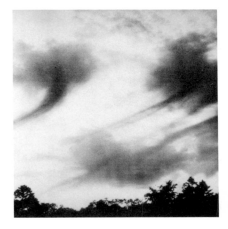

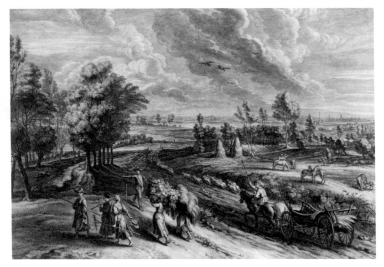

5. Cirrocumulus and cirrus.
 Photo: Courtesy George Siscoe.

6. Schelte à Bolswert after Peter Paul Rubens,
 Return from the Harvest,
 engraving, 43.9 x 63 cm.
 New York, The Metropolitan Museum of Art,
 The Elisha Whittelsey Collection, The
 Elisha Whittelsey Fund, 1951, no. 51.501.7744.

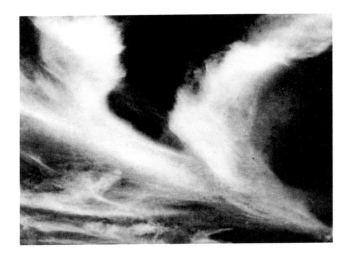

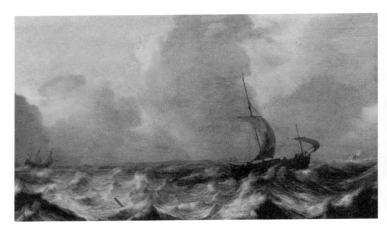

7. Stratocumulus.
 Photo: Courtesy George Siscoe.

8. Jan Porcellis,
 A Hoeker in a Fresh Breeze, ca. 1629,
 oil on panel, 37 x 62 cm.
 Lund, Lunds Universitets Konstmuseum.

the horizon by the painter, they make a towering wall — in effect, the back wall of the perspective box into which we look. The water forms the floor, and the sky, which ought to be the ceiling of the box, is displaced to the back. This handy transposition was practiced by landscape painters throughout the century.

Another form of alteration can be appreciated if we compare pictures such as Porcellis's with more realistic renderings of clouds. A Philips de Koninck panorama in Glasgow (fig. 9) is exceptional, for it shows what Porcellis does not: clouds stretching from the far horizon forward toward the spectator, becoming bigger and extending over the spectator's head to form the ceiling that is missing from the Porcellis painting. This device, an invention of the 1650s, is uncommon in painting — even with De Koninck, who does not shrink from the somber effect of dense clouds. The relatively uniform, flat bases are a faithfully recorded attribute of stratocumulus, which, like all clouds, form at a uniform level because of more or less uniform temperature. This truthful observation is rare in Dutch art, even in the work of De Koninck. He typically shows instead a splendid undulating mass of clouds whose bases rise and sink gracefully, if impossibly (fig. 10). There is a similar arbitrariness in the cloud base of Jan van de Cappelle, who like De Koninck was a brilliant inventor, improviser, and fantasist, and who regularly combined and distorted clouds of various kinds (fig. 11). A meteorologist reacts to Van de Cappelle's work the way a geologist might react to Joachim de Patinir's, with astonishment and perhaps *mal de mer*.

The case of Jacob van Ruisdael is more complex and interesting. The landscape in the National Gallery in London (fig. 12), for instance, has another hybrid sky: at the right is a growing cumulus and at the left, implausibly, a cloud based on the normal stratiform type but rendered as a sweeping compound curve. It is uncertain whether the cloud is meant to be horizontal and projecting toward the viewer or climbing to great heights. Van Ruisdael, though capable of this kind of imaginative alteration, was one of the most accurate observers of the skies and painted clouds of several types not encountered in other artists' work. (This is not surprising in view of the painstaking accuracy with which he rendered trees and shrubs.)[8] He nevertheless combined and recombined clouds at will. His basically accurate panorama of Amsterdam seen from the south (fig. 13) is interesting for many reasons but stands out in this context, as Siscoe has pointed out to me, by showing the only cumulonimbus in Dutch art — the tall cloud with wisps of

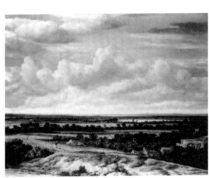

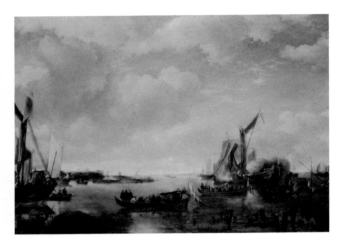

9. Philips de Koninck,
 Panoramic Landscape, ca. 1655,
 oil on canvas, 111.8 x 155 cm.
 Glasgow, Hunterian Art Gallery, University
 of Glasgow, Hunter bequest.

10. Philips de Koninck,
 Extensive Landscape with a Road by a Ruin,
 1665,
 oil on canvas, 137.4 x 167.7 cm.
 London, National Gallery, no. 6398.

11. Jan van de Cappelle,
 *A River Scene with a Dutch Yacht Firing a
 Salute*, 166(?),
 oil on canvas, 93 x 131.1 cm.
 London, National Gallery, no. 966.

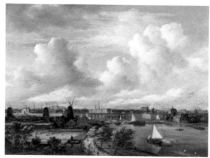

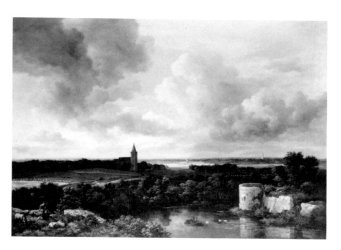

12. Jacob van Ruisdael,
 *A Landscape with a Ruined Castle and a
 Church*, ca. 1665–1670,
 oil on canvas, 109 x 146 cm.
 London, National Gallery, no. 990.

13. Jacob van Ruisdael,
 *Panoramic View of the Amstel Looking toward
 Amsterdam*, ca. 1675–1681,
 oil on canvas, 52.1 x 66.1 cm.
 Cambridge, Fitzwilliam Museum, no. 74.

ice particles that give it a frizzy top. It is combined in the same picture with another of those tailed hybrids (baptized by Siscoe "pseudocumulus codalis Ruisdaelis"), a cloud that supplies the picture's formal energy.[9]

We may wonder what accounts for the recurrence of this great curving plume of cloud in works by artists spanning a half century, from Rubens and the early sea painters through Salomon van Ruysdael and Jacob van Ruisdael. It cannot simply be a constant optical illusion in nature or a common error of artists. The cloud is a pictorial motif. It travels from artist to artist by means of pictures, like other conventional elements of nature in Dutch landscape such as diverging roads, a ford in the stream, a dune with spectators, and other plausible ingredients that organize a composition while evoking the familiar.

To substantiate this claim I offer another cloud motif, a strange, double-branched affair found in many Dutch landscapes. Though it may have a basis in nature, it looks mostly fanciful in the fresco by Paul Bril in the Scala Santa in the Vatican and in various related works by the artist (fig. 14),[10] all stylized with late Mannerist exuberance. Something very like it appears in an engraving after Hendrik Goltzius of a fish seller[11] — a cloud with a contrapposto similar to that of the fish seller. Such clouds survive in a more sober beach scene by Hendrik Vroom of the 1610s or early 1620s[12] and reappear many times later, especially in paintings and prints by Haarlem artists, including several by Jacob van Ruisdael in which they are dominant elements of the compositions (fig. 15).[13] This kind of cloud is a meteorological anomaly at best. It takes various forms in the hands of different artists, gaining or losing plausibility, while its peculiar general shape — which is the motif — can always be recognized. This is one more example of the general phenomenon of landscape painters reinventing nature with conventional patterns as a guide, correcting and refreshing their version of nature by observing nature itself.[14]

We might wonder whether some of these distortions and stereotypes reflect ideas about meteorology accessible to seventeenth-century artists. The contemporary scientific literature is not encouraging, however. The basic information about clouds was well understood and accurately described by a number of meteorological treatises — the six books on meteorology by Libertus Froidment of Louvain (1627), for example — and in various university handbooks for the so-called "physiology of natural science," such as that of Frans Burgersdijk, professor of natural physiology at Leiden

14. Mattheus or Paul Bril,
 Storm at Sea (study for *Jonah Thrown to the
 Whale* [?]), before 1589,
 pen, black chalk, and wash on paper, 16.3 x 27.9 cm.
 Paris, Musée du Louvre, Département des
 Arts Graphiques, no. 19.819.

15. Jacob van Ruisdael,
 The Banks of a River, 1649,
 oil on canvas, 134 x 193 cm.
 Edinburgh, National Gallery of Scotland,
 no. 75, on loan from the University of
 Edinburgh, Torrie Collection.

16. Jacob van Ruisdael,
 Extensive Landscape with a View of Haarlem,
 ca. 1668–1672,
 black chalk and gray wash on paper,
 10.7 x 15 cm.
 The Hague, Museum Bredius, no. т96–1946.

17. Jacob van Ruisdael,
 View of Haarlem with Bleaching Grounds,
 ca. 1670–1675,
 oil on canvas, 62.2 x 55.2 cm.
 Zurich, Kunsthaus, Stiftung Prof.
 Dr. L. Ruzicka, no. R.32.

from 1620 to 1635.[15] These books were all in Latin, and to my knowledge there was no vernacular handbook; but we may assume that painters, if they wished to, could learn the basics one way or another. The basics were virtually all there was to learn, for meteorology had not progressed far beyond the principles of Aristotle's *Meteorologica* and its ancient and medieval commentators. Seventeenth-century treatises repeated Aristotle's explanation of the interaction of the four elements: vapors were drawn up from the earth by the heating action of the sun, passed through a cool layer of upper air, and congealed to a thicker consistency, becoming clouds. The cycle of the water rising and returning to earth as precipitation was also understood. But nothing like empirical observation of clouds was reflected in scientific writing during most of the seventeenth century, and only Robert Hooke's combined use of thermometer and barometer in the 1660s provided a foundation for modern meteorology. Dutch painters had evidently to depend on observation and formulas; science provided neither models nor stimuli.

Improvisation and poetic license came naturally to cloud painters from the conditions under which they worked and from the kinds of visual information on which they relied. All indications are that landscape paintings were invariably made indoors, never in the field. Recollection, including the recollection of other artists' pictures, must have been the main source of images. Dutch painters did not make the sort of sky studies that Johan Dahl and John Constable executed in the field a century and a half later.[16] They made drawings, of course, but these virtually never include clouds that look like they were recorded on the spot. Jacob van Ruisdael's panoramic drawing of Amsterdam seen from a tower[17] has a few of the perfunctory clouds that typically appear in landscape drawings, sometimes included to show a printmaker what was wanted, sometimes to dress up a drawing for sale. This is very different, however, from directly recording features of the land. The paintings by Van Ruisdael that are based on such drawings, like the panorama in an English private collection,[18] are dominated by clouds. In Van Ruisdael's *Haarlempjes* (fig. 16), three of four chalk drawings show the sky perfectly blank;[19] in the paintings the clouds dominate the compositions and no two skies are alike (fig. 17). We conclude that they were conjured up later in the studio by an artist who knew how to reinvent both plausible and fanciful skies without reference to notes made in the field.

Skies present a revealing case history of the relationship between Dutch art and nature. Selecting, stereotyping, and altering for the sake of more

effective images of nature, all resemble the processes of flower painters, who combined blossoms from different times of the year in impossible bouquets, or view painters, who put well-known monuments from different cities into the same picture.

As for the purposes to which clouds were put in landscape paintings, I can only touch on the subject. It is obvious that clouds proved to be a versatile pictorial device for Dutch painters, helping them to reinforce shapes in pictures, to organize entire compositions, to provide formal equilibrium, to bolster perspective structure, and so on. This repertory of uses has remained serviceable for landscape painters ever since. When Constable described the function of the sky, he called it "the key note, the standard of scale, and the chief organ of sentiment."[20] The seventeenth-century painter would have accepted Constable's first two claims; "sentiment" he would have understood differently. But the idea of sentiment suggests other uses of the sky in landscape, affective and possibly symbolic uses.

Emotional affect for seventeenth-century audiences has proven hopelessly difficult to gauge, and as historians we can make only cautious guesses about how landscapes or any other form of art worked upon the feelings of contemporary spectators. In the more dramatic instances, however, such as the stormy landscape by Rembrandt in Braunschweig or Jacob van Ruisdael's *Jewish Cemetery*, one can safely surmise that the audience was meant to feel awe at the immense storm clouds and admiration at the spectacle.[21]

It is less certain whether clouds carried literary or religious associations for seventeenth-century audiences. Claims to this effect have been made by Hans Kaufmann and Wilfried Wiegand, as well as Marek Rostworowski and, in a very different way, Hubert Damisch.[22] Each has rummaged in emblem books and poetry, found a few of the many instances of cloud metaphors in literature since the Renaissance, and suggested or implied that the morals or other messages drawn from clouds *raisonnés* are present in painted landscapes. It is certainly true that clouds have many associations in English poetry, most often with power or its nemesis, changeability, with *Fortuna*, and even with death. But for all the uses for which clouds have served poets — and Kaufmann and Damisch cite many — no one has yet successfully applied a cloud metaphor to a painting. One problem is that Dutch lyric and dramatic poetry seem to use few cloud images (but here much more exploration is necessary). A larger difficulty is that religious or other metaphorical interpretations of landscape generally have not succeeded:

except for the *Jewish Cemetery* and various sea storms, I believe that there are actually few landscapes that have high signal value and thus support any sort of plausible symbolic reading.[23]

But surely some spectators looked at painted nature for the presence of God in the way Constantijn Huygens looked at nature itself, seeing the sky as the roof of God's creation and taking note of "God's goodness from the top of every dune."[24] It is hard to imagine Jacob van Ruisdael creating such a picture as the panorama of Amsterdam at Bowood, which shows the proudest works of man dwarfed and dominated by the realm of God, the sky, without some such thoughts in mind.[25] What are we to make of the role of the sky in a picture such as Paulus Potter's *Young Bull*? Could it be insignificant that a huge rain cloud moves across the fields and half fills the background opposite the potent bull and his companions? The picture draws on a tradition of allegories of spring and fecundity. Must not the benevolent processes of the weather have formed part of this construct?[26]

Let me end with two paintings by Nicolaes Berchem in which clouds must be considered in any reading of the painting. Here they make what we might call "natural" metaphors, as distinct from literary or scriptural metaphors. If they do not elucidate the action, they reinforce its sense. In one, oxen and farmers are shown at the plow, straining up the hill and expending great effort while a huge cumulus cloud looms behind them — much too low to occur in nature — expanding in the sunlight (fig. 18). Anyone who looked out of doors in the seventeenth century could see this kind of cumulus cloud, and every scientific commentator from Aristotle on had described the process of its formation. The energetically growing cloud is the perfect companion to the kinetic human activity here; it is a kind of meteorological commentary on it.

In one of Berchem's many scenes of peasants in the ruins of the Roman Campania (fig. 19), the sky offers another kind of comment. The cloud overhead is a formation typical of late afternoon, decaying in the cooling air and declining light. Such clouds form earlier in the day and swell in the sun; here the earlier energy of the cloud is gone and it reveals a different kind of beauty. This quotidian history of clouds was part of the everyday experience of the artist and his audience. Both could recognize a cloud at this stage of life, so to speak, and perceive its picturesque decline as a meaningful part of the imagery of a landscape of ruins.

What we ultimately want to know about landscapes in our role as art

18. Nicolaes Berchem,
 A Man and a Youth Ploughing, ca. 1650–1655,
 oil on canvas, 38.2 x 51.5 cm.
 London, National Gallery, no. 1005.

19. Nicolaes Berchem,
 Peasants with Cattle by a Ruined Aqueduct,
 ca. 1655–1660,
 oil on panel, 47 x 38.7 cm.
 London, National Gallery, no. 820.

historians, of course, is how they functioned: what the artist put into them, what expectations their original audiences brought to them, why they were bought, what needs they satisfied, and how they might have been apprehended by viewers of varying degrees of sophistication. No doubt there were more messages for the seventeenth-century spectator than we can yet discern, whether general truths about God and human life or more specific ones about places and human vice or virtue. It seems to me that the literature will only get us so far in this process of recovering meaning and that the best way to grasp these messages is to try to understand the conventions of landscapes, their rhetorical structure, and the sort of devices I have just identified in Berchem's clouds. Clouds have more to tell us about the patterns of thought that motivated artists to paint landscapes and made their owners value them.

NOTES

A somewhat different version of this paper, "Clouds: Function and Form," was read in the session "Art into Landscape in the Netherlands, ca. 1500–1700" organized by Egbert Haverkamp-Begemann at the College Art Association meeting in Boston in February 1987. I am grateful above all to George Siscoe, professor of Atmospheric Sciences at the University of California, Los Angeles, for his tutelage and encouragement; to David Freedberg for his critical reading of this text; and, for various useful suggestions, to Sheppard Craige, Thomas and Barbara Gaehtgens, Stanley Gedzelman, John Hollander, Gary Schwartz, Cynthia Schneider, Seymour Slive, and Peter Sutton. The library staff of the Getty Center under the direction of Anne-Mieke Halbrook was helpful in countless ways. I also want to thank Theresa Williams, Patricia Howard, and Julia Smith for their work on the manuscript.

1. For storms at sea and for an acute examination of typologies and pictorial rhetoric that extends to other types of painting, see Lawrence O. Goedde, *Tempest and Shipwreck in Dutch and Flemish Art* (University Park, Penn., and London: Pennsylvania State Univ. Press, 1984), esp. 163–206.

2. Evert van Straaten, *Koud tot op het bot: De verbeelding van de winter in de zestiende en zeventiende eeuw in de Nederlanden* (The Hague: Staatsuitgeverij, 1977), 10–13.

3. Karel van Mander, *Het schilder-boeck* (Haarlem: Passchier van Westbusch, 1604), chap. 8, v. 15–16; idem, *Den grondt der edel vry schilder-konst*, ed. and trans. Hessel Miedema (Utrecht: Haentjens, Dekker & Gumbert, 1973), 1: 209.

4. For this categorization of landscape types, see Peter Sutton's introduction to *Masters of*

Seventeenth-Century Dutch Landscape Painting, exh. cat. (Boston: Museum of Fine Arts, 1987), 3–5; Wolfgang Stechow, *Dutch Landscape Painting of the Seventeenth Century* (London: Phaidon, 1966), vii–viii.

5. The "mapping impulse" imputed to Dutch artists by Svetlana Alpers (*The Art of Describing: Dutch Art in the Seventeenth Century* [Chicago: Univ. of Chicago Press, 1983], 119–68) implies a methodical objectivity and schematization rarely found in the drawings and prints, much less the paintings, which she uses as examples. See, among other critiques of Alpers on this point, Jan Białostocki in *The Art Bulletin* 67 (1985): 524, and Goedde (see note 1), xvi.

6. Marek Rostworowski, "L'Atlas des nuages en peinture hollandaise," in *Ars Auro Prior: Studia Ioanni Białostocki Sexagenario Dicata* (Warsaw: Panstwowe Wydawnictwo Naukowe, 1981), 459–63; Margarita Russell, "Seascape into Landscape," in *Dutch Landscape: The Early Years, Haarlem and Amsterdam, 1590-1650*, ed. Christopher Brown, exh. cat. (London: National Gallery Publications, 1986), 68–70. Russell claims that "[Hendrik] Vroom and his followers were the first artists to depict scientifically correct shapes of clouds," citing an undated pen drawing of a beach scene, which she dates implausibly early, and whose chief feature is a cloud that would be an anomaly in nature (see note 12).

7. John Ruskin described these phenomena and gave a geometrical diagram (John Ruskin, *Modern Painters*, 4th ed. [London: G. Allen, 1903–1904], 5: 130–32).

8. Peter Ashton, Alice I. Davies, and Seymour Slive, "Jacob van Ruisdael's Trees," *Arnoldia* 42 (1982): 2–31.

9. It should be remembered that there is such a thing as a "mixed" sky, in meteorological terms, with several kinds of clouds separated by the necessary distance and altitude. We sometimes see such skies in Dutch paintings. What is anomalous is the combining of different types in close proximity or in actual connection.

10. For the versions, see Goedde (see note 1), 225, n. 94.

11. Anonymous, *Aqua*, from *The Elements*, II, 13.23 (101); see Walter L. Strauss, ed., *The Illustrated Bartsch* (New York: Abaris Books, 1980), 3: 305.

12. Russell (see note 6), 68, fig. 6 (dated about 1600, surely far too early); also idem, *Visions of the Sea: Hendrick C. Vroom and the Origins of Dutch Marine Painting* (Leiden: E. J. Brill & Leiden Univ. Press, 1983), 142, fig. 124.

13. See, for instance, the engraving by Allart van Everdingen of *The First Spring at Spa* (?) (F. W. H. Hollstein, *Dutch and Flemish Engravings, Etchings, and Woodcuts, ca. 1450-1700* [Amsterdam: Menno Hertzberger, 1949–], 6: 195; David Freedberg, *Dutch Landscape Prints of the Seventeenth Century* [London: British Museum Publications, 1980], pl. 99) and two very different paintings by Van Ruisdael, the large river landscape of 1649 in Edinburgh and the small dune landscape in the Frans Halsmuseum, Haarlem (Seymour Slive, *Jacob van Ruisdael*, exh. cat. [New York: Abbeville, 1981], nos. 9 and 28).

14. For this process, see E. H. Gombrich, "The Renaissance Theory of Art and the Rise of Landscape," in *Norm and Form: Studies in the Art of the Renaissance* (London: Phaidon, 1966), 107–21, with particular reference to clouds, and idem, *Art and Illusion* (New York: Pantheon, 1960), 126–52.

15. For a survey of seventeenth-century meteorological literature, see Lynn Thorndike, *History of Magic and Experimental Science* (New York: Columbia Univ. Press, 1923–1958), 7: esp. 47–62, 372–497, and 653–62. More useful for ideas is S. K. Heninger, *A Handbook of Renaissance Meteorology with Particular Reference to Elizabethan and Jacobean Literature* (Durham, N.C.: Duke Univ. Press, 1960), 3–87, with a good bibliography.

16. For an up-to-date discussion of the working methods of landscape painters, see Sutton (see note 4), 5–8. Sutton cites the only instructions about clouds given to painters in a seventeenth-century treatise (other than Van Mander's advice that they paint the pure blue sky; see note 3), Van Hoogstraten's advice to "observe the lovely gliding of the clouds, how their drift and shapes are related to one another, because the eye of the artist must always recognize things by their essence[s], while the common folk see only weird shapes." (Samuel van Hoogstraten, *Inleyding tot de hooge schoole der schilderkonst* [Rotterdam: F. van Hoogstraeten, 1678], 140; Sutton, [see note 4], 10.) The emphasis is on *oorzaken* (essences), not structure or detail. David Freedberg's discussion of the concept of *naar het leven* is useful in this connection (Freedberg [see note 13], 10). For Dahl and Constable, see especially Kurt Badt, *John Constable's Clouds* (London: Routledge & Kegan Paul, 1950); idem, *Wolkenbilder und Wolkengedichte der Romantik* (Berlin: W. de Gruyter, 1960).

17. Amsterdam, Rijksprentenkabinet, no. 1960: 116; Slive (see note 13), no. 87.

18. Marquess of Lansdowne, Bowood; Slive (see note 13), no. 46.

19. Slive (see note 13), nos. 88–90 (The Hague, Museum Bredius), and 91 (Amsterdam, Rijksprentenkabinet). The sky in the Amsterdam drawing may be a later addition by Dirck Dalens, as Giltay suggested, or by someone else (J. Giltay, "De tekeningen van Jacob van Ruisdael," *Oud Holland* 94 [1980]: 161, no. 6).

20. Letter to John Fisher, 23 October 1821; C. R. Leslie, *Memoirs of the Life of John Constable, R.A.* (London: The Medici Society, 1937), 118.

21. Slive (see note 13), no. 20, for a discussion of interpretations of the *Jewish Cemetery*; for the Rembrandt, see Cynthia P. Schneider, *Rembrandt's Landscapes* (New Haven: Yale Univ. Press, 1990), 63–71 and 175–78. These general issues are dealt with in relation to convention and the tradition of ekphrasis by Goedde (see note 1), 113–30 and 193–206.

22. Hans Kaufmann, "Jacob van Ruisdael: 'Die Mühle von Wijk bij Duurstede,'" in *Festschrift für Otto von Simson zum 65. Geburtstag* (Frankfurt: Propyläen Verlag, 1977), 379–97; Wilfried Wiegand, "Ruisdael-Studien: Ein Versuch zur Ikonologie der Landschaftsmalerei" (Ph.D. diss., Universität Hamburg, 1971); Rostworowski (see note 6); Hubert Damisch, *Théorie*

du nuage: Pour une histoire de la peinture (Paris: Editions du Seuil, 1972).

23. Wiegand's dissertation (see note 22) has given impulse to other attempts to explain Dutch landscape as laden with Christian symbolism, especially Hans-Joachim Raupp, "Zur Bedeutung von Thema und Symbol für die holländische Landschaftsmalerei des 17. Jahrhunderts," *Jahrbuch der Staatlichen Kunstsammlungen in Baden-Württemberg* 17 (1980), 85–110, and Josua Bruyn, "Toward a Scriptural Reading of Seventeenth-Century Dutch Landscape Paintings," in Sutton (see note 4), 84–103. Rarely, however, do the authors demonstrate a sufficiently close connection between the moralized motifs in literature and their use in landscape paintings. Lacking are both contemporary literary evidence (the authors cited are from the late sixteenth and early eighteenth centuries) and a consistent juxtaposition of pictorial elements that would confirm the moralizing intention. E. de Jongh's sensible rules for the plausibility of interpretation (see his essay in this volume) are generally ignored. De Jongh commented on Bruyn's essay and on the use and misuse of "associations" in a paper delivered at a symposium at the Museum of Fine Arts, Boston, "Mountains in the Lowlands," 12 March 1986. See also Christopher Brown's cogent review of the Boston catalog in *Simiolus* 18 (1988), 76–81. These issues are treated sensitively by Freedberg (see note 13), 9–20, and more recently and extensively by Goedde (see note 1).

24. P. A. F. van Veen, "De soeticheydt des buyten-levens, vergheselschapt met de bouken: Het hofdicht als tak van een georgische literatuur" (Ph.D. diss., Univ. of Leiden, 1960; Utrecht, 1985), 19; Sutton (see note 4), 12–13.

25. See note 18.

26. Amy W. Walsh, "Paulus Potter: His Works and Their Meaning" (Ph.D. diss., Columbia Univ., 1985), 171–84.

1. Jan Miense Molenaer,
 A Young Man and a Woman Making Music,
 early 1630s,
 oil on canvas, 68 x 84 cm.
 London, National Gallery, no. 1293.

E. de Jongh

Some Notes
on Interpretation

Until recently, history paid less attention to art history than art history to history. Johan Huizinga was one of the very few historians to demonstrate a professional interest in the fine arts in accordance with his desire, as expressed in *The Waning of the Middle Ages*, to describe "forms of life and thought" — a sort of morphology of the past.[1] Lately, however, an increasing number of historians have begun to show an interest in visual matters. Historical publications are often richly illustrated as, for example, is the new *Algemene geschiedenis der Nederlanden* — even though art history does not seem to be taken completely seriously in this standard work.

But with which kind of art history is the present-day historian or student of cultural history (who has a vested interest in art history) likely to come into contact? I do not want to discuss the vexing question of precisely what is covered by the term "cultural history," but I envision historians with broad interests who can put the results of recent research in art history to some use. Let us say that such a historian works on the seventeenth-century Netherlands. Surely, it must matter whether colleagues in art history claim that seventeenth-century Dutch art is one great manifestation of moral teaching in symbolic dress code, an "art of describing," or a combination of these and yet other opinions.

It is perhaps not surprising that during a congress held in Amsterdam in December 1985, which was devoted to the theme of "cultural history in a changing perspective," iconology, of all art-historical methods, came up for discussion on several occasions.[2] The results of iconological research into seventeenth-century Dutch art were considered useful, but unmistakably critical qualifications were also voiced. These came mostly from J. L. Price,

119

who claimed that "the iconology of Dutch art is not an important part of its significance, however measured, but only decoration or the *impedimenta* of the past."[3] Price seems to think that iconological methods are appropriately applied both to Renaissance art and to much seventeenth-century art but are not at all suitable for what he calls "the art of the artisan painters of the Republic."[4]

One member of the Amsterdam congress who expressed himself fairly consistently in favor of iconological research as applied to seventeenth-century Dutch art was Josua Bruyn.[5] He, like Price, took the view that this art reveals conservative traits, especially in the presentation of elements bearing meaning. Bruyn made a statement that should be taken to heart in any consideration of the work of art as a historical document. He issued a warning — as had others — against the danger of regarding objects and people depicted in plausible situations as necessarily reflecting true pictures of reality.

> It takes considerable detachment, training, and the instincts of a detective before one can feel at home with a different reading of an apparently realistic picture and can formulate this reading in such a way that it will convince others. The art historian's contribution to cultural history must be the effort necessary to get to the bottom of seventeenth-century pictorial matter in its determinants, and to read it as one might read a text. The resulting interpretations will not be the most obvious ones. They often seem to go against common sense and against the historian's tendency to take the outward appearance of a work of art at its face value.[6]

Bruyn's faith in iconological interpretation was equally uncompromising in a lecture on meaning in seventeenth-century painted landscapes, entitled "Toward a Scriptural Reading of Seventeenth-Century Dutch Landscape Paintings," which he gave at the meeting of the College Art Association in Boston in 1987. It is significant that he called the painted landscape a "configuration of ideograms." Bruyn has explored this theme further in the catalog of the exhibition of Dutch landscape paintings held in 1987–1988 at the Rijksmuseum, Amsterdam, and thereafter in Boston and Philadelphia.[7] His view of seventeenth-century Dutch landscape painting is partly an extension of the interpretations put forward by Wilfried Wiegand and Hans-Joachim Raupp, but his ideas go deeper and are more fundamentally integrated into

a general cultural framework.[8] This approach to landscape, therefore, differs essentially from that presented at the National Gallery, London, in 1986.[9] But Bruyn was well aware of the difference and distanced himself from the formalistic conception of the London exhibition and catalog.

One can easily be led to feel that, except on very rare occasions, it takes more than a little temerity to interpret painted landscapes as expressions of religious and moralistic thought. My own first reaction was one of suspicion. But Bruyn regards such mistrust as unfounded and illogical and skillfully defends his argument in his 1987–1988 essay. His reasoning goes something like this: If we accept that symbols and moralization are present in still life and genre painting and in other categories of seventeenth-century Dutch art, then it is inconsistent to assume that one particular category, in this case landscape, should have been spared. My own contribution to the interpretation of landscapes is much more limited, since I have always shrunk back from the amount of speculation inevitably involved.[10] Perhaps Bruyn's interpretations do lay bare the real intentions of seventeenth-century landscape painters, but it is hard to find visual proof of the symbolic readings he proposes.

For all that, Bruyn's iconological study is impressive in comparison with other recent contributions on sixteenth- and seventeenth-century art, such as the catalog of the Joachim Beuckelaer exhibition held in Ghent in 1986.[11] This disquieting publication may be regarded as the antipode of the London landscape catalog of the same year. The London catalog contains a number of articles by art historians and other historians whose combined message, however implicit, is that we should save ourselves the trouble of searching for any depth of meaning in painted landscapes.[12] The Ghent catalog, on the other hand, suggests that more or less everything means something, so that every turnip, cabbage, hazelnut, and bird is sexually loaded. When my own work was invoked by the pen-happy sexologists, my momentary sympathy was soon dispelled; this was chiefly the result of my conviction that the iconography of paintings by Beuckelaer and similarly inclined artists does carry a meaning beyond what meets us at first sight but certainly not of the sort suggested by the Ghent catalog. The debate on sixteenth-century marketplace paintings opened so cautiously by Jan Emmens has taken on grotesque forms.[13] I may seem to resemble Satan rebuking sin, but I have become increasingly concerned about the craze for interpretation that threatens to run more prudent iconology underfoot. Let me thus offer

some remarks about what seems to be the proper domain and potential of interpretation.

One of the difficulties is defining limits, establishing where sense ends and nonsense begins. Within the last decade, a whole body of publications, mostly on genre painting, has keenly demonstrated the lack of consensus about borders. During the symposia held in Philadelphia and London on the occasion of the genre exhibition of 1984, I made an attempt to formulate a few rules for the art of interpretation.[14] My mainstay was the concept of "specificity." We find many motifs in seventeenth-century painting that are not specific in the sense of being sufficiently at odds with normal use or normal occurrence. This is not to say that a nonspecific motif cannot have a metaphorical meaning, but the likelihood that such a motif could provide access to interpretation seems rather remote. In this connection I contrasted the act of sweeping with a broom as a theme in seventeenth-century Dutch art with the act of holding a bunch of grapes, as people posed in typical portrait stance do. The first rendering, showing routine housework, can be considered as nonspecific; the second displays an unusual action. The latter is, indeed, very specific and invests the grape motif, in semiological terms, with a high signal value. (The brooms in question are probably not meaningless but are less clearly iconographical because of their setting.)

This "rule" of specificity testifies to a certain reticence and restraint, but of course in the final analysis it lacks solidity. Nor did the useful and witty plea for common sense that Peter Hecht put forward in Pittsburgh in 1986 possess the desired, unattainable solidity, although it merits much closer attention than it has received so far.[15]

When one surveys the field of recent seventeenth-century Dutch art history, one is immediately struck by its lack of coherence. Paradigms to aid our understanding are more readily available on the scholarly market than ever before. Ramification and disintegration abound. Aside from the many cautious and incautious variations of iconology, we may distinguish the complicated methods of the Rembrandt Research Project; the neoformalistic pretensions to cultural history of Svetlana Alpers and her adherents; the reflections of Hans-Joachim Raupp on the theoretical foundations of genre painting; the socioeconomic inquiries into art history of which John Michael Montias and S. Dudok van Heel are the chief exponents; the historical approach of Gary Schwartz, combining interpretations of Rembrandt's paintings with a reconstruction of his social milieu; and the semiotic, semi-

otic-psychoanalytical, and semiotic-psychoanalytical-feminist approaches to a work of art. Such a sampling is thoroughly unsystematic and anything but comprehensive; but even in this chaos of different approaches, the three traditional bases of art history — archival research, connoisseurship and stylistics, and iconography and iconology — can be recognized. I will limit my comments to the third, the category of iconography and iconology.

What is it about works of art — representations — that so easily attracts nonsense, with the result that art history, much more readily than any other discipline, often seems like a free-for-all? One important reason is that pictures are so patient and by definition multivalent.[16] It is in the nature of pictures to be more receptive to what people may project onto them than are grain prices, council bylaws, or even literary texts. Some pictures, being more than just passively receptive, possess certain qualities that incite the viewer to excesses of reading, and the beholder's share often assumes monstrous proportions. Representations are constantly loaded with meanings that were not and could not have been intended by the artist.

One might ask, for instance, how Dutch marriage portraits of the seventeenth century could possibly be conceived of as performances in which "appearance," "manner," and "setting" were thought to "define the characters of the sitters."[17] In the same way, one might ask — especially bearing in mind what E. H. Gombrich called "the primacy of genres" — how a genre piece by Jan Miense Molenaer, presumably intended to be witty, could be ponderously classified as a political allegory and given the title *The Harmony and Well-Being of the Prosperous Dutch Republic under the Leadership of the House of Orange* (fig. 1).[18] How can one possibly understand Rembrandt's *Rape of Ganymede* (fig. 2) as a form of "exceedingly violent criticism...of notions prevailing at court and in contemporary humanistic circles?" In such an interpretation the picture offers insight "into the intensity of the ideological class struggle in Holland."[19] The author who saw castration anxiety, phallic symbolism, and sexual penetration in Rembrandt's *Blinding of Samson* (fig. 3) interpreted Samson himself as a baby, a woman in labor, and a victim of male aggression.[20]

What strikes me about many writings is the lack of care and respect with which authors approach context and meaning, the lack of consideration given, for instance, to the pictorial tradition and the "primacy of genres." Even more striking is the extent to which many authors believe the past to be knowable. Amongst historians, epistemology has been a subject of much

2. Rembrandt Harmensz. van Rijn,
 The Rape of Ganymede, 1635,
 oil on canvas, 171.5 x 130 cm.
 Dresden, Staatliche Kunstsammlungen
 Dresden, Gemäldegalerie Alte Meister,
 no. 1558.

3. Rembrandt Harmensz. van Rijn,
 The Blinding of Samson, 1636,
 oil on canvas, 236 x 302 cm.
 Frankfurt, Städelsches Kunstinstitut, no. 1383.

discussion.[21] Unfortunately, one rarely hears it discussed by art historians, although a greater insight into questions of what can and cannot truly be known might have saved us from some of the more incredible pronouncements about artists and art. Sometimes these pronouncements are so naive or bizarre that one wonders whether the author was even aware of the problem. Rembrandt's sexual anxieties, for example, are bound to elude us; nor can we ever hope to fathom his character. I take the recalcitrance of the past as a given and remain certain that much essential information is always kept from us. But pseudo-knowledge is always available for it can be extracted at will by means of projection.

Because reliable knowledge of the past is only possible to a limited extent, the essence and meaning(s) of works of art can only be partly understood. The gaps in our knowledge are not entirely due to the obstinacy of works of art as we try to prise out their secrets (they are, of course, patient toward those who deceive themselves by projecting). It is also true that language is inadequate when talking about the visual arts. George Boas summarized part of this problem as follows: "The most reasonable reply of an artist to the question, 'What were you trying to do in this painting?' is, 'To paint this painting.' For just as one cannot express in words the character, the peculiar quality, the feel of any individual experience, so one cannot succeed in completely describing a work of art. The most important lesson for the critic is to learn the limits of speech."[22]

If we succeed in determining the iconography of a representation and get a grasp on what, for want of a better word, I refer to as the iconology of the work of art, the work of art placed in its time and milieu and in its relation to contemporary conceptions and notions — in short, the work of art in its context — there still remains much to be desired. We still need more information. For example: What was the artist's intention when a particular painting was conceived? How involved was the artist with the theme? How was the picture supposed to work?[23]

In considering such questions and in the light of George Boas's remarks, two of Vincent van Gogh's letters readily come to mind, one to his brother Theo and one to his friend Emile Bernard. In them Van Gogh explains in minute detail all that he was trying to achieve in his *Night Café* (fig. 4) and describes what he put into the work emotionally.[24] He relates how he tried "to express the terrible passions of humanity by means of red and green" and "to express the idea that the *Night Café* is a place where one can ruin

4. Vincent van Gogh,
 The Night Café, 1888,
 oil on canvas, 70 x 89 cm.
 New Haven, Yale University Art Gallery,
 Bequest of Stephen Carlton Clark, B. A.,
 1903.

oneself, go mad, or commit a crime. So I have tried to express, as it were, the powers of darkness in a low, public house, by soft Louis XV green and malachite, contrasting with yellow-green and harsh blue-greens, and all this is an atmosphere like a devil's furnace, of pale sulphur." Even these few sentences provide us with remarkable information about Van Gogh's intention, his involvement with the theme, and the mood that he wanted to convey. They give us some sense of his symbolic use of his own palette. Would anyone ever have arrived at the intended meaning of this painting without the artist's letters to help us? But — to complicate matters even further — is the artist's professed intention necessarily a reliable guide to the meaning of his work?

Van Gogh has simply been introduced here by way of contrast. Of course there is no comparable document relating to a seventeenth-century Dutch artist, if only because a letter like Van Gogh's with its personal notions about artistic expression would have been inconceivable at the time. Van Gogh's subjective understanding of art as exhibited in his letters has, to the best of my knowledge, no counterpart in the seventeenth century. What we do find, though rarely, are businesslike explanations. The letter Peter Paul Rubens sent to Justus Sustermans to elucidate his allegory *The Horrors of War* comes to mind.[25] But such a letter does not go beyond a description of the detailed iconography and never penetrates below the surface, as Van Gogh's does. Since Rubens's imagery is mainly traditional, we could probably have obtained it from the painting itself. Not so in Van Gogh's case: "terrible passions," madness, and crime cannot be deduced from the *Night Café* itself.

Although inquiries into the personalities behind seventeenth-century works of art — especially given seventeenth-century concepts of art and our heuristic limitations — can never be fully pursued, the varied research of the last few decades has certainly provided answers to other questions. We have found, for example, that some works of art have considerable meaning, are rich in symbolic content, and are clearly referential. Other works of art do not mean very much at all — in extreme cases, no more than they indicate at first sight. This was common knowledge even before Svetlana Alpers published *The Art of Describing*. We need to be alert to such differences, but we should remember that the last word on the legibility of works of art, on the telling factors, on the translating of the visual code, has not been uttered. This much is clear: some representations possess a more extensive and more active signal system than others. An explicit *vanitas* still life has a greater degree of specificity, and therefore exercises a stronger

semantic impact, than the average river landscape by Jan van Goyen.[26]

Recent research has gradually made it clear that morality plays a less central role in seventeenth-century Dutch art than I once believed. I was sometimes too dogmatic in this respect and found more traces of edification than could reasonably be proved. I now tend toward the conviction that, in addition to morality, pictures often display more than a hint of pseudo-morality, whether or not it is tongue-in-cheek. There may even be no concern with morality at all.[27] The point of a representation sometimes seems to turn on "wit" or on nothing more substantial than a trivial joke. But this brings one back to the nebulous domains of tone and intention, to say nothing of the epistemology of humor, which requires particular caution.

In looking for the point of a particular representation, I have been primarily concerned with the recovery of original meaning, with the meaning, in all its facets, that the artist attached to his creation. That a work of art can change its meaning or have its meaning changed the moment it leaves the studio — and not just once but time and again, according to the needs of successive generations or even individuals — is self-evident and of the greatest interest to the cultural historian. It is here that we are granted those frequent and unexpected glimpses of the changing concepts of art and society. Frans Hals's *Regents of the Old Men's Alms House* (fig. 5) and *Regentesses of the Old Men's Alms House* (fig. 6), for example, which were still being praised at the end of the eighteenth century as "gods toward humanity" and as "wise and beneficent almoners," have been seen in the most negative light since the last quarter of the nineteenth century.[28] This has in the first instance to do with developments in social ethics, but it also affects our experience of the pictures to such a degree that it conceals their original intention.

Works of art take on new meanings at least partly because of what I earlier called the "patience of the picture," the capacity of images to absorb notions that the beholder projects onto these works. The human need to find a home for feelings or ideas in works of art has often led to curious results. In the specific examples cited earlier in this essay — Rembrandt in his sexual and social modes, Molenaer as an allegorizing Orangist, marriage portraits as performances, with their sitters as characters in the theater — there was at least some agreement about what actually can be seen on the surface of the picture, but this is by no means always the case. Intellect and perception interact. When personal ideology, personal conviction, or simply a

5. Frans Hals,
 Regents of the Old Men's Alms House,
 ca. 1664,
 oil on canvas, 172.5 x 256 cm.
 Haarlem, Frans Halsmuseum.

6. Frans Hals,
 Regentesses of the Old Men's Alms House,
 ca. 1664,
 oil on canvas, 172.5 x 256 cm.
 Haarlem, Frans Halsmuseum.

personal point of view dominates the interpretative act unduly, awareness can be so reduced that the interpreted subject assumes a different form, one that accommodates the meaning that the interpreter hopes to find. One might claim that this always happens to some degree, but I will concentrate on a few specific lapses, in particular, cases of confusion of gender.

In the catalog to the Leiden exhibition *Vanity of Vanities* (1970) the chambermaid in Molenaer's well-known depiction of Lady World was seen as a man (fig. 7).[29] The author of this particular entry worked out a romantic plot in which the young woman in the principal role had been deserted by her husband, and the man, wearing stage clothes as her dresser, used the situation to win her favors. The whole interpretation was pure fantasy. Mieke Bal, who exuberantly sexualized Samson, was so blinded by the fire of her semiotic, psychoanalytical, and feminist contentions that she too took a woman to be a man.[30] This time the aged crone in Rembrandt's *Danae* (fig. 8) underwent a change of sex and was identified as a "Peeping Tom" to whom "the naked and completely exposed body of the woman is visually subjected." This Peeping Tom, however, is no man; even if one does not find Rembrandt's depiction of the attendant as a female sufficiently convincing, the pictorial tradition itself provides a secure enough identification of her sex.[31] And there is no element of peeping, since both women evidently look in the same direction, expecting rather than rejecting the intruder.

Another writer recently found in Rembrandt's *Portrait of Jan Six* (fig. 9) a "creature" that "seems to be chained to his hat" and that "looks very much like an ape."[32] "This ape-creature in Jan Six's hair," we read, "may signify on the one hand his struggle with base qualities in his own self. And on the other hand, it may serve as a caution to Rembrandt himself against the adulatory imitation of the sitter's features." The author was particularly concerned with Jan Six as a melancholic. This, according to her, was why there was a monkey in his hair: "The vague image of an ape in his hair may thus be perceived as warning against the excessive absorption with melancholy thoughts which may lead to dullness, sloth, and folly."

But scorn should here give way to humility. On at least one occasion I was myself afflicted by temporary blindness. In writing about Geertgen tot Sint Jans's *Holy Kinship* (fig. 10) for the Dutch radio program *Openbaar kunstbezit*, my ambition was to add something new to James E. Snyder's detailed and convincing interpretation of that painting.[33] I found that all the analyses of Geertgen's painting had neglected to mention the basket of

7. Jan Miense Molenaer,
 Lady World, 1633,
 oil on canvas, 102 x 127 cm.
 Toledo, The Toledo Museum of Art, Gift of
 Edward Drummond Libbey.

8. Rembrandt Harmensz. van Rijn,
 Danae, 1636,
 oil on canvas, 185 x 203 cm.
 Leningrad, State Hermitage Museum,
 no. 802.

9. Rembrandt Harmensz. van Rijn,
 Portrait of Jan Six, 1654,
 oil on canvas, 112 x 102 cm.
 Amsterdam, Six Collection.

apples on the left in front of Saint Anne's feet. On top of the basket I saw a loaf of bread! This could hardly be accidental, I argued, because bread was ideally suited to the iconography of the *Holy Kinship*. Or was I perhaps trying too hard to find something new in disguise? In any event, I wrote categorically that "the bread found on top of the basket alludes to the birthplace of Christ, Bethlehem, which means 'house of bread.'" And I referred, naturally enough, to the highly significant sheaf of corn on the Portinari altar and to the passage in the gospel according to Saint John in which Christ refers to himself as the bread that came down from heaven. This I felt to be a creditable find. But shortly afterward, I was interviewed on the radio by someone on the staff of *Openbaar kunstbezit* who was not an art historian. We stood in front of Geertgen's work in the Rijksmuseum, and the interview began with this question: What made me think that the object on top of the basket was a loaf of bread? Surely it was the lid of the basket? It was indeed. In fact, I found that I could no longer see the object in question as a loaf of bread at all. Fortunately, I was able to make a virtue of necessity and alter the topic to that of iconological fallacies. I went on to speak of the dangers of learning that so affect one's powers of observation.

My lapse concerning the bread of Bethlehem occurred sixteen years ago. How clear or cloudy my art historical eye is today I do not know. But I believe it would be worthwhile having an art historical companion to David Hackett Fischer's *Historians' Fallacies* and investigating our mistakes and projections systematically.[34]

I am well aware that the examples I have offered here are incidental rather than systematic, and it is probably true that Freudian and feminist vulgarities are more easily detected than mistakes of less-determined ideological basis. But the fact that such varied and glorious errors occur constantly should inspire timidity. I regard myself as one of those who feel that hermeneutic problems, like problems of connoisseurship, must frequently be solved by what should probably be called trained intuition. But this premise should not charter the belief that in matters of interpretation the sky is the limit.

133

10. Geertgen tot Sint Jans,
 The Holy Kinship, ca. 1490,
 oil on panel, 138 x 105 cm.
 Amsterdam, Rijksmuseum, no. A500.

NOTES

1. Johan Huizinga, *Herfsttij der Middeleeuwen* in *Verzamelde Werken* (Haarlem: H. D. Tjeenk Willink & Zoon, 1949), 3: 4 (*"Voorbericht bij den eersten druk"*). See also M. E. H. N. Mout, " 'Een nieuwe lente en een nieuw geluid': De beoefening van de Nederlandse cultuurgeschiedenis van de zeventiende eeuw in toekomstperspectief," *Theoretische geschiedenis (Cultuurgeschiedenis in veranderend perspectief)* 13 (1986): 259–72, esp. 260.

2. This conference, entitled "Cultuurgeschiedenis in veranderend perspectief" was held at the Universiteit van Amsterdam. See Josua Bruyn, "Het probleem van het realisme in de zeventiende-eeuwse Hollandse kunst van Huizinga tot heden," *Theoretische geschiedenis (Cultuurgeschiedenis in veranderend perspectief)* 13 (1986): 209–18; J. L. Price, " 'Sicklied O'er with the Pale Cast of Thought': Theoretical and Practical Problems Concerning the Social History of Dutch Culture in the Seventeenth Century," *Theoretische geschiedenis (Cultuurgeschiedenis in veranderend perspectief)* 13 (1986): 247–57.

3. Price (see note 2), 254.

4. Ibid.

5. Bruyn (see note 2).

6. Ibid., 216.

7. Josua Bruyn, "Toward a Scriptural Reading of Seventeenth-Century Dutch Landscape Paintings," in Peter C. Sutton, ed., *Masters of Seventeenth-Century Dutch Landscape Painting*, exh. cat. (Boston: Museum of Fine Arts, 1987), 84–103.

8. Wilfried Wiegand, "Ruisdael-Studien: Ein Versuch zur Ikonologie der Landschaftsmalerei" (Ph.D. diss., Universität Hamburg, 1971); Hans-Joachim Raupp, "Zur Bedeutung von Thema und Symbol für die holländische Landschaftsmalerei des 17. Jahrhunderts," *Jahrbuch der Staatlichen Kunstsammlungen in Baden-Württemberg* 17 (1980): 85–110.

9. Christopher Brown, ed., *Dutch Landscape: The Early Years, Haarlem and Amsterdam 1590–1650*, exh. cat. (London: National Gallery Publications, 1986).

10. Cf. E. de Jongh, "Realisme en schijnrealisme in de Hollandse schilderkunst van de zeventiende eeuw," in Paleis voor Schone Kunsten, *Rembrandt en zijn tijd*, exh. cat. (Brussels: La Connaissance, Europalia, 1971), 143–94, esp. 150–52.

11. Museum voor Schone Kunsten, *Joachim Beuckelaer: Het markt- en keukenstuk in de Nederlanden, 1550–1650*, exh. cat. (Ghent: Museum voor Schone Kunsten, 1986).

12. According to Hessel Miedema it seems clear that the London exhibition was "not in the last place meant to be a response to the metaphorical interpretation which is especially brought to the fore" by the present author (Hessel Miedema, "Overwegingen bij een nieuwe editie van Karel van Manders *Leven der doorluchtighe Nederlandtsche, en Hooghduytsche schilders*," in *Eer is het lof des deuchts: Opstellen over renaissance en classicisme aangeboden aan dr. Fokke*

Veenstra [Amsterdam: De Bataafsche Leeuw, 1986], 278–86, esp. 279 and n. 20).

13. The relevant literature is mentioned in J. P. Filedt Kok, W. Halsema-Kubes, W. Th. Kloek, eds., *Kunst voor de beeldenstorm*, exh. cat. (Amsterdam: Rijksmuseum, 1986), 342–46.

14. Peter C. Sutton, ed., *Masters of Seventeenth-Century Dutch Genre Painting*, exh. cat. (Philadelphia: Philadelphia Museum of Art, 1984). E. de Jongh, "The Interpretation of Genre Paintings: Possibilities and Limits," in *Images of the World: Dutch Genre Painting in Its Historical Context*, ed. Christopher Brown (forthcoming).

15. Hecht presented his plea at a conference entitled "Tradition and Innovation in the Study of Northern European Art," which was held at the University of Pittsburgh. See Peter Hecht, "The Debate on Symbol and Meaning in Dutch Seventeenth-Century Art: An Appeal to Common Sense," *Simiolus* 16 (1986): 173–87.

16. Cf. George Boas, *Wingless Pegasus: A Handbook for Critics* (Baltimore: The Johns Hopkins Univ. Press, 1950), 47–64; idem, *The Heaven of Invention* (Baltimore: The Johns Hopkins Univ. Press, 1962), 236–54.

17. David R. Smith, *Masks of Wedlock: Seventeenth-Century Dutch Marriage Portraiture* (Ann Arbor: UMI Research Press, 1982), 5.

18. E. H. Gombrich, *Symbolic Images: Studies in the Art of the Renaissance* (London: Phaidon, 1972), 5–11; Nanette Salomon, "Political Iconography in a Painting by Jan Miense Molenaer," *Mercury* 4 (1986): 23–38, esp. 33.

19. Nicos Hadjinicolaou, *Kunstgeschiedenis en ideologie* (Nijmegen: Sun, 1977), 199–204. This is a Dutch translation of *Histoire de l'art et lutte des classes* (Paris: F. Maspero, 1973).

20. Mieke Bal, *Het Rembrandt effect: Visies op kijken* (Utrecht: Hes Uitgevers, 1987), 18–30.

21. Cf. F. R. Ankersmit, *Denken over geschiedenis: Een overzicht van moderne geschiedfilosofische opvattingen* (Groningen: Wolters-Noordhoff, 1984), 71–87 and 138–40.

22. Boas, 1962 (see note 16), 243.

23. Cf. Gombrich (see note 18), 1–25 ("Aims and Limits of Iconology").

24. Françoise Forster-Hahn, *French and School of Paris Paintings in the Yale University Art Gallery: A Catalogue Raisonné* (New Haven: Yale Univ. Press, 1968), 12–13. J.-B. de la Faille, *The Works of Vincent van Gogh: His Paintings and Drawings* (Amsterdam: Meulenhoff International, 1970), 209.

25. See *The Letters of Peter Paul Rubens*, trans. and ed. Ruth Saunders Magurn (Cambridge, Mass.: Harvard Univ. Press, 1955), 408–9.

26. Cf. E. de Jongh, *Still-life in the Age of Rembrandt*, exh. cat. (Auckland: Auckland City Art Gallery, 1982), 28. For a different view, see Bruyn (see note 7).

27. I mentioned these nuances before in my review of Peter C. Sutton, *Pieter de Hooch: Complete Edition with a Catalogue Raisonné* (Oxford: Phaidon, 1980), which appeared in *Simiolus* 11 (1980): 181–85, esp. 184.

28. P. J. Vinken and E. de Jongh, "De boosaardigheid van Hals' regenten en regentessen," *Oud Holland* 78 (1963): 1–26, esp. 10–14.

29. Stedelijk Museum de Lakenhal, *IJdelheid der ijdelheden: Hollandse vanitasvoorstellingen uit de zeventiende eeuw*, exh. cat. (Leiden: Stedelijk Museum de Lakenhal, 1970), 17.

30. Bal (see note 20), 16.

31. See Erwin Panofsky, "Der gefesselte Eros: Zur Genealogie von Rembrandt's *Danae*," *Oud Holland* 50 (1933): 193–217.

32. Luba Freedman, "Rembrandt's *Portrait of Jan Six*," *Artibus et Historiae*, no. 12 (1985): 89–105, esp. 103 and 105.

33. E. de Jongh, "Geertgen tot Sint Jans (1460/65–1490/95): De heilige maagschap," *Openbaar kunstbezit* 15 (1971), no. 39. James E. Snyder, "Geertgen schildert de voorouders van Christus," *Bulletin van het Rijksmuseum* 5 (1957): 85–94.

34. David Hackett Fischer, *Historians' Fallacies: Toward a Logic of Historical Thought* (New York: Harper & Row, 1970).

1. Jan Massys,
 Unequal Couple, date unknown,
 oil on panel, 41 x 56 cm.
 Antwerp, Koninklijk Museum voor Schone
 Kunsten, no. 566.
 Photo: Copyright ACL-Brussels.

Jochen Becker

Are These Girls Really So Neat?

On Kitchen Scenes and Method

*Ein jeder Jüngling hat nun mal
nen Hang zum Küchenpersonal* [1]
 —Wilhelm Busch

This essay is half theory, half practical example. It is intended both to instruct and delight. Some general remarks on the interpretation of Dutch genre and still life paintings will be followed by an attempt to verify a hypothesis using pictures and texts that illustrate a single motif: the cleaning of a pot.

Ever since their "rediscovery" in the late eighteenth and early nineteenth centuries, Dutch genre and still life paintings have been subjected to a number of narrow interpretations.[2] They have been considered expressions of the simplicity of the Dutch character and the democratic nature of government in Holland; evidence for the justification of realistic painting; typically Calvinistic works of art; examples of hidden, or disguised, symbolism; and, finally, proof of the visual character of seventeenth-century Dutch culture.

Of all these possibilities or combinations thereof, the search for hidden symbolism seems to be the most widely accepted approach today. It has much historical evidence in its favor, and its defenders have done a great deal of impressive research in iconography, cultural history, and art theory, relying heavily on the connections between art and literature. As a result, the study and the interpretation of emblems have come to characterize this branch of research.[3]

I believe that such emblematic interpretations are, at least to some degree,

the natural consequence of an art historical tradition that seeks to "defend" the glory of the Dutch school. Furthermore, they seem to be based on iconological methods of investigation that were developed with reference to Italian history painting — a "high" genre in which iconography and metaphor, as well as style, are very specific. Such forms of interpretation constitute a reaction — and possibly an overreaction — to realistic and purely formal interpretations and are imbued with a puritanical and Calvinist spirit, as was recently acknowledged in a learned "emblematic" interpretation of Dutch landscape.[4]

Those who criticize the emblematic method on the basis of its failure to be sufficiently attentive to the distinctiveness of a particular visual culture also criticize an iconological approach in which verbal "translations" of the contents of pictures (with, for example, the help of emblems) play an important part. Svetlana Alpers has caricatured such a method, and it must be pointed out that some second-rate interpreters do read pictures as texts composed of motifs found in emblem books. Moreover, such scholars often do not directly draw on the emblem books themselves but on Guy de Tervarent and Arthur Henkel and Albrecht Schöne, or other secondary compilations. However useful such resources may be, they isolate each visual motif and reduce it to a single meaning, disregarding its possible connotations. Such interpretations may appear learned, but they succumb to the "dictionary fallacy."[5]

Even the more prudent and cautious readers of emblem books often make a fundamental error: they ignore the fact that the *discours* of an emblem is very different from that of an easel painting. Although an emblematic interpretation may appear brilliant, it may be far from what the artist intended or what his contemporaries would have understood. Furthermore, these intellectually refined and highly researched interpretations of the "painted text" may fail to distinguish the relative importance of various motifs or other pictorial proposals within the painting.[6]

To search for and interpret motifs only makes sense within a given context. That context may be established within the picture by correlating different motifs; or it may be established outside the picture by comparing written texts or a series of works and identifying a common origin or comparable function. Because most seventeenth-century Dutch paintings were produced for an open market, we know next to nothing about their precise function. Regarding the internal coherence of motifs in genre and still life

2. Jean-Baptiste-Siméon Chardin,
 L'écureuse, 1738,
 oil on canvas, 43 x 36 cm.
 Formerly Rothschild Collection, Paris;
 destroyed during World War II.

painting, simple motifs and pictures are generally the most difficult to understand, whereas elaborate compositions are often relatively easy to explain. (The latter proved complicated for their authors, who resorted to dictionaries [mythological, symbolical, etc.] that we can still consult today.) The plainest language does not invite explication, nor did it originally require any; but when codes change, such "simple" language can become exceedingly difficult to understand.[7]

As an example of this process let us consider the history of interpretation of some simple pictures. In the Paris Salon of 1738, Jean-Baptiste-Siméon Chardin exhibited two paintings: *Le garçon cabaretier* (*The Cellar Boy*) and *L'écureuse* (*The Scullery Girl*) (fig. 2).[8] These pictures met with favorable response. This could explain the existence of copies, one of which, *Une femme qui récure* (*A Scouring Woman*), was admired in the Salon of 1757 for its expression of the "true qualities of nature itself and all her harmony." Such admiration was justified by Denis Diderot, whose assessment took into account the then-current rules of art theory: "Yes, of course Chardin is allowed to depict a kitchen with a maid washing up, bent above a barrel. Without the sublimity of the technique Chardin's *ideal* would be miserable."[9] When Chardin's pictures were discussed in an article appearing in *L'Illustration* in 1846, he was admired — apparently with a hint of horror — as a "brutal realist." To our eyes such pictures are not at all brutal. But are they realistic?[10]

Copies as well as graphic reproductions testify to the popularity of Chardin's images. In 1740 the skilled engraver Charles Nicolas Cochin produced a version of Chardin's maid that was then published by the otherwise unknown H. Zanelli. Cochin added a caption: *"C'est Mademoiselle Manon qui vient d'écurer son chaudron."*[11] Since Manon was a very common name, this text seems to give an extremely simple, almost superfluous description of what we see: Good Manon scours the kettle. From the sixteenth century onward this act was seen as a demonstration of cleanliness, a virtue that could be subject to criticism if practiced excessively. The caption, however, could provide quite a different interpretation of the scene. *"Il faut écurer son chaudron"* can also mean that we should confess our sins, just as we speak about a "spiritual cleansing."[12] The metaphor comes from the Bible, where the cleansing of the soul is compared to washing or scrubbing pans (e.g., Matthew 23:25ff). Furthermore, outer and inner purity can be contrasted: he or she who only cleans the surface of a vessel is a

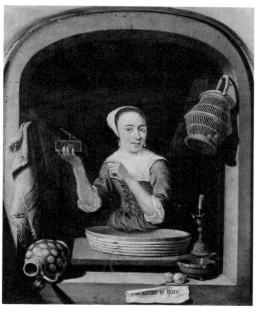

3. Willem van Odenkerken,
 Woman Scouring a Vessel, date unknown,
 oil on panel, 73 x 59 cm.
 Amsterdam, Rijksmuseum, no. A1279.

4. Abraham Snaphaen,
 Girl at the Window, 1682,
 oil on panel, 21 x 18 cm.
 Leiden, Stedelijk Museum de Lakenhal.

143

hypocrite or a pharisee. He or (most often) she can also be accused of exaggerating housekeeping *ad absurdum*, as Jacob Cats explains in one of his emblems. Jan Luiken repeats such warnings in one of the genre scenes in his *Leerzaam huisraad*.[13]

This last interpretation would probably not be appropriate in the case of Willem van Odenkerken's *Woman Scouring a Vessel* (fig. 3), which may simply portray a maid or faithful servant, just as faithful horses were portrayed. It could also provide an everyday example of cleanliness, as demonstrated by the woman and her companion, who works by the fireside. A more "scholarly" approach, as we have seen, might suggest that the picture serves as a "hidden allegory" of spiritual purity: the neat girl herself; the lantern on the floor, which reminds us that Christ is the light (John 9:5); the servant at the chimney who lights flames of spiritual love; and the straw which may be seen as a symbol of death and resurrection. With the same display of iconographical erudition, however, we could use another set of references to invert the spiritual meaning of the picture and interpret it as an invitation to make love, as is sometimes conveyed very bluntly (fig. 4).[14] If Odenkerken's maid were older, we would be even more sure of our interpretation of the painting as an allegory of spiritual purity. The pot in this case would not be interpreted as evoking Freud, Jung, or Vincken but instead, Jeremiah and the Apocalypse. In opting for this latter interpretation, however, we would be forgetting just how insipid (to our way of thinking) and crude seventeenth-century humor could be.[15]

Jan Miense Molenaer's *Kitchen Scene* (fig. 5) is much less confusing in its candidly erotic subject matter. An elderly peasant selling eggs embraces a diligent maid, his right hand searching through her apron to fondle her. His gesture is echoed by the girl's own right hand, which scours the interior of a vessel.[16] Four people watch the couple; the two observers at the left overtly mock them. The acceptance of these four witnesses emphasizes the girl's sexuality, and it is also a sign of permissiveness. They turn a blind eye, or to use the Dutch expression, *zij zien het door de vingers* (they look through their fingers).[17]

Molenaer's peasant is much too old for the young woman, making them an "unequal" couple. Representations of such ill-suited men and women became more common with the social changes that occurred in the sixteenth century. The idea that couples should be properly matched in age as well as in social position was frequently discussed in books of courtesy, comical

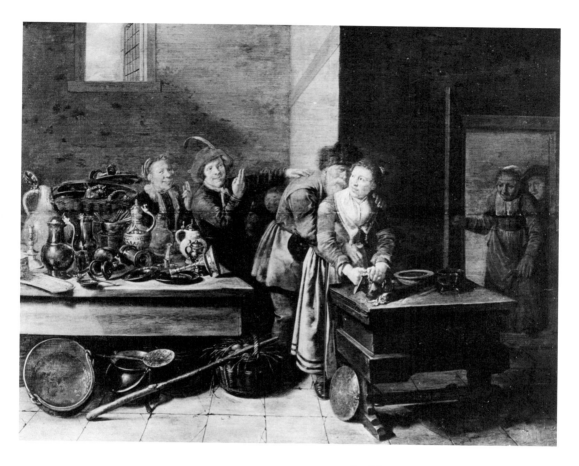

5. Jan Miense Molenaer,
Kitchen Scene, date unknown,
oil on panel, 50.5 x 63.5 cm.
Copenhagen, Statens Museum for Kunst.

plays, or novels.[18] Illustrations of "unequal" couples appear with regularity in Flemish and Dutch art. It is sufficient to recall examples by Hendrik Goltzius, Jan Steen (who borrows from an emblem by Jacob Cats), and the typical Dutch scene by Nicolaes Moeyaert — lifted almost directly from a contemporary comedy.[19]

Erasmus described in great detail how unnatural and ridiculous it was to bridge the age gap for purposes of lust or greed. His contemporary, the painter Quinten Massys depicted unequal lovers accompanied by a fool. Massys's son, Jan, in the course of depicting yet another "unequal" couple put the "fool" in contemporary dress and made him an eavesdropper at the door (fig. 1); this more realistic guise recalls the two youths at the left of Molenaer's painting.[20] All of these figures serve to indicate that the scene depicted requires commentary. By his very character the fool per se had indicated the moralizing intention of the painter; it is probably safe to assume that subsequent "onlooker" or "witness" figures preserved something of this character.[21]

The fur cap worn by the man in Molenaer's painting may suggest lechery; on the other hand, he may wear it because he is old and gets cold easily. The impressive stick used to carry the egg basket could also allude to his lust, as the egg basket itself surely does. Eggs, which were considered an aphrodisiac, often appeared in erotic scenes, as did sellers of eggs. A rather strange egg vendor appears in a painting by Adriaen van de Venne, and another may be seen in Cornelis Massys's *The Jealous Wife of the Farmer* (fig. 6). The caption in the latter painting represents the wife's lament: *"My man syn eyeren onlaeyt/In eens anders nest en laet my ontpaayt"* (My husband lays his eggs — o pity — in a stranger's nest/At home with me he never does his best.)[22]

The jug, another attribute laden with meaning, figures prominently in Molenaer's picture. Goltzius depicted an unequal couple, showing a young woman anxiously covering a jug with her hand (fig. 7). The accompanying text — closely approximating the language of comedy, which frequently treated such themes — comments on this detail:

Decrepitus juvenem lepidamque movere puellam
Conatur, turpi victus amore senex
Cascus ait, cascam: corpucula digna patula
Quaero: conjugii spes tibi nulla mei.[23]

6. Cornelis Massys,
 The Jealous Wife of the Farmer, 1549,
 engraving and drypoint, 8.3 x 5.3 cm.
 Brussels, Bibliothèque Royale Albert 1er.

7. Jan van de Velde (?) after Hendrik Goltzius,
 Unequal Couple, 1628,
 etching, 16.6 x 11.9 cm.
 Private collection.

147

(Taken by shameful love the decrepit old man
tries to persuade the jolly girl. But she says:
Old goes with old, I look for a lid that fits my jug
I think you don't match me.)

The expression *op ieder potje past een dekseltje* (every pot has a lid that fits it) is still current in Dutch and German and even appears in advertisements written by women looking for suitable husbands. The sixteenth-century Flemish poet Anna Bijns humorously treated this notion: *"tot alle cannekens vindtmen schelen gebroken potkens by gescheurde kannekens... geen soo slimmen scheelken, t en vindt zynen pot"* (for all pitchers you find lids, broken pots to cracked jugs, no lid so ugly not to meet its vessel).[24] A special Dutch variant on this theme, the scouring of the jug, pan, or any similar object, is worthy of attention. An illustration in a small Dutch songbook of 1622, *Venus minne giftjens*, shows life on the bank of a canal (fig. 8). The inscription reads:

Al waert een dienstmeyt maar, soo kanse aardig schuren,
En isse selver vrouw', te beter kanzet sturen:
Zy dunckt my even knap, en wacker uyt de mouw,'
zoo dat ick haare tobb' oock graagh' eens schuren wouw.[25]

(Even if she is just the maid, she's good at scrubbing
And if she is herself the lady, that is all the better:
She seems to be nice and handsome enough
So that I'd like to do the little job with her as well.)

If there should be any doubts left, these lines may convince us of the meaning of Molenaer's painting. This meaning is further reinforced by the picture's curious accumulation of all sorts of vessels and a candlestick, signs that are easily read by anybody familiar with Freud and which were found in Cats and other popular seventeenth-century texts.[26]

Although Molenaer's picture can be thus explained, this particular motif does not allow for abstract definition and makes sense only in context. And how is such a context determined? In David Teniers's *Cottage beside a River* (fig. 9), which is similar to the songbook engraving of 1622, we would have difficulty ascertaining what is happening were it not for the

8. Dirk E. Lons (?),
 illustration for *Venus minne giftjens...*,
 1622 (?),
 etching, 7 x 11 cm.
 Private collection.

9. David Teniers, Jr.,
 A Cottage beside a River, ca. 1650,
 oil on panel, 48 x 67 cm.
 London, National Gallery.

149

10. Jan Miense Molenaer,
 The Farmer's Wife, 1650,
 oil on panel, 49.5 x 36.5 cm.
 Copenhagen, Statens Museum for Kunst,
 no. 478.

11. Albert Cuyp,
 Interior of a Stable, ca. 1645,
 oil on panel, 65 x 92 cm.
 Dordrecht, Dordrechts Museum.

presence of the angry wife. As small as she appears within the door frame, she nevertheless implies a narrative. The children and the inscription in Molenaer's *The Farmer's Wife* (fig. 10) provide even clearer clues. With a picture like Albert Cuyp's *Interior of a Stable* (fig. 11), only a real connoisseur could detect erotic allusions, pointing of course to the cat, the mussels, and the bunghole. Others would probably draw attention to the fact that the girl cleans the vessel's outer side, implying that she is merely an overly assiduous person.[27]

Eighteenth-century French usage of seventeenth-century Dutch bourgeois motifs can be interpreted only when accompanied by a text, and even in those cases where a text is present, we may never be certain. We encounter this problem with Chardin and again with André Bouys, who, even before Chardin, painted a "richer" but much less convincing version of the theme of the scouring maid (fig. 12). When Jean-Baptiste Greuze employed the theme, or at least borrowed the girl's pose, its erotic qualities became undeniable, albeit less in a symbolic than a formal sense. The invitation inherent in the fact that the girl leans forward so ostentatiously must be obvious in all centuries (fig. 13). During the nineteenth century the motif was simply considered an appealing position for a model (as used, for example, by the Dordrecht painter Abraham van Strij [fig. 14]).[28] When the nineteenth-century German poet Eduard Mörike wrote a birthday poem about Johann Georg Wille's engraving after Gerrit Dou's *Girl Scouring a Pan* (figs. 15, 16), he was conscious of its possible symbolism. In true Victorian spirit, however, he limited this symbolism to neatness:

Sieh hier ein Mägdlein, wie ich dir in allem Ernst
sogar auf deine mustersame Nolde hier
eins wünschen darf! Dies Gesichtchen spricht
Verstand
und gar ein sittsam Wesen aus. (Der liebe Blick,
den sie vom Küchenfenster auf die Strasse tut,
scheint höchst unschuldig).
'Ordnung' aber und 'Reinlichkeit'
ist ohne Zweifel ihr 'Prinzip'.
Was willst du mehr?[29]

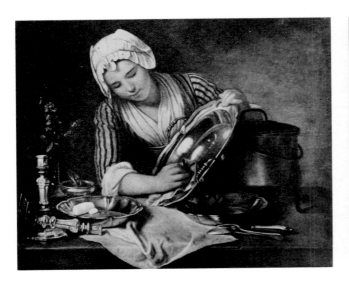 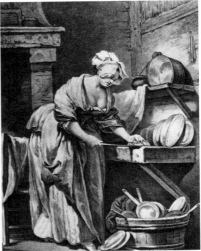

12. André Bouys,
 Girl Polishing Silver, date unknown,
 oil on canvas, 100 x 79 cm.
 Paris, Musée des Arts Décoratifs.

13. After Jean-Baptiste Greuze,
 Kitchen Maid, ca. 1760,
 engraving, 27 x 21 cm.
 Private collection.

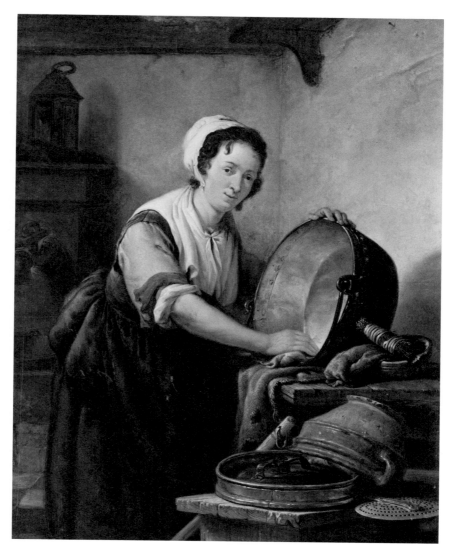

14. Abraham van Strij,
 Woman Scouring the Inside of a Cauldron,
 ca. 1810,
 oil on panel, 34 x 27 cm.
 Amsterdam, Rijksmuseum, no. A1143.

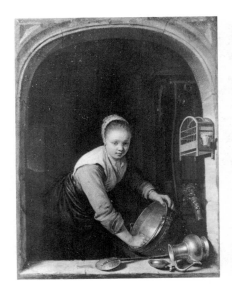

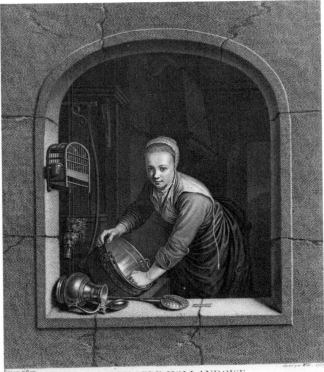

15. Gerrit Dou,
 Girl Scouring a Pan, 1663,
 oil on panel, 17.1 x 13.3 cm.
 London, Royal Collection.
 Photo: With gracious permission of Her
 Majesty the Queen, copyright reserved.

16. Johann Georg Wille after Gerrit Dou,
 La ménagère hollandoise, 1757,
 engraving, 19.9 x 17 cm.
 Private collection.

154

(Look at this girl
Notwithstanding your excellent Nolde
I would wish you had someone like her
Her face expresses reason and a really decent character.
[The kind look,
from the window of the kitchen into the street,
seems very chaste.]
'Order' and 'neatness'
are without doubt her 'principle.'
You could not ask for more.)

These lines suggest petty bourgeois cleanliness in every sense of the word. The same idea is expressed in children's books, those storehouses of forgotten symbolism and last rudiments of emblematic traditions. At the end of the eighteenth century, in the troubled years before the revolution, the Orangist Dutch historian Jan le Francq van Berkhey wrote a series of short texts for the genre-like illustrations etched after drawings by dilettante Christina Chalon of Leiden. Among these intimate scenes is a girl scouring a vat (fig. 17), which is described in the traditional way. Le Francq evidently knew of Cats and his criticism of outward cleanliness:

Griet boent vast, en schuurt het vat,
Zoo het schijnt, van buiten glad:
Reinigt zij 't van binnen niet,
't is de vrouw dan tot verdriet.
Dus is hij, die, buiten net,
't Hart van binnen houdt besmet.[30]

(Griet scrubs and scours the tub
as it seems, from the outside:
if she does not clean the inside
her mistress will be disappointed.
So is he, who clean on the outside
has a dirty heart.)

Only one year after the publication of this book, a parody of it was published by an anonymous author, most probably a political opponent of Le

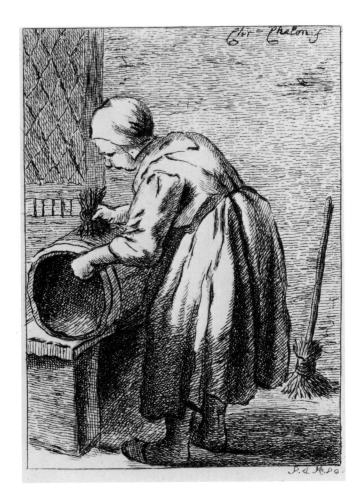

17. Pieter de Mare after Christina Chalon,
Woman Scouring a Vat,
etching, 8.5 x 6 cm.
In Jan le Francq van Berkhey, *Zinnespelende
gedigjes, op de geestige printjes ge-etst door
Pieter de Mare, na de teekeningen van
Mejuffrouw Christina Chalon, berustende in
de verzameling van den kunstbevorderenden
Heere H. A. Dibbets*, 1779, 15.
Private collection.

Francq. The parodist seems to have been familiar with Le Francq's domestic circumstances, ridiculing the man who lived with his housekeeper for several years:

Jan schuurt, als 't kan zijn, het vat,
Van zijn Hester helder glad,
En boent Jantjes borstel niet,
Dan zit Hesje in groot verdriet:
Want, hoe zij hem houdt in't net,
Echter acht zij hem besmet.[31]

(Jan scours whenever he can,
Hester's butt. But when his brush
doesn't work, she is very sorry.
However she keeps him clean,
She's afraid he is contaminated.)

A survey of this material reveals that any given motif may be used to convey a number of very different meanings. In some cases the artist employs more motifs to clarify his meaning. In other cases the artist's intention is less clear, and we have to depend on inscriptions by an engraver or editor, on tradition, or on our own imagination — all of which may or may not reflect the creator's intentions. We are inclined to rely on the traditional use of the motif, but why shouldn't the artist or beholder be free to propose variations or simply to ignore the question of meaning? Relying on tradition alone would be as inadequate as explaining the meaning of words solely in terms of their etymology without considering their semiotic and semantic functions. In other words, the *causa formalis* gives one possible explication, but the *causa finalis* and *causa efficiens* provide others.

Many iconologists demonstrate the extent of their knowledge by deciphering the disguised symbolism of seventeenth-century genre paintings. What once seemed a simple depiction of everyday life can be thus transformed into a moral allegory. But other explanations — often simpler and less learned — may often more accurately reflect the artist's intentions. Interestingly, offering several different comments on the same picture was a rather popular game in seventeenth-century society. Contemporaries were allowed to give moralistic interpretations, to reduce the painting to risqué

puns, or simply to enjoy the image it portrayed or its artistic quality. Seven-teenth-century conversation was a highly developed art manifesting itself in *Gesprächsspiele* (conversation games) and riddles. It would seem highly unlikely therefore that spectators would have felt compelled to arrive at a single agreed-upon meaning. It is possible in fact that the desire to avoid such an unalterable reading may have contributed to the witty display of more complicated and elaborate readings.[32]

Riddles describing pictures of simple genre scenes demonstrate the different ways in which these scenes can be described. These often make the listener blush by seeming to propose an obscene solution, which is actually averted through revelation of the "factual," or "realistic," answer. Things become even more complicated when we realize that we are dealing with complete double entendres: the very same scenes that serve to illustrate riddle books could be combined with didactic verses and used as *specula virtutis* (mirrors of virtue) to teach morals and good manners to ladies and gentlemen.[33]

There is no reason why we should not suspect that the painter, too, intended different "solutions" or at least left the meaning of the picture open. A picture is thus seen as an ambiguous communication (a "text") to be treated in a variety of ways. We may assume that the viewers' reactions depended upon their intellectual capacities, religious beliefs, social positions, and, last but not least, on the circumstances in which the work was viewed.[34]

Claritas and *perspicuitas* are ideals of the courtroom, the high genres in literature, and history painting. *Ambiguitas* in these fields is a serious fault; it causes misunderstanding and impairs *decorum*. But these high standards of truth and taste do not apply to still life and genre painting. In these genres *ambiguitas* can even be desirable. Furthermore, the very high technical quality of Dutch pictures lower in the hierarchical scale could be explained in rhetorical terms: the less important the content, the more important the presentation.[35]

Generally speaking, ambiguity was a vital necessity for many seventeenth-century Dutch painters. They had to sell their products to a widely divergent public on an overcrowded, open market. As a merchant, the painter had to avoid sectarianism and deliver a product acceptable to many different potential customers. He had to observe the same open-mindedness (or, if you prefer, lack of character) that contributed to the success of Dutch trade in general.[36]

158

APPENDIX

It would be rewarding and amusing to give an extensive annotated list of jugs, barrels, and the like in art and literature. I restrict myself to a few instances.

Woman is called the "weaker vessel" in 1 Peter 3:7. Pots in annunciation scenes and the ointment vessel of Magdalene could easily be interpreted in a sexual manner. The comedy *Dulcitius* by Hrosvitha of Gandersheim (Hrosvitha, *Opera*, ed. H. Homeyer [Munich, Paderborn, and Vienna: Schöningh, 1970], 263–77) is a treat for psychologists: the heathen governor of Thessalonike falls in love with three Christian girls, Agape, Chionio, and Irene. He gets into their house but, as a result of divine intervention, becomes so confused that he embraces the pots and pans in the kitchen, mistaking them for the girls. Their virginity is thus preserved — but not their lives. They are murdered and so become the "three sister martyrs."

The painting of kitchen utensils is regarded as one of the hallmarks of eighteenth-century Dutch art. One has only to think of the final scene in William Hogarth's *Marriage à la mode* (1745), where the paintings in the couple's room reflect their miserable state: the former Italianizing histories and exemplary portraits have disappeared and three Dutch paintings have taken their place, a "pisser" à la Teniers, a couple with a jug à la Brouwer, and a still life with jugs. Horace Walpole's remarks on taste and collecting reflect a common practice as much as his aversion to it:

> And as for the Dutch Painters, those drudging Mimics of Nature's most uncomely coarseness, don't their earthen pots and brass kettles carry away prices only due to the sweet neatness of Albano, and to the attractive delicacy of Carlo Maratti? The gentelest fault that can be found with them, is what Apelles said of Protogones 'Dixit enim omnia sibi paria esse, aut illi meliora, sed uno se praestare, quod manum ille de tabula nescire tollere' Plin.[ius *Historia naturalis*] lib. 35 cap. 10. Their best commendation was the source of their faults; their application to their art prevented their being happy in it.

(Horace Walpole, *Aedes Walpolianae: Or, a Description of the Collection of Pictures at Houghton-Hall in Norfolk, the Seat of Horace Walpole, Earl of Oxford*, 3rd ed. [London: Privately Printed, 1767], xi–xii.) (These points are exactly the same as those that traditional rhetoric uses in reference to

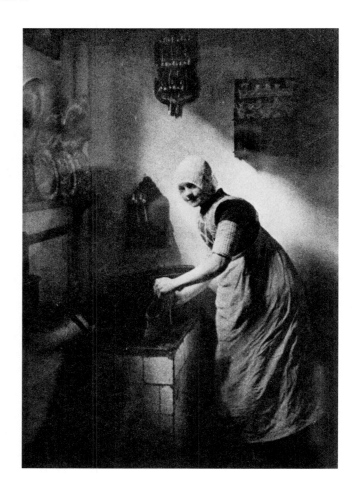

18. Adriaan Boer,
 Het meisje van Vermeer, ca. 1900,
 reproduction of an original photograph.
 Photo: Courtesy B. Roodnat.

representations of subjects low on the hierarchical ladder, cf. note 34.)

This same preference, manifested by conservative Dutch collectors (who wanted *"vijftig schurende vrouwtjes en drinkende riddertjes"* [fifty scrub-women and little knights drinking]), was criticized in the *Nederlandsche kunstspiegel* (1848): 122 (quoted by Marlou Thijssen, "De Maatschappij Arti et Amicitiae," in *Kunst en beleid in Nederland*, Jaarboek Boekmanstudies [Amsterdam: Boekmanstichting; Van Gennep, 1986], 2: 63). The theme, of course, was most popular with mediocre artists, as is exemplified by the unhappy Aegidius Punter who sent "a kitchen maid scouring a copper ket-tle" to the exhibition where it was very poorly placed; cf. Hildebrand [Nico-laas Beets], "Eene tentoonstelling van schilderijen," in *Camera Obscura*, 31st ed. (first edition 1858; Haarlem: Thieme, 1930), 292–301.

In the enormous Manchester art exhibition of 1857 Nathaniel Hawthorne greatly admired Murillo's *Good Shepherd* and Dou's *Woman Cleaning a Sauce Pan* (cf. note 28). He noticed in the Dutch masters "such life like rep-resentations of cabbages, onions, turnips, cauliflowers, and peas.... Even the photograph cannot equal their miracles" (Nathaniel Hawthorne, *The English Notebooks*, ed. Randall Stewart [New York: Black, 1941], 56, quoted by Francis Haskell, *Rediscoveries in Art* [London: Phaidon, 1976], 99). Not only the meticulous description of reality but composition and light (the light of Vermeer) obviously influenced photographers such as Adriaan Boer (1875–1940) whose *Het meisje van Vermeer* (*Girl in the Style of Vermeer*) shows a girl in folkloric dress scouring a pan in a typically Dutch atmo-sphere (fig. 18).

Nineteenth-century realists emphasized the anti-idealism of jugs. For example, Wilhelm Busch comments: "A simple pitcher with a flickering light on it is enough of an idea for me.... With Teniers and Brouwers I have seen incredibly *spiritual* pans" (the original German here gives the Dutch *geestig* and is probably intended as a misreading, since the word just means "witty" and does not — originally, at least — evoke the realm of ideas); cf. Wilhelm Busch, *Sämtliche Briefe*, ed. F. Böhne (Hannover: Wilhelm-Busch-Gesellschaft, 1968), 136, letter dated 14 March 1875.

NOTES

This article reflects discussions following lectures in Berlin, Santa Monica, Wassenaar, and Amsterdam. Special thanks are due to Mary Jo Arn, Lysbeth Croiset van Uchelen, Andrea Gasten, Charles Hope, Elizabeth McGrath, Sixten Ringbom, and James Lindesay. A first draft was written during my stay as fellow of the Netherlandish Institute for Advanced Studies (NIAS) in Wassenaar.

1. "Every young man, for sure, has a certain bent for kitchen maids."

2. For the theory of reception of Dutch genre painting, see Peter Demetz, "Defenses of Dutch Painting and the Theory of Realism," *Comparative Literature* 15, no. 2 (Spring 1963): 97–115; for a theory of genre and a review of older literature, see Hans-Joachim Raupp, "Ansätze zu einer Theorie der Genremalerei in den Niederlanden im 17. Jahrhundert," *Zeitschrift für Kunstgeschichte* 46 (1983): 401–18; for a discussion of the changing attitude toward Dutch art of the Golden Age see Josua Bruyn, *Een gouden eeuw als erfstuk: Afscheidscollege* (Amsterdam: Kunsthistorisch Instituut der Universiteit van Amsterdam, 1986).

3. See the best-known example, E. de Jongh, *Tot lering en vermaak: Betekenissen van Hollandse genrevoorstellingen uit de zeventiende eeuw*, exh. cat. (Amsterdam: Rijksmuseum, 1976), with a critical note on the use of emblems by exhibition organizer E. de Jongh.

4. Josua Bruyn, "Toward a Scriptural Reading of Seventeenth-Century Dutch Landscape Paintings," in Peter C. Sutton, ed., *Masters of Seventeenth-Century Dutch Landscape Painting*, exh. cat. (Boston: Museum of Fine Arts, 1987), 84–103; the very title of this exhibition in Amsterdam, *Onze meesters van het landschap*, illustrates my first point.

5. Svetlana Alpers, *The Art of Describing: Dutch Art in the Seventeenth Century* (Chicago: Univ. of Chicago Press, 1983). The author's argument could be strengthened by Filippo Mignini, *Ars Imaginandi: Apparenza e rappresentazione in Spinoza*, La cultura del idee (Naples: Edizione scientifiche italiane, 1981), 6. For recent positions on the "description-meaning debate," see the contributions of Peter Hecht and Anne Walter Lowenthal to the Pittsburgh conference of historians of Dutch art, published in *Simiolus* 16, no. 2/3 (1986); Eric J. Sluijter, "Belering en verhulling: Enkele 17de-eeuwse teksten over de schilderkunst en de iconologische benadering van Noordnederlandse schilderijen uit die periode," *De zeventiende eeuw* 4 (1988): 3–28. (Sluijter's article has been translated and appears in this volume.) On the "dictionary fallacy" see E. H. Gombrich, "The Evidence of Images," in *Interpretation: Theory and Practice*, ed. Charles S. Singleton (Baltimore: The Johns Hopkins Univ. Press, 1969), 35–104; idem, "Aims and Limits of Iconology," in *Symbolical Images: Studies in the Art of the Renaissance* (London: Phaidon, 1972), 1–26, esp. 11ff.

6. For some general remarks see Eva Frodl-Kraft, "Kunstwissenschaft-Kunstgeschichte: Eine Krise des Faches?" *Kunsthistoriker: Mitteilungen des österreichischen Kunsthistorikerverbandes* 2, no. 4–5 (1985): 22–31.

7. This problem seems to stem from the vanishing of a systematically coherent picture of the world. It is reflected in iconography by Ripa's alphabetical arrangement of his book, which thus becomes a modern dictionary rather than a traditional (medieval) encyclopedia. The special problems of simplicity are briefly discussed by Claudia Henn, "Simplizität, Naivität, Einfalt: Studien zur ästhetischen Terminologie in Frankreich und Deutschland, 1674–1771" (Ph.D. diss., Freie Universität, Berlin; Zurich, 1974). The connection between simplicity and problems in interpretation was established by Hans Sedlmayr, "Probleme der Interpretation," in *Kunst und Wahrheit: Zur Theorie und Methode der Kunstgeschichte* (Reinbek: Rowohlt, 1958), 87–127, esp. 105f.

8. For both the paintings and the various copies see G. Wildenstein, *Chardin: Catalogue raisonné*, revised and enlarged by D. Wildenstein (Oxford: Phaidon, 1969), no. 184ff.; Pierre Rosenberg, *Chardin 1699–1779*, exh. cat. (Cleveland: Cleveland Museum of Art, 1979), no. 79; Pierre Rosenberg, *Tout l'oeuvre peint de Chardin* (Paris: Flammarion, 1983), no. 113. Cf. with an interesting series of scullery maids in Philip Conisbee, *Chardin* (Oxford: Phaidon, 1986), 119–32.

9. See Denis Diderot's criticism of the salon of 1765 in Denis Diderot, *Salons*, ed. Jean Seznec and Jean Adhémar (Oxford: Oxford Univ. Press, 1960), 2: 107–8.

10. *"Ce brutal réaliste, au temps de Greuze et de Boucher, sans aucun égard pour les scrupules de la mignardise, nous peint une Femme qui tire de l'eau à la fontaine, le Garçon cabaretier, la Récureuse; et dans la suprême indifférence de son pinceau, il termine la fontaine aussi bien que la femme, et, si sa partialité apparaît, c'est plutôt en faveur du broc qu'en faveur de la figure du garçon cabaretier. Le procédé d'empâtement est uniforme jusqu'à la monotonie."* A. J. D., "L'exposition des ouvrages de peinture au profit de la caisse de secours de la société d'artistes," *L'illustration* 10 (September 1847–February 1848): 362, with an illustration of the *Récureuse* on 361 and the notation *"appartenante à M. Marcille."* Chardin's role as *"témoin de la petite bourgeoisie"* and his indebtedness to Dutch painting were stressed by the Goncourt brothers *"Dans toutes les galeries de l'Europe, je ne sache qu'un tableau dont Chardin paraît descendre: c'est dans le cabinet Six, l'admirable* Laitière *de ce maître si varié et si divers, van der Meer"* (Edmond and Jules de Goncourt, "Chardin," *Gazette des beaux-arts*, 1st ser. [1863]: 514–33 and [1864]: 144–67, 148, and 160; also idem, *Journal: 1851–1861* [Paris: G. Charpentier et cie, 1887], 1: 282–83 [September 8, 1861]). Comparisons of Chardin to Dutch painters are also made by Théophile Gautier, "Chardin et Greuze," *L'Artiste* (1886), 174–76. For the influence of seventeenth-century Dutch painting on Chardin, see Ella Snoep-Reitsma, "Chardin and the Bourgeois Ideals of His Time," *Nederlands kunsthistorisch jaarboek* 24 (1973): 147–243, esp. 180ff. In the nineteenth century the cleaning girl was a favorite motif in realistic genre painting; she was also a central motif of working-class iconography in naturalistic painting; see Martin Drolling, *Maid at the Window* (1809), reproduced in Valentina Nikolaevna Berezina, *French Painting: Early and Mid-Nineteenth Century*, The Hermitage Catalogue of Western European Painting (New York: Johnson; reprint, Harcourt Brace Jovanovich; Florence: Giunti Marcello, 1983), 175; Antonin Proust, *Salon de 1891* (Paris: L. Baschet, 1891), 169, 183.

11. Emmanuel Bocher, *Jean-Baptiste-Siméon Chardin* (Paris, 1876), no. 16.

12. Up to the present, cleanliness has been regarded as a typically Dutch virtue; see Gerard de Lairesse, *Groot schilderboek* (Haarlem: Hendrick Desbordes, 1740), 1: 193–94, who says that the *"al te groote zindelijkheid"* (over-tidiness) of Dutch women is a form of idolatry. He uses the motif of a maiden cleansing tiles as an illustration of vanity. A. van Heemskerck, *Bataavsche Arcadia*, 8th ed. (Amsterdam, 1651), 59, praises the *nettigheid* (cleanliness) of his room in a Dutch inn as compared with foreign accommodations. Jan le Francq van Berkhey, *Natuurlijke historie van Holland* (Amsterdam: Yntema en Tieboel, 1776), 3: 662–65, discusses Dutch neatness and even mentions the concept of *"afgodische zindelijkheid"* (idolatrous cleanness), 662, in reference to William Temple's *Observations upon the United Provinces of the Netherlands* (London: A. Maxwell, 1673; Cambridge: Cambridge Univ. Press, 1932), 96. Temple gives a generally accepted explication for this characteristic feature: "The extreme moisture of the air, I take to be the occasion of the great neatness of their houses, and cleanliness in their towns." For a contemporary view, see Simon Schama, "Cleanliness and Godliness," in *The Embarrassment of Riches: An Interpretation of Dutch Culture in the Golden Age* (New York: Alfred A. Knopf, 1987), 377ff.

13. Jacob Cats, *Spiegel van den ouden ende nieuwen tijdt...* (The Hague: Burchoorn, 1632), 1: 104, no. 34, *"Een open pot, of open kuyl, daer in steeckt licht een hont sijn muyl"*; ibid., 1: 120, no. 40, *"De kanne gaet soo lange te water, totse eens breeckt"*; ibid., 2: 47, no. 12, *"Als morsige lieden kuys worden, so schuerense de panne van achteren."* Jan Luiken, *Het leerzaam huisraad* (Amsterdam: P. Arentz & K. Vander Sys, 1711), 34ff., no. 10 *"de pot,"* 84ff, no. 24 *"de was-tobben."* For the vessel metaphor in general see Ute Davitt Asmus, *Corpus Quasi Vas: Beiträge zur Ikonographie der italienischen Renaissance* (Berlin: Mann, 1977); for some general remarks on method, see Elisabeth Hermann-Fichtenau, "Küchenstücke und Topfstilleben in der deutschen Barockmalerei," *Wiener Jahrbuch für Kunstgeschichte* 40 (1987): 123–40.

14. Straw can allude to resurrection, see (with more literature) Jochen Becker, "Das Buch im Stilleben – das Stilleben im Buch," in Westfälisches Landesmuseum für Kunst und Kulturgeschichte, *Stilleben in Europa*, exh. cat. (Münster: Landschaftsverband Westfalen-Lippe, 1979), 448–78 and 589–94, 591, n. 26; straw can also allude to worthlessness and the loss of virginity, see J. ter Gouw, *De volksvermaken* (Haarlem: E. F. Bohn, 1871), 538; also Elfriede Moser-Rath, *Lustige Gesellschaft: Schwank und Witz des 17. und 18. Jahrhunderts im Kultur- und sozialgeschichtlichen Kontext* (Stuttgart: Metzler, 1984), 88ff. For a pictorial representation see Jan Steen's *Marriage Scene* (Leningrad, State Hermitage Museum, date unknown); cf. S. J. Gudlaugsson, *De Komedianten bij Jan Steen en zijn tijdgenooten* (The Hague: Stols, 1945), 38ff. The comparison of a lantern to the soul was made by Constantijn Huygens, *De gedichten*, ed. J. A. Worp, 3rd ed. (Groningen: Wolters, 1893), 3: 145, *"Candela candelabro inserta,"* and by Joost van den Vondel *"Bespiegelingen van Godt en godsdienst"* (1.1235), in *De werken van Vondel,*

ed. J. F. M. Sterck (Amsterdam: Maatschappij voor Goede en Goedkoope Lectuur, 1936), 9: 453. The fire symbol *in bono* and *in malo* has biblical sources (Pentecost and Ecclesiastes 23:22); use in erotic contexts is frequent in *Cats* (see note 13), 1: 43, no. 1; 45, no. 16; 115, no. 38 (here also connected with straw); 138, no. 46. The problem with Odenkerken's picture is that we are unable to discern whether the lantern is lit or not. If it is dark, we should remember *Cats* (see note 13), 1: 141, no. 47, *"Mulier sine verecundia, lampas sine lumine"* (a woman without modesty is like a lamp without light). The contrast between a large, unlit lantern and a small, lighted one is explained as that of *"ryckdom, schoonheydt, edelheydt,"* opposed to *"vernuft of wetenschap"* by Roemer Visscher, *Sinnepoppen*, ed. L. Brummel (1614; The Hague: M. Nijhoff, 1949), 23, no. 1.23. A "positive" interpretation of the occupations of the kitchen maid is given in the very popular broadsheet "Geistliche Hausmagd," which was frequently reprinted beginning in the sixteenth century. A Protestant version of 1573 explained:

> *Wenn ich das feür ann mach oder anzeundt, so bitt ich*
> *Gott, das es das feür goettlicher liebe in mir*
> *anzuendt....*
> *Spuel ich ab, so bitt ich Gott, das er mir abwasch*
> *alles das im ein mißfallen ann mir ist.*

> (Whenever I light a fire, I pray god to light the fire of
> divine love in my heart....
> When I wash up, I pray god, that he washes off everything
> which displeases him in me.)

(Adolf Spamer, *Der Bilderbogen von der "Geistlichen Dienstmagd": Ein Beitrag zur Geschichte des religiösen Bilderbogens und der Erbauungsliteratur im populären Verlagswesen Mitteleuropas*, ed. Mathilde Hain, Veröffentlichungen des Instituts für mitteleuropäische Volksforschung an der Philipps-Universität Marburg/Lahn 6 [Göttingen: Vanderhock, 1970], 69–70.) See also Barbro Werkmäster, "The Image of Cleanliness," in Hedvig Brander Jonsson, *Visual Paraphrases: Studies in Mass Media Imagery*, Acta Universitatis Uppsaliensis – Figura, n.s. 21 (Uppsala: Almqvist & Wiksell, 1984), 145–92. The attractiveness of kitchen maids seems to be a constant feature of literature. It figures in the stories of Abraham and Jacob, in Apuleius's *Golden Ass* (*Metamorphoses* 2.9), as well as more modern texts. See Arthur Schnitzler, *Der Reigen* (Berlin: Fischer, 1914), 35ff. and Stefan Zweig, *Die Welt von Gestern: Erinnerungen eines Europäers* (Frankfurt: Fischer, 1947), 102. For Dutch maidens, see Simon Schama, "Wives and Wantons: Versions of Womanhood in Seventeenth-Century Dutch Art," *Oxford Art Journal* 3 (1980): 5–13; Donald Haks, "Huwelijk en gezin in Holland in de 17de en 18de eeuw," in *Hes historische*

herdrukken 20 (Utrecht: Hes Uitgevers, 1985): 76; Schama (see note 12), 455ff. The girl in Abraham Snaphaens's *Girl at the Window* is definitively not a maiden but a whore (Leiden, Stedelijk Museum de Lakenhal) with the subscript *"kamer te huer"* (room to let); see E. de Jongh, "Erotica in vogelperspectief: De dubbelzinnigheid van een reeks 17de eeuwse genre-voorstellingen," *Simiolus* 3 (1968–1969): 22–74, 46, pl. 17. Hans Buys has drawn my attention to the problem of "kitchen" humor: see Ernst Robert Curtius, *Europäische Literatur und lateinisches Mittelalter*, 6th ed. (Bern: Francke, 1967), 431–43, *"Küchenhumor und andere Ridicula."* In modern American and European humor and society, the role of the maiden has been filled by the female office worker; see G. Legman, *No Laughing Matter: An Analysis of Sexual Humor* (Bloomington: Indiana Univ. Press, 1968), 1: 252ff.

15. Jeremiah 19:11: "Thus saith the Lord of hosts; 'Even so will I break this people and this city, as one breaketh a potter's vessel, that cannot be made whole again'"; Apocalypse 2:27: "And he shall rule them with a rod of iron; as the vessels of a potter they shall be broken to shivers"; for the other authors cited, see note 26, below. For seventeenth-century humor see M. A. Screech and Ruth Calder, "Some Renaissance Attitudes to Laughter," in *Humanism in France at the End of the Middle Ages and in the Early Renaissance*, ed. A. H. T. Levi (Manchester: Manchester Univ. Press, 1970), 216–28. For a very general survey based on a Dutch collection of jokes, see Rudolf Dekker and Herman Roodenburg, "Humor in de zeventiende eeuw: Opvoeding, huwelijk en seksualiteit in de moppen van Aernout van Overbeke (1632–1674)," *Tijdschrift voor sociale geschiedenis* 10 (1984): 243–66. On rhetorical functions and social implications see Herman Pleij, "De sociale funktie van humor en trivialiteit op het rederijkerstoneel," *Spektator: Tijdschrift voor Neerlandstiek* 5 (1975–1976): 108–27.

16. Royal Museum of Fine Arts, *Catalogue of Old Foreign Paintings*, exh. cat. (Copenhagen: Royal Museum of Fine Arts, 1951), 468; Paul Gammelbo, *Dutch Still-Life Painting from the Sixteenth to the Eighteenth Centuries in Danish Collections* (Copenhagen: Munksgaard, 1960), no. 10, "ascribed to Jan Molenaer." In 1640 the Amsterdam art dealer Johannes de Renialme owned *"een schuurster met veel bywerk van Molenaar"* (a scouring girl with many accessories by Molenaer), see Abraham Bredius, *Künstler-Inventare* (The Hague: M. Nijhoff, 1915), 1: 1–26, "Das Nachlassinventar von Jan Miense Molenaer," 13.

17. There are many examples of this sort of spectator, among them the fool in the adultery scenes of Sebastian Brant's *Ship of Fools*; his peer in the painting from the workshop of Dirck Jacobz. (now in the Groninger Museum), which G. J. Hoogewerff has called the "first Netherlandish genre painting"; or Frans Hals's *Revellers*, 1615 (New York, The Metropolitan Museum of Art), a company so merry that it has been retouched several times. See Sebastian Brant, *Das Narrenschiff*, trans. H. A. Junghans and ed. Hans-Joachim Mähl (Stuttgart: Reclam, 1964), 119ff., no. 33; a Dutch translation, *Der sotten schip*, appeared in Antwerp in 1584. G. J. Hoogewerff, *De Noord- en Zuidnederlandsche schilderkunst* (The Hague: Nijhoff, 1939), 3: 534 and pl. 288.

For Hals's *Shrovetide Revellers* (New York, The Metropolitan Museum of Art, 1615), see Seymour Slive, *Frans Hals* (London: Phaidon, 1974), no. 5, 3ff.

18. A. Pigler, *Barock-Themen: Eine Auswahl von Verzeichnissen zur Ikonographie des 17. und 18. Jahrhunderts*, 2nd ed. (Budapest: Ungarische Akademie der Wissenschaften, 1974), 2: 568–70, s.v. *"Ungleiche Liebespaare"*; W. A. Coupe, "Ungleiche Liebe: A Sixteenth-Century Topos," *Modern Language Review* 62 (1967): 661–71; Louis Dunand, "Une étude de moeurs à propos de deux estampes de Jacques de Gheyn II," *Bulletin des musées et monuments lyonnais* 4 (1967): 189–208; Lawrence A. Silver, "The Ill-Matched Pair by Quinten Massys," *Studies in the History of Art* 6 (1974): 105–23; Alison G. Stewart, *Unequal Lovers: A Study of Unequal Couples in Northern Art* (New York: Abaris, 1978); Lawrence A. Silver, "Lectures and Laughter: Massys's Secular Images," in *The Paintings of Quinten Massys* (Oxford: Phaidon, 1984), 134–60; Konrad Renger, "Alte Liebe, gleich und ungleich: Zu einem satyrischen Bildthema bei Jan Massys," in *Netherlandish Mannerism: Papers Given at Stockholm*, ed. Görel Cavalli-Björkman, National-musei skriftserie 4 (Stockholm: Nationalmuseum, 1985), 35–46. For Dutch dramatizations of the theme see especially J. van Vloten, *Het Nederlandsche kluchtspel van de 14e tot de 18e eeuw*, 2nd ed. (Haarlem: De Graaf, ca. 1880), 1: 19ff. (see also 74–77 for a *"tafelspel"* (interlude) on *"kip en eieren"* (the hen and the eggs) that explains the egg as a metaphor for Christ but is full of erotic allusions); W. M. H. Hummelen, *Repertorium van het rederijkersdrama 1500–ca 1620* (Assen: Van Gorcum, 1968), nos. 10K 10 and 3SG (in 10I 15 there is another farce involving an egg-selling peasant).

19. An example after Goltzius appears as figure 7 in this article. For Jan Steen's painting in Moscow's Pushkin Museum, cf. H. L. M. Defoer, " 'Ex morte levamen,' een ongelijk paar door Jan Steen," *Antiek* 15 (1980): 262–66. Nicolaes Moeyaert, *The Choice between Old and Young* (Amsterdam, Rijksmuseum) possibly illustrates a scene from Gerbrand Adriaensz. Bredero's *Het spel van de moor*; see Pieter van Thiel, "Moeyaert and Bredero: A Curious Case of Dutch Theatre as Depicted in Art," *Simiolus* 1 (1972–1973): 29–49.

20. See especially Quinten Massys's *Brothel Scene* (Washington, National Gallery); Jan Massys's *Unequal Lovers* — with a fool (Douai, Musée de Douai) — and the pictures with the same couple but now spied on by an elderly woman (probably not the old man's wife) in Stockholm (Nationalmuseum) and Copenhagen (Statens Museum for Kunst); and his *Unequal Lovers* tossing around with a *lien d'amour* (?) (Antwerp, Museum voor Schone Kunsten). In Jan Massys's *Boorish Couples* (Vienna, Kunsthistorisches Museum, and Cherbourg, Musée Thomas-Henry — the latter probably from his workshop), the boors depicted are handling pitchers and flutes — obviously symbols of their lust. Compare also Silver, 1984 (see note 18). It should be noted that the participants in charivaris mocked unequal couples; see Anton C. Zijderveld, *Reality in a Looking-Glass: Rationality through an Analysis of Traditional Folly* (London: Routledge & Kegan Paul, 1982), 72.

21. The function of the onlooker is discussed, without mention of this tradition, by A. W. A. Boschloo, *De veelzeggende toeschouwer* (Leiden: Rijksuniversiteit, 1976).

22. *"Onder de pels"* (under the fur) refers to a womanizer, according to A. de Cock, *Spreekwoorden en zegswijzen over de vrouwen: De liefde en het huwelijk* (Ghent: 1911), 62. For Van de Venne, see F. W. H. Hollstein, *Dutch and Flemish Etchings, Engravings, and Woodcuts, ca. 1450–1700* (Amsterdam, n.d.), 11: 233, no. 350 (here ascribed to Jacob Matham but was, in fact, by Jan Matham). The caption reads: *"Wanneer ickt hebt verkerft en Trijn begint te schreijen/Neem duske pillen in, dan kan ick haer weer peijen"* (Whenever I have done wrong and Trijn starts crying, then I take these pills and I can please her again.) Jan van der Stock, *Cornelis Matsys 1510/11–1556/57: Grafisch werk* (Brussels: Bibliothèque Royale Albert 1er, 1985), no. 55; the sheet of 1549 follows an engraving by Beham (H. 165). For further references see Jozef de Coo, *De boer in de kunst van de 9e tot de 19e eeuw* (Rotterdam: Wyt, 1964), pl. 57, 59, 72, and 95. For *"eieren,"* (eggs), see M. de Vries and L. A. te Winkel, eds., *Woordenboek der Nederlandsche taal* (The Hague: M. Nijhoff, 1882), 3: 3977, with some chaste misunderstandings. For *"paaien"* (satisfy) with a sexual connotation and *"nest"* (bed), cf. *Woordenboek* 12: 7ff. and 9: 1853ff. For a contemporary reading of the egg seller, see L. Wuyts, "Eierverkoopster of verliefde boer? Een bijdrage tot de studie van de hennetaster," *Jaarboek van het Koninklijke Museum voor Schone Kunsten Antwerpen* (1987), 207–17.

23. Cf. Hollstein (see note 22), 8: 136, no. 403. For three drawings of unequal couples by Goltzius, see E. K. J. Reznicek, *Die Zeichnungen von Hendrik Goltzius* (Utrecht: Haentjens, Dekker, & Gumbert, 1961), nos. 192–94. For the pot as a sexual symbol, see De Vries and Te Winkel (see note 22), 18: 867 s. v. *"vat,"* I.3, and 17: 258 s. v. *"tobbe"* I.3.b.

24. Konrad Renger, "Tränen in der Hochzeitsnacht: Das Zubettbringen der Braut, ein vergessenes Thema der niederländischen Malerei," in *Festschrift für Otto von Simson zum 65. Geburtstag*, ed. L. Grisebach and K. Renger (Frankfurt: Propyläen, 1977), 310–27. Complementing Renger's examples and providing some earlier examples is Burr Wallen's *Jan van Hemessen: An Antwerp Painter between Reform and Counter-Reform*, Studies in Renaissance Art History 2 (Ann Arbor: UMI Research Press, 1983), 64ff.

25. *Venus minne giftjens inhoudende veelderhande nieuwe deuntjens* (Amsterdam: Cornelis Willemsz. Blau-Laecken, ca. 1622), 30v–31r. The etching is probably by Dirk E. Lons. For *"schuren"* in an erotic sense, see De Vries and Te Winkel (see note 22), 14: 1211, A.7 and B.1; 12: 1522, *"zijn pieck schuren."* For *"vegen,"* synonymous with *"schuren,"* see De Cock (see note 22), 171 and 289; F. van Duyse, *Het oude Nederlandsche lied* (The Hague: M. Nijhoff, 1905), 2: 1181, and idem, "Een Antwerpsche muziekdruk van 1563," in *Tijdschrift voor boek- en bibliotheekwezen* 6 (1908): 197–215, 203. The poem (signed "Ronsaeus") next to the etching describes a comparable scene even more explicitly:

Doen sach ick een Meydt
Staan schuren haar tobb' bij gheval
Ontrent het swarte Huys, op de Wal.

(Then I saw a girl,
scouring her tub,
near the black house on the bank.

Ick zeyd' haar, troost!
Hoe dus vroegh in't til?
Wel mijn Soort
(Zeyd' se) Wat is u wil
Staen ick jouw inde weegh
Of wilje een veegh
Hebben van dit goet?
En stracx zy't oock doet
En gheeft mij een steeck, in het mal,
Over Hoet, over Kleet, over al.

I said: Hello!
So early at work?
As usual,
she said. What do you want?
Am I in your way
or do you want a share
of this stuff?
And so she does
and in jest splashes me
over my hat and dress, all over.

Ick neem haar weer
En legg' ze in't gras
Rugghelings neer,
Want het doen mijn beurt was,
En duw' ze in het groen
Met een aardighe soen,
Zy vinghd' en zy tockt
De rock over 't hooft, en ick sagh
Haar bloot en naackt zooze voor mij lagh.

I take her again
and lay her down in the grass
on her back,
because now it is my turn,
and I push her in the green
with a sweet kiss.
She accepted and pulled
the dress over her head, and I saw
her naked lying in front of me.

Wat kon ick min
Als haer decken doen,
En 't scheen haar sin
Naar ick doen kost vermoen,
Haer tobbetjen was vuyl,
Priapus *te kuyl*
Die schuerter schoon om
Terweijl leijtse stom,
Maer doen hij hield stil, riepze och!
Noch eens als een Man, ay! repje noch.

What could I do
but to cover her,
which seemed to agree with her
as far as I could see.
Her tub was dirty,
the hole for *Priapus*,
who cleanly scrubs it
while she lies there silently.
But when he stopped, she cried: ah!
Oh, once more like a man hurry up!)

26. Cf. P. J. Vincken, "Some Observations on the Symbolism of the Broken Pot in Art and Literature," *The American Image* 15 (1958): 149–74 (with references to older literature); Gisela Zick, "Der zerbrochene Krug als Bildmotiv des 18. Jahrhunderts," *Wallraf-Richartz-Jahrbuch* 31 (1969): 141–204. C. G. Jung, *Wandlungen und Symbole der Libido* (Leipzig: F. Deuticke, 1925), 206ff. and 351ff.; idem, *Psychologische Typen* (Zurich: Rascher, 1930), 326 and 331; idem, "Gestaltungen des Unbewussten," with an introduction by Aniela Jaffé, *Psychologische Abhandlungen* 7 (Zurich: Rascher, 1950), 359ff.; Hans Hestermans, *Erotisch woordenboek* (Baarn: Erven Thomas Rap, 1977), 81 *"kaars,"* 161 *"pot"*; cf. also 179 *"schrobben,"* 180 *"schuren,"* 211 *"vegen"*; and possibly also Cats (see note 13), 1: 98, *"Om de minne van de smeer leckt de kat den kandeleer"* (for the sake of tallow, the cat licks the candle).

27. Cf. Gregory Martin, *The Flemish School, circa 1600–1900*, exh. cat. (London: National Gallery, 1970), 261, no. 861. See also no. 862 with a comparable scene and many similar interiors or farmyards. Especially comparable is a reduced version (Amsterdam, Joseph A. Ritman); see Margret Klinge, *Adriaen Brouwer – David Teniers the Younger*, exh. cat. (New York: Noortman & Brod, 1982), no. 13.

28. André Bouys, *La servante qui récure de la vaiselle d'argent* (Paris, Musée des arts Décoratifs); see Michel Faré, "André Bouys 1656–1740: Portraitiste et peintre de genre," *Revue des arts* 10 (1960): 201–12. The picture was first exhibited at the salon of 1734. Jean-Baptiste Greuze's *L'écureuse* was engraved after a drawing in about 1760; Anita Brookner, *Greuze: The Rise and Fall of an Eighteenth-Century Phenomenon* (London: Elek, 1972), 98ff. and pl. 21. Abraham van Strij's *Woman Scouring the Inside of a Cauldron* (Amsterdam, Rijksmuseum) was probably purchased at the exposition of 1810.

29. Eduard Mörike, *Sämtliche Werke*, ed. H. G. Göpfert, 3rd ed. (Munich: Winkler, 1964), 344; Renate von Heydebrand, "Eduard Mörikes Gedichte zu Zeichnungen," in *Bildende Kunst und Literatur*, ed. Wolfdietrich Rasch (Frankfurt: Klostermann, 1970), 121–54 (with a reproduction of Johann Georg Wille's engraving); Christopher White, *The Dutch Pictures in the Collection of Her Majesty the Queen* (Cambridge: Cambridge Univ. Press, 1982), 39. "In that picture of a robust serving maid cleansing a brass pot, you fancy that you see and hear the very grit as it cuts into the yellow metal," comments Henry Merritt, *Henry Merritt: Art Criticism and Romance* (London: C. K. Paul, 1879), 1: 169.

30. Jan le Francq van Berkhey, *Zinnespelende gedigjes, op de geestige printjes ge-etst door Pieter de Mare, na de teekeningen van Mejuffrouw Christina Chalon, berustende in de verzameling van den kunstbevorderenden Heere H. A. Dibbets* (Leiden: Frans de Does, 1779), 15. Christina Chalon (1753–1826) began to make drawings when she was three or four years old. She received instruction from her niece Sara Troost – the painter's daughter – and the famous collector and printmaker Cornelis Ploos van Amstel. See for Christina Chalon (and her family), T. J. Meijer, "Een lector in de Geneeskunde," *Jaarboekje voor geschiedenis en oudheidkunde van Leiden en*

omstreken 60 (1968): 139–62; especially on the *gedigjes*, see L. Buijnsters-Smets, "Christina Chalon: Een achttiende eeuwse tekenares," *Antiek* 16 (1982): 471–80.

31. Jan le Francq van Berkhey, *Zinspeelende keerdichtjes op de geestige gedichtjes, door den heere J. le Francq van Berkhey* (Blokzeil [probably Leiden], 1784), 15.

32. The witty description of pictures was still a game in the early nineteenth century, see Walter Migge, ed., *Arnims Werke* (Munich: Hanser, 1963), 2: 123–435 *"Der Wintergarten"*; and the story of how Kleist's *Der zerbrochene Krug* (1803–1806) was written for a poetry competition describing Le Veau's engraving after a lost painting by Debucourt; see Jacob Otto Kehrli, *Wie "Der zerbrochene Krug" von Heinrich von Kleist entstanden ist*, Bibliothek des Schweizerischen Gutenbergmuseums 22 (Basel: Gutenbergmuseum, 1957).

33. Georg Philipp Harsdörffer, *Frauenzimmer Gesprächsspiele*, ed. Irmgard Böttcher, Deutsche Neudrucke des Barock 13–20 (1641–1669; Tübingen: Niemeyer, 1968), 1: 113 on specialization; 1: 107 on the different ways people can enjoy art; but above all compare the whole structure of his conversations, which are meant to establish standards for polished social discourse. Allan Ellenius, *De Arte Pingendi: Latin Art Literature in Seventeenth-Century Sweden and Its International Background*, Lychnos bibl. 19 (Uppsala: Almqvist & Wiksell, 1960), 243ff. For a more general view, see K. G. Knight, "G. P. Harsdörffer's 'Frauenzimmergesprächsspiele,'" in *German Life and Letters* 13 (1959–1960): 116–25; Rosmarie Zeller, *Spiel und Konversation im Barock: Untersuchungen zu Harsdörffers "Gesprächsspielen,"* Quellen und Forschungen zur Sprach- und Kulturgeschichte der germanischen Völker NF 58 [177] (Berlin: De Gruyter, 1974). To my knowledge there is no comparable conversation literature in Dutch. This is compensated to some degree by the existence of a few riddles, the so-called Arcadias and books of sayings, anecdotes, and quotations, which obviously served as instructions for conversation. Roemer Visscher, *Zinne-poppen; alle verciert met rijmen en sommighen met proze door zijne dochter Anna Roemers* (Amsterdam: Willem Jansz., n.d.), fol. A2v, explains the making of his emblems:

> *Dit werck had ick doen conterfeyten of maken in seeckere pampieren bladen, doch sonder eenighe uytlegghinge oft glose om tot vermaeckelijkheydt van mijn sinnen te ghebruycken, ende voort die altemet een goed vriendt te vertoonen, met de mondt beduydende wat mijn meeninghe was.*

(I had this work drawn or made on certain sheets of paper, but without any explanation or comment to divert myself and further so I could sometimes show it to a good friend, just telling him what my interpretation was.)

This is obviously a sort of game of explication now sustained by *"kleyne glosckens of bedietselen"* (small interpretations of meanings) added in print. For the general possibility of a multivalent interpretation of these emblems, see Bernhard F. Scholz, "Magister Artis Venter: Rationalisierung der Lebenspraxis in den *Sinnepoppen* (1614) Pieter [!] Roemer Visschers," in *Literatur und Volk im 17. Jahrhundert: Probleme populärer Kultur in Deutschland*, ed. Wolfgang Brückner, Wolfenbütteler Arbeiten zur Barockforschung 13 (Wiesbaden: Harrassowitz, 1985), 1: 401–23. The threefold reading of emblems by Cats is generally cited. The ambiguity that can arise in explaining emblems by a single author is demonstrated by Aegidius Albertinus, *Hirnschleiffer*, ed. Lawrence S. Larsen, Bibliothek des Literarischen Vereins Stuttgart 299 (Stuttgart: Hiersemann, 1977), 369–70, no. 54, where among many other examples, Visscher's lantern emblem is interpreted (see note 14).

The same lack of evidence is true for the more "aesthetically" oriented conversation on art, but a valuable document exists that proves that paintings were a fashionable subject of small talk for the upper classes, namely the "Brussels manuscript" (no. 15 552) of 1635; see Mary Philadelphia Merrifield, *Original Treatises Dating from the XIIth to XVIIIth Centuries on the Art of Painting* (London: J. Murray, 1849), 759–841, 825 *"La façon de parler des beaux tableaux."* For the connection of joke, emblem, and genre, see Jochen Becker, "Introduction," in *Incognitis Scriptoris Poemata: Nieuwe Nederduytsche gedichten ende raetselen* (Leiden, 1624; Soest: Davaco, 1972); " 'De duystere sin van de geschilderde figueren': Zum Doppelsinn in Rätsel, Emblem und Genrestück" in Herman Vekeman and Justus Müller-Hofstede, eds., *Wort und Bild in der niederländischen Kunst und Literatur des 16. und 17. Jahrhunderts* (Erfstadt: Lukassen, 1984), 17–39; Barbara C. Bowen, "Two Literary Genres: The Emblem and the Joke," *Journal of Medieval and Renaissance Studies* 15 (1985): 29–36. On the ambiguity of seventeenth-century Dutch attitudes in general see Simon Schama, "The Unruly Realm: Appetite and Restraint in Seventeenth-Century Holland," *Daedalus* 108 (Summer 1979): 103–23; see also idem (see note 12).

34. Apothegms, of course, also belong to the *genus humile*. In combination the different comments on one and the same item (picture) could make it impossible to use metaphors in the low genre; see Cicero, *De oratore*, 21.69. This might also be one of the reasons for the decline of classical style differentiation (the other probably being the mingling of styles in Christianity since Saint Augustine); for general information see Ernst Walser, *Die Theorie des Witzes und der Novelle nach dem De sermone des Jovianus Pontanus: Ein gesellschaftliches Ideal vom Ende des 15. Jahrhunderts* (Strasbourg: K. J. Truebner, 1908); Thomas Frederick Crane, *Italian Social Customs of the Sixteenth Century and Their Influence on the Literatures of Europe* (New Haven: Yale Univ. Press, 1920; reprint, New York: Russell & Russell, 1971); Ulrich Wendland, *Die Theoretiker und Theorien der sogenannten galanten Stilepoche und die deutsche Sprache*, Form und Geist 17 (Leipzig: Eichblatt, 1930), esp. 56ff.; Theodor Verweyen, *Apophtegmata und Scherzrede: Die Geschichte einer einfachen Gattungsform und ihrer Entfaltung im 17. Jahrhundert*, Linguistica

und Litteraria 5 (Bad Homburg v.d. Höhe: Gehlen, 1970); Jutta Weisz, *Das Epigramm in der deutschen Literatur des 17. Jahrhunderts* (Stuttgart: Metzler, 1979), esp. 110–18; Moser-Rath (see note 14), esp. 9, 49, 89ff., 272.

35. For the rhetorical justification cf. Quintilian, *De institutio oratoria*, 6.3.48 *"amphibolia"*; cf. also on humor: Cicero (see note 34), 2.58. For the implications regarding quality, see E. H. Gombrich, "Tradition and Expression in Western Still Life," in *Meditations on a Hobby Horse and Other Essays in the History of Art* (London: Phaidon, 1963), 95–105. This is not the place to argue about the polyvalence and ambiguity of signs for different readers as understood by empirical and reception theorists. As mentioned above, I am limiting myself to possible interpretations in a historical context. It would be the object of a much longer study to demonstrate how some central ideas of modern aesthetics have their roots precisely here, where the different possibilities of reaction to a work of art are taken into account; see the seminal work by Umberto Eco, *Opera aperta* (Milan: Bompiani, 1962). Modern use of the term "ambiguity," which seems to have become fashionable, is not always very clear, as in Max Imdahl, ed., *Wie eindeutig ist ein Kunstwerk?* (Cologne: DuMont, 1986).

36. On ambiguity in semiotics, see Johannes G. Kooij, "Ambiguity in Natural Language" (Ph.D. diss., Gemeente Universiteit, Amsterdam, 1971); and John Lyons, *Semantics*, 2 vols. (Cambridge: Cambridge Univ. Press, 1978), 396ff. and 550ff. The most famous example of ambiguous behavior is the trade of the Dutch Republic with its political opponents; see J. H. Kernkamp, *De handel op de vijand, 1572-1609*, 2 vols. (Ph.D. diss., Rijksuniversiteit te Utrecht, 1931–1934).

Eric J. Sluijter

DIDACTIC AND DISGUISED
MEANINGS?

Several Seventeenth-Century Texts on Painting and the Iconological

Approach to Northern Dutch Paintings of This Period

Judging from numerous recent publications, the debate concerning the nature of seventeenth-century Dutch painting — especially genre painting — is still raging. In recent years countless investigations have focused on the meaning and function of this art within its historical context.[1] Little agreement has been reached, however, regarding the goals pursued by Dutch painters and the perception of their works by contemporary audiences. In a recent summary Jan Białostocki listed three possible answers: In 1876 Eugène Fromentin asserted that the painter had no other motivation than a purely artistic need to depict reality; a hundred years later iconologists, of whom E. de Jongh may be considered the most important, have suggested that the intention of these artists was *"tot lering en vermaak"* (to instruct and delight); Svetlana Alpers has offered another solution, suggesting that the aim of Dutch painters was to increase the visual knowledge of reality.[2]

The iconological method of explaining seventeenth-century Dutch genre painting — which has been enthusiastically employed since the 1960s, particularly by Dutch art historians — has been the most successful. Its results have significantly enriched our knowledge of Dutch genre art. Generally speaking, this method, which has also been somewhat imprecisely typified as "emblematic interpretation,"[3] attempts "to decipher layers of meaning and literary allusions hidden in paintings and to relate the significance of genre painting to the classical concept of *docere et delectare* (to teach and delight)."[4] As a result, a non-narrative art, which for the most part appears to be devoid of any relationship to textual references, has nevertheless been joined to texts. This has led to such far-reaching conclusions as the following: "The joyful, often coarse domestic and tavern scenes have been con-

vincingly established as instructive lessons, warning against sin, recalling death, challenging the viewer to lead a God-fearing life."[5]

These new insights have been translated into literature intended for a broad, nonspecialized public — educational brochures, exhibition wall texts, newspaper articles, and a recent survey of Dutch art. Such materials lead one to believe that a general consensus exists concerning seventeenth-century audiences' perception of this art.[6] Furthermore, in contrast to what Josua Bruyn believed in 1981,[7] guides leading tours in Dutch museums extensively, and almost exclusively, inform visitors about the hidden meanings, disguised symbols, and moralizing messages contained in genre pieces, still lifes, and even landscapes. Viewers are told what a painting "really means." Its "message," disguised by the painting's realistic appearance, usually contains an easily formulated warning and an edifying lesson.[8]

One must ask, however, whether a number of notions that have become familiar due to the success of iconological investigations (e.g., ideas regarding didactic function and the disguising of meaning) are fully justified and whether arguments in their favor are sufficiently valid. It is not my intention to analyze or elaborate on the criticisms that have been leveled at the iconological method as applied to Dutch art.[9] I merely want to take this opportunity to question several notions that have taken hold in wider circles. I will do so by using the same type of material that iconologists have so often employed to defend their arguments, namely, seventeenth-century texts. It should be emphatically stated that the important insights and results yielded by this iconological research are by no means to be dismissed; on the contrary, it is precisely these results that allow one to question whether the frameworks in which they have been placed are adequate or whether they require revision.

One of the well-known obstacles for the iconologist attempting to comprehend the aims and aspirations of the seventeenth-century Dutch painter, as well as the attitude of the artist's public, is the scarcity of contemporary literature shedding light on the matter. Given the period on which I wish to concentrate, circa 1620–1670 (qualitatively and especially quantitatively, the period of Dutch painting's greatest development), the only substantial text about painting is Philips Angel's little treatise *Lof der schilder-konst* (*In Praise of Painting*), published in 1642. This was the text of a lecture given to the community of painters in Leiden on Saint Luke's Day in 1641.[10] One might expect that this speech by an average painter, which was presented

to an audience consisting primarily of landscape, still life, and genre paint-ers[11] and was intended to underscore the dignity of their shared profes-sion, would have played an important role in attempting to trace the ideas of seventeenth-century Dutch artists. It has not yet, however, been sufficiently considered within the framework of art-historical literature.[12] A closer look at Angel's treatise may help us to grasp some of the concepts considered significant enough at the time to be formulated for that group of painters.

First, however, I would like to consider briefly Jacob Cats's account (cited by Angel) of the painter and the poet who fought for the hand of Rhodope. It serves as a useful point of departure since it reveals much about the image of the painter and the art of painting.[13] The passage, which is taken from "De beschryving van de op-komste van Rhodopis" ("Description of the Rise of Rhodope") — the most extensive story in Cats's *Trou-ringh* (*Wedding Ring*) of 1637 — relates how a poet and a painter, together with a military officer, a counselor, a merchant, and an embroiderer, vie for the hand of the lovely Rhodope. In order to impress her, each suitor gives a detailed description of the dignity of his profession.

S. F. Witstein has demonstrated that the seventeenth-century reader of Cats's story would indeed have recognized in the poet's plea the con-temporary image of "the poet" and that his role as philosopher of morals would have been entirely familiar.[14] In contrast to the other suitors, the poet presents himself as engaged with higher matters; he determines ethical prin-ciples and provides instruction regarding virtues and passions. This descrip-tion is in agreement with the intellectual and moral duties traditionally identified with the art of poetry. The Horatian dictum *"Omne tulit punctum qui miscuit utile dulci"* (He who unites the useful with the pleasant is praised) is central to this ideology.[15] Furthermore, the poet gives a sample of his emblematic faculties when he perceives a *"diep geheym"* (profound secret) in the conduct of a flea that jumps onto him from Rhodope. Finally, he assures her that her name will live forever should she marry him.[16]

In contrast, the painter mentions no high intentions or lofty principles in describing his art,[17] although his narrative begins with the traditional comparison between painters and poets. The painter creates mute poetry, while the poet makes paintings that speak; both art forms serve *"de weerelt tot vermaecken"* (to amuse the world) and ease the mind. It should be noted that even in this account of shared intentions, the painter does not broach the loftier goals stressed by the poet. The painter believes that his art ranks

higher than poetry for the following reason: the poet, he says mockingly, earns praise, laurels, and eternal fame with his mind and its *"hooghe vlucht"* (lofty concerns), but he can neither make a living nor support a wife and children. The painter, on the other hand, can earn money with his art.

> *De waerde Schilder-Kunst verdient al grooter loff,*
> *Want boven haer vermaeck soo komter voordeel off.*
> *Ick winne machtich gelt, ick maecke groote stucken,*
> *Oock weet ick op de Plaet de Vorsten uyt te drucken:*
> *Hier drijf ick handel meed', en vry met groot ghewin,*
> *En dat's een dienstich werck voor huys en huysghesin.*[18]

> (The worthy art of painting deserves the highest praise,
> Since, besides the pleasure it brings, it produces gain.
> I earn a lot of money, I paint great works,
> And also I know how to portray monarchs in print.
> With this I conduct trade, free and with great profit,
> And that is useful for home and family.)

The painter relates that he has recently been paid handsomely by a monarch who also presented him with a gold chain. In contrast, his friend the poet received only a laurel wreath and a coat of arms from the same monarch for a poem *"enckel geest en van een hooghe toon"* (full of noble spirit and lofty thoughts). The painter is thus led to remark:

> *Maer waerom langh verhaelt? Ick kan te samen voegen*
> *Dat u, dat al het volck, dat Princen kan vernoegen,*
> *En dat oock bovendien mijn voordeel geven kan.*[19]

> (But why dwell any longer on this? I can invent things
> that can entertain you, princes, and all other people,
> And which in addition give me profit.)

A little later the painter also compares himself with the merchant and assures Rhodope: *Soo ghy een Coopman lieft, Ick kan oock handel drijven, En kan noch door de Konst mijn saecken beter stijven.*[20] (Should you love a merchant, well, I can also conduct trade, And can swell my purse through

178

art.) Furthermore, the painter claims to be a better tradesman than the merchant because he produces his own merchandise. His art will never desert him, while a merchant would go bankrupt if, for example, his merchandise were to be lost in a shipwreck.

As an alternative to the poet's promise that he can make Rhodope's name eternal, the painter claims that he can capture *"dit aerdich Beelt van uwe jonghe daghen"* (the beautiful image of your youth) and preserve it for succeeding generations, so that for a thousand years all will be able to admire her. Thus, through his art she will live eternally. The warrior's suit is parried by the argument that the painter can depict everything; he can even show Rhodope battles, if she wishes to experience them without risk. Should she find the counselor attractive because he frequently works in courtly circles, she must bear in mind that princes have honored painters for aeons.[21]

Cats starkly contrasts the painter with the poet in various ways. The painter derives his dignity not from the pursuit of lofty goals but from the production of superior merchandise, which brings him profit, and from the appreciation, largely financial in nature, that powerful patrons bestow on him.[22] The aim of his art is to delight and *"vernoegen"* (entertain), to represent what people wish to see, and, finally, to fix transient physical beauty, thus vanquishing time.[23]

Cats's description of the painter as a respected craftsman who produces superior products (a rather unfavorable image from the standpoint of the liberal arts) must have been entirely acceptable to his contemporaries — even to painters. Angel repeats this characterization in extenso when lauding the dignity of his profession, and he ranks the painter above the poet. After devoting more than three of the fifty-eight pages of his treatise to quoting Cats, Angel concludes: *"Siet daer, door een Poët selfs de Schilder-Konst boven de Poësy ghestelt!"* (See there, a poet himself has placed the art of painting above poetry!)

Furthermore, Angel gives no indication that the lofty, didactic aims of poetry are equally applicable to painting; he makes no mention of teaching and edification, deeper wisdom, or other intellectual pretensions. In this respect, the idea of *ut pictura poesis* (like painting, like poetry) seems to play no role for Angel. He appears equally unconcerned that existing humanistic art theory was predominantly based on the rules of poetics and rhetoric, although he gratefully makes use of Karel van Mander when it suits him. Angel must also have been aware of Franciscus Junius's *De schilder-*

179

konst der oude (*The Painting of the Ancients*), which had just been published in Dutch;[24] however, he seems to have been interested in the foreword by Jan de Brune the Younger as opposed to the book itself. The pragmatic painter Angel culled from existing theoretical vocabulary about painting only those aspects that suited his needs at the moment.

When Angel wants to demonstrate the dignity and the venerability of his profession, he plunders Van Mander for names and biographies of painters from antiquity.[25] Characteristically, he concludes this section with the story of Zeuxis and Parrhasius as exemplifying the highest rank of painting reached in antiquity. Zeuxis could imitate nature so perfectly that even birds were deceived by the grapes that he painted on his panel. Nevertheless, Parrhasius surpassed Zeuxis because his imitation of nature could fool even a reasoning being, including a painter; Parrhasius painted a cloth over his painting which Zeuxis tried to pull aside.[26] When Angel discusses the high esteem that people in power have accorded painters throughout history, he again uses examples drawn primarily from Van Mander. It is apparent, however, that Angel considers the painter's status and recognition to be predominantly linked to the financial rewards that he continually and emphatically notes. He sets the conclusion of this section within the ramparts of Leiden with a discussion of the successful Leiden painter Gerrit Dou, who received five hundred *gulden* annually from a connoisseur who wished to have first choice among the paintings produced by the artist. According to Angel, this establishes how *"geacht en ghe-eert"* (respected and honored) painters are.[27]

Next, Angel addresses the traditional comparison between painting and sculpture (basing his arguments mainly on Jan de Brune's preface to Junius's work); this is followed by the comparison between painting and poetry — which has been discussed above — in order to show that painting deserves more praise than the other two arts. Angel's most important argument for ranking painting above sculpture is based on the fact that the former can imitate all that is visible in nature. To help convey this point, he enumerates subjects that can be rendered in painting but not in sculpture, including insects such as flies and spiders; the physical appearance of different kinds of metal; and intangible natural phenomena such as rain, lightning, clouds, mist, dawn, dusk, night, and reflections. Painting's capacity to capture *"schijn sonder sijn"* (semblance without being) satisfies his most important criterion.[28]

When Angel finally discusses in detail the requirements that the artist must meet and the qualities that he must possess to be worthy of the title of painter, he divides the various components of this art into specific categories. A few of these can, with some effort, be traced to such traditional theoretical notions as *iudicium*, *ingenium*, *disegno*, and *decorum*. Angel's characteristically simplified descriptions of these concepts, however, have little to do with the more learned connotations used in humanistic art theory.[29] His first requirement, *"recht oordeel"* (right judgment), only consists of a warning that one should not borrow indiscriminately from the compositions of others. Next, he advises a *"ghewisse Teycken-hant"* (steady hand for drawing): one should make no mistakes in draftsmanship. He gives the drawing of a *"tronie"* (head) as an example and points out that one eye is often not aligned properly with the other, the ears are too small, the nose too short or too long, etc.[30] *"Vloeyende ende eyghentlijcke by een voeghende gheest"* (capacity for combining things in a fluid and natural manner) refers to the painter's ability to imagine many different subjects and compose them according to their nature in order to produce an *"aenghenamen bevallijcken luyster"* (pleasantly attractive splendor). Furthermore, what has been represented must be completely comprehensible to the observer.[31] *"Kennisse van Hystorien"* (knowledge of history) means that in order to portray correctly *"Goddelicke, Poëtische en Heydensche Historien"* (religious, poetic, and mythological histories), an artist must carefully read the stories to be represented and accurately render the information that they contain. The concept of *"hooge na-gedachten"* (lofty reflections) or *"verre en eyghentlicke nagedachten"* (profound and natural reflections) means that what has been read must be thoroughly considered, so that everything depicted is consistent with what is described in the narrative — even aspects not specifically related in it. Once again, the observer must be able to discern clearly what is taking place.[32] Angel says nothing about expressing the deeper meanings contained in these stories, nor does he emphasize the expression of emotions as a means of appealing to the viewer's feelings.

Angel constantly stresses the need to imitate visible things precisely, so that they appear "almost real." Light and shadow must be distributed in such a way that even objects that seem virtually inimitable with brush and paint *"seer eyghentlijck schijnen"* (appear like the thing itself). Furthermore, the *"waerneminghe van d'eyghen natuyrlicke dinghen"* (observation of the actual natural things) ensures that the artist carefully observes optical effects

and reproduces them faithfully.[33] Given that *"wy na-bootsers van 't leven sijn"* (we are imitators of life), Angel states that no effort should be spared if it means that one *"de natuerlicke dingen daer mede nader by komt"* (comes nearer to natural things). In support of this, he cites examples of specific features that painters should closely observe: *"Bataelje-Schilders"* (battle painters) and *"History-schilders"* (history painters) should study the effect of a wheel turning; *"Zee-Schilders"* (marine painters), the smoke trailing from a cannon shot; *"Landschap-schilders"* (landscape painters), the reflections in water; and the painters of the *"Corteguarden"* (guardrooms), the effect of a fuse glowing as it is swung around.[34]

Angel speaks of anatomy in terms of the precise observation of limbs and muscles and their movement without mentioning correct proportions or ideal beauty.[35] He also mentions the careful rendering of texture — a seemingly typical requirement at this time — distinguishing among fabrics such as velvet, wool, and satin.[36] Most noteworthy in this discussion of working carefully after nature is a passage concerning the relationship between *"natuyrlicke na-bootsinge"* (imitation of nature) and *"handelinghe"* (manner of painting). In this passage Angel maintains that a painting by the best master should be recognizable not by any particular manner of painting but rather *"uyt de ongewoone overeenkominge die het met het leven heeft"* (by the exceptional resemblance it bears to life). He states that the highest praise one can receive is that *"men noyt te voren van sulcke na-by-kominghe nae 't leven gehoort en had"* (one had never before heard of such close renderings after life).[37] As a final point, Angel advises *"netticheyt"* (neatness, i.e., a careful, smooth, and finely detailed manner of painting) that must, however, be coupled with a certain *"lossicheyt"* (looseness) to prevent lapsing into a *"stijve nette onaerdigheyt"* (stiff [and] tidy unpleasantness); the *"noyt ghenoegh ghepresen"* (never sufficiently praised) Gerrit Dou is cited here as an example. Should this prove too much for the painter, he continues, it would be better to apply a *"los, wacker, soetvloeyend Penceel"* (loose, lively, smoothly flowing brush), or the artist's results will be greeted by ridicule rather than praise.[38] Finally, of course, pleasant behavior, virtue, and diligence — the latter is particularly emphasized — are necessary to attain the highest honor and fame.[39]

In discussing these requirements, Angel's constant emphasis on the need to appeal to the observer's eye is indeed remarkable. The *"aerdigh-vercierende Rijckelijckheydt"* (abundance that pleasantly embellishes, i.e.,

the representation of a variety of subjects in a painting) is particularly necessary because of the

> *opweckende toe-gheneghentheyt, die men daer door in de ghemoederen van de*
> *Konst-beminders wacker maeckt…soo datse met een wensch-begheerte, het*
> *oogh der Liefhebberen tot haer dinghen verrucken en dat daer door de Stucken*
> *haer te beter van de handt gaen.*

> (rousing affection this kindles in the art lover's mind…so that they [the
> paintings] delight the eyes of art lovers and fill them with desire; and through
> this the painter will sell his paintings all the better.)

Furthermore, rendering texture skillfully is *"op 't aengenaemste voor yders
ooge"* (the most appealing to everyone's eyes).[40] Through the *"schijn eyghent-*
lijcke krachte (soo noem ick het)" (appearance-simulating power [as I phrase
it]), which is achieved through a proper distribution of light and shadow,
one will *"het ghesichte der Konst-beminders overweldighen en in nemen"*
(overwhelm the sight of art lovers and captivate them).[41] The meticulous
observation and rendering of optical effects must *"niet min behaeghlijck, als*
natuerlijck zijn in de ghemoederen der Konst-beminders, en oock een meerder
begheer-lust tot de Kunst verwecken" (be no less pleasant than natural in the
minds of art lovers and must also arouse more desire for art), while a true-
to-life palette of colors *"onse Konst in 't ooghe van de Kunst-beminnende*
Liefhebbers en wel-ghevallen doet hebben" (makes our art appealing in the
eyes of art lovers).[42] Angel's dedication of his *"Schilders Konsts-Lof-spraeck"*
(encomium to painting) to Johan Overbeeck is meant to express his grati-
tude for having been given the opportunity to see the latter's art collection,
where he was able *"te versadighen de lust van mijn nieuwsgierighe ooghen"* (to
slake the desire of my inquisitive eyes) on the *"menichte van die uytnemende*
aerdigheden" (multitude of excellent niceties).[43] Once again, not a word is
spared for painting's edifying function. On the contrary, its appeal and
delight to the eye are emphasized at length.

Finally, there is no conscious hierarchy to be discerned for the various
genres in Angel's treatise.[44] As mentioned earlier, when he wants to clarify
an aspect in his discussion of the requirements that a good painter must
fulfill, he presents a *"tronie"* (head) as an example in his passage on draw-
ing. Elsewhere, he cites with equal ease the work of painters of battlefields,

history pieces, seascapes, landscapes, and guardroom scenes.[45] Angel apparently considered these various subjects to be specialties, which they were at the time. He does require that painters of history pieces carefully read narrative texts in order to faithfully represent them in a clear, correct, and suitable manner; he then discusses representations of various biblical and mythological subjects extensively. Yet he does not view the painting of history pieces as the painter's highest goal.[46] His admiration for Dou, who at the time painted primarily interior scenes and *tronies*, is no less than that he expresses for Rembrandt or Jan Lievens. It is these three painters — not coincidentally all from Leiden — who receive his greatest praise.[47]

Although Angel's treatise, like any other seventeenth-century treatise, does not give much information about a painter's choice of subject matter and content, I have reviewed both Cats and Angel at some length in an attempt to delineate what would have been the important points of discussion for a Leiden painter around 1641, when the status of the painter and his art were at stake. (It should be noted in passing that Angel undoubtedly saw himself as being fairly learned and was, most likely, above average in this regard.) In the first place, emphasis was placed on painting as a distinguished and respectable craft, not on the painter's intellectual aspirations.[48] Angel's audience probably included painters such as Dou; David Bailly (portraits and still lifes); Pieter van Steenwijck (still lifes); Pieter Dubordieu (portraits); Quiryn van Slingelandt, Louys Elsevier, and Maerten Frans van der Hulst (landscapes); Jan van de Stoffe (battle scenes); Cornelis Stooter (seascapes); Johannes van Staveren, Abraham de Pape, and Adriaen van Gaesbeeck (genre painters and followers of Dou), all of whom presumably listened with approval.

Angel only broaches literary aspects of content when discussing the clear rendering of a narrative text.[49] Indeed, no mention is made of a "noble, didactic purpose of the art of painting."[50] Furthermore, despite the fact that Van Mander was an important source, links with humanistic art theory can only be detected with some effort. As mentioned earlier, Angel had no interest in Junius except for De Brune's preface and the names of a few classical painters and writers on art, which he borrowed from the text.[51]

In fact, it is difficult to find anything in texts on the art of painting from this period that would indicate that didacticism was an important aim.[52] We cannot assume that the lack of writing on this subject resulted from the

fact that it was considered self-evident. This is highly implausible if only because literary-theoretical discourses and innumerable prefaces to literary works, reiterated time and time again the Horatian ideology *utile dulci* (uniting the useful with the pleasant), the edifying function, the deeper wisdom packaged in an amusing form. Assuming that the notion of *ut pictura poesis* was deeply rooted, it would be natural to address these issues, especially if one wanted to say something about the dignity of an art that, more than literature, can give rise to substantial misunderstandings about such moralizing intent. Moreover, this art could be censured by critics as being *"schoubaer oogh fenijn"* (venom for the eyes)[53] precisely because of its amusing, appealing, and sensual appearance. The fact that these issues were not addressed should, at the very least, give us cause for thought.

Art historians have put forward analogical arguments defending the principles of didacticism and disguise as points of departure for the interpretation of seventeenth-century Dutch paintings (particularly genre paintings), frequently considering these principles as the essence of the meaning of these paintings.[54] These arguments originate from a stretching of *ut pictura poesis*, which has led to an oversimplified equation of the functions and aims of poetry and painting. The passages cited as examples of *"belering en verhulling"* (didacticism and disguise) are taken from Roemer Visscher's preface to *Sinnepoppen*, Cats's prefaces to *Proteus* and *Spiegel vanden ouden en nieuwen tijdt*, Bredero's preface to *Geestig liedboeksken*, etc.[55] Thus, commonplaces taken from emblem literature in particular have been projected onto painting, despite their entirely different nature, context, function, tradition, and pictorial themes.[56] As stated above, one searches in vain in texts about painting for clichés concerning the hard outer shell and the sweet kernel within, edification through amusement, and the display of vices as a warning and an exhortation to virtue. These notions are, however, endlessly repeated in emblem books and innumerable prefaces to other types of literature, including songbooks, comedies, and adaptations of mythological material.

When, occasionally, arguments are drawn from texts that are directly related to painting, they prove inadequate. The often cited poem by Samuel van Hoogstraten about *"bywerk dat bedektelijk iets verklaert"* (accessories that explain something covertly), for example, has been used to justify the idea of deep, hidden meanings secreted within genre painting.[57] However, Van Hoogstraten's words are specifically directed at historical scenes with

single figures (personifications, for example) in which the "accessories" (such as particular attributes) unobtrusively make clear that which is actually represented. This passage explains nothing about genre paintings; moreover, Van Hoogstraten does not speak about hidden meanings but rather about clarifying the representation in order for *"de toezienders haer beeld te doen kennen"* (the observers to comprehend the image).[58]

Adriaen van de Venne's verses about *"sinne-cunst"* (emblematic art) in his *Zeeusche mey-clacht: Ofte schyn-kycker* form another case in point.[59] In my view, these verses exclusively concern images accompanied by texts, such as emblems, and not painting in general. The first half of the poem speaks of painting as a source of joy. It captures beauty, arouses desire, and entices the eyes; it can record and visualize all that exists. A number of the significant aspects of painting frequently encountered in texts are treated in this section of the poem. Van de Venne, who was also a poet and an illustrator of emblem literature, then proceeds to discuss the sister arts of painting and poetry, noting that the latter can express *"hooghe en diepe dinghen"* (high and deep things). He demonstrates how the two arts can be combined and how their different characteristics complement each other. This leads Van de Venne to *"sinne-cunst"* — almost certainly meaning the combination of image and text — which he finds so admirable because the mind is *"soo sin-rijck meegedeelt"* (so significantly informed) by it.[60] Van de Venne does say that, among other things, painting can represent virtue and vice as well as human flaws, but this is the closest he comes to a didactic approach.[61]

Karel van Mander wrote his *Schilder-boeck* within the context of a literary-humanistic circle; it was written at a time when painting in general and the art market were on the verge of entirely new developments: history painting still dominated, specialization in the various genres had yet to develop, and the production and collecting of paintings had by no means attained the quantitative leaps that were to become noticeable several decades later. Surprisingly, Van Mander's text does not explicitly mention a didactic function or deeper meaning of painting in either the *Grondt* (a pretentious poetic work that makes extensive use of intellectual metaphors and exempla) or the *Levens*.[62] When Van Mander mentions paintings in the *Levens*, he says remarkably little about their subject matter and nothing about their content or literary aspects. He is almost exclusively interested in outward appearance.[63] The common assertion that Van Mander saw didacticism as the most important function of painting is not convincing.[64]

186

Considering that seventeenth-century authors, as stated above, found it important to elaborate continually on this function in their discussions of poetry, emblem literature, etc. (Van Mander makes extensive use of such ideas elsewhere, for example, in his introduction to *Wtleggingh op den Metamorphosis* [*Explanation of the Metamorphoses*]),[65] it seems all the more remarkable that he does not address it.

It is impossible to sustain the idea that the didactic goal of painting is repeatedly underscored in the aforementioned literature.[66] Equally untenable is the assertion that in this art literature the aspect of people gaping at the physical appearance of paintings while remaining unaware of their hidden meaning was lamented.[67] In short, based on these sources, one has to ask whether such didactic principles had an important place in the minds of the majority of Dutch painters of this time and whether their audiences considered moralizing an important function of the paintings. By no means do I wish to argue that didactic-moralizing intentions are never present in paintings but rather that it appears incorrect to use such notions as the basis for interpretation.

A continually recurring notion encountered in texts pertaining to the art of painting or to individual paintings is that a painting imitating nature possesses the power to render everything, to capture beauty, to entice and seduce the eye, to arrest earthly transience, and thereby to "conquer" nature.[68] Furthermore, the fascination with imitation is often manifest, as is the play with appearance and being and the "deception" of the eye.[69] This is expressed in many variations, and it should come as no surprise that extremely successful painters such as Gerrit Dou and Frans van Mieris were frequently compared to Zeuxis and Parrhasius.[70]

Van Hoogstraten summarized such ideas wonderfully in the beginning of his chapter "Van het oogmerk der schilderkonst; watze is, en te weeg brengt" (On the Aim of the Art of Painting: What It Is and What It Brings About): *"De Schilderkonst is een wetenschap, om alle ideen, ofte denkbeelden, die de gansche zichtbaere natuer kan geven, te verbeelden: en met omtrek en verwe het oog te bedriegen"* (Painting is a science that can represent all the ideas or concepts offered by all of visible nature and which deceives the eye with contours and paint). After again referring to Parrhasius and Zeuxis, Van Hoogstraten continues with the frequently quoted statement: *"Want een volmaekte Schildery is als een spiegel van de Natuer, die de dingen, die*

niet en zijn, doet schijnen te zijn, en op een geoorlofde vermakelijke en prijslijke wijze bedriegt" (Because a perfect painting is like a mirror of nature, making things which do not exist appear to exist, and which deceives in an acceptably amusing and honorable manner).[71] He goes on to mention the fact that poets made a connection between the origin of painting and Narcissus and, without actually saying so,[72] evokes associations with vain and transient beauty (which Narcissus could not preserve, but which painting can); these associations are also implied by the mirror metaphor. This may serve as a nice description for a great deal of Dutch painting of this period: the rendering of pleasant and amusing images, which, like a reflection, appear deceptively real. "As if [looking] in a mirror," the viewer is confronted by the associations evoked by what is reflected (with all the connotations of self-knowledge, beauty, vanity, and transience related to the mirror metaphor).[73] Didactic lessons as such are not obviously implied but are not excluded. In my opinion, however, we can discount the idea that meanings were intentionally hidden or disguised.

It should be pointed out that the often-cited qualities of semblance and "deception" of the eye could also be perceived as dubious, and they are frequently mentioned in the context of negative opinions about painting. Both the positive and negative views of the enticement of the eye through appealing and deceptive appearances are recurring topoi. These were all the more powerful because it was written time and again that the eye, and thus the sense of sight, aroused sensual feelings and lust.[74] Naturally, these are often old topoi derived from classical texts, but the way in which they are continually repeated seems no less significant. Following the footsteps of Johannes Evertsz. Geesteranus, Dirk Rafaëlsz. Camphuysen, himself once a painter, even goes so far as to denounce the art of painting as being a *"verleydt-Ster van 't gezicht dat sich verstaart op 't sterffelijck"* (seductress of sight, spellbound by all that is transient). His opinions, though extreme and formulated from an orthodox religious standpoint, are revealing in their vehemence. He even says that paintings have no use or purpose and contain nothing worth learning, but are merely: *"Een vleyend'd oog bedroch, 't welck naackt t'aenschouwen geeft, Hoe dat hy is in 't hart die 't maeckt en die het heeft"* (A seductive deceit of the eye, that shows us openly what the real disposition is of those who make and possess them).[75] Shortly before, Camphuysen had stated:

't Geen d' oogen weyt en leyt bevalt den sinnen soet
En d'ydle beeltenis beheerst het swack gemoet.
So komt het dat gy ('t wijl 't gesicht sich laet bedriegen,
En 't hert verwondert staet door 't schoone schilderliegen)
Soo als ghy alles geern in schildery aen-schout,
Alsoo oock in der daet geern doen en hebben sout.
Dus krijght d'onwijse lust door schildery sijn voetsel,
En ondeugt wort geteelt door 't sotte breyns uytbroetsel.[76]

(What the eyes behold gives the senses sweet satisfaction
And the illusive image will reign over the mind.
In this way [while the eyes are deceived,
And the heart is astonished by the beautiful lies of painting],
One wants to do and to have
Everything which one beholds in a painting.
Thus desire is fed by painting,
And vice is generated by these foolish contrivings of the painter's brain.)

Not suprisingly, seemingly contradictory impulses can be detected in a society wherein a certain segment showed an incredible avidity for paintings. (Who today has between 100 and 250 paintings in his or her house? In the second and third quarter of the seventeenth century, a substantial number of Leiden inventories, for example, can be found with such high numbers.) Yet the same society also displayed an ambivalent attitude toward the image and the sense of sight; hence, it is understandable that preoccupations with pleasure, seduction, earthly beauty, and transience are so often inseparably linked in paintings and directly expressed in both subject and style. In this regard, the innumerable genre pieces in which love, youth, virtue, and vice play an important role — usually with a young woman as the focus — come to mind. Also evoked are the almost always idyllic, amorous mythological and pastoral scenes, as well as many still lifes and landscapes. A certain "moral" is definitely present, and moralizations are often readily accessible for application within specific contexts. However, this does not mean that such paintings were generally intended as warnings or didactic-moralizing messages disguised by a realistic *mom-aensicht* (mask). It seems more likely that thoughts and attitudes about nature and human endeavors were visualized and represented in paintings in an immediately recognizable way.

Associations were given direction through selective choice of subject matter, motifs, and related conventions for the representation of daily life. The subjects and motifs depicted in non-narrative paintings transmitted meaning to the viewer through adaptation to or deviation from pictorial conventions; through stereotypes recognizable to the public for whom they were intended; and through the visualization of simple, accessible metaphors.[77] The viewer or buyer could make these connotations more specific by interpreting them in terms of his own intellectual, social, and religious background.[78]

Few seventeenth-century viewers would have expected to be edified by the visually appealing images of vice, pleasurable pastimes, and amorous or erotically tinged scenes that were so frequently found in Dutch paintings of the time. That moralizations — which might be formulated to justify such paintings — could be seen as merely verbal additions with no essential bearing on the representation was stated by Camphuysen as follows:

> Nochtans 't heeft mee (segt gy) sijn nut. Men kan 't uytleggen,
> En leven naem en daet al 't saem doen sien, door seggen.
> Maer (och!) wat uytleg en wat lof kan veylig staen,
> By toonsels die 't gemoet uyt eygen aert beschaen?[79]

> (Yet it still has its use [you say]. One can explain [the image].
> One can reveal all of life, name and deed in word,
> But [oh!] what explanation and what praise can safely withstand,
> The things displayed which by their very nature shame the mind?)

Perhaps the somewhat titillating tension between sensual pleasure and "dangerous" seduction was one of the factors determining the appeal of many subjects.[80]

The iconological method was initially developed for interpreting fifteenth- and sixteenth-century art, which was often closely related to textual sources; this art frequently originated within the context of programmatic commissions and was intended for a specific place. Such a method has been applied with insufficient adaptation to an art that, to a large degree, lacks these specific aspects. As has been shown, its use has been justified by placing great emphasis on the idea of *ut pictura poesis*, which stems from human-

istic art theory, and by transferring literary principles to the art of painting, supported with arguments primarily drawn from emblem literature.

Furthermore, one gets the impression that the goal of iconography, namely bringing to the surface and "deciphering" significant elements no longer obvious to the modern observer, has been confused with the existence of disguised or hidden meanings.[81] It also seems that the means used for this type of deciphering — specifically with regard to emblems — are equated with the painter's own sources, and this has frequently given rise to overly specific interpretations.[82] In addition, interpretations involving such a use of emblematic and literary-theoretical sources have often projected an extremely unlikely intellectual load and erudition onto the painter, his paintings, and his public.[83]

The limitations that this approach can place on interpretation also result from the separation between form and content and, related to this, the curious distinction between meaning and meaninglessness.[84] Searching for *the* meaning — usually in fairly isolated interpretations that do not consider an entire thematic group with its conventions and deviations — has only aggravated the problem. In my opinion, because of the separation between form and content, late medieval and sixteenth-century concepts have been all too easily transferred to the seventeenth century without taking into account the tremendous changes that occurred in the outward appearance of paintings and the context in which they functioned.[85] In so doing, the radical seventeenth-century developments in form and subject matter, the production and trade of paintings, and the differentiation of the art-purchasing public, which filled its houses with numerous paintings, have been underestimated. These factors must have had far-reaching consequences for the way in which the seventeenth-century consumer perceived paintings.

People at the time were aware that something special was happening with their "own" art, produced by the *"Verciersels van ons Vaderlandt"* (the embellishments of our fatherland).[86] In 1629 Constantijn Huygens wrote that his Dutch compatriots had progressed further than anyone in their ability to render all sorts of shapes and poses of people and animals and the appearances of trees, rivers, mountains, and other elements of the landscape.[87] In 1678 Van Hoogstraten, in the course of admonishing rulers of the republic to buy more art to present as gifts abroad, stated that *"de Schilderkonst in onzen staet, als in een nieuw Grieken, in 't best van haer bloeijen is"* (the art of painting in our own land, as in a new Greece, is at the

height of her glory). He continued to say that therefore the art of painting, *"den Vaderlande eygen, als een onkostelijke mijne, parelvisserye, en edelsteente groeve, dagelijx veel rijke juweelen van kabinetstukken kan uitleveren"*[88] (as befits our fatherland, like an invaluable quarry, a pearl fishery, or mine of precious stones, can daily produce many rich jewels of cabinet painting).

The loving attention with which such paintings were produced and with which the visible was rendered is not merely a modern projection. Not only the paintings themselves make this apparent but also the following lines by Van Hoogstraten. As the primary requirement of the painter, he cites: *"Dat hy niet alleen schijne de konst te beminnen, maer dat hy in der daet, in de aerdicheden der bevallijke natuur uit te beelden, verlieft is"*[89] (That he not only appears to adore art, but that he in fact is in love with representing the pleasantries of beautiful nature). Numerous questions concerning the reasons for the great profusion as well as the strict selectivity of those lovingly rendered *"aerdicheden der bevallijke natuur"* (pleasantries of beautiful nature), the associations they aroused, as well as the relationship between style, choice of subject matter and the public, have not as yet been satisfactorily answered. While the iconological approach has indicated many fruitful directions, its limitations should be kept in mind.

Notes

This is a translation of an article that originally appeared under the title "Belering en verhulling: Enkele 17de-eeuwse teksten over de schilderkunst en de iconologische benadering van Noordnederlandse schilderijen uit die periode," in *De zeventiende eeuw* 4 (1988).

1. For an overview of this literature up to 1984, see Justus Müller-Hofstede, " 'Wort und Bild': Fragen zu Signifikanz und Realität in der holländischen Malerei des 17. Jahrhunderts," in *Wort und Bild in der niederländischen Kunst und Literatur des 16. and 17. Jahrhunderts,* ed. Herman Vekeman and Justus Müller-Hofstede (Erftstadt: Lukassen, 1984), ix–xxii. For an overview of the past few years up to 1987, see Egbert Haverkamp-Begemann, "The State of Research in Northern Baroque Art," *The Art Bulletin* 79 (1987): 510–19. Additional pertinent articles for this discussion are found in Carol J. Purtle et al., "Tradition and Innovation: A Selection of Papers Read at the First International Research Conference of the Historians of Netherlandish Art in Pittsburgh, 9–12 October 1985," *Simiolus* 16 (1986): 91–190; and Henning Bock and Thomas W. Gaehtgens, eds., *Holländische Genremalerei im 17. Jahrhundert: Symposium Berlin 1984,* Jahrbuch Preussischer Kulturbesitz, Sonderband 4 (Berlin: G. Mann, 1987). See also the short

summary of lectures given at the symposium "Images of the World: Dutch Genre Painting in Its Historical Context" at the Royal Academy of Art in London, 9–10 November 1984, on the occasion of the exhibition *The Age of Vermeer and De Hooch: Masterpieces of Seventeenth-Century Dutch Genre Painting* (Philadelphia, London, Berlin, 1984) in *Art History* 8 (1985): 236–39. The above-mentioned literature concerns genre and history painting primarily; with regard to landscape painting, various viewpoints have also been presented. In particular, see the introductions to Peter C. Sutton, ed., *Masters of Seventeenth-Century Dutch Landscape Painting*, exh. cat. (Boston: Museum of Fine Arts, 1987); and the outstanding review of this catalog by Christopher Brown in *Simiolus* 18 (1988): 76–81. Furthermore, a striking insight into the various points of view — one could even speak of a polarization — can be gained from the numerous critiques of Svetlana Alpers's, *The Art of Describing: Dutch Art in the Seventeenth Century* (Chicago: Univ. of Chicago Press, 1983). For example, E. H. Gombrich in *The New York Review of Books* 30, no. 17 (November 1983): 13–17; I. Gaskell in *The Oxford Art Journal* 7 (1984): 57–60; J. Glynne in *Art History* 7 (1984): 1–4; E. de Jongh in *Simiolus* 14 (1984): 51–59; Simon Schama in *New Republic* (May 1984): 25–31; J. Stumpel, "Boekenbijlage," *Vrij Nederland* 25 (February 1984): 34–37; K. H. Veltman in *Kunstchronik* 37 (1984): 262–67; Josua Bruyn in *Oud Holland* 99 (1985): 155–60; Anthony Grafton and Thomas DaCosta Kaufmann in *Journal of Interdisciplinary History* 16 (1985): 255–65; Jan Białostocki in *The Art Bulletin* 67 (1985): 520–26; and the introduction by W. Kemp in the German edition of Alpers's *Kunst als Beschreibung* (Cologne, 1986), 7–20. The most balanced and thoughtful discussions are the very different commentaries by Grafton and Kaufmann, Gaskell, and Białostocki.

2. Białostocki (see note 1), 525. See idem, "Einfache Nachahmung der Natur oder symbolische Weltschau: Zu den Deutungsproblemen der holländischen Malerei des 17. Jahrhunderts," *Zeitschrift für Kunstgeschichte* 47 (1984): 429.

3. Alpers, 1983 (see note 1), 229–34, "Appendix: On the Emblematic Interpretation of Dutch Art"; and the harsh review by E. de Jongh on the use of this terminology, which suggests that this manner of interpretation is entirely based on the use of emblems (see note 1), 58. See also Jan Baptist Bedaux, "Fruit and Fertility: Fruit Symbolism in Netherlandish Portraiture of the Sixteenth and Seventeenth Centuries," *Simiolus* 17 (1987): 151–57, esp. n. 2, where a good, corrective explanation is given about the methodological use and abuse of emblems. It cannot be denied that the term applies in that many principles that are apropos the function and meaning of emblems were seen as valid for the interpretation of painting.

4. This description is borrowed from Hans-Joachim Raupp's, "Ansätze zu einer Theorie der Genremalerei in den Niederlanden im 17. Jahrhundert," *Zeitschrift für Kunstgeschichte* 46 (1983): 401; also cited by Bedaux (see note 3), 151.

5. Josua Bruyn, "Toward a Scriptural Reading of Seventeenth-Century Dutch Landscape Paintings," in Sutton (see note 1), 84.

193

6. For instance, with regard to the interpretation of works of art, Bob Haak's monumental survey *The Golden Age: Dutch Painters of the Seventeenth Century* (New York: Harry N. Abrams, 1984) relies solely on E. de Jongh's iconological approach (see especially the chapter "Realism and Symbolism"). This was also the case earlier, though with varying degrees of insistence, in much more concise surveys by R. H. Fuchs and Madlyn Millner Kahr. A few educational guides from the Rijksmuseum, Amsterdam, may be mentioned as illustrative but are by no means exceptional. With regard to newspaper articles, those by P. Milder and R. van Gelder are typical; from this viewpoint, they criticized the large "genre" exhibitions in Philadelphia, London, and Berlin of 1984 (see "De kunsthistorische misvattingen over de Gouden Eeuw," *De Volkskrant*, 22 June 1984, 15; and "Hoe amusant was Nederland," *NRC/Handelsblad*, 29 June 1984, Cultureel Supplement, 6).

7. Josua Bruyn, *Geschiedschrijving als parabel* (Lecture given on the occasion of the 349th anniversary of the University of Amsterdam, 8 April 1981), 5: *"de meer of minder bloemrijke, op 'Einfühlung' berustende commentaren waarop gidsen hun toeristen, ouders hun kinderen en allerhande scribenten hun lezers en lezeressen tot op de huidige dag vergasten"* (the more or less florid commentaries based on "empathy," with which to this day guides regale their tourists, parents their children, and writers their readers.) This "empathy" appears to have vanished in the past few years, at least with regard to Dutch genre pieces.

8. The success may be partially explained by the fact that from the beginning De Jongh introduced his approach in an appealing form intended for a broader public: see E. de Jongh, *Zinne- en minnebeelden in de schilderkunst van de zeventiende eeuw* (Amsterdam: Nederlandse Stichting Openbaar Kunstbezit en Openbaar Kunstbezit in Vlaanderen, 1967); E. de Jongh, "Realisme en schijnrealisme in de Hollandse schilderkunst van de zeventiende eeuw," in Paleis voor Schone Kunsten, *Rembrandt en zijn tijd*, exh. cat. (Brussels: La Connaissance, Europalia, 1971); and E. de Jongh, *Tot lering en vermaak: Betekenissen van Hollandse genrevoorstellingen uit de zeventiende eeuw*, exh. cat. (Amsterdam: Rijksmuseum, 1976). According to an education department employee in a Dutch museum, polls reveal that the public currently prefers information on symbolism and "hidden meanings." Typical of this approach was the slide show based on Bruyn's article (see note 5) in the catalog for the 1988 landscape exhibition at the Rijksmuseum. Bruyn's view was the most theoretical and speculative, and – given the nature of the exhibition – the least appropriate. It was, however, certainly the easiest to put into words, so now moralizing messages and hidden symbolism have also been provided for landscape.

It is significant that De Jongh, in his criticism of Alpers (see note 1), 59, expressed fear that her vision would have wide appeal, because it would provide a "unified field theory" wherein diverse phenomena would be seen to express one and the same mentality: something for which we seem to have a deep-seated need. Ironically, De Jongh's approach, which also has Hegelian roots – in this context, see E. H. Gombrich, *In Search of Cultural History* (Oxford: Oxford

Univ. Press, 1969), on Panofskian iconology — appears to have had precisely the effect he feared. He used appealing generalizations about the mentality, such as "the tendency to moralize" that is "all encompassing" and "the strong preference for disguising, veiling, for allegorizing and ambiguity" (De Jongh, 1971 [see note 8], 144).

9. For the most severe criticism see the introduction and appendix to Alpers, 1983 (see note 1); several points had been formulated earlier in Svetlana Alpers, "Taking Pictures Seriously: A Reply to Hessel Miedema," *Simiolus* 10 (1978/1979): 46–50. W. Kemp's introduction to Alpers, 1986 (see note 1) is also very outspoken. Countless critical modes ranging from the temperate to the subtle can be found among the publications mentioned in note 1.

10. Philips Angel, *Lof der schilder-konst* (Leiden: Willem Christiaens, 1642). As the printer notes, it is *"een Schets ende voorwerpsel... van het aenstaende werck dat by onsen Autheur berust"* (a sketch and a draft... of the forthcoming work now with the author); unfortunately, no more than this "sketch" was ever published.

11. Virtually no works by Angel (circa 1618–after 1664) are known, except for a few etched *tronies* (heads) in the manner of Rembrandt (see L. J. Bol, "Philips Angel van Middelburg en Philips Angel van Leiden," *Oud Holland* 64 [1949]: 3–19). Angel gave his lecture at a time when Leiden painters were busy — and Angel was directly involved — gaining permission to establish a guild to protect them economically and probably also to be recognized as a group with an important socioeconomic status in Leiden society (see Eric J. Sluijter, "Schilders van 'cleyne, subtile ende curieuse dingen': Leidse fijnschilders in contemporaine bronnen" in Sluijter et al., *Leidse fijnschilders: Van Gerrit Dou tot Frans van Mieris de Jonge, 1630–1760*, exh. cat. [Zwolle: Uitgeverij Waanders, 1988], 29–31). Angel's emphasis on the status and dignity of the painter's craft appears to be related to this attempt. The lecture probably appeared at the same time as the city governors' promise to establish several measures for the economic protection of Leiden painters. In the list compiled in 1644 (it was not yet an official guild), Angel figures as *hooftman* (dean). It may be assumed that the painters who signed this list were approximately the same who attended Angel's lecture on Saint Luke's Day (the names of several of these painters are mentioned in the text below); the complete list of the painters and art dealers was published in D. O. Obreen et al., *Archief voor de Nederlandsche kunstgeschiedenis* (Rotterdam, 1882–1883), 5: 177–78.

12. Jan A. Emmens, the first to sketch an overview of art theory in the Netherlands in *Rembrandt en de regels van de kunst* (Utrecht: Haentjens, Dekker & Gumbert, 1968), quoted Angel only very summarily and lumped him together with Van Mander. On this, see Hessel Miedema's criticism in *Oud Holland* 84 (1969): 249–56; and idem, "Philips Angels *Lof der schilder-konst*," *Proef* (December 1973): 27–33, esp. 27. In the latter article, Miedema gives a concise analysis of Angel's pamphlet, primarily contrasting it with Van Mander's *Grondt*; unfortunately, he does not elaborate further. Despite the fact that Angel's treatise is mentioned

fairly often, it has not received the place it deserves because it does not fit in with the development of "academic" art theory traceable from Van Mander to Van Hoogstraten and De Lairesse. This is the case, for instance, in B. Brenninkmeyer-De Rooij's chapter on art theory in Haak (see note 6), 60–70. P. Chapman discusses Angel's tract with some thoroughness especially with regard to the title print, in "A *Hollandse Pictura*: Observations on the Title Page of Philips Angel's *Lof der schilder-konst," Simiolus* 16 (1986): 233–48.

13. Jacob Cats, *Proef-steen van den trou-ringh*, in *Alle de werken* (Dordrecht: Matthias Havius, 1637), part 3, 662–741 (Amsterdam: N. ten Hoorn, 1712), 2: 189–208. On the story itself (partially based on Aelianus), see: S. F. Witstein, "Portret van een dichter bij Cats," in T. Harmsen et al., *Een Wett- steen vande Ieught: Verzamelde artikelen van Prof. dr. S. F. Witstein* (Groningen: Wolters-Noordhoff, 1980), 61–62.

14. Witstein (see note 13), 65.

15. Ibid., 65–67.

16. Ibid., 70–72.

17. For the plea of the painter see Cats, 1712 (see note 13), 2: 196; it is also cited in full in Angel (see note 10), 27–30. The quotations in my text are taken from Angel.

18. Angel (see note 10), 27–28.

19. Ibid., 28–29.

20. Ibid., 30.

21. Ibid., 29–30.

22. For the relationship between *eer* (honor) and *gewin* (profit), see Emmens (see note 12), 170, 174, and 178. In contrast to Italian art theoreticians, who (following contemporary literary theory) ranked honor much higher than profit, Van Mander placed *"eere en ghewin"* on a par. Moreover, he counseled that one should avoid *"Dicht-const Retorica"* (rhetorical poetry) because, in contrast to painting, it did not put *"meel in de Keucken"* (bread on the table). Of course for Junius, profit as a goal was nothing less than despicable; but Van Hoogstraten, like Van Mander, equated it with honor (and the love of art). It is noteworthy that Huygens, after questioning whether painting was still as respected as it had been in Pliny's time and noting that the patronage of distinguished persons, or the practice of painting by distinguished persons, was sufficient to earn this respect wrote in his autobiography: *"Altijd heeft ze onmetelijk voordeel opgeleverd (als men tenminste onder dat woord het profijt van stoffelijke winst verstaat)"* (It has always provided immense advantage [that is, if one takes the word to mean the profit from materialistic gain]). See *De jeugd van Constantijn Huygens door hem zelf beschreven*, trans. A. H. Kan (Rotterdam: Ad. Donker, 1971), 65. See also note 27, on the financial advantage of painting.

23. It is striking that the only lines by Cats that might suggest a certain didactic purpose (the first sentences spoken by the painter) are the only ones that Angel does not quote: *"Wel aen, ick laet het volk haer eygen vuyl ontdecken,/En leggen voor het oog haer onbekende vlecken"*

(Well now, I will let the people discover their own filth,/And present their unknown stains for all to see). In other words, the painter can present human faults to the observer.

24. See Miedema, 1973 (see note 12), 28–33; and Franciscus Junius, *De schilder-konst der oude* (Middelburg, 1641). The Dutch translation appeared in the same year as Angel's lecture; the first Latin edition dates from 1637. For the derivations from Jan de Brune, see note 28. The learned work of the philologist Junius, in which texts from antiquity were grouped together based on a rhetorical categorization, was influential on art-theoretical writings later in the century but does not clarify the thoughts harbored by Dutch painters at that time (Emmens [see note 12], 67ff.). On Junius, see also Allan Ellenius, *De Arte Pingendi: Latin Art Literature in Seventeenth-Century Sweden and Its International Background*, Lychnos bibl. 19 (Uppsala: Almqvist & Wiksell, 1960), 33–54.

25. See Miedema, 1969 (see note 12), 28.

26. Angel (see note 10), 12–13. Angel probably derived this story, originating in Pliny, from Van Mander's "Het leven der oude antijcke doorluchtige schilders" in *Het schilder-boeck* (Haarlem, 1603–1604), fol. 68r; presumably this anecdote was generally known and would have appealed to Dutch painters (see note 70). Angel selected several examples of antique artists from Van Mander but arranged them in his own sequence. After the Zeuxis-Parrhasius story he comments: *"Dus is onse Konst van trap tot trap op gheklommen"* (Thus our art has risen, step by step).

27. Angel (see note 10), 23. This was Spiering Silvercroon, the emissary of Christina of Sweden; see Sluijter (see note 11), 26 and 36. For the obsession with prices in the seventeenth-century with regard to the work of Dou and Van Mieris, see ibid., 26–28.

28. Angel (see note 10), 24–26. This discourse, based on a passage from De Brune's preface to Junius's book, echoes the ongoing (especially in Italy) *"paragone* debate." See Peter Hecht, "The *Paragone* Debate: Ten Illustrations and a Comment," *Simiolus* 14 (1984): 125–36. Following the example of De Brune, Angel turns the traditional accusation that the art of painting is merely *"schijn sonder sijn"* (semblance without being) into a positive argument: the tangible, three-dimensional character of sculpture is not a merit of the art of imitating nature but a phenomenon of nature itself (cf. also the related line of reasoning in a letter by Galileo cited in Hecht, 133). Thereafter follow Angel's most important arguments, namely a summation of all the things that sculpture cannot represent. The most significant addition he offers in comparison to De Brune are the various metals (gold, silver, copper, tin, and lead); this reflects the increasing emphasis placed during this time on the individual properties of various materials, a point to which Angel returns later.

29. Miedema, 1973 (see note 12), 29–30. It is a pity that Miedema treats this so summarily; he primarily mentions the theoretical origins of Angel's categorization without making it clear that Angel's interpretations (in my opinion) have very little to do with them. Angel's require-

ments are as follows: (1) *"ghesont Oordeel"* (a healthy judgment); (2) *"seeckere en ghewisse Teyckenhandt"* (a confident and steady drawing hand); (3) *"vloeynde Gheest om eyghentlick te Ordineeren"* (a fluent mind able to compose naturally); (4) *"geestighe Bedencken der aenghename Rijckelijckheyt"* (the talent to imagine attractive embellishments); (5) *"wel schicken der Daghen en Schaduwen"* (the accurate depiction of light and shadow); (6) *"goede waerneminghe der eyghen natuerlicke dinghen"* (a good observation of actual natural phenomena); (7) *"wel-gheoeffent verstant in de Perspectijven"* (a well-practiced understanding of perspective); (8) *"ervaren in kennisse der Hystorien"* (experience in the knowledge of histories); and (9) *"begrijp der Matimatische dingen"* (an understanding of mathematical matters). Furthermore, a good artist is someone who: (10) *"de Anatomy grondich verstaet"* (thoroughly understands anatomy); (11) *"de Natuyr meer soeckt na te bootsen dan andere Meesters handelinge"* (seeks to imitate nature, rather than the works of other masters); (12) *"de Verwe vleysich onder een weet te smeuren"* (has the capacity to combine paint in a succulent manner); (13) *"onderscheyt van alle Wolle-Laeckenen, Linde, en Zijde Stoffe weet uyt te drucken"* (knows how to represent the difference between all wool, linen, and silk fabrics); and (14) *"een wacker, doch soet verliesent Penceel heeft"* (has an alert, yet sweetly flowing brush). Angel discusses the knowledge of perspective only summarily and does not discuss the *"Matimatische dingen"* (mathematical matters) at all.

30. Angel (see note 10), 35–38.

31. Ibid., 38–39, 31.

32. Ibid., 44–51.

33. Ibid., 39–41.

34. Ibid., 41–43.

35. Ibid., 52–53.

36. Ibid., 55.

37. Ibid., 53–54.

38. Ibid., 55–56. For the traditional distinction between *nette* (neat, i.e., precise or detailed) and *losse* (loose) painting, see Jan A. Emmens, *Album Disciplinorum Prof. dr. J. G. van Gelder* (Utrecht: Martinus Nijhoff, 1963), 125–26, and B. P. J. Broos in *Simiolus* 10 (1978–1979), 122–23. With regard to the Leidse *"fijnschilders,"* see Sluijter (see note 11), 15–29. For Vasari, painters who painted in the "loose" manner displayed their imagination and virtuosity; also for Van Mander, the "loose" manner was more difficult to execute and therefore was reserved for the best painters.

39. Sluijter (see note 11), 57–58.

40. Ibid., 39 and 55.

41. Ibid., 40.

42. Ibid., 43 and 54–55.

43. Ibid., 2.

44. This was already stated by Miedema, 1969 (see note 12), 31: *"een opmerkelijke veronacht-zaming van hiërarchie van voorstellingen"* (a remarkable disregard of a hierarchy of images).

45. Because the vocabulary previously used for writing about painting applied primarily to narrative, or history, painting, it is remarkable that Angel had no problem citing various non-narrative representations when he wished to clarify matters not solely applicable to history painting. It is noteworthy that Raupp hardly cites Angel in his forced literary-theoretical *"Gattungshierarchie"* (hierarchy of genres) construed from later art literature that is, according to him, applicable to seventeenth-century painting. When he does briefly refer to Angel, he conveys the latter's point of view incorrectly in order to suit his theory (Raupp [see note 4], 411). Aside from the fact that he makes it seem as though Angel spoke primarily about the problems of history painting, decorum, and *"Affektenschilderung"* (painting of emotions), it is incorrect to propose that Angel links *"realistische Naturwiedergabe"* (realistic rendering of nature) to genre pieces in particular (the *"corteguarden"*). As stated before, Angel cites history painting as well as all the other specialties. It is significant that Angel mentions these various specialties in the same breath and that he applies his emphasis on imitating nature to all of them equally.

46. On the basis of this, the recent assumption that history painting was generally considered to be the highest goal of painting during this period seems to rest on somewhat shaky ground (even Van Hoogstraten remained quite ambivalent about this several decades later). Incidentally, I do not mean to imply that this view was not held by a number of Dutch painters who concentrated intensively on history painting and who were often engaged in a direct dialogue with Italian art; "academic" aspirations can certainly be discerned in this period as well (see Hessel Miedema, "Kunstschilders, gilde en academie: Over het probleem van de emancipatie van de kunstschilders in de Noordelijke Nederlanden van de 16de en de 17de eeuw," *Oud Holland* 101 [1987]: 13–21). Since the exhibition *Gods, Saints and Heroes* — in which so many aspects of Dutch history painting were rightly rescued from obscurity — there has been a tendency to exaggerate the proportion of history paintings in Dutch art production (for example, Białostocki [see note 2], 432). Interest in history paintings during this period was quite minimal. In Leiden, for example, there were hardly any history painters active around mid-century, and even in extremely rich Leiden collections of this period, the percentage of history paintings is very small, and these are often sixteenth-century pieces. It is also incorrect to propose, as is done quite often nowadays, that history paintings were generally the most expensive. Among the most expensive paintings of the seventeenth century were depictions of maidservants, fashionably dressed young women, drinkers, etc. by painters such as Dou and Van Mieris.

47. Significantly, in the same year that Angel gave his lecture — the year in which the Leiden painters established their own guild (see note 11) — Jan Orlers published the second edition of his *Beschrijvinge der Stadt Leyden*, to which he added several pages about Leiden painters. In

doing so, he appears to have consciously striven to create a respectable Leiden painting tradition. See also Sluijter (see note 11), 15 and 31.

48. It is probable, for example, that Dou and his equally successful pupil Frans van Mieris — painters who gained exceptional national and international fame and to whom Angel's ideas would appear to be particularly applicable — considered themselves without reservation as craftsmen (albeit of an extremely high level). Both came from a milieu in which the craft was already carried out on a high socioeconomic level (see Sluijter [see note 11], 28–29). For the relationship between craft, guild, and "academic" ambitions, see Miedema (see note 46), 1–29.

49. Thus, in my view, it is not at all evident that Angel had *"een volledige, traditioneel bepaalde waardering voor de literaire, inhoudelijke aspekten van de inventie"* (an entirely traditionally determined appreciation for literary aspects of invention), as Miedema wrote in 1973 (see note 12), 31.

50. Chapman (see note 12), 246. In my view, Chapman's opinion that this was the goal of Angel's book is unfounded, as is the idea that "in keeping with humanist art theory he ranks history painting highest," 235. It seems equally incorrect to say that "Angel glorifies the art of painting as an intellectual activity" and that "[he] draws heavily on classical authors and Italian art theory, filtered through Van Mander, and, to a lesser extent, Junius," 234. On the contrary, it seems characteristic that Angel shows little interest in or understanding of all of this. Chapman wrongly perceives Angel as an erudite individual who, to some extent, popularized Van Mander. In addition, the title print (the subject of Chapman's article), though clever, is less erudite than she assumes. Depictions of Athena/Minerva on a pedestal within an enclosed garden were a type of title already used in Leiden (the *Athena Batava*); see, for example, Heinsius's edition of Iohannis Secundus, *Hagensis Batavi Itineraria* (Leiden, 1618). This type was combined with Minerva as Pictura used in the title page of Marolois (Chapman [see note 12], fig. 2).

51. Angel includes a list of names of authors (mostly from antiquity) who wrote about painting in order to demonstrate the dignity of this art. He extracts some names from Junius as well as from Van Mander (Miedema, 1973 [see note 12], 28). More interesting than the names that he includes are those that he omits: aside from Junius himself, one searches in vain for important Italian writers such as Leon Battista Alberti and Giorgio Vasari (only Leonardo is mentioned), let alone more recent Italian writers such as Gian Paolo Lomazzo and Giovanni Battista Armenini. Jan Orlers, however does appear on the list (see note 47).

52. Nor, for example, does Huygens speak of it in his lengthy account in which he makes no secret of his admiration for many aspects of Dutch painting (Huygens [see note 22], 64–87). Neither is it mentioned in De Brune's preface to Junius (see note 24), where the dignity of painting is emphasized using a variety of arguments. The same can be said of the laudatory poems on painting collected in Thomas Asselijn, *Broederschap der schilderkunst* (Amsterdam, 1654).

53. Dirk Rafaëlsz. Camphuysen, "Tegen 't geestigdom der schilderkunst," a translation in verse of Johannes Evertsz. Geesteranus's "Idolelenchus" (circa 1620) in *Stichtelycke rymen* (Amsterdam: J. Colom, 1647), 218–19. This is discussed further in note 75.

54. This is most clearly seen in recent publications by Bruyn. For example, Bruyn (see note 7); see also *Een gouden eeuw als erfstuk: Afscheidscollege* (Amsterdam: Kunsthistorisch Instituut der Universiteit van Amsterdam, 1986), farewell lecture held 26 September 1985; idem, "Mittelalterliche 'doctrina exemplaris' und Allegorie als Komponente des sog. Genrebildes," in Bock and Gaehtgens (see note 1), 33–59; and idem in Sutton (see note 5). The quotation cited at the beginning of this article (see note 5) is quite characteristic.

55. See for example De Jongh, 1967 (see note 8), 5–22; idem, 1971 (see note 8), 144–46; idem, 1976 (see note 8), 20, 25, 27–28; Bruyn, 1986 (see note 54), 11; idem in Bock and Gaehtgens (see note 1), 39–42; Raupp (see note 4), 411; Haak (see note 6), 73–74. In equating the literary theory of comedy with a theoretical framework for genre painting, Raupp even goes so far as to assert that when *"vermakelijk"* (amusing) is mentioned in art literature, *"belerend"* (edifying) is really meant (Raupp [see note 4], 407). Again, it seems significant that in seventeenth-century texts on painting there is frequently mention of the one (*"vermakelijk"*) and never of the other (*"belerend"*), while in statements about comical poetry, the authors continually refer to both aspects.

56. Bruyn is the most outspoken in equating the principles of emblem literature with painting, for example:

Wat Cats hier definieert is het embleem of zinnebeeld...maar de definitie gaat zonder meer op voor het schijnbaar realistisch bedoelde beeld dat de schilderkunst biedt en datgene wat wij geleerd hebben erachter te zoeken.

(What Cats defines here is the emblem, however, the definition certainly applies to the seemingly realistically intended image which painting evokes and that which we have learned to seek behind it).

See Bruyn, 1986 (see note 54), 11. Differences in form, context, function, and tradition are not considered. Prints with moralizing inscriptions are also, of course, eagerly cited and equated with *the* meaning of the image (and even considered a "guarantee" for it), see Bruyn in Bock and Gaehtgens (see note 1), 35. I shall not elaborate here on the fact that one must be very careful in using prints bearing inscriptions because, after all, they fulfill a very different function than paintings. Moreover, an inscription does not necessarily inform us about the meaning of an image; the inventiveness of the poet, who relies on his own traditions, serves as accompaniment to the "eloquence" of the pictorial image. See, for example, the excellent article by

E. McGrath in Vekeman and Hofstede (see note 1), 73–90. A moralization is seldom expressed in poems about paintings; see K. Porteman, "Geschreven met de linkerhand? Letteren tegenover schilderkunst in de gouden eeuw," in *Historische letterkunde*, ed. M. Spies (Groningen: Wolters-Noordhoff, 1984), 107. In no way do I mean to suggest that emblematic literature and prints with inscriptions cannot be extremely important tools for the interpretation of paintings (see also note 82).

57. Samuel van Hoogstraten, *Inleyding tot de hooge schoole der schilderkonst* (Rotterdam: F. van Hoogstraeten, 1678), 89–90. See De Jongh, 1967 (see note 8), 22; idem, 1971 (see note 8), 146; idem, 1976 (see note 8), 20; and Haak (see note 6), 75.

58. De Lairesse describes the same idea in greater detail when he says that for clarity it may be necessary to include symbols that represent, for instance, dissimulation, perfidy, or deceit in the form of *"beelden, beesjes, of Hiroglifize figuren"* (statues, animals, or hieroglyphic figures), *"om alle duisterheid en twijffelachtigheden weg te ruimen"* (to remove all obscurity and doubts). See Gerard de Lairesse, *Groot schilderboek* (Amsterdam: Hendrick Desbordes, 1712), 1: 70. The chapter in Van Hoogstraten entitled "Van de byvoegsels door zinnebeelden en poëtische uitvindingen" deals entirely with historical representations.

59. De Jongh, 1976 (see note 8), 14 (citing Adriaen van de Venne, *Zeevsche nachtegael* [Middelburg, 1623; facs. ed. Middelburg: Verhage & Zoon, 1982], 63):

Waerom wert Sinne-cunst, sou yder mogen vragen,/Iuyst boven ander cunst soo hooghe voor-gedragen?/Ick seg om dat den geest daer sonderling in speelt;/Men vindt geen dergelijck; soo sin-rijck mee gedeelt.

(One might ask, why is it that emblematic art/is held in higher esteem than other arts?/ I say, it is because the mind plays a singular role therein;/One finds nothing like it, communicated so ingeniously.)

60. See also Porteman (see note 56), 108: *"een pleidooi voor het samengaan van de zuster-kunsten in de zogenaamde 'Sinne-cunst' "* (a plea for the union of the sister arts in the so-called art of emblematic representation). It seems to me characteristic that here, too, whenever Van de Venne speaks about poetry, terms such as an "elevated mind," "learned," "high and deep thoughts," and "edification" appear repeatedly.

61. See note 23 (the same thought expressed by Cats).

62. Even more remarkable than the words *"De seer vermaecklicke en vernuft-barend edel Schilder-const"* (the amusing and ingenious noble art of painting) with which Van Mander opens the preface to his *Grondt* – which seem to imply *miscere utile dulci* (the union of the useful with the pleasant) and have been cited as proof that *"het lerende en onderhoudende doel van de*

kunst" (the edifying and entertaining goal of art) was stressed repeatedly (De Jongh, 1976 [see note 8], 27) — is the fact that he does not discuss this any further. That Van Mander published his artists' biographies *"tot nut en vermaeck der Schilders en Const beminders"* (for the benefit and amusement of painters and art lovers), a phrase also cited by De Jongh in the above mentioned argument, says nothing about an edifying goal of painting. The fact that only such meager quotations could be brought forward in support of this argument speaks volumes.

63. See Eric J. Sluijter, *De 'heydensche fabulen' in de Noordnederlandse schilderkunst, ca. 1590-1670* (Leiden: Rijksuniversiteit te Leiden, 1986), 283–86.

64. Hessel Miedema, *Kunst, kunstenaar en kunstwerk bij Karel van Mander* (Alphen aan den Rijn: Canaletto, 1981), 214–15. See Sluijter (see note 63), 284, esp. n. 2.

65. See Sluijter (see note 63), 313–21, where it is argued that this must be viewed as an independent commentary on the *Metamorphoses* fitting entirely within a specific literary tradition.

66. De Jongh, 1976 (see note 8), 27; see note 62.

67. Raupp (see note 4), 416. Raupp speaks of art literature but he cites the familiar topos of the bitter pill and the sweet nugget, etc., from works totally unrelated to this literature. (On this repeated topos, but in relation to commentaries on the *Metamorphoses*, see Sluijter [see note 63], 314).

68. See also, for example, Van de Venne (see note 59), 59–60. Following De Brune's example, Angel (see note 10), 25, states that everything is transient except God, but *"soo konnen de Schilderyen eenige honderde jaren duyren, het welcke ghenoech is"* (paintings can last several hundred years, which is enough). The motif of capturing transient matters and vanquishing time occurs very frequently (to name just one example, De Bie says of Van Mieris's art that it *"Die soo natuer braveert, en trotst den grijsen tydt"* [challenges nature and defies gray time]); see Cornelis de Bie, *Het gulden cabinet van de edel vry schilder-const* (Antwerp, 1661), 404. This motif is common, especially in poems on visual images. The theme of vanquishing time is central to Jan Vos's poem "Strijdt tusschen de doodt en natuur, of zeege der schilderkunst," in *Alle de gedichten* (Amsterdam, 1726), 1: 193–207. It is to be hoped that more literary studies will appear, like those by Porteman, which deal with various poems on visual images (see, for example, K. Porteman, "Vondels gedicht 'Op een Italiaensche schildery van Suzanne,'" in G. van Eemeren et al., *'T ondersoeck leert: Studies over middeleeuwse en 17de-eeuwse literatuur ter nagedachtenis van Prof. Dr. L. Rens* (Amersfoort: Uitgeverij Acco, 1986), 301–18. These studies are of great importance for a better understanding of the perception of painting in this period because they can clarify what is traditional and what is special in these poems and in the approach of the poet.

69. On the painting as a "deceit" of the eye see, for example, Camphuysen (note 75), and Van Hoogstraten (note 72). Jan de Brune the Younger elaborates on this subject in his *Alle volgeestige werken* (Harlingen, 1665), 317:

Doch haer bedroch is een genuchelik en onschadelik bedrogh; want aan dingen, die niet en zijn, zich zo te vergapen, als ofze waren, en daar zoo van geleit te worden, dat wy ons zelven, sonder schade, diets maken datze zijn; hoe kan dat tot de verlusting onzer gemoederen niet dienstigh wezen? Zeker, het vervroolikt yemand buite maat, wanneer hy door een valsche gelikenis der dingen wort bedrogen.

(Yet its deceit is enjoyable and harmless, for to gape at things which do not exist as though they actually do exist and to be influenced by them to such an extent that we — of our own accord — without harm make believe they exist; how can that not serve to give us pleasure? Certainly it must give one great joy when one is deceived by a false likeness of things.)

See also note 70.

70. Dirck Traudenius's poem on the work of Dou — who was dubbed *"de Hollandsche Parrhasius"* (the Dutch Parrhasius) — incorporates many of the elements cited: *"Zag Zeuxis dit bancket, hy wierd al weer bedrogen:/Hier leit geen verf, maer geest en leven op 't paneel"* (If Zeuxis were to see this banquet, he would be deceived once again:/Here it is not paint lying/on the panel but spirit and life). See *Rijmbundel*, bound with the *Tyd-zifter* (Amsterdam, 1662), 17. W. van Heemskerck's poem praising Van Mieris advises: *"Let hoe Penceel en Verw met 't leven dingt om strijd./Indien 't Parrhasius, en Zeuxis mogten zien: Zij staakten 't wedspel,/en streên wie de Eerkrans hem zou biên"* (Notice how brush and paint contend with life as in battle./If Parrhasius and Zeuxis were to see this, they would cease their competition,/and, instead, would vie to offer [Van Mieris] the laurel wreath). This was an inscription which appeared below A. Blooteling's engraving after Van Mieris's self-portrait; it is also cited by Arnold Houbraken, *De groote schouburgh der Nederlandtsche konstschilders en schilderessen* (Amsterdam: Arnold Houbraken, 1718–1721; The Hague: J. Swart, C. Boucquet & M. Gaillard, 1753), 3: 5. The painted curtains which appear to hang in front of paintings by, for example, Leiden *"fijnschilders"* such as Dou, Van Gaesbeeck, De Pape, and Van Mieris undoubtedly allude to this anecdote (see for example Sluijter et al. [see note 11], figs. 11 and 37 and cat. nos. 9, 19).

71. Van Hoogstraten (see note 57), 24–25.

72. He probably borrowed this from Van Mander (see note 26), fol. 61v, who, however, quotes it within a different context.

73. For this, and, in my view, the related fascination with mirrors and reflections in Dutch art of the period, see Eric J. Sluijter, " 'Een volmaekte schilderij is als een spiegel van de natuer': Spiegel en spiegelbeeld in de Nederlandse schilderkunst van de 17de eeuw," in *Oog in oog met de spiegel*, ed. N. J. Brederoo et al. (Amsterdam: Aramith Uitgevers, 1988), 146–63.

74. This is discussed extensively in Sluijter (see note 63), 270–77. These thoughts concern-

ing the eye, when linked to paintings, were primarily applied to the much criticized representation of nudes, but in less explicit form this same attitude could be applied to other kinds of paintings and certainly to the scenes of amorous amusement and affluence that dominated genre painting. In several verses devoted to the image of a beloved, Van de Venne employed the idea of the powers of the eye and painting; he ends with the beautiful line: *"De oog is noyt vervult, 't gewens is noyt versaet,/soo lang men met de cunst en min-sucht omme-gaet"* (The eye is never satisfied, desire is never sated,/As long as one remains involved with art and [earthly] love), see note 59, 60. Such Petrarchian thoughts seem important for the interpretation of innumerable genre pieces in which a young woman is the center of attention, usually in an amorous situation that implies seduction (a seduction that is often directed at the observer).

75. Dirk Rafaëlsz. Camphuysen (see note 53), 224. Furthermore, in an earlier poem included in this collection, Camphuysen speaks about the *"verwende Konst, van malle Malery,/Het voedtsel van qua'e lust en fieltsche sotterny"* (spoiled art of foolish painting,/The food of evil lust and villainous idiocy) (ibid., 4).

76. Ibid., 223.

77. See also Lawrence O. Goedde, "Convention, Realism, and the Interpretation of Dutch and Flemish Tempest Painting," *Simiolus* 16 (1986), 146. He arrives at such a formulation on the basis of his study of seascapes. His working method is based on a thorough investigation of the range of subjects and motifs within a particular theme and the conventions occurring therein. This seems an extremely fruitful point of departure for a more balanced interpretation of meaning. I strove for a similar method with regard to mythological themes (see note 63), esp. 3 and 8.

78. As has already been noted, we are concerned here with art that was sold on a large scale by art dealers and thus had to cater to a broad, primarily anonymous public. The buyer created the context for the work based on his own background. For this reason alone, it is futile to search for *the* meaning of a painting. Rather, a whole range of possible thoughts and associations that relate to a particular theme and manner of representation should be considered (see also Sluijter [see note 63], 8 and 290–92).

79. Camphuysen (see note 75), 224. Undoubtedly, Camphuysen was referring primarily to biblical and mythological scenes containing erotic allusions, but the manner in which he distinguishes between the effect of the image and the verbal addition seems significant, nevertheless.

80. On the choice and representation of mythological subjects in the Northern Netherlands, see Sluijter (see note 63), 2 passim, particularly chap. 5. In this respect, Schama's interpretations also offer much food for thought, see Simon Schama, *Overvloed en onbehagen: De Nederlandse cultuur in de gouden eeuw* (original English ed., New York: Knopf, 1987; Amsterdam: Uitgeverij Contact, 1988), esp. chaps. 5 and 6. It is noteworthy that when interpreting paintings, Schama uses the traditional iconological method as a point of departure but often arrives at strongly divergent interpretations on the basis of his own approach.

81. For related criticism directed at Panofskian "disguised symbolism" in fifteenth-century Flemish painting, which directly influenced this approach, see J. H. Marrow, "Symbol and Meaning in Northern European Art of the Late Middle Ages and the Early Renaissance," *Simiolus* 16 (1986): 151; for a critical approach to the term "disguised symbolism," see also Jan Baptist Bedaux, "The Reality of Symbols: The Question of Disguised Symbolism in Jan van Eyck's Arnolfini Portrait," *Simiolus* 16 (1986): 5–26.

82. See Bedaux (see note 3), 151–54. His theory that there are virtually no genre pieces in which an emblem constitutes a direct source for the representation seems correct. A distorted image has come into being precisely because several examples have been emphatically and successfully brought forward (even in the case of a showpiece such as Dou's *The Quacksalver* [see p. 71 of this volume], I do not think that emblems in any way constitute a source for the painting, nor were they of direct importance to contemporary observers for the interpretation of the work). In this respect, Bedaux's correction of the symbolism of the bunch of grapes is illuminating. See also Sluijter (see note 63), 253 and n. 5, where the over-specific interpretations of the bunch of grapes are also pointed out. This is not intended to deny the importance of emblems as aids to interpretation but to emphasize that they must be used primarily to trace possible associations for specific motifs.

83. On the projection of an undue theoretical load, see Jochen Becker's excellent review (*Oud Holland* 101 [1987]: 280–86) of Hans-Joachim Raupp, *Untersuchungen zu Künstlerbildnis und Künstlerdarstellung in den Niederlanden im 17. Jahrhundert* (Hildesheim: Georg Olms Verlag, 1984), a study which bases interpretations almost entirely on art-theoretical concepts.

84. The clearest expression of this is found in De Jongh, 1971 (see note 8); the title "Realisme en schijnrealisme" already indicates this schism, and on this basis De Jongh can consider *"waar symboliek ophoudt en 'lege' vorm begint"* (where symbolism ends and 'empty' form begins) and whether *"een schilder soms niet meer bedoelde dan hij liet zien"* (a painter perhaps meant nothing more than he represented). The same ideas have been expressed more recently in Bruyn (see note 7); idem 1986 (see note 54); idem in Sutton (see note 5); idem in Bock and Gaehtgens (see note 1). As an alternative to his viewpoint on meaning, Bruyn sees only an implied meaninglessness *"Realität...als Selbstzweck"* (Realism...as goal in itself), *"een realistische uitbeelding als zodanig"* (a realistic image as such), or *"rein aesthetische empfunden Realität"* (a purely, aesthetically perceived reality) and interprets the representation of quotidian matters as *"een blijkbaar in Holland aanvaarde wetmatigheid"* (an evidently accepted standard in Holland) to which conventional symbolism had to be adapted (Bruyn, 1986 [see note 54], 7). See also note 85.

85. Once again, this is expressed most prominently in the above-mentioned articles by Bruyn. He even goes so far as to state that the seventeenth century really does not offer anything new, or if it does, *"het moet zijn de steeds kunstiger verhulling van deze oude gegevens in de afschildering van de alledaagse omgeving en een steeds subtielere vertakking van de thematiek"*

(it must be the increasingly clever disguise of the traditional concepts in the representation of quotidian surroundings and the increasingly subtle diversification of the theme); see Bruyn (see note 7), 14. The separation between form and content is complete here. In this view, references to one's own surroundings and the associations which are evoked by them mean nothing; they merely further disguise meanings. Moreover, continually linked to this is the idea that the perceptions of the early eighteenth century can no longer tell us anything about the seventeenth-century approach.

86. Angel (see note 10), 3v ("Den Drucker tot den schilders") (The Printer Addressing the Painters).

87. Huygens (see note 22), 66.

88. Van Hoogstraten (see note 57), 330.

89. Ibid., 11–12. Compare the change with regard to Van Mander, who speaks of the necessary love for Pictura, who is like a beautiful, jealous woman (*Grondt*, fol. 2r, and *Levens*, fol. 143v); see Hessel Miedema, *Karel van Mander: Den grondt der edel vry schilder-const* (Utrecht: Haentjens, Dekker & Gumbert, 1973), 2: 365–66.

Lyckle de Vries

The Changing Face of Realism

for Henk van Os

There are few painters who have less in common than Pieter Bruegel, Gerrit Dou, and Jan van Goyen,[1] yet all three are considered typical Netherlandish artists and, as such, true "realists." Seventeenth-century Dutch art in particular has been indelibly imprinted with the stamp of "realism." A study of this field is impossible without using the term, although discussions attempting to understand precisely what "realism" means have occasioned more confusion than insight, and the suggestion that we should ban the term completely is worth considering. The fact that this irritating label is still in use is not just a consequence of intellectual sluggishness. Netherlandish art is made up of a complex of characteristics that determine its attractiveness. Until we can specify more precisely what this complex consists of, there is no better solution than to keep calling it "realism." The perception of Dutch art has changed dramatically in recent decades, and as a result the current conceptions of "realism," no matter how tentatively formulated, are also changing. Moreover, it is becoming increasingly clear that this word must describe something that has been expressed visually in widely varying ways, unless we are prepared to state that one of the three artists — Bruegel, Dou, and Van Goyen — was a "realist" and the other two were not.

Heinrich Wölfflin's *Kunstgeschichtliche Grundbegriffe* begins with an anecdote about four nineteenth-century German draftsmen who agreed to draw an Italian landscape with the greatest possible precision.[2] Completing their work at the end of a long day, they discovered to their amazement

how different their individual results were, even though they had treated exactly the same subject. These Romantic artists were not the only ones who gave credence to the idea that "realism" and style were mutually exclusive. In the nineteenth-century revolt against academicism, style was more or less equated with convention, which in turn was equated with the unnatural, the insincere, and the mannered.[3] Understandably, an idealized view of seventeenth-century Dutch art evolved during this time in which it was believed that each painter individually discovered and depicted reality. It was thought that the appearance of the paintings originating in this fashion was exclusively determined by the ever-changing choice of subject matter and not by a formal language passed on from master to pupil. Consequently, the formation of schools within Dutch art was considered an impossibility.[4] The idea, so prized by the Romantics, that every true artist made a completely new beginning also influenced the perception of seventeenth-century Holland — no matter how inappropriate the role of the primitivist may seem to us when applied to the real-estate speculator Van Goyen, the gauger of wine casks Meindert Hobbema, or the physician Jacob van Ruisdael.[5]

The traditional view of "realism" is as much related to a certain style, or lack of style, as it is to its usual subject matter. Two incompatible opinions on this issue were accepted. According to some authors, the Dutch observed reality with such great avidity that they indiscriminately illustrated all that they encountered in their immediate surroundings. Charles Blanc stated that one had only to view all of seventeenth-century Dutch paintings to obtain an exhaustive image of reality in that time and place.[6] Blanc was an ardent propagandist of Dutch art during a period when it was enjoying increasing popularity but was not without its critics. These critics believed that the range of subject matter in Dutch art was the result of pronounced selection — namely, in favor of the simple and quotidian, if not the vulgar and trivial. For them, drunken, fighting peasants or soldiers, beggars and vagabonds, lice pickers, and porridge-eating old tarts dominated the picture.

Supporters and adversaries agreed, however, that what was represented in Dutch art had been reliably documented. The Dutch people and their cities, polders, and dunes must have looked exactly as they appeared in the paintings, drawings, and prints. Reproductions of artworks were used as documents in studies concerning the history of costume, architecture, manners, and customs. This supposedly proto-photographic aspect of "realism"

went hand in hand with a painting technique that made possible a maximal rendering of texture. Precisely because of the almost tangible surface structure of silk and woolen fabrics, gleaming copper, chased and polished silver, basketry, floor tiles, apples, onions, fish, or whatever, representation and reality seemed to have become interchangeable. The soundness of detail seemed to confirm the reliability of the whole.

It would be intriguing to investigate how these ideas originated and to examine the history of their application to seventeenth-century Netherlandish art, but that is not the aim of this article. Nor do I see any purpose in contesting these theories, since they are no longer held to be true. Nonetheless, they are worth outlining as clearly as possible, for they have in varying degrees affected recent visions of Netherlandish art as a whole; and they still do so, more strongly than we are willing to admit. Moreover, there are no entirely satisfactory alternatives to replace the old ideas. On the other hand, however, important and very extensive research has been conducted in the field of iconography. The significance of art theory for the practice of art in the Netherlands has become clear to us, thanks chiefly to the pioneering work of Jan A. Emmens.[7] The social and economic position of artists and the social function of works of art are being increasingly studied.[8] Literary historians are focusing attention on texts that hitherto have been infrequently studied and that may not fall within the commonly accepted definition of "literature"; these texts appear to be closely related to "realistic" genre painting in subject, manner of presentation, and social function.[9] Bearing in mind these recent trends in scholarship, let us return to the discussion of what has been traditionally designated "realism."

Subject Matter

Rather than producing a new vision of the whole, the recent reevaluation of large sections of Netherlandish art has resulted in an incoherent combination of more and more fragments. After the other European followers of Caravaggio were given center stage, the Dutch Caravaggisti were also restored to a place of honor. Shortly thereafter, the rehabilitation of the Mannerists from Hendrik Goltzius's circle began. Following the 1980–1981 exhibition *Gods, Saints and Heroes*, all of Dutch history painting became presentable.[10] In this exhibition, the group of Haarlem artists around Salo-

mon de Bray and Pieter de Grebber held a prominent position. Even Gerard
de Lairesse and Adriaen van der Werff (incorrectly grouped together as
"classicists") have now begun to return to favor. In the meantime the repu-
tation of the Italianates has risen sharply, and no exhibition of landscape
painting would now be planned without including them and their late
seventeenth-century followers such as Johannes Glauber.

It is no wonder that it is difficult for us to continue to call Dutch art
"realistic"! To give a fair and accurate picture of the meaning of "realism"
in this context, we need to know approximately how the entire artistic pro-
duction broke down in terms of history painting, genre, portrait, landscape,
and still life. Although I have no statistics at my disposal,[11] the ratios would
certainly have changed substantially after the Iconoclasm of the sixteenth
century and especially during the explosive economic growth of the Dutch
cities in the early seventeenth century.

What is unique about Netherlandish art is clearly not that it made the
tavern and peasant hut its primary subject matter but that these subjects
occurred alongside the same biblical and mythological themes popular in
Italy and France during the sixteenth and seventeenth centuries. Nether-
landish painters displayed an unprecedented range of subject matter. It was
only in the eighteenth and nineteenth centuries that genre and landscape
painting developed fully elsewhere, thanks to the Netherlandish example.
Academicism arranged these subject matters in strict hierarchical order,[12]
but in the seventeenth-century Netherlands the appreciation for the vari-
ous categories of painting was fairly uniform. Karel van Mander's ideal art-
ist was not specifically the history painter but the *algemeen schilder* (general
painter), who mastered all aspects of the craft equally well.[13] In 1750 Johan
van Gool called Jan Weenix an *algemeen schilder* because of the diversity
of his subject matter, even though history paintings were missing from his
oeuvre.[14] In 1729 Jacob Campo Weyerman included genre painters and his-
tory painters in one group, to which he applied the terms *figuurschilders*
(figure painters) and *historieschilders* (genre and history painters) without
distinction.[15] The contemporary fame of Dou, Gerard ter Borch, or Frans
van Mieris was hardly less than that of Abraham Bloemaert or Rembrandt.
After all, both groups of specialists had to fulfill the same conditions, even
though the "modern" painters (that is, genre painters) were thought to have
less knowledge of literature and archaeology than the "antique" painters
(that is, history painters). Portraiture was not highly valued by the theo-

rists because no skills other than the ability to produce a faithful copy were deemed necessary for *conterfeyten* (the act of portrayal). That this was a gross misconception can be ascertained by every museum visitor; nor should we assume that the seventeenth-century public was deceived on this score.

An unprecedented number of artistic specialties coexisted in the Netherlands during the seventeenth century. The extent to which they influenced each other should be stressed. This is as much a stylistic as an iconographic phenomenon. Pieter Bruegel's *Massacre of the Innocents*, circa 1566 (Vienna, Kunsthistorisches Museum), and his *Census*, 1566 (Brussels, Koninklijke Musea voor Schone Kunsten), in which biblical stories are set in snow-covered Brabant villages, may appear to be isolated incidents, but they reveal a constant in Netherlandish art, namely the attempt to bring texts to life by representing them as familiar scenes. The manner in which Rembrandt and his followers dealt with biblical stories stems at least in part from this tradition. Gerard van Honthorst and Hendrick ter Brugghen's red-nosed fiddlers and singers are recognizable in the artists' genre pieces as well as their biblical scenes. Daily life and the commonplace form the chief ingredient of many Netherlandish paintings; in others they add a dash of spice.[16]

The same can be said of more distinguished and exalted pictorial elements: sometimes they are the main concern, and at other times they serve as piquant additions. Cornelis Bega, for example, knew how to confer a sense of classic dignity on his peasants. Dirck Barendsz. drew bourgeois families at the table, and Karel van Mander depicted tipsy peasants; these two artists, however, vested their lowly subjects with Mannerist refinement.[17] In the oeuvres of Godfried Schalken and Van der Werff the line between genre and history painting is barely detectable. Jan de Bray seems to have established a precarious balance between history, genre, and portraiture in nearly all his works. From this vantage point "realism" is still an insufficiently studied component of Dutch art. The popularity of scenes from the lives of the petit bourgeois, country folk, soldiers, and the proletariat remains unexplained. We understand little about the preference for depicting still lifes of cheap knickknacks and landscapes of areas that were accepted as tourist attractions only centuries later. As an aid to understanding, the concept of the picturesque must be discussed, as well as the iconographic content of the subjects mentioned.

213

Iconography

Following the pioneering work of Sturla Gudlaugsson, Hermann Rudolph, Hans Kaufmann, and others who published before World War II, it was primarily the Utrecht art historians Jan A. Emmens and E. de Jongh who stimulated iconographic research in Netherlandish genre painting. Despite the large number and variety of their publications and those of their followers, it is possible to summarize their findings. For these scholars, almost all Netherlandish art contains a moralizing message based on the Christian-humanist ethic of writers like Erasmus, Dirck Volkertsz. Coornhert, Hendrick Laurensz. Spieghel, and their popularizers.

During the sixteenth century, when the Netherlands was subjected to swift and violent change, many people became unsure about what was expected of them morally and, in turn, what they could expect from others. The need for rules and the inclination to implement them was correspondingly strong. This moralizing message in art pertained primarily to the manner in which man treated his fellow man. In practice, therefore, it had to do with social behavior, and the line between catechism and etiquette manual occasionally blurred. Perhaps, in light of this, it would be better to speak of a "didactic" rather than a "moralizing" art.[18]

In the sixteenth century attention was focused on two major complexes of problems, one public and one private. The former dealt with issues such as how to reconcile capitalism, industrialization, and the resultant wealth with the traditional teachings of the church and which position to adopt with regard to the growing legions of the poor who had no share in the increasing prosperity.[19] The latter complex involved the attempts made to find new codes of behavior for sexuality, marriage, family life, and the education of children. Warnings against excess and profligacy resounded throughout the seventeenth century, as did exhortations to austerity and frugality. One was constantly showered with urgent advice to be chaste and to eschew sexual encounters outside of wedlock; biting satire was directed at vital old men, lusty youths, and enterprising women who disregarded these rules.[20] The advice and warnings presupposed that spiritual salvation is more important than earthly pleasure: all is vanity and *memento mori*.

Painting did not play a leading role in the campaign for "modern" ethical values and rules of conduct. This modern view is first detectable in literature, plays, *rederijker* poetry (poetry made by guilds of rhetoricians),

and satirical folk songs. In addition to sixteenth-century examples, Herman Pleij has discussed some texts dating from as early as the end of the fifteenth century. At that time printmaking also began to develop as a means of propaganda, primarily in Germany. Its combination of word and image was extraordinarily effective.[21]

Painted genre pieces did not come into fashion until the second quarter of the sixteenth century; prior to this time they had not constituted a full-fledged specialty in the Netherlands. Although examples by earlier artists such as Quinten Massys and Hieronymus Bosch are of great importance, they were isolated occurrences, incunables of genre painting. Genre scenes enjoyed their first flowering only around the middle of the sixteenth century. Bruegel's predecessor, Frans Verbeeck, worked in tempera on canvas — an inexpensive medium — which would seem to indicate that genre motifs had not yet been fully accepted in official painting.[22] Some of Bruegel's own early genre paintings, such as *Proverbs*, 1559 (Berlin-Dahlem, Staatliche Museen), *Children's Games*, 1560, and *The Battle between Carnival and Lent*, 1559 (both Vienna, Kunsthistorisches Museum), with their high horizons and tiny, seemingly unconnected, silhouetted figures strewn across the surface, derive their compositions from the propagandistically oriented graphic arts. I assume that this visual indication helped to clarify the artist's intentions.[23]

That sixteenth-century genre painting is indebted to literature is sufficiently well known and is abundantly evidenced in Konrad Renger's *Lockere Gesellschaft*.[24] It is not only the twentieth-century researcher, I suppose, who finds literary texts and print captions necessary to understanding old genre paintings. The meaning of a genre painting, which by definition is presented to the viewer without written or printed text, can only be understood when the beholder is familiar with its codes. Didactic painting only makes its point when the intended viewer is acquainted with the content of related literature or prints that carry explanatory texts. By definition, the medium of painting can only serve as a vehicle of propaganda for ideas that have already found wide acceptance among members of its audience. As long as a strong cultural connection exists between patron, painter, and public, the effectiveness of paintings as a means of propaganda can be great. Thus, such propaganda is most effective when it is least necessary, when it is directed inward rather than outward. While it has the desired consolidating effect on the group from which it originates, it will rarely change the minds of outsiders.[25]

215

After its first flowering, Netherlandish genre painting developed steadily, and production probably increased with the overall growth in numbers of paintings produced. The number of themes treated expanded tremendously, resulting in great stylistic diversity. Simultaneously, the tendency toward specialization increased sharply. Individual painters began to restrict themselves to ever narrower choices from the increasing range of subject matter. Apparently, painted and written propaganda promoting "modern" middle-class morals became increasingly popular. Simultaneously, the exchange of information and the cultural affinity between painters and their public must have diminished. Obviously, one can identify all of seventeenth-century Holland, Utrecht, and Zeeland society as bourgeois, and a general consensus surely ruled with respect to the most obvious moral matters. The principal variations of "thou shalt" and "thou shalt not" had been largely concretized since Jacob Cats's first publication in 1618. However, agreement on moral questions between a burgomaster, a cloth merchant, and a cobbler could be maintained only as long as none of the three went into detail. In addition to addressing general rules, Bruegel's *Battle between Carnival and Lent* and Joachim Beuckelaer's *Ecce Homo*, 1561 (Schleissheim, Gemäldegalerie) had touched upon current points of contention.[26] This was no longer possible in seventeenth-century genre painting.

Genre painting was influenced not only by the expansion of its public but also by related changes in the production process. We know that Bruegel was acquainted with Abraham Ortelius, but it would not help to know with whom the Van Ostades were acquainted and what company was kept by Jan Miense Molenaer, Quirijn van Brekelenkam, and Hendrik Martensz. Sorgh. Their work was produced for the market, and direct contact between artists and collectors was not the rule. Middlemen selected works of art from the artist's stock of paintings and managed their distribution. The production of paintings in Holland increased incredibly rapidly, especially in the first decades of the seventeenth century. Countless painters, whether refugees from Flanders and Brabant or long-term inhabitants, attempted to profit from the increasing prosperity. The competition became fierce, and the most tried and true method for protecting one's share of the market was specialization. Painters had to confront economic laws rather than the wishes of a Maecenas. They had to differentiate themselves from their competitors, but at the same time they had to comply with the expectations of a conservative public that was always demanding more of the same. Painters began to

concentrate on a recognizable combination of subject, composition, and personal style. Hence the collector who wanted a fish still life, an inn scene with three to five figures, a river landscape, or a landscape by moonlight knew where to go and what to expect. The soundness of execution appears to have been a reliable selling point as well.[27] In such a system the appearance of works of art cannot have been determined primarily by iconographical considerations. Subjects were drawn from tradition and varied; their didactic message was assumed to be known by all and was, as a rule, neither confirmed nor denied. After a few generations the *soortelijk gewicht* (specific density) of the endlessly and thoughtlessly repeated moralizations must have diminished greatly.[28] No contemporary artist or collector commented on the half-hidden moralizations in seventeenth-century genre scenes. Printed sources only reveal that the tradition of *schijnrealisme* (pseudo-realism) had virtually vanished by the beginning of the eighteenth century. I consider this to be the result of a process that progressed virtually unnoticed during the entire seventeenth century; on an earlier occasion I referred to this phenomenon as iconographic *slijtage* (abrasion).[29]

Presentation

Until just a few decades ago the fact that a great deal of Netherlandish genre painting had a moralizing intent, or could at least be explained in a didactic fashion, went virtually unnoticed. At the time when Dutch and Brabant "realism" were made to serve as historical propaganda for Gustave Courbet and Jean-François Millet, observers understandably wanted to see in it nothing other than the unmanipulated rendering of reality.[30] That this misunderstanding, formulated around 1850, could last for so long stems from the manner in which the subject matter of Netherlandish art is presented to the viewer. From the literature that nourished them, genre painters borrowed a strong preference for using exempla. In his *Tabletop* Bosch had already shown a striking example of gluttonous behavior instead of relying on a personification of *Gula* (Gluttony), circa 1510 (Madrid, Museo del Prado). The popularity of exempla in *rederijker* poetry and the theater, and later in genre painting, was due to the folk sermon, which has been referred to as the mother of modern literature.[31] This tradition also explains the preference for crude and coarsely comical exempla, a preference in which

the painters matched the writers. That negative exempla ridiculing sin and foolishness were so much more popular than positive ones can be traced back to a basic precept of rhetoric or perhaps of human psychology. This preference in painting also had to do with the tradition of satirical literature that flourished in the sixteenth century. Sinful and asocial behavior was revealed through mock praise, just as Erasmus had done in his *Lof der zotheid* (In Praise of Folly), 1509. The didactic intention is evident, particularly in the use of meaningful names. An insouciant person was called *Sorgheloos* (Carefree); someone who squandered his possessions, a pilgrim to *Sint Reynuit* (Saint Clear Out).

In the late Middle Ages people were primed in all sorts of ways to view common objects and occurrences as bearers of a higher meaning, especially since the Church had always preached that God was revealed in all of creation. This conviction resulted in a vision of reality pithily summarized in the words of Saint Thomas of Aquinas: "*Spiritualia sub Metaphoris Corporalium*" (corporeal metaphors of things spiritual).[32] Dove, fish, walnut, and cherry denoted Christ's role as savior, while a variety of flowers indicated the purity and suffering of his mother. In the sixteenth century this vision began to lose its validity, but the manner of viewing and interpreting conditioned by it lasted much longer.[33] In the second half of the sixteenth century emblems were known and loved in the Netherlands. The inclination to endow almost anything with a deeper significance was further stimulated by emblem literature; finding new icons for existing concepts and new interpretations for existing images was a favorite game. In this way, the theologically determined relation between one object or image and one meaning disintegrated further, while the inclination to see images as bearers of meaning was preserved or reinforced. Pleij raises the question of whether the fifteenth- or sixteenth-century theater audience could have interpreted scenes as anything other than exempla with a didactic intent.[34] Equally justified is the question as to whether sixteenth-century viewers of genre paintings could possibly have seen them as anything other than didactic exempla. But regardless of how strongly conditioned the audience's thinking was, interpretation was the task of each individual viewer; what the work of art meant was not unequivocally established by the painter through the representation on the panel.

The Netherlandish artists themselves laid the basis for what we might regard as the later "realistic misunderstanding," which claimed its first

victims not in the nineteenth century but rather in the seventeenth century, if not earlier. When Cornelis de Bie described the work of Adriaen van Ostade in 1661, he listed scenes that the painter never depicted.[35] De Bie obviously assumed that all agrarian activities appeared in the work of Van Ostade since he had, after all, illustrated peasant life so well.

The seemingly meaningless or insignificant little scenes from daily life in genre painting are not only common but often crude, and a combination of candor and coarseness is not unusual when issues of sexuality are addressed.[36] Much of what is taken for granted in reality, however, appears to be unacceptable subject matter for the visual arts: eighteenth-century aestheticians and nineteenth-century art historians were much less flexible on this point than we are nowadays. They set requirements for painting in general that Netherlandish art did not appear to meet. In the instance of Dutch art, however, the vulgar is no breach of "decorum" but rather a consequence of its preservation. Just as crassness is unbecoming in biblical or mythological scenes, cultivation and refinement are misplaced in peasant scenes. The general acceptance of banality and boorishness in scenes with peasants, beggars, soldiers, and prostitutes can be understood if one applies the concepts of decorum and mode to Netherlandish art.[37] Genre painters, it seems, titillated their public with their daring representations but only when they had created a context in which such candor was regarded as permissible. In the context of peasant and folk genre, the coarse and banal were acceptable because they were part and parcel of the subject matter. Nonetheless, their works retained something nicely provocative. A comparable situation occurred in Netherlandish theatrical farces three or four centuries ago. The playwright or actor did not use crude language as an end in itself but because the role would not have been convincing without it.[38] This tradition provided genre painters with a stimulating model.[39]

Art theorists have scarcely dealt with the application of mode and decorum to subjects classified as "low," though the foreword to Adriaen van de Venne's *Sinne-mal* can be interpreted as an apology for the peasant genre.[40] In practice the painters knew very well how they should behave. Subjects drawn from the lowest levels of society, for which theatrical farces served as the model, were presented with the appropriate degree of crassness. The use of local dialect in plays clarified the writer's tone, his modus operandi. Comparable signals are evident in painting — local and peasant garb or old-fashioned clothing, the wearing of knives and daggers, the use of worn-out

or defective household effects, etc. The tone appropriate for both acted and painted farce was obviously that of humor, and it is not difficult to recognize what could provoke laughter in the sixteenth century: flaws in body build, caricatured heads, exaggerated expressions of joy, anger, or other emotions, as well as unrestrained reactions to physical stimuli and expressions of ignorance and stupidity. The entire world of acted and painted farce was populated by exaggerated stereotypes, which were derived not from reality but from a schematic synopsis of commonly accepted prejudices about reality. Nevertheless, genre and farce have been called "realistic," as if they illustrated quotidian situations in a reliable manner. This misunderstanding can be traced back, in part, to sixteenth- and seventeenth-century artists, who over time adapted their farcical peasants to observations *naer het leven* (after life). However, the typical figure type found in Adriaen van Ostade's work, for example, did not become more believable during the painter's long life. It was adapted to another and more "modern" cliché: the knife-wielding kermis visitors were supplanted by the contented inhabitants of an idyllic countryside.

The gradual loss of understanding of the didactic intent in genre scenes and its possible causes — growing distance between artist and collector and the massive production of art that bolstered the mindless repetition of traditional motifs — have been mentioned above. An essential third factor must be added to these two: namely, the practice of not explicitly indicating the interpretation of the scenes represented. Between 1550 and 1670 it became increasingly common to omit unequivocal keys for a didactic interpretation; more accurately, artists allowed collectors a greater freedom of interpretation. Those who wanted to buy a painting by Ter Borch or Van Mieris as an example of artistic ability and painterly refinement could acknowledge a moralizing explanation of their amorous scenes with a disinterested nod. Those who came to these artists seeking a painted sermon got what they were looking for, packaged, moreover, in the most advanced design.

Reliability

An extremely accurate rendering of actual objects was a constituent element of fifteenth-century Netherlandish art. Style, technique, and iconography combined to express a late medieval piety. Whatever changes transpired in

the sixteenth century, Netherlandish art maintained a high technical level and performed miraculous feats in the meticulous rendering of plants, animals, and small precious objects. Skill in the "almost real" rendering of plants, animals, and inanimate objects continued to play an important role both in the education of artists and in collectors' expectations. Nevertheless, the precise rendering of reality in Netherlandish art after 1500 is not to be understood solely as a tenacious medieval tradition. Leon Battista Alberti claimed that the visual arts were capable of illustrating every aspect of reality, and this idea continued to play a role in later art theory. In Italy this tenet never led to a noticeable form of "realism," since the precept that artists should strive for ideal beauty took precedence over the idea that all that exists or can be imagined lies within the artist's territory. Alberti's theory that the artist had all of creation as his domain was stressed in the writings of Albrecht Dürer, who placed a lower priority on the pursuit of ideal beauty.[41] Dürer's study of figural proportions revealed to him that perfect beauty did not exist on earth and therefore could not be known by man.[42] Moreover, he believed that the quality of a work of art was not determined solely by (the beauty of) the subject[43] but also by how the artist treated it.[44] To a large extent, this argument justified the choice of ugly and humble subjects,[45] and it appears that Dürer's ideas found acceptance in the Netherlands. In any case, the pursuit of classical beauty remained limited to history painting or, rather, to a part of it. The meticulous illustration of reality is an element of every other form of painting and, as a rule, of history painting as well.

Working *naer het leven* constituted an important step in the genesis of works of art: theorists all agreed on this point. However, there were considerable differences of opinion concerning both the process of assimilation that was supposed to follow the initial study of reality and the desirable result. Seventeenth-century Netherlandish art — later called "realistic" — resulted from transforming segments of observed reality and uniting these elements in new entities.[46] In the creative process that took the study of the real as its point of departure, accents were shifted, contrasts intensified, combinations invented, and models manipulated. Bits of reality were used as material for an interpretative illustration of this reality. The mistaken notion that these works of art were no more than reliable representations of factual situations became unavoidable as soon as new approaches in artistic theory and practice began to supplant time-honored Dutch tra-

ditions. Samuel van Hoogstraten does not appear to have rejected traditional Netherlandish art a priori, but he showed no understanding of its iconography.[47] Gerard de Lairesse judged the works of his predecessors more harshly and did not recognize their aesthetic principles or iconographic programs.[48]

Style

The concept of "style" has been defined in extremely diverse ways. Meyer Shapiro, for example, gave it enormous latitude by attaching elements of content and expressive features to formal traditions.[49] Conversely, if one restricts the definition of "style" to the *formal* traits common to a group of artworks — without considering the relationship between these forms and the meaning that they express — a "realistic" component may be perceived as running through Netherlandish art. (I am speaking of a formal language used for those paintings that, until now, have been called "realistic.") This "realistic" style is closely connected to a specific range of subjects; to the moralizations that are more or less concealed therein; to the tone characteristic of folk and peasant subjects; and to the inclination to allow observations *naer het leven* to be recognizable in completed works of art. No matter how closely this style may be associated with a certain range of subject matter, however, it remains something essentially different. Form and content, style and choice of subject matter, no matter how interwoven, can and must be distinguished from each other.

Regardless of how realism is defined, a component of Netherlandish art will always be typified by this term. In my opinion, "realism" should be considered an important characteristic of a vast segment of Netherlandish art but not the only one. After all, *Stilpluralismus* (plurality of styles) also occurred in the Netherlands. More than one style was practiced simultaneously due to the development of local schools and the fact that not every subject could be treated in the styles developed for other genres and also as a result of foreign influences. It is a well-known fact that some artists changed styles to suit their subject matter.[50] Thus, "realism" should not be considered the main characteristic of Dutch art; rather, the fact that this art expressed itself in a number of styles, of which "realism" seems to be the most conspicuous, determines its nature. Styles in Netherlandish art

developed and gained independence, and they also intermingled in count-less and ever-changing permutations. It is impossible to demonstrate here how the various styles evolved through continual interaction in the sixteenth and seventeenth centuries. It would be fair to say, however, that the "realis-tic" style had its roots in late medieval Netherlandish art, while other cur-rents were primarily determined by influences from abroad.

The "realistic" style in Netherlandish art is obviously best recognized in a good deal of genre art, a segment of landscape painting, and many por-traits. In this context, the fact that style is a personal achievement is not contradictory, especially in a country where specialization was prominent. "Realism" may also appear as a constituent element in history painting. This is obvious in the contrast between the dead body of Christ in Rembrandt's *Deposition*, 1633 (Munich, Alte Pinakothek), and that in Rubens's treatment of the same theme, 1612 (Antwerp, Cathedral). However much Rembrandt endeavored to emulate Rubens, he remained less Baroque and more "real-istic" than his Flemish model. One is reminded of the slippers that Rem-brandt's *Abraham* almost loses when he sacrifices his son, 1636 (Munich, Alte Pinakothek), of how *Samson's* toes curl up as he is being blinded, 1636 (Frankfurt, Städelsches Kunstinstitut), and of the coat rack on which Christ's cloak hangs in the *Supper at Emmaus*, 1648 (Paris, Musée du Louvre). With these examples, I may have overstepped the boundary line between form and content, but it is clear that "realism" is somehow related to a specific narrative style that attempted to captivate the beholder by setting the nar-rative in familiar surroundings. "Realism" was a style that could refer to the quotidian and that might better be described as executed in a *schilderachtig* (picturesque) manner.

A work of art's importance is not determined by its subject matter: an artist's creativity can bestow great value on seemingly trivial matters. For two or three centuries Netherlandish art apparently adhered to this idea recognized by Dürer — an idea that clashed with Italian artistic theory and practice. Although idealization and embellishment were not pursued, the rendering of reality in many Netherlandish paintings is less reliable than was thought until recently, because the observed was manipulated in the artistic rendering. The transformation of daily reality was guided neither by a classical ideal of beauty nor by the quest for objective faithfulness. Artists strove for the picturesque. Dürer's assertion that an artist can demonstrate his power in something small was intended to reveal more about the creative

process than about the subject matter.[51] Nonetheless, the later Netherlandish craze for picturesque subjects was legitimized and promoted by his words and his example. The hard-to-define picturesque was considered to be as much inherent in certain objects as it was a product of the artist's brush. The irregular, imperfect, old, worn, and defective could become positive experiences. This applied to utensils, buildings, and trees, as well as to the poor and elderly. The imperfections lent them a degree of individuality missing in ideal beauty and suggested time, history, and meaning. Picturesqueness elevated the commonplace to a higher level without alienating it from the viewer's own experience. None of this was, however, systematized or defended in contemporary writing. We know of Netherlandish picturesqueness only from seventeenth-century paintings and later denunciations of the phenomenon, particularly by De Lairesse.[52] Striving for the picturesque was primarily evident in categories of painting with no grand intellectual pretensions: landscape and genre painting.[53] Picturesqueness suits the modes of farce and comedy, not the literary and pictorial forms of drama and classical erudition. Much of what has up to now been labeled "realism" had its origins in the pursuit of the picturesque.

I will attempt here to specify the formal traits of this "realistic" Netherlandish art, recapitulating as concisely and systematically as possible the impressions that I have gathered in looking at what we call "realistic" art over time. (It should be noted, however, that each of the following points deserves to be elaborated in a separate chapter.) "Realists" must have had a preference for a fine and precise handwriting in which their personal graphology was suppressed; variations in their brushwork served primarily to enhance the rendering of fabric texture. Bright colors and sharp contrasts of color were not favored; the "realists" preferred subtly modulated colors and a subdued, even monochromatic, tonality. Abrupt transitions and sharp contrasts in lighting were also avoided, although the intensity and direction of the light are usually recognizable. More emphasis was placed on the rendering of texture and the effect of light on surfaces than on defining contour and volume. That a certain degree of formlessness was preferred is also witnessed by the many *profils perdus* (lost profiles) and figures seen from the back. Compositional schemes are often difficult to recognize because overemphasis is avoided. In fact, an appearance of coincidence seems to have been sought. As a rule, pictorial space is not very deep and not explicitly closed off to the left and right. Thus, the frame appears to demarcate an

accidental fragment from a greater whole and is reminiscent of a window or doorway. The human figures are not idealized but individualized, so that the artist's models are often recognizable; imperfections serve to disclose social, psychological, or personal idiosyncrasies. The movements of figures are given little emphasis, and the viewer is not engaged by their gestures or glances; as a result, these are often difficult to interpret.[54]

It would be hard to name a work of art that according to the above criteria, could be described as totally "realistic." However, what we might call the "realistic syndrome" can be recognized to a greater or lesser extent in many paintings. It is a complex of stylistic traits developed in connection with the striving for picturesqueness; furthermore, it has a great deal to do with a narrative style, as well as with a way of presenting iconographic content characteristic of genre art. All the elements are orchestrated to give the impression that what is represented is not the dramatic highpoint of an exceptional event but a fairly arbitrary moment taken from an incident in daily life. The painted figures perform without drama or emphasis. The rendering of space, the composition, and the placement of figures underscore the impression of coincidence. Setting, clothing, and other attributes indicate situations with which the viewer is familiar. It goes without saying that the origin and development of this style are closely connected with the history of genre. Nevertheless, one of the characteristic traits of the Netherlandish situation is the degree to which history painting exhibited "realistic" features. I have already mentioned Rembrandt's *Blinding of Samson*. Although here, as in no other work, the painter tried to match the baroqueness of Rubens, Rembrandt's painting still contains realistic features. Whoever compares Rembrandt's *Supper at Emmaus*, circa 1628 (Paris, Musée Jacquemart-André), with the version of 1648 in the Louvre or his *Repentance of Judas*, 1629 (Mulgrave Castle, Normanby Collection), with the repentant *Prodigal Son*, circa 1666 (Leningrad, State Hermitage Museum), realizes that the illustration of a dramatic story does not always require impassioned gestures.

Technique

The vast number of extant Netherlandish paintings is not just a consequence of the magnitude of production during the sixteenth and seventeenth centuries but also of their high technical quality. This is a positive result of the

fact that the distinction between art and craft was not yet great. While Netherlandish paintings passed from hand to hand, and from auction to auction, little damage was caused. In fact, most paintings have suffered more damage in the last fifty years than in the preceding three centuries.[55]

The Netherlands also produced quality work in another respect. The expression *stofuitdrukking* (which we might translate as "rendering of texture") exists only in Dutch; nowhere else was so much effort expended on attaining the greatest possible likeness between a real object and its depiction with regard to surface structure, color, and the play of light. The material characteristics of what was depicted had to be recognizable at a glance, yet remain convincing under close scrutiny. Still lifes featured silver and pewter objects placed next to each other, garments made of various fabrics, wine glasses reflecting the artist's studio — no challenge was too great. Trompe l'oeil in the literal sense was rarely used in Holland, probably because the desired effect of optical confusion could not be fully achieved with paintings that had no fixed place in the interior. Yet the illusion of an object's tangible presence seems to have been frequently sought.

For all their differences, the works of Dou, Van Mieris, Ter Borch, and Johannes Vermeer share an extreme precision of execution. Individual brushstrokes are only distinguishable when enhancing the rendering of texture. Thus, although the artist's personal handwriting can elude attention, the fact that these works serve to portray objects cannot escape the notice of the spectator. This combination of style and technique apparently aims at making the viewer believe that reality is faithfully rendered and even mirrored, so that nothing can distract him from what is represented.[56] This idiosyncrasy of Netherlandish art, or at least of its "realistic" segment, is connected to the pursuit of the picturesque. The differences between pewter and silver, the varied ornamentation of two silver pitchers, the dents and cracks in the surface of copper buckets and earthenware dishes are all part of the identity of individual objects. By acknowledging the individuality of things, they become picturesque.

An apparently faithful reflection of reality, which at most seems slightly more picturesque than reality itself, does not in the least preclude an opinion about what is illustrated. The mimicry of reality in works of art, pursued with the aid of the picturesque and *stofuitdrukking*, supports a narrative style that aspired to having the greatest possible effect. No matter how instructive it may be, "exalted" subject matter remains at a distance; it is

likely, therefore, that the wise lessons it offers are recognized but not applied to the viewer's own existence. Moralizations on objects or occurrences from the viewer's immediate experience, however, can hardly be ignored. The narrative style appropriate to Netherlandish "realism" avoided the exalted, the exceptional, and the emphatic. Everyday matters were displayed and explained in a quiet tone as something completely normal. Often compositions seem to be the result of carelessness or coincidence, but the opposite is true. Through the manipulation of subject matter, the painter carefully guided the viewer in the scrutiny and interpretation of the work — even if there was not much to explain.

Conclusions

The term "realism" was originally employed to indicate the faithful and unmanipulated rendering of reality that was thought to be recognizable in a segment of Netherlandish art. Thereafter, the term was increasingly used to indicate a complex of factors that made possible the illusion of "realism." After having examined this complex, I have reached the following tentative conclusions. "Realistic" art favored subjects drawn from the viewer's immediate surroundings, including standardized visions of the common and the crude known from literature and theater. These subjects were frequently used for didactic ends. Because of the use of exempla, the moralizing content was not overtly presented but was expected instead to be implicit in the image. This was accompanied by an unemphatic narrative manner and a modus appropriate for farce and comedy; a form of more or less crude humor was deemed suitable. The view that an artist was not required to copy reality but should instead confront the existing world with a new reality deriving from his creative spirit was considered valid, as much for "realistic" artists as for those following other styles. For the creation of this new "reality," artists were inclined not so much to idealize as to strive for the picturesque. Their style facilitated an unemphatic presentation of subject matter. Finally, they attempted to achieve a convincing rendering of texture.

These aspects did not remain constant for two hundred or more years. However, the changes that Netherlandish "realism" underwent during the course of its existence have never actually been documented. Nor would this be an easy task. It is impossible to say, for example, what percentage of

the total art production constituted specifically "realistic" subjects during different periods. Before Pieter Aertsen, Jan van Hemessen, and Bruegel genre art had not attained its full development. Landscape art, however, had already begun its triumphant ascendancy much earlier. The percentage of landscapes and genre scenes must have continued to increase between 1500 and 1600, probably not gradually but in spurts. It is impossible to determine whether this percentage continued to increase after 1600 or if these genres just kept pace with the explosive growth of the total production. Certainly, the chance for survival of seventeenth-century "realistic" paintings was greater than that of sixteenth-century genre and landscape or for other genres of painting from either century. Still lifes, which had only been produced incidentally and had not been practiced as an independent specialization in the sixteenth century, became extremely popular around 1600. The number of still lifes in relation to the total production of works of art must have risen from less than one per thousand to a few per hundred in approximately ten years.[57] The popularity of portraiture must have also increased as of the middle of the sixteenth century. Since the patterns of trading and collecting portraits differed from those for other types of painting, it is even more difficult in this case to estimate the relation between lost and existing artworks. It goes without saying that, as with still lifes and genre pieces, not every portrait is realistic.

The growing popularity of genre and landscape painting was coupled with the increasing emancipation of these specializations. In Van Hemessen's oeuvre the difference between genre and history painting is still slight; this also applies to Aertsen and Bruegel, though in a different manner. With the passage of time, the genres appear not only to have gained independence but to have become isolated as well. The "realistic" element in biblical and mythological scenes gradually diminished, and the intentional overstepping of a subject's boundary became rarer. After Bruegel's *Massacre of the Innocents* was set in the snow and Van Hemessen's *Prodigal Son*, 1536 (Brussels, Musées Royaux), was set in an inn, it is a long time before Benjamin Cuyp's *Annunciation to the Shepherds*, circa 1640 (Braunschweig, Herzog Anton Ulrich-Museum), which was set in a real shed with real Dutch cattle herders. Painted a few decades later is the even more exceptional *Bathsheba* by Steen, circa 1660 (Great Britain, private collection), set in an elegant Dutch living room.[58] The increasing distance between the genres was not only a result of the fact that genre painting developed in an entirely differ-

ent direction from history painting (the two had originally been barely distinguishable). At the same time, history painting became increasingly oriented to the requirements of international art theory, which considered the mixing of history with genre-like elements incompatible with decorum. Thus, in the course of time one segment of Netherlandish art became more "realistic," and the other less.

The iconographic content of genre pieces is obviously not statistically calculable. Still, it is possible to indicate some changes over time. In his discussion of the work of Aertsen and Beuckelaer, Jan A. Emmens pointed to the wide applicability of the concepts *voluptas carnis* (lust of the flesh) and *diffidentia dei* (lack of trust in God).[59] Painters of this generation criticized the lack of faith in God's grace, overconfidence in one's earthly possessions, and excessive attachment to worldly pleasures. These sins could manifest themselves in a great variety of ways. As of the early seventeenth century sexual morality, education, and family life occupied a central position; greed and stinginess were less commonly attacked. The intemperate eating and drinking so often demonstrated by peasants from Bruegel to Brouwer dropped to second place circa 1630, as did the unrestrained fighting of soldiers and peasants. By the middle of the seventeenth century the demand for moralizations in paintings seems to have diminished notably. We can only guess the reasons for these changes. Did the interest in ethical problems decline after 1630? Did the general level of civilization increase? These theses appear to be untenable. Had a new moral ethic generally been accepted in the meantime with a concomitant decrease in propaganda? This too cannot be proven and is, moreover, hard to believe. I have already pointed to the increased distance between artist and buyer, which could have led to a less explicit presentation of the messages embodied in genre pieces. While the Flemish patriciate of the fifteenth century emulated the life-style of the aristocracy, the sixteenth-century bourgeoisie found its own values and style by contrasting itself to the nobility. In this respect Christian-humanistic ethics functioned as a unifying factor and as a means of distinguishing members from outsiders. One might suspect that the patriciate still needed to formulate its own identity circa 1550 but that this was no longer the case a hundred years later. Thus, citizens from the middle of the seventeenth century may have felt less need to criticize those who did not abide by the rules. Possibly the bourgeoisie gradually became accustomed to the idea that it was no longer made up of *nouveaux riches* needing to

justify their own values and life-style. In seventeenth-century Holland, the *haute bourgeoisie* was the pace-setting cultural group; after all those years, this simple fact seems to have become generally evident to all, most importantly to the group itself.

As a result of the division of the Netherlands and the wave of migrations from the South to the North circa 1600, the economic foundation of Netherlandish art production changed radically. Working for the anonymous art market became the rule rather than the exception, and contact between artist and buyer became rare. Production increased greatly and, therewith, both competition and specialization. The expanded supply found a wider buying public. The changes in the iconography of didactic art, the expansion of the audience that it reached, and the growing distance between artists and buyers were strongly interrelated. These factors contributed to the gradual decrease of the *soortelijk gewicht* (specific density) of didactic art. Obviously, light-hearted pieces can be found in the sixteenth century and heavy-handed moralizing works in the late seventeenth century, but such was the general trend. If "realistic" means the rendering of reality — selectively and with much manipulation to be sure, but without didactic intentions — it can be said that Netherlandish art gradually became more "realistic."

An exemplum or other literary theme forming the basis of a genre painting has the desired didactic effect only when correctly interpreted. By including a key to interpretation in his work, the painter can minimize the danger of its being misunderstood.[60] The advantage of this is evident, the disadvantage likewise: the appearance of coincidence and the unemphatic quality can easily be disturbed, thus weakening the impression of "realism." A well-known instance of this phenomenon is Jan Miense Molenaer's *Lady World* who rests her foot on a skull.[61] This "unrealistic" detail was later covered over and only came to light in our century: a foot warmer had been painted over it. Lack of clarity on the one hand and pedantry on the other were the reefs to be navigated. The "realism" of Netherlandish art increased in the course of time, in the sense that the appearance of coincidence increased, while the *claves interpretandi* (keys to meaning) became less clear or were omitted entirely. This development is related to the above-mentioned changes in the art market and to the altered ideas about decorum.

When explicitness is favored in farces, permissible boundaries are soon reached. Much of what was initially accepted as humor and valued as such was later viewed as coarse and crude.[62] This is not just the by-product of a

gradual civilizing process, as is commonly believed. The separation between
art and craft in landscapes and genre pieces had become extremely diffi-
cult to distinguish due to the massive production of paintings in the first
half of the seventeenth century, but from the middle of the century art
increasingly recovered its position as Art. Collecting Netherlandish paint-
ings became well respected and prices began to rise.[63] As a result, the view
of what was suitable in the visual arts was more stringently applied to all
specializations. Genre evolved from farce to comedy, and the modus in
which the narrative was presented changed accordingly. The kind of humor
used, as well as the narrative style of the entire piece, was adapted to the
new demands of taste and propriety.

Styles are usually defined in current art historical writing to clarify spe-
cific aspects of the works of a small group of artists, a single oeuvre, or
even just a part thereof. My suggestion of describing "realism" as the for-
mal language applied to a large segment of sixteenth- and seventeenth-
century Netherlandish art is not an attempt to isolate some exceptional
phenomena but to highlight the general. In using the redefined concept as
an instrument, however, the danger exists that nothing more may be gained
than the formulation of a few extremely general remarks. I hope, neverthe-
less, that insight into the specific individuality of Netherlandish art will be
broadened when the term "realism" is used in the manner proposed here.
It should not be forgotten that this, in fact, was the intended goal when the
word "realism" was introduced and applied to Netherlandish art. I stated
above (and it was not an original thought) that our increased knowledge of
old Netherlandish art has made it impossible to perceive it as a coherent
entity. The desire to discern coherence was my principal motivation for
becoming involved with the problem of "realism."

Between 1520 and 1670 the degree of realism in Netherlandish art seems
to have gradually increased, although this may merely reflect my definition
of the term. Therefore, I will reformulate my view. The style traditionally
called "realism," which is most recognizable in the works of genre and
landscape painters from the middle of the seventeenth century, developed
gradually. This development can be traced back to the beginning of the
sixteenth century and is strongly rooted in the art of the fifteenth cen-
tury; it concerns a part of Netherlandish art and influenced Netherlandish
art expressed in other styles in varying degrees. Its impact on all of Dutch
art increased with time. "Realism" did not originate shortly after 1600,

causing a break in the stylistic development of Dutch art; nor is "realism" a style exclusive to the Northern Netherlands.

Periodization

Virtually every mention of Dutch painting — whether detailed, summarily sketched, or referred to in passing — assumes that a new period was initiated in Northern Netherlandish art with the introduction of realism shortly after 1600. As yet, general skepticism about the utility of the term "realism" and the equally general skepticism concerning the usefulness or feasibility of periodic divisions have not affected this assumption. I cannot adduce meaningful arguments for a new periodization of Netherlandish art in the space allotted; I will simply attempt to counter briefly the accepted arguments.

In the art of landscape, the generation of Willem Buytewech, Claes Jansz. Visscher, and Esaias and Jan van de Velde is considered to have made a revolutionary new beginning. What was innovative in the work of these artists was not the faithful illustration of existing topographical conditions. Nor was their choice of subject matter revolutionary; the so-called Master of the Small Landscapes, whose subjects and compositions were readily adopted by the Haarlem artists, worked a half century before this generation. More importantly, an unbroken tradition of painted and drawn *Dorflandschaften* (village landscapes) existed, linking this Master, who can probably be identified as Joos van Liere, and the "Haarlem realists."[64] New in the work of the Haarlem artists was the volume of their production and the importance placed on landscapes with farms, small villages, fields, and meadows. Van Liere was not rediscovered by the "realists"; they merely form the second or third consecutive generation of his followers. Their strong degree of specialization has thrown the spotlight on an element already present in Netherlandish art much earlier, albeit on a much smaller scale.

Several of Goltzius's landscape drawings have been used to show that this graphic artist was a pioneer of "realism." This is unjustified. In his finished works, with the exception of his portraits, all observations from reality were transformed and adapted to the artist's free-floating world of imagination. Studies after reality (*naer het leven*) were meant to give the draftsman a better understanding of the quintessence of objects studied. This deeper insight into the nature of things gave him the freedom to create *uit*

de geest (from imagination). When conceiving his paintings or prints, he was not supposed to resort to his initial study drawings. Goltzius's practice and Van Mander's theory seem to have been in perfect unison in this respect. When we call Goltzius a forerunner of realism, we give precedence to three or four sheets, saved coincidentally from his workshop, over all his work for the public at large. This means that we disregard the true nature of his art.

The Mannerist preference for personification and allegory supposedly succumbed circa 1610–1620 to "realists" who depicted fishermen in place of *Aqua* (Water) and ice scenes with skaters in place of *Hyems* (Winter). This hypothesis is founded on a conscious manipulation of the facts. Goltzius's oeuvre includes a print with personifications of the four elements, but he also executed a series of prints with genre scenes representing the five senses. Allegories and exempla appeared alongside each other in sixteenth-century Netherlandish art as equal possibilities; in this respect, Goltzius added nothing new. Does the novelty of the Haarlem "realists" lie in the fact that they restricted themselves exclusively to exempla because personification could not be united with their "realistic ideals"? It seems more likely that they did not make personifications and allegories simply as a consequence of strict specialization. Apparently, art history does not always sufficiently distinguish stylistic developments from changes in the nature and volume of the production of works of art. In fact, allegory hardly vanished from Netherlandish art after 1620; the combination of allegorical figures with mythological and historical persons in a single image is one of the chief characteristics of the work of Rubens. In the North, allegory was still favored and was often used for subjects that hardly seem to have deserved the honor. After 1620 the seasons, senses, and cardinal sins are rarely found in allegorical form, simply because they had lost their popularity in any form.

Contemporary with "modern" Haarlem landscape art, the genre scenes of Willem Buytewech, Esaias van de Velde, and Dirck Hals are also considered to have ushered in Dutch "realism." The Mannerism retained in the poses of the figures in these paintings is camouflaged by their stylish clothing. The gatherings of merrymakers in luxurious interiors or grand parks obviously do not present a picture of daily life in the young republic. For that matter, comparable banquets can be found in works by the Francken family, Goltzius, Joos van Winghe, Dirck Barendsz., and earlier sixteenth-century artists. In the development of this theme, the clothing of the fig-

233

ures illustrated was strongly modified, the iconography hardly at all; the most popular compositional schemes changed noticeably but gradually. The solid bourgeois interior with figures conducting themselves in an exemplary fashion is just as rare in the work of Buytewech and his group as circa 1600 or during the sixteenth century. Only with Gerrit Dou, considerably later and after the so-called introduction of "realism," did this subject reach full potential. It goes without saying that no new chapter was begun in the history of the peasant genre around 1610–1620. Brouwer shortly before 1630 and Teniers and the Van Ostades shortly after began developing new possibilities based on the still potent example of Pieter Bruegel the Elder.

The emergence of Dutch realism circa 1610–1620 seems to have been an axiom that, although unresearched and unproven, was adhered to unanimously all the same. The polarity between Mannerism and the "realistic" art immediately following in Haarlem presents a dramatic contrast. Here, we are dealing with a pseudo-contrast. It is fundamentally incorrect to apply the twentieth-century model of successive avant-gardes and generations reacting to each other to a seventeenth-century situation. For Buytewech and his generation, Mannerism cannot be regarded as something that had to be overcome. They were specialists in landscape and "modern" scenes working next to painters of "antique" subjects who, as a result of recent developments, were similarly reduced to the status of specialists. If Mannerism was superseded, it was largely due to the efforts of the Mannerists themselves, most notably Goltzius and Bloemaert, who with their later works fostered the development of North Netherlandish classicism.[65] The realists joined with the traditions inherent to the specializations they practiced. It is easy to understand why the novelty of their work was so strongly emphasized at the expense of its traditional components. Traditional art-historical writing, deeply rooted in the nineteenth century, has a strongly chauvinistic bias. Searching for the roots of Haarlem art of the 1610s would have meant looking at the art of the Southern Netherlands. Until recently such a gaze across national borders was by no means obvious to art historians. Pieter Geyl's eloquent protest against the application of modern political divisions to old Netherlandish art has had little or no effect for decades. Recent research has established beyond the shadow of a doubt the significance of the immigration of the Southern Netherlandish artists to the North.[66]

There appear to be no conclusive arguments for establishing a chronological division (circa 1610–1620) between two chief periods when describ-

ing general developments in Netherlandish art. One can no longer ignore the question of which division or arrangement provides more insight into the history of Netherlandish art. That attempts to finding a good solution have not yet yielded satisfactory results means only that the problem has thus far been approached incorrectly. Though interwoven with the concept of "realism," this is not the issue at hand. I cannot, therefore, elucidate the argument that introducing caesuras circa 1510–1520, 1565–1575, and 1710–1720 could enlarge our understanding of the character of Netherlandish art as much as the divisions of circa 1610–1620 and 1669 hinder it.

NOTES

1. There is a vast amount of literature on the problem of realism. I name here only a few publications: Peter Demetz, "Defenses of Dutch Painting and the Theory of Realism," *Comparative Literature* 15, no. 2 (Spring 1963): 97–115; E. de Jongh, "Realisme en schijnrealisme in de Hollandse schilderkunst van de zeventiende eeuw," in Paleis voor Schone Kunsten, *Rembrandt en zijn tijd*, exh. cat. (Brussels: La Connaissance, Europalia, 1971), 143–94; Svetlana Alpers, "Breugel's Festive Peasants," *Simiolus* 6 (1972–1973): 163–76: Hessel Miedema, "Over het realisme in de Nederlandse schilderkunst van de zeventiende eeuw," *Oud-Holland* 89 (1975): 2–16; Svetlana Alpers, "Realism as a Comic Mode," *Simiolus* 8 (1975–1976): 115–44; Hessel Miedema, "Realism and Comic Mode," *Simiolus* 9 (1977): 205–19; Svetlana Alpers, "Taking Pictures Seriously: A Reply to Hessel Miedema," *Simiolus* 10 (1978–1979): 46–60; Eric J. Sluijter, "Belering en verhulling: Enkele 17de-eeuwse teksten over de schilderkunst en de iconologische benadering van Noordnederlandse schilderijen uit die periode," *De zeventiende eeuw* 4, no. 2 (1988): 2–28.

2. Heinrich Wölfflin, *Kunstgeschichtliche Grundbegriffe*, 13th ed. (Basel: Schwabe, 1963), 13.

3. Tobias van Westrheene Wz. saw a battle between convention and naturalness in the art of his own time (*Jan Steen: Etude sur l'art en Hollande* [The Hague: M. Nijhoff, 1856], 18). Therefore, the contrast between Dutch realism and Italian convention in the seventeenth century was topical: *"L'art typique conventionnel fleurit en Italie"* (Typically conventional art flourished in Italy), 20–21. W. Bürger [T. E. J. Thoré], *Musées de la Hollande* (Paris: Veuve Jules Renouard, 1860), 2: xv: *"Or, l'art hollandais est le premier qui ait renoncé à toute imitation du passé, et qui se soit tourné vers du neuf"* (Dutch art was the first to renounce all imitation of the past and to turn itself to the new). Eugène Fromentin, *De meesters van weleer*, ed. Henri van de Waal (Rotterdam: Ad. Donker, 1951), 102–3 (translation of the French edition of 1876): *"Nooit heeft enig land zijn kunstenaars…met meer nadruk gedwongen origineel te zijn, op straffe van in het geheel niet te zijn"* (No country ever compelled its artists so urgently to be completely original, on pain of

not being at all). Willi Drost, *Barockmalerei in den germanischen Ländern: Handbuch der Kunstwissenschaft* (Wildpark-Potsdam: Akademische Verlagsgesellschaft Athenaion, circa 1926), 118–19: *"der Sieg des Realismus über die von Italien abhängenden Gruppen…die mit der Tradition brechende, betont bodenständige Richtung"* (the victory of realism over the groups depending on Italy…the emphatically indigenous direction which breaks with tradition). Richard Hamann, *Geschichte der Kunst von der altchristlichen Zeit bis zur Gegenwart* (Berlin: Th. Knaur Nachf., 1933), 584: *"die holländische Kunst…ihre erste Phase mit einem Protest gegen den Formalismus erfüllte"* (Dutch art…its first phase resulted from a protest against formalism), and 598: *"Radikal und revolutionär kämpfte man für die Natur"* (Radically and rebelliously they strove for nature).

4. For instance, compare François-Xavier de Burtin, *Traité théorique et pratique des connaissances qui sont nécessaires à tout amateur des tableaux* (Brussels: Impr. de Weissenbuch, 1808), 1: 178–79. De Burtin is quoted with approval by Van Westrheene (see note 3), 9. See further ibid., 19–20. As late as 1941 historian Johan Huizinga stated that the Dutch painters *"nauwelijks wisten, wat stijl beteekende"* (hardly knew what style meant) (Johan Huizinga, *Nederlandse beschaving in de zeventiende eeuw: Een schets* [Haarlem: H. D. Tjeenk Willink & Zoon, 1941], 137, [a reworking of a lecture given almost ten years earlier]).

5. Italian art was usually seen as based on abstract ideas, while Dutch art was considered to be based on observations of reality. Therefore, Dutch art was supposed to lack an intellectual component. For example, Bürger (see note 3), xiii: *"le principe de l'art hollandais: Faire ce qu'on voit et ce qu'on sent. Le reste dépend du génie"* (the premise of Dutch art: do what one sees and what one feels. The rest depends on genius). See also Van Westrheene (see note 3), 19–20; W. Martin, *De Hollandsche schilderkunst in de zeventiende eeuw* (Amsterdam: J. M. Meulenhoff, 1935), 1: 71: *"Al is hun kunst er ook bij uitstek een van gevoelen en kijken en niet een van bedenken, formuleeren en weten"* (Admittedly, theirs is primarily an art of sensibility and observation, not of reflection, articulation, and knowledge).

6. Charles Blanc, *Histoire des peintres de toutes les écoles: École hollandaise* (Paris: Librairie Renouard, 1861–1877), 1: 1–20 (introduction). Blanc describes Dutch art as being like the ideal Dutch house, in which each room is a genre painting by another master. Compare Drost (see note 3), 186:

Aber zusammengesetzt ergeben diese Mosaikstücke ein Gesamtbild, in welchem sich keine Lücke findet. Man fasst diese Kleinkunst am besten als ein intimes Tagebuch auf, in dem alles Alltägliche zur Sprache kommt.

(But, put together, these tesserae provide a complete image without any holes. We can best consider this minor art as an intimate diary, in which everything commonplace is touched upon.)

7. Jan A. Emmens, *Rembrandt en de regels van de kunst* (Amsterdam: G. A. van Oorschot, 1979), vol. 2.

8. See John Michael Montias, *Artists and Artisans in Delft: A Socio-Economic Study of the Seventeenth Century* (Princeton: Princeton Univ. Press, 1982); and idem., "Art Dealers in Seventeenth-Century Netherlands," *Simiolus* 18, no. 4 (1988): 244–56. See also Albert Blankert, *Kunst als regeringszaak in Amsterdam in de 17e eeuw: Rondom schilderijen van Ferdinand Bol* (Lochem: De Tijdstroom, 1975); and Gary Schwartz, *The Dutch World of Painting*, exh. cat. (Vancouver: Vancouver Art Museum, 1986).

9. See Herman Pleij, *Het gilde van de Blauwe Schuit*, 2nd ed. (Amsterdam: Meulenhoff, 1983), and other publications by the same author.

10. Albert Blankert et al., *Gods, Saints and Heroes: Dutch Painting in the Age of Rembrandt*, exh. cat. (Washington, D. C.: National Gallery of Art, 1980).

11. See Ad van der Woude, "The Volume and Value of Paintings in Holland at the Time of the Dutch Republic," in this volume, and Montias, 1982 (see note 8), chap. 8.

12. Emmens (see note 7), 2: 144; *"In deze voor ons chaotische reeks zal door het klassicisme en de 18de eeuwse esthetiek rigoreuze ordening worden gebracht"* (In this enumeration, which strikes us as chaotic, classicism and eighteenth-century aesthetics will create a strict hierarchy).

13. Karel van Mander, *Den grondt der edel vry schilder-const*, ed. Hessel Miedema (Utrecht: Haentjens, Dekker & Gumbert, 1973), 2: 343, 345, 348, 560. Cf. also Samuel van Hoogstraten, *Inleyding tot de hooge schoole der schilderkonst* (Rotterdam: F. van Hoogstraeten, 1678), 69–73.

14. Johan van Gool, *De Nieuwe Schouburg* (The Hague, 1750; facs. ed., Soest: Davaco, 1971), 1: 81.

15. Jacob Campo Weyerman, *De levens-beschryvingen der Nederlandsche konstschilders en konst-schilderessen*, vols. 1–3 (The Hague: E. Boucquet, 1729), vol. 4 (Dordrecht: A. Blusset & Zoon, 1769), see 1: 27; 3: 359, 387; Lyckle de Vries, "Jacob Campo Weyerman und Johan van Gool," *Mededelingen van de Stichting Jacob Campo Weyerman* 12, no. 1 (1989): 1–7.

16. The clearest example of the misunderstandings that this aspect of Dutch art caused for later critics is Reynolds's judgment of Jan Steen's history scenes. Joshua Reynolds, *Sir Joshua Reynolds: Discourses on Art*, ed. R. R. Wark (New Haven: Yale Univ. Press, 1981), 236, 13th discourse.

17. Jay Richard Judson, *Dirck Barendsz., 1534–1592* (Amsterdam: Van Gendt, 1970), nos. 57 and 71; F. W. H. Hollstein, ed., *Dutch and Flemish Engravings, Etchings, and Woodcuts, ca. 1450–1700* (Amsterdam: Menno Hertzberger, 1955), 11: 165, no. 175 (Van Mander); see also George S. Keyes, *Hollstein's Dutch and Flemish Etchings, Engravings, and Woodcuts*, ed. K. G. Boon (Amsterdam: Van Gendt, 1980) 23: 73–74, nos. 97 and 98.

18. Here I follow Pleij (see note 9), chap. 4: "Van standenideologie naar burgermoraal."

19. Konrad Renger, "Bettler und Bauern bei Pieter Breugel d.Ä," *Kunstgeschichtliche Gesell-*

schaft zu Berlin: Sitzungsberichte 20 (Berlin: Gebr. Mann Verlag, 1971–1972): 9–16; Keith P. F. Moxey, "Sebald Beham's Church Anniversary Holidays: Festive Peasants as Instruments of Repressive Humor," *Simiolus* 12 (1981–1982): 107–30; Paul Vandenbroeck, in *Beeld van de andere, vertoog over het zelf*, exh. cat. (Antwerp: Koninklijk Museum voor Schone Kunsten, 1987), 63–116; Hans-Joachim Raupp, *Bauernsatiren: Entstehung und Entwicklung des bäuerlichen Genres in der deutschen und niederländischen Kunst ca. 1470-1570* (Niederzier: Lukassen, 1986).

20. Even without statistical analysis of the material, it is clear how current these themes were in genre art. Approximately one-third of the works in the exhibition *Tot lering en vermaak* (Amsterdam, Rijksmuseum, 1976) had to do with love or eroticism. A comprehensive publication on the issues of love, erotica, and sexuality as represented in Dutch genre art does not exist. See (among others) E. de Jongh, "Erotica in vogelperspectief: De dubbelzinnigheid van een reeks 17de eeuwse genrevoorstellingen," *Simiolus* 3 (1968–1969): 22–74; Alison G. Stewart, *Unequal Lovers: A Study of Unequal Couples in Northern Art* (New York: Abaris, 1978); Petty Bange et al., *Tussen heks en heilige* (Nijmegen: SUN/Nijmeegs Museum "Commanderie van Sint-Jan," 1985).

21. Pleij (see note 9); idem, "De sociale funktie van humor en trivialiteit op het rederijkerstoneel," *Spektator: Tijdschrift voor Neerlandistiek* 5 (1975–1976): 108–27.

22. P. Vandenbroeck, "Verbeeck's Peasant Weddings," *Simiolus* 14 (1984): 79–124. Bruegel also painted a few works in tempera on canvas, though later painters stopped using this technique.

23. I introduce this hypothesis here as a contribution to the clarification of the great stylistic differences that exist in Bruegel's oeuvre. Compare his painting of the Proverbs, 1559 (Berlin-Dahlem, Staatliche Museen) to the engraving by Frans Hogenberg, *"Die Blav Hvicke is dit meest ghenaemt, Maer des Weerelts Abvisen he(m) beter betaempt"* (This is commonly known as the Blue Cloak [deceit], but the shortcomings of the world would be more appropriate). This engraving is not in Hollstein; a copy is in the Royal Library, Brussels.

24. Konrad Renger, *Lockere Gesellschaft: Zur Ikonographie des verlorenen Sohnes und von Wirtshausszenen in der niederländischen Malerei* (Berlin: Gebr. Mann Verlag, 1970).

25. The ideas that I develop in this paragraph are meant to contribute to the clarification of the fact that painted genre scenes cause a great number of problems of interpretation.

26. Jan A. Emmens, "Eins aber ist nötig," in *Kunsthistorische Opstellen 2* (Amsterdam: G. A. van Oorschot, 1981), 4: 189–221. Carl Gustaf Stridbeck, *Bruegelstudien* (Stockholm: Almqvist & Wiksell, 1956), 192–206.

27. John Michael Montias has convincingly demonstrated the connection between the style and technique of monochrome painters of the generation of Jan van Goyen, on the one hand, and the speed and volume of their production and their (low) prices on the other. Obviously, other artists worked slowly, their execution was precise, and their small production made their works scarce and expensive. The price of a painting by Gerrit Dou was determined by the actual

number of hours he spent working on it (John Michael Montias, "Cost and Value in Seventeenth-Century Dutch Art," *Art History* 10 [1987]: 455–66).

28. De Jongh (see note 1), indicated that the *soortelijk gewicht* (specific density) of the moralizations in seemingly realistic paintings differs greatly; sometimes a serious didactic intent can be suspected, sometimes the intention appears less strong or is even entirely absent.

29. Lyckle de Vries, *Jan Steen "de kluchtschilder"* (Groningen: privately printed, 1977), 83–88. The translation "iconographic erosion" is from Peter C. Sutton, *Pieter de Hooch: Complete Edition with a Catalogue Raisonné* (Oxford: Phaidon, 1980), 67, nn. 9, 47, and 48.

30. This opinion in all its permutations is the one most often repeated with regard to Dutch painting. For a few arbitrary examples see J. H. Wilhelm Tischbein, "Aufenthalt in Holland, 1772–1773," in *Aus meinem Leben*, ed. Carl G. W. Schiller (Braunschweig: C. A. Schwetschke & Sohn, 1861), 1: 106: *"Seine Künstler haben alles gemalt, wie es da ist"* (Its artists painted everything exactly as it exists). Bürger (see note 3), xiv: *"Les Hollandais ont peint à la perfection leurs compatriotes. Ce que l'esthétique leur reproche, ce n'est que leur sincérité."* (The Dutch painted their compatriots to perfection. What they are reproached for aesthetically is only their sincerity). Christiaan Kramm, *De levens en werken der Hollandsche en Vlaamsche kunstschilders, beeldhouwers, graveurs en bouwmeesters* (Amsterdam, 1861), 5: 1563: *"Photographiën der natuur"* (Photographs of nature). C. Lemcke, "Jan Steen," in *Kunst und Künstler des Mittelalters und der Neuzeit*, ed. R. Dohme, first section, vol. 2 (Leipzig: E. A. Seemann, 1877–1886), 4, nos. 27–28: *"Je näher dem Leben, je besser der Maler!"* (The closer to life, the better the painter). Karl Woermann, *Geschichte der Kunst aller Zeiten und Völker*, 2nd ed. (Leipzig: Bibliographisches Institut, 1920), 5: 291: *"Naturkunst, ja Wirklichkeitskunst blieb die holländische Malerei…vom Anfang bis zum Ende"* (The art of nature, yes even the art of reality, this is what Dutch art remained from beginning to end).

31. G. R. Owst, cited in Pleij (see note 9).

32. Erwin Panofsky, *Early Netherlandish Painting* (Cambridge, Mass.: Harvard Univ. Press, 1953), 131–48.

33. Josua Bruyn, *Over het voortleven der Middeleeuwen* (Amsterdam: M. Hertzberger, 1961).

34. Pleij (see note 9).

35. Cornelis de Bie, *Het gulden cabinet van de edel vry schilderconst* (Antwerp: Ian Meyssens, 1661; facs. ed., Soest: Davaco, 1971), 258: *"Hoe neerstich slaet OSTADI ga.… Oft waer dat Fop de mestkair vuert/Oft brenght de peerden op het landt/Die hy daer inde ploeghe spant"* (How diligently Van Ostade observes.… How Fop [a peasant] drives the dung-cart or leads his horses to the field where he puts them to the plough).

36. De Jongh (see note 20), especially his remarks on the *schaamtegrens* (threshold of modesty).

37. Jan Białostocki, "Das Modusproblem in den bildenden Künsten," in *Stil und Ikono-*

graphie (Dresden: Verlag der Kunst, 1966; 2nd ed., Cologne: DuMont, 1981), 12–42; see Alpers, 1975–1976 (see note 1), 115–44.

38. The clearest examples are the play *Trijntje Cornelisdr.* by the courtier and diplomat Constantijn Huygens in which two different dialects are employed, and the farces and comedies *Klucht van de Koe, Klucht van de Molenaer, Moortje,* and *Spaanschen Brabander* by the distinguished citizen of Amsterdam Gerbrand Adriaensz. Bredero.

39. In exceptional cases, however, poets appealed to what was customary for painters. See L. Ph. Rank, J. D. P. Warners, and F. L. Zwaan, eds., *Bacchus en Christus: Twee lofzangen van Daniel Heinsius* (1616; Zwolle: W. E. J. Tjeenk Willink, 1965), 101:

> *Ander hebben dat bedectelicker gedaen, ende schrijvende de lof vande Goden, der selver schanden ende leelickheden ontdect, als ick meyne dat wy oock gedaen hebben.... Gelijck nu noch de schilders doen, die niemant qualick af en neemt, dat zy het gebreck van dronckenschap, ende natuer van de dranck, alsoo te kennen geven.*

> (Others did so less openly [i.e., reviewed human shortcomings as though they were discussing classical gods], and when writing in praise of the gods they uncovered their disgraces and evils, just as I believe we [Daniel Heinsius] have also done [i.e., in writing a panegyric on Bacchus].... Just as painters still do nowadays, whom nobody blames for exposing the faults of inebriation and the nature of alcohol in precisely this way [i.e., while seemingly promoting the habit of drinking].)

40. In the "Mey-clacht," Adriaen van de Venne pleads for *"sinne-cunst"* (visual art with an intellectual content) as the highest form of the visual arts and the one that, through its literary content, is intimately connected to poetry and is thus of equal merit. Great emphasis is placed on the edifying task of painting. In the volume of poetry *De zeevsche nachtegael* Van de Venne's "Sinne-mal" is included along with the "Mey-clacht." The poems in this volume that have peasant and folk subjects are fundamentally equated with genre paintings in a separate *voor-reden* (preface). Considering that they had a didactic intention, they were unconditionally considered as *sinne-cunst.* This is said in the preface with regard to (visual and literary) art with folk subjects in general and further elucidated for each poem in the volume (Adriaen van de Venne, "De zeevsche mey-clacht, ofte schyn-kycker," in *De zeevsche nachtegael,* ed. P. J. Meertens and P. J. Verkruijsse [Middelburg: I. P. van de Venne, 1623; Middelburg: Verhage & Zoon, 1982], 91–104); idem, "Tafereel van Sinne-mal," 255–366.

41. Erwin Panofsky, *Albrecht Dürer* (Princeton: Princeton Univ. Press, 1948), 1: 273: "Like all his Italian contemporaries and predecessors, Dürer demanded verisimilitude and was specific in his repeated exhortations...to elaborate on the smallest details."

42. Ibid., 266, 274.

43. Ibid., 275.

44. Ibid., 283–84.

45. Emmens (see note 7), 2: 163: *"Dann es ist eine grosze Kunst, welcher in groben bäurischen Dingen ein rechten Gwalt und Kunst kann anzeigen"* (But it is great art, which can demonstrate real creative power and insight in coarse and boorish objects). See also Panofsky (see note 41), 274, 283.

46. For example, see Uwe M. Schneede, "Gabriel Metsu und der Holländische Realismus," *Oud Holland* 83 (1968): 45–61. See further (among others) De Jongh (see note 1). This insight is found earlier in Max J. Friedländer, *Essays über die Landschaftsmalerei und andere Bildgattungen* (The Hague: A. A. M. Stols, 1947), 207:

Der Genremaler bildet scheinbar, was er mit leiblichem Auge erblickt hat. Streng genommen, hat er es nicht erblickt, wenigstens nicht im Zusammenhang. Entscheidend ist der Eindruck: er...könnte es im alltäglichen Ablaufe des menschlichen Daseins erblickt haben.

(The genre painter appears to illustrate what he has seen with his own eyes. But strictly speaking, he has not seen it, that is, not as a coherent whole. Decisive is, whether or not he creates the impression that he...could have seen it in regular, daily life.)

47. Van Hoogstraten (see note 13), 187:

En zeker, de geene die zich bevlytigen iets uit te beelden, daer niet waerdichs in te zien is, besteeden haren vlijt qualijk.... Maer, ô Herkules! wat zal men dan met den meesten hoop der snorrepijpen, van veel onzer lantsluiden, uitrechten? Hier met een Sitroen, en daer met een queepeer,...Het minste datmen ter handt slaet, behoort een volkomen zin te hebben.

(Those who diligently depict something that comprises no element of any value certainly apply their diligence poorly.... But, O Hercules, what to do with most of the trifles created by so many of our compatriots? Here a lemon, there a quince,...the least thing one puts his hand to should have a proper meaning.)

Even though Van Hoogstraten did not negatively judge such specializations as still lifes and landscapes, he was obviously not in a position to recognize *een volkomen zin* (proper meaning) in *snorrepijpen* (trifles) now interpreted as painted moralizations.

48. Gerard de Lairesse, *Groot Schilderboek* (2nd ed., Haarlem: Johannes Marshoorn, 1740; facs. ed., Soest: Davaco, 1969), 2: 268: *"Dat de Stillevens gemeenlyk zonder zin verbeeld worden"*

(That still lifes are mostly depicted without having any meaning) is the marginal note to a paragraph in which Willem Kalf is named as a bad example. The author fiercely attacks traditional genre painting naming *"Bamboots, Ostade, Brouwer, Molenaer"* as bad examples (1: 167–74). A marginal notation on this reads *"De Moderne Konst [genre] werd als een handwerk gereekent"* (Genre is considered a craft), 172. See also note 52.

49. The historian of art "uses style as a criterion of the date and place of origin of works.... But the style is, above all, a system of *forms with a quality* and a meaningful expression through which the personality of the artist and *the broad outlook of a group* are visible. It is also a vehicle of expression within the group, communicating and fixing certain values of religious, social, and moral life through *the emotional suggestiveness of forms*," see Meyer Shapiro, "Style," in *Anthropology Today*, ed. A. L. Kroeber (Chicago: Univ. of Chicago Press, 1953), 287–312 (my italics).

50. Compare, for instance, Michiel van Miereveld's "Mannerist" history paintings with his "realistic" portraits, or Adriaen van de Velde's "realistic" landscapes and cattle pieces with his "classicizing" religious works.

51. See notes 41–45, above.

52. De Lairesse (see note 48), 1: 418–34; Emmens (see note 7), 2: 152–69.

53. E. H. Gombrich, "The Renaissance Theory of Art and the Rise of Landscape," in *Norm and Form: Studies in the Art of the Renaissance* (London: Phaidon, 1966), 107–21.

54. Lyckle de Vries, "Hat es je eine Delfter Schule gegeben?" in *Probleme und Methoden der Klassifizierung*, ed. Elisabeth Liskar, Akten des XXV. Internationalen Kongresses für Kunstgeschichte, vol. 3, sec. 3 (Vienna: Hermann Böhlaus Nachf., 1985), 79–88.

55. See note 27. At some stage of his career, Jan Steen must have tried to find a solution for his financial difficulties by making many inexpensive and rapidly produced works. In contrast to his father-in-law, Jan van Goyen, the technical quality of Steen's work seems to have suffered in the process. This could explain the fact that quite a few of his paintings are now in poor condition. Perhaps he was an exception in comparison with his contemporaries; it is possible also that most of the inexpensive seventeenth-century paintings were less soundly executed than those of the artistically and commercially successful top layer that are still extant. See also note 11.

56. Eric J. Sluijter, " 'Een volmaekte schilderij is als een spiegel van de natuer': Spiegel en spiegelbeeld in de Nederlandse schilderkunst van de 17de eeuw," in *Oog in oog met de spiegel*, ed. N. J. Brederoo et al. (Amsterdam: Aramith Uitgevers, 1988), 146–65.

57. Surveys of still life painting rarely discuss the abrupt increase in production around 1600 which is, nevertheless, easy to determine with the help of an extensive photo collection such as the Rijksbureau voor Kunsthistorische Documentatie in The Hague. The cause of this lacuna is the tenacious, traditional view that still life, along with the other genres, gradually developed from fifteenth-century roots. See for instance Friedländer (see note 46), 358: *"In der niederländischen Malerei des 15. und 16. Jahrhunderts verfolgt der Historiker das Aufkeimen des*

Stillebens" (In Netherlandish art of the fifteenth and sixteenth centuries, the historian sees the germination of the still life). This theory of evolution was never sufficiently founded and rests on premises that have been abandoned. Even if the market and kitchen scenes by Aertsen and Beuckelaer could be interpreted as independent still lifes, which, given Emmens's convincing interpretation (see note 26), is incorrect, the number of flower, fruit, *pronkstillevens* (sumptuous still lifes), and mixed still lifes created around 1600 by far surpasses the number of sixteenth-century incunabula. The iconographic similarity between seventeenth-century still lifes and late medieval traditions demonstrated by Bergström cannot be used as proof of continuity in the production of still lifes in the sixteenth century or of the existence of an unbroken stylistic tradition (Ingvar Bergström, *Dutch Still-Life Painting in the Seventeenth Century* [London: Faber & Faber, 1956], 4–41).

58. Lyckle de Vries, "Jan Steen zwischen Genre- und Historienmalerei," *Niederdeutsche Beiträge zur Kunstgeschichte* 22 (1983): 113–28.

59. Emmens (see note 26).

60. R. Keyselitz, "Der 'Clavis interpretandi' in der holländischen Malerei des 17. Jahrhunderts," (Ph.D. diss., Munich Univ., 1956).

61. E. de Jongh, *Tot lering en vermaak: Betekenissen van Hollandse genrevoorstellingen uit de zeventiende eeuw*, exh. cat. (Amsterdam: Rijksmuseum, 1976), 176–79.

62. This is evident from nineteenth-century overpainting, which camouflaged urinating figures in works by Jan Steen and others. Countless condemnations of Dutch genre art as vulgar can be found in eighteenth- and nineteenth-century literature on art. Writers who valued Dutch art felt obliged to justify themselves as a result. Blanc did this in an original fashion (see note 6), 15:

> *Ses artistes ont reproduit la nature telle quelle, triviale et laide quand elle était laide et triviale; mais ils l'ont vue avec une naïveté si touchante, avec un amour si sincère et si profond, qu'ils sont parvenus à nous intéresser à elle,… Rien dans le monde, ou plutôt dans leur patrie, ne leur a paru grossier, vulgaire ou insignifiant. Les matelots s'enivrant à la fête, les marauds au cabaret, les fumeurs de Brauwer, les paysans d'Ostade, c'étaient les gueux de mer qui avaient battu l'Anglais à Dunkerque et l'Espagnol à la bataille des Dunes; c'étaient les vieux soldats de Martin Tromp et Guillaume: ils avaient le droit de se reposer et de boire.*

(Its artists have reproduced nature as it was, as trivial and ugly when it was trivial and ugly; but they saw it with such touching naïveté, and a love so sincere and profound that they managed to interest us in it…. Nothing in the world, or rather in their nation, seemed coarse, vulgar, or insignificant to them. The sailors getting drunk at a fête, the knaves at an inn, Brouwer's smokers, Van Ostade's peasants, they were the Beggars of the Sea who

fought the English at Dunkerque and the Spanish at the Battle of the Downs; they were Maarten Tromp's and William's old soldiers: they had the right to rest and to drink.)

Blanc's argument can be seen as a variant on a comment by de Burtin (see note 4), 201: Admirers of Italian art who condemn Dutch art must keep in mind

> *que ces paysans, qu'ils appellent magots, sont leurs semblables, beaucoup plus intéressants qu'eux, par leur utilité, quoique couverts d'habits plus simples; et qu'ils sont d'autant plus respectables, aux yeux de l'observateur sensé, qu'ils lui présentent l'homme moins corrompu, moins masqué, et plus près de l'état de nature.*

(that these peasants, whom they denounce as apes, are their equals, [and] much more interesting than they are, because [of] their usefulness, though wearing more simple attire; [keep in mind], that in the opinion of a sensible observer, they are more respectable, insofar as they confront him with a less corrupted mankind, which dissimulates less and is closer to a natural state.)

63. Whether the stylistic changes that began to play a role in the middle of the century were the cause or the result of the increasing appreciation enjoyed by the visual arts, I dare not say. Preciousness, sophistication, and refinement appear to be key words to describe art of the third quarter of the century. In the last quarter of the seventeenth century the quantity of art production began to decline, while the status of the art of painting increased. Soon thereafter the prices of painting also rose quickly (see Lyckle de Vries, *Diamante gedenkzuilen en leerzaeme voorbeelden: Een bespreking van Johan van Gools Nieuwe Schouburg* [Groningen: Egbert Forsten, 1990], 87–101).

64. Egbert Haverkamp-Begemann, "Joos van Liere," in *Pieter Bruegel und seine Welt*, ed. O. von Simson and M. Winner (Berlin: Gebr. Mann Verlag, 1979), 17–28.

65. Albert Blankert, "Classicisme in de Hollandse schilderkunst" (see note 10), 183: *"Goltzius' voorbeeld maakte Haarlem tot het eerste centrum van het Hollands classicisme"* (Goltzius's example turned Haarlem into the first center of Dutch classicism). Naturally, Antwerp classicism as practiced by Maerten de Vos and Otto van Veen, among others, had originated earlier. The still insufficiently researched contribution of Abraham Bloemaert to the development of classicism seems to be underrated in my opinion. See also Lyckle de Vries, "Groepen en stromingen in de Hollandse historieschilderkunst," *Nederlands kunsthistorisch jaarboek* 33 (1983): 1–19.

66. Jan G. C. A. Briels, *Zuid-Nederlanders in de Republiek, 1572–1630* (Sint-Niklaas: Danthe, 1985); and idem, *Vlaamse schilders in de Noordelijke Nederlanden: In het begin van de gouden eeuw* (Haarlem: H. J. W. Becht, 1987).

PART II: ART, ECONOMY, AND SOCIETY

1. Meindert Hobbema,
The Avenue at Middelharnis, 1689,
oil on canvas, 104 x 141 cm.
London, National Gallery, Peel Collection.
Photo: Courtesy Photo Bulloz, all rights
reserved.

248

Jan de Vries

Art History

Art history and economic history have this in common: neither is readily integrated into what, for want of a better term, I will call general history. Both are specializations strongly oriented toward autonomous disciplines possessing distinct methods and theories. Such specialization offers real advantages to scholarship but also exacts its price. History is a discipline of context; it suffers when vast sectors of human experience are treated as separate domains that are appended to, but do not form an integral part of, the enterprise of historical explanation.

Any proposal to remedy this state of affairs, however modest, requires some consideration of the intellectual framework in which the historian's contextualizing activity takes place, and an essential element of that bundle of assumptions and theories is periodization. Historians are not much given to introspection. Perhaps because they so rarely call attention to the philosophical underpinnings of their enterprise — or even to the academic concepts on which they rely for everyday explanations — periodization is usually regarded as a sterile and uninteresting subject. Either it is considered a simple matter of convenience for the historian who, after all, must begin and end a study somewhere, or it is treated as a necessary evil, artificially rending the seamless web of history for the sake of convention and practicality.

Historical periodization is not nearly so innocent an activity as these defenses suggest. It is not simply a matter of convenience but of commitment: periodization indicates how we think that "history happens." Western history's basic periodization imposes a dramatic, familiar division: antique, medieval, modern. This invention arose during the Renaissance when prominent figures were such masters of self-publicity that the claims

that they made for themselves (and against others) have been accepted by most historians at face value ever since.

The periodization of modern history was founded on cultural terms, but these gradually shifted and became political. This too has had strong implications for the historical explanation of all types of phenomena. Ultimately, everything was made to fit a politics-based historical narrative, which cited the Renaissance as the cultural origin of modernity. The implications for historical inquiry are self-evident: whole categories of historical questions are, as a result, almost impossible to ask, let alone answer.

This historical paradigm no longer remains unchallenged. Prior to World War II a critique emerged, and among the last generation of historians a well-articulated alternative took shape. This "New History" rejected both the narrative form of organization and politics-based periodization, advocating instead analytical organization of historical data and a new periodization.[1] But on what was this to be based? One historian recently described the New History as based on "periods more closely related to the historical process itself."[2] But this leaves the "historical process" undefined. A clue is offered by Fernand Braudel, who in his essay of 1958, "History and the Social Sciences" minced no words in identifying what does *not* constitute the historical process. He focused on the "continued allegiance of scholars to a *pernicious humanism*, which," he argued, "can no longer serve as a framework" for research in either the social sciences or history.[3] The New History has sought to make history a modern academic discipline, that is to say, to make it scientific: capable of participating in the development of social theory. To be suited to this purpose, history has had to broaden its gaze beyond the old humanist agenda. No single cause can claim full credit for this breach in historiography, but the most profound factor was discomfort with a narrative form that greatly restricted the types of historical experiences available for explanatory purposes. Narrative history had the ball and chain of the discrete, short-term historical event, or *histoire événementielle* attached to it.

The first, enduring achievement of the movement to construct a New History has been to change our thinking about a key concept: time, or duration. And it is here that we find the basis for the new periodization. In an article written over thirty years ago, Braudel discussed this subject: "Traditional history, given its attention to the short term, the individual, and the event, accustomed us long ago to its sudden, dramatic, breathless narrative.

The most recent economic and social history brings cyclical oscillations into the forefront of its research." (In this context Braudel emphasized price history; one might now add demography and foreign-trade patterns.) He went on to state "that there is today, alongside traditional narrative, the description of the conjuncture, enquiring into large sections of the past, 10, 20, or 50-year periods.... Beyond this second type of narration again, there is a history of even more sustained breadth, embodying hundreds of years: it is the history of very long time periods."[4] Braudel asserted that this long-term history is the opposite of the short-term event, which he demoted to the status of historical flotsam and jetsam. "The event is explosive, it is something new. It blinds the eyes of contemporaries with clouds of smoke; but it does not endure, and its flame is hardly visible."[5] After all these years this statement still rankles. The message should be clear: the historian must develop and deploy a more complex concept of duration, one that is capable of incorporating into historical explanation phenomena that make themselves felt over time spans longer than "the sudden, dramatic, and breathless event."

It is possible to support these claims on the basis of grand theory, but I am attracted to them more for their obvious usefulness in interpreting historical evidence. The new concept of duration expands our notions about potentially fruitful contexts for historical explanation. And what is history if it is not a discipline of context and duration, both of which must guide and constrain social theory? The expanded context made possible by a more complex concept of duration has robbed traditional history of its power to convince — not because mere events cannot be important but because we know they are not sovereign and we ask for interpretation not possible in conventional narrative. The British cultural historian Peter Burke introduced volume thirteen of the *New Cambridge Modern History* (which he edited) by noting the following: "In the Twentieth Century we have seen a break with traditional narrative history, which like the break with the traditional novel or with representational art, or with classical music, is one of the important cultural discontinuities of our time."[6]

While the New History has cast doubt on the efficacy of the old forms of periodization by attacking the narrative history that is so closely associated with them, a second line of attack has been more direct, eroding support for the intellectual suppositions of periodization. Consider the words of the Renaissance historian William Bouwsma, who opened his presidential

address to the American Historical Association in 1978 as follows: "I should like to discuss a remarkable historiographical event.... This event is the collapse of the traditional dramatic organization of Western history." By this Bouwsma meant the abandonment of or indifference to the notion of the Renaissance as the origin of modernity. He continued to note that "since we are baffled by the modern world, we are hardly in a position to argue for the relevance to it...of the Renaissance."[7] Bouwsma identified several factors that helped to rob the Renaissance of its centrality, but one that received much of his attention was the New History, which depreciates the sovereign importance of high culture and establishes a periodization — understood as intelligible temporal unities — on wholly different grounds.

The most radical statement of the New History's challenge to the dramatic organization of Western history is E. Le Roy Ladurie's inaugural lecture of 1973 to the College de France. He used that dramatic occasion to argue that French history from the eleventh to the eighteenth century had been essentially motionless. The key feature of that long period was the work of "twelve to thirteen generations of peasants who were busy reproducing themselves within limits of finite possibilities whose constraints proved inexorable."[8] This, then, is a periodization of biology rather than class struggle, of economics rather than politics, of technology rather than culture. And what about the non-peasants, the elite? Ladurie dismissed them with a Gallic gesture: "The accomplishments of the elite are situated on a higher and more isolated plane, and are not really significant except from the point of view of a noisy minority."[9]

Surely these historiographical observations can only be received as provocation by such confirmed "pernicious humanists" as art historians, whose scholarly concern is almost by definition event centered (the painting) and culture based (the life of the artist). What could be the value of adopting a methodology that seems to deny the relevance of their chief concerns? My purpose is modest: to explore the possibilities of multidurational and economic-demographic periodizations for cultural analysis. It seems worth pursuing here because the historiographical developments that I have reviewed have had the greatest impact on the study of the "early modern" era (from the Renaissance to the French Revolution), where all theories of modernity seek their origins. And it is here that the Dutch hold, however briefly, center stage. Finally, it is here that the integration of Dutch with European history has repeatedly failed to find satisfactory resolution. Tra-

ditional historiography does not readily accommodate the Dutch Republic in its dramatic organization of modern history. Since this complaint is far from novel, I will limit illustration of it here to three brief examples.

Since its publication in 1941 Johan Huizinga's *Dutch Civilization in the Seventeenth Century* has enjoyed continuing influence as a synthetic interpretation of Dutch culture, and its central message is Dutch exceptionalism: in Baroque Europe the Dutch Republic stood apart. After reciting the characteristic accomplishments of a series of Dutch painters, Huizinga concluded: "All of them breathe a completely different spirit, sound an entirely different note. In fact, in its essentials, the Netherlands of the seventeenth century bore only the slightest resemblance to contemporary France, Italy, or Germany."[10]

A generation later, with the trumpets of European integration ringing in his ears, historian Ivo Schöffer insisted on the essential unity of Dutch and European history. Now the Baroque "reveals itself in Dutch painting," and the Dutch Republic, "while here and there attaining to unexpected heights...was yet every time drawn back to its own place at a junction of waterways, among the great powers, among the civilizations of the West, drawing breath with the rise and fall of the destiny of European nations."[11] Unfortunately, this insistence on presenting the Dutch as "good Europeans" runs aground as Schöffer confronts the most important new unifying concept of European economic and political history: the "general crisis" of the seventeenth century. Schöffer must reject this concept, though it forms the subject of his essay. The general crisis concept has been developed further since then and remains highly influential. But Schöffer correctly sensed that it only reinforced the inconvenient historical doctrine of Dutch exceptionality.

The most recent interpretation of Dutch culture in the seventeenth century, Simon Schama's *Embarrassment of Riches*, returns without apology to the theme of exceptionality. "There was something special about the Dutch situation...that did set it apart from other states and nations in baroque Europe. That something was its precocity."[12] Just what Schama has in mind here is not transparent, given his "shameless eclecticism,"[13] but "precocity" suggests being out of step with others — dealing with problems that do not (yet) trouble others, exploring a social terrain that is still terra incognita to the other European societies.

This brief historiographical survey is far from complete, but it suffices

to render plausible the claim that traditional periodization and its attendant methodology have never served Dutch history very well. It imposed a dramatic organization in which the Netherlands could only perform in subplots and supplied concepts that did more to distort than to reveal. A new periodization based on demographic, economic, and technological factors accommodates the Netherlands more comfortably and allows us to examine afresh the origins of modern society. But it threatens to leave culture, at least high culture, out of the picture. I will now explore some potentially fruitful points of contact.

The most basic periodization scheme developed by the New History is grounded in the long-term interaction between population and the resource-and-technology base of society. This interaction produces trends in real wages and rents and generates a pattern of relative prices. These factors in turn influence the character of the social structure. This complex of interrelated factors traces a slow oscillation of long periods of expansion (population growth, increases in food prices, declines in real wages, increased social inequality) and contraction, sometimes referred to as the "secular trend."[14]

A great challenge facing historians who work with this framework is to extend its applicability from the material and social toward the political and cultural — to achieve a "total history."[15] The concept of a seventeenth-century general crisis is a relatively recent historiographical innovation that seeks to do just that. The concept is variously interpreted, but most variants are specific applications of New History periodization: Europe is plunged into crisis at the point when the long expansionary phase — what Braudel called the "long sixteenth century" — dissolved into its opposite, roughly around the 1620s. Many historians have used this concept to explore the interconnections between economic turning points, political crises, ideologies, and even artistic styles.[16]

A second task before New History periodization is the mapping and analyzing of systematic differences across regions and sectors within the larger secular trend. The Dutch Republic, for example, simultaneously floated on the tides of the secular trend and "precociously" explored uncharted social waters. In certain respects the explosive growth of the Dutch economy in the decades after the revolt against Spanish rule is part of a century-long expansion of the larger European economy. The revolt created an unexpectedly fruitful niche for the intensive exploitation of that favorable environment, but the creativity of economy and society drew on recogniz-

able elements of the "long sixteenth century." A very different approach is necessary to account for the period beginning with the 1620s and extending through the 1660s, when the republic's economy continued to grow, although more slowly, and consolidated its international position — but now in a hostile international environment of crisis and dislocation. Each advance of the Dutch state and economy met strenuous resistance; the era of its "hegemony" was also the era of its most acutely felt exceptionality. After the 1660s most sectors of the republic's economy suffered sharp setbacks not fully offset by new initiatives. The disequilibrating effects of the 1670s and 1680s were only reinforced by a recessionary international economy in which state power came to count for more than market power. If the republic's early expansion was leveraged by its political precociousness, that same quality gave it fewer defenses in this third phase.

The task before us is to relate the sudden, explosive rise of Dutch economic power to the similarly surprising and rapid flowering of Dutch cultural life, especially in the visual arts. Huizinga set the agenda in *Dutch Civilization in the Seventeenth Century* when he wrote: "Truly, Dutch civilization in Rembrandt's day was concentrated in a region not much more than sixty miles square. That this cultural concentration occurred just there and just then remains a most remarkable fact."[17] The issues, then, are as follows: (1) the sudden emergence of a mature Dutch culture; (2) its radical confinement to a restricted area of urban Holland; (3) its lack of strong ties to the rest of Europe; and (4) its sudden demise no more than a century after its emergence (the last is unstated but implicit). How can this agenda in cultural history be related to the periodization of economic history sketched above? The answer depends on how we believe that creativity and production, or, if you prefer, quality and quantity, are related in the cultural sphere.

If creativity and the volume of production are unrelated, the links between economic history and art history must be tenuous, if not insignificant. For example, if we assume that the number of painters and the volume of their output was broadly constant over time, then the emergence of a so-called Golden Age — arising suddenly in a restricted area and endowed with unique characteristics — would have to be explained by focusing on such intangible issues as style, taste, the influence of one or a few great figures, and the effect of their achievements on other artists.

The end of this Golden Age would require a similar explanation: painters painted on, but something corrupted their style, and posterity judges

it inferior. In the words of one art historian, "The end of the Golden Age of Dutch painting…was like the gradual dimming of the golden sunlight as dusk approaches. There was a brilliant afterglow [in the works of a small handful, but]…the great creative surge had ended, along with the period of rapid economic expansion."[18] This confidently asserted but unexamined relationship between the creative surges and the state of the economy is not obvious to all observers. Huizinga expressed both anguish and puzzlement: "What causes such periods of greatness to decline as if they were human lives?" Without conviction he recited such frequently suggested factors as the French influence, changing tastes, and a decline in skill. Huizinga expressed more confidence about what could *not* have contributed: "The change can hardly be ascribed to a social and economic decline: the country was richer than ever, and the demand for paintings as great as before. Nothing stood in the way of new masters and yet they failed to appear."[19] The authorities cited here offer bromides and perplexity, respectively; the topic warrants further consideration.

What can we hope to know about the number of painters active in Holland in the course of the sixteenth, seventeenth, and eighteenth centuries? There are, in fact, three independent sources of information about painters in the Dutch Republic: biographical compendia based on modern museum holdings, attributions of paintings listed in probate inventories of the seventeenth and eighteenth centuries, and membership lists for municipal Saint Lucas guilds.

Each of these sources suffers from serious shortcomings; each is biased and incomplete. But that does not mean that they are of no use to us. To the extent that the biases can be identified and the incompleteness measured, it is possible to reach conclusions about the number of painters active in Holland. Statistical methods make inferences about an underlying "population" on the basis of "samples" drawn from that population. Classical statistics requires that the samples be drawn "randomly" from the population, a requirement rarely met in historical studies and certainly unattainable here. But even with nonrandom samples much can be done. Consider first the information provided by museum holdings. A recent survey of Dutch paintings held in United States museums, Peter C. Sutton's *Dutch Art in America*, is a convenient source. Sutton's appendix, which lists all attributed Dutch paintings by museum and artist, reveals that American museums possess 2,657 paintings by 493 Dutch painters. Of these painters, 17 cannot

be categorized by period of birth and another 52 were born after 1800. This leaves 424 painters born before 1800 and 2,277 paintings, whose distribution across time is displayed in table 1.

The most striking feature of this distribution is the extreme concentration of Dutch artists in a short period: 71 percent of all pre-1800 Dutch artists whose work has been collected by museums in the United States were born in the period 1575–1639. Even more concentrated are the paintings themselves; 85 percent of the paintings were the creations of the artists born in the 1575–1639 period. No one would argue that this "sample" is random. Obviously, it reflects the history of collecting and the acquisition policies of museums in the United States, a fact reinforced by the observation that a mere 19 much-admired Dutch painters produced 22 percent of these paintings. We are dealing, thus, with a sample heavily biased toward the most famous painters of the Golden Age; other painters are underrepresented (table 1).

A second compendium of museum holdings can help determine the degree to which they are underrepresented. Christopher Wright's *Paintings in Dutch Museums* describes some 350 Dutch institutional collections. Altogether, they include over 30,000 paintings. I have identified 1,761 Northern Netherlandish artists born before 1800 from among the over 3,000 painters listed in this volume (see table 1, column 4). It is instructive to compare Sutton's sample with this much larger one. It is reasonable to expect that the collections documented by Wright would make more of an effort to represent Dutch artistic production as a whole and concentrate less on the works of a historically favored few.

In table 1 the distribution across time of the painters included in Dutch museum holdings shows a family resemblance to the United States museum distribution in that a large number of painters are concentrated in the period 1575–1639. Instead of the 71 percent of all pre-1800 painters found in United States museums for this period, however, the Dutch museums show 52 percent. Column 5 shows the ratio of the number of painters found in American museums to that found in Dutch museums. As we would expect, the United States collections score high in the Golden Age (and in the numerically weak pre-1500 period) but neglect Dutch painters born after 1700.

The "sample" of Dutch painters represented by the Wright compilation is less biased than the Sutton study. But it would be rash to conclude that it

257

is unbiased. After all, it too is a product of selective collecting by connoisseurs and curators over decades and centuries. No one would argue that the objective of these decision makers was to leave a representative cross section of Dutch art production to posterity. The problem of collecting bias would not be terribly serious if we knew that a large majority of active artists was represented in these Dutch museums and that the bias of collectors was chiefly expressed in the number of an artist's paintings that had survived; but this is not the case. The research of W. Brulez into the nationality of artists recorded in the massive *Allgemeines Lexikon der bildenden Künstler von der Antike bis zur Gegenwart* (henceforth cited as Thieme-Becker) yielded a total of 1,417 painters born in the Northern Netherlands between 1380 and 1780.[20] He found an additional 981 painters born in the Southern Netherlands. Since Brulez compiled data from every third volume of Thieme-Becker's 37 volumes, we can conclude that the entire *Lexikon* included some 4,250 painters born in the Northern Netherlands and 2,950 Southern Netherlandish painters.

We now have a sample of the population of Dutch painters that is over twice the size of that provided by Wright's *Paintings in Dutch Museums.* Unfortunately, Brulez did not investigate how these painters were distributed by date of birth. Therefore we do not know whether the distribution found in the Wright sample is confirmed by this larger sample, and the task of assembling this information from Thieme-Becker is formidable.

At this point we can pause to take stock of what we know and what we still need to learn about the number of active, professional painters in the Netherlands. Sutton and Wright's surveys of museum holdings allowed us to chart some 1,800 pre-nineteenth-century Dutch painters by their dates of birth. The resulting distribution reveals a great concentration of activity in the period 1575–1639. The number of painters born after 1640 does not gradually decline; it falls abruptly to a much lower level. We must explore further whether this pattern is real or merely reflects its source, museum collections.

The biographical collections of documented painters have been treated as samples of the entire population of Dutch painters for the period 1500–1800. Wright identified approximately 1,760 painters active in the Northern Netherlands while Thieme-Becker yielded a much larger number: some 4,250 painters born in the North between 1380 and 1780. It is clear that the painters represented in Dutch museums are but a small sample of the total population. But does Thieme-Becker approach complete coverage, or does

it too provide only a sample of the total? The two questions posed here —
what was the true distribution of artistic activity over time, and how large
was the population of Dutch painters — can be approached with the use of
two additional sources: probate inventories and guild membership records.

Probate inventories, listings of the possessions of the deceased for pur-
poses of estate administration, exist in large numbers, and historians have
used them to explore many aspects of wealth distribution, economic activ-
ity, and material culture.[21] Paintings were often recorded among the pos-
sessions of deceased Dutchmen, and at times the documents also described
the paintings, assigned a monetary value, and recorded the name of the
artist. This last information is pertinent to our concerns. Most of the paint-
ings recorded in the probate inventories were unattributed, but attributions
are sufficient in number to use as a guide to the active painters of the sev-
enteenth century. That is, we can treat the list of painters identified in a
sample of probate inventories just as we treated the list generated by the
Sutton and Wright museum surveys. Neither sample is complete, and each
is biased, but — and this is the important point — each is generated inde-
pendently of the other. Selection criteria applied to seventeenth-century
private collections were different from those used for modern museum
acquisitions. Therefore, if the characteristics of a probate-inventory-based
sample of painters were to prove similar to the museum-based sample, we
could be more confident that those characteristics were not simply an arti-
fact of the source.

John Michael Montias pioneered the modern use of probate inventories
as a source in Dutch art history.[22] His sample of 362 Amsterdam invento-
ries for the period 1620–1679 establishes the base of a provenance index
maintained by the Getty Art History Information Program. Montias's sam-
ple has been supplemented by 20 inventories for 1680–1689 assembled by
Marten Jan Bok and an additional 108 drawn up in the period 1700–1714
and gathered by S. A. C. Dudok van Heel. The Getty Provenance Index also
seeks to provide coverage for later periods, but the analysis described here
is based on this composite sample of 490 Amsterdam inventories made in
the period 1620–1714.[23]

Altogether these inventories yield the names of 655 documentable Dutch
painters born in the period 1500–1699. This number is far smaller than the
number of painters in the Wright sample but does provide independent
information. In contrast to the small Sutton sample (424 painters), which

259

was essentially a subset of the larger Wright sample, the Getty-Montias data base is an *intersecting* set. It includes painters not represented in the larger Wright sample. Moreover, the percentage of "new" painters varies a great deal from one period to the next. Table 2 displays the relevant information. Note how the percentage of painters not already listed in Wright and Sutton is only about 20 percent for those born between 1600 and 1639 (also for the very small number of pre-1575 painters) but is much higher — and rises with time — after 1640. This pattern of overlap tends to confirm our suspicion that the museum-based sample underrepresented post-Golden Age painters. Seventeenth-century collectors held the works of many painters rejected by later collectors and curators (table 2).

However, that same overlap allows us to draw a second conclusion: the radical decline in the number of Dutch painters born after 1640 is not as great as the museum sample suggests, but it remains real and substantial. This assertion can be defended with the use of a statistical technique originally developed for the purpose of wildlife management, the "capture-recapture technique."[24] This is a method for estimating the population of migratory waterfowl or other creatures without actually counting every one. By capturing a "sample" of, say, Canadian geese, marking them, releasing them, and taking another sample later, and so on, one can estimate the size of the total population of Canadian geese by noting the frequency with which marked geese are recaptured in later samples. The less frequently recapturing occurs, the larger is the total population. For these inferences to be valid certain conditions must obtain, the most basic of which is that each element of the population — each goose — must have an equal chance of being captured in each successive sample.

In the case of the Dutch painters it is evident that our two samples — the museum-based sample identified by Wright and the inventory-based samples provided by the Getty-Montias data base — are not truly random. However, one condition is met: a painter's inclusion in one sample is independent of his chance of inclusion in the other. The capture-recapture technique can be applied to estimate the total population of painters, with the proviso that this figure will remain a substantial underestimate, since most of the paintings of the Getty-Montias data base were unattributed. Table 2 displays the partial population of painters, period by period, as estimated by this technique. Note that the large overlap between the two samples in 1620–1639 results in an estimated population only 28 percent larger than

the number of painters in the Wright sample, but the smaller overlap in 1680–1699 yields estimates 60 to 75 percent larger than those based only on the Wright sample for the last periods.

Even after large numbers of "invisible" post-1640 painters are added to the distribution, table 2 continues to show a sharp and sudden decline in the number of Dutch painters born after 1640 and active after the 1660s. Museum collections exaggerate this decline, but it is certainly real. An independent source of information that reinforces this conclusion is Montias's analysis of the composition of art collections in Amsterdam probate inventories (see table 9 of Montias's contribution to this volume, p. 363). Montias categorized all attributed paintings in his samples as either the works of "contemporary artists" (those who died in the same period as the deceased whose collection is recorded in the inventory) or of "old masters" (those who had died earlier and whose paintings could not have been purchased "new" by the deceased owner).

Montias found that nearly two-thirds of the attributed paintings observed in inventories of the 1630s were by contemporaries and that contemporary works continued to dominate throughout the 1660s. This domination early in the century is most likely a consequence of the high levels of production and the small number of paintings that had survived the Iconoclasm and attendant cultural changes. The percentage of contemporary works gradually declined in later decades as continued high production levels caused the stock of older paintings to grow. But Montias's analysis uncovers a sudden plunge in the "market share" of contemporary artists in collections completed in the 1680s. Only 14 percent of the attributed paintings were by contemporaries, and the larger sample of inventories made in 1700–1714 shows much the same situation.

Could the market share of contemporary painters suddenly have dropped from over 40 percent in the 1670s to under 20 percent in the following decade? It is possible that his findings reflect the growing taste of Amsterdam collectors for the works of old masters and that it says nothing about the level of art production in the post-1660 era. But it is comforting to note that if the number of active painters followed the trend displayed in column 5 of table 2, a simple model estimating the production of paintings in each twenty-year period generates a mix of new and old paintings that tracks the findings of Montias very closely.[25] Such a model does not prove anything, of course, but the knowledge that a set of plausible assumptions gives

261

results compatible with the Montias findings does lend support to our hypothesis that the number of painters active in the Dutch Republic fell sharply after the 1660s.

The trends charted by columns 5 and 6 of table 2 are given support by several bodies of evidence. In my opinion these trends cannot be dismissed as artifacts of biased data, but the *level* of activity — the number of painters active in each period — remains undetermined. We know that the Wright sample, representing modern Dutch museum holdings, is far from complete. The probate inventories of seventeenth-century collectors identify many additional painters, and the large number of unattributed paintings recorded in the inventories forces us to acknowledge that there were many more painters now undocumentable.[26]

In theory the membership records of the Saint Lucas guilds should provide direct evidence concerning the number of active painters. These municipal guilds of painters and ancillary craftsmen were established in most Dutch towns during the seventeenth century, and many of their surviving records are conveniently available in published form. Unfortunately, such records are not bountiful, and those of the largest city, Amsterdam, have vanished altogether. Moreover, any study of their membership rolls must be careful to distinguish artist painters from sign painters, decorators, faience painters, art dealers, and others eligible for membership in the guild. For example, Montias, in his study of the Delft guild, regarded only 52 of the 109 members in 1650 as "artist" painters.[27]

It is no accident that Saint Lucas guilds' records are most abundant in the Golden Age period. Montias has gathered the available lists of guild masters for dates around 1650. The six Dutch cities for which these lists are available claimed 280 master painters around 1650. Montias calculated the ratio of painters to the urban population in those cities and applied that ratio to the many Dutch cities for which no guild records exist. If their painter densities were comparable, the number of master painters must have totaled 712 in 1650.[28] There is reason to doubt that painters were found in all Dutch cities in the same proportions as in such art centers as Delft, Haarlem, and The Hague. On the other hand, we can be confident that lists of guild masters understate the true number of active painters. Not all painters were members of the guild, and not all were masters.

The 712 master painters of 1650 estimated by Montias can be compared to the number of mid-seventeenth century painters identified from the sam-

ples used in this study. The museum and probate inventory sources combined identify 466 painters, and the capture-recapture technique yields a probable total of 591 painters active in 1660. No firm conclusion can be reached given the present state of our knowledge, but the guild records suggest that the estimates in table 2 could be increased by 20 to 40 percent.[29]

One final feature of the Dutch painter population deserves our attention here: mortality. It would be useful to know the length of the adult, productive lives of Dutch painters and whether their longevity differed from that of the general population. The biographical information recorded in the Getty Provenance Index proves useful here. Of the 655 Dutch painters born between 1550 and 1699 who are included in the index, specific birth and death dates are provided for 557. Table 3 displays the average age at death of these painters according to periods of birth. There is a tendency for the life span to decline from the sixteenth century to a low point in the period 1620–1639; thereafter, the life span of painters increased.[30] Keep in mind that the only persons included in this data base are painters who enjoyed a career of sufficient length to be acknowledged by contemporaries and remembered by posterity. Although one painter was found to have died at the age of 23, we can assume that few painters could have entered this data base before the age of 25, even though they may have begun their careers somewhat earlier. If painters completed their apprenticeships between the ages of 20 and 25 and lived, on average, to between the ages of 56 and 60 (as shown by table 3) then seventeenth-century Dutch painters could look forward to about 25 to 30 years of productive life (table 3).

It is important to note that the *average* life span of Dutch painters varied from 56 to 60 years, but deaths, of course, were distributed across all adult ages. The data provided in the Getty Provenance Index permit the construction of a life table that reveals the probability of death and the expectation of remaining life at each age.[31] A life table for the 557 Dutch painters born between 1550 and 1699 allows us to compare their experience with that of large populations for whom demographers have calculated standard life tables. In table 4 (Life Table for Dutch Painters Born in the Period 1550–1699) the pattern of death by age generally corresponds to the so-called Princeton Model North life table with an expectation of life *at birth* of 28.4 years. Obviously, only the adult years of this life table can be observed for the painters, and at this point their life expectancy exceeds that of a population at birth because of the extremely high infant and

child mortality rates of pre-industrial populations (table 4).

Of more immediate interest is the discrepancy between the predicted mortality at ages 25–29, 30–34, and 35–39 and that experienced by the painters in the Getty-Montias data base. The model life table predicts a far higher mortality than that experienced by the 557 Dutch painters. The most probable reason for this discrepancy is not the extraordinary good health of young painters but rather the likelihood that many painters who died young had not yet established a reputation sufficient to warrant later incorporation in lexicons, biographical dictionaries, and the like. The painters' life table points to the absence of some 90 painters who died between the ages of 25 and 39 and presumably had too little time to enter into the ranks of the "remembered artists."[32] The fact that they died young may help explain why many painters enrolled as guild members are unknown to us in any other way.

After age 40 the painters' life table and the standard life table are in general agreement (although the results for the highest ages are less than fully dependable since the number of surviving painters is too small). This exercise gives us no reason to believe that the mortality of seventeenth-century Dutch painters differed materially from the urban population at large.

The data examined in this study are flawed and incomplete. No single source of information can elicit much confidence; but examined together the sources cited reinforce a consistent set of inferences that generate a striking pattern of growth, intense production, and collapse. Until the 1590s the number of Northern Netherlandish painters probably did not exceed 100 at any given time. With the turn of the century the number of new artists grew steadily to the 1640s and may have risen more slowly thereafter, reaching a peak in the 1650s. At that time 700 to 800 master painters may have been active and possibly many additional apprentices, copyists, and non-guild painters.

After 1660 the number of new painters entering the profession fell sharply. Within twenty years most of the growth that had taken place during the first fifty years of the century was undone. As older generations of painters died or became inactive, the number of painters fell to a level perhaps no more than one-quarter of the mid-century peak. This low level of activity was certainly reached by 1700 and persisted until late in the eighteenth century. After 1775 the numbers rise again but not with the intensity of the seventeenth century.

We are now ready to return to the questions, derived from Huizinga's statement, that launched us on this exploration of the number of painters. The sudden emergence of Holland as an art center is perhaps the least difficult phenomenon to relate to contemporaneous social and economic changes. The great era of Dutch art emerged in the crucible of political liberation and religious reformation, the same forces that set the Dutch economy on a new course. I do not mean to suggest that Dutch art was nationalistic or specifically Calvinist. Rather, the circumstances of the late sixteenth century enlarged the supply of painters by setting in motion a massive migration from Flanders to Holland; these same circumstances increased the demand for paintings by establishing a cultural environment that converted art from a "public good" (provided by state and church) to a "private good" (acquired by individuals). In this environment the growing number of artists made possible the reinvigoration or (re)establishment of Saint Lucas guilds, more formal apprenticeships, specialization, and export.

These organizational changes established a scale and specialization that, to use the terminology of economics, facilitated product and process innovations. By the former I refer to the developments of genre, still life, and landscape painting, to cite the most obvious innovations, that responded to the new market for paintings as private goods. Process innovations include technical developments that permitted the rapid creation of cheap landscapes, on the one hand, and the remarkable impressions of surfaces and textures of the *fijnschilders*, on the other.[33]

The increasing specialization and differentiation achieved by these measures led to one final organizational innovation. Montias observes that "there were relatively few professional [art] dealers in the northern Netherlands in the early years of the seventeenth century," but based on his studies of Delft and Amsterdam, "they became much more common in the 1630s and 1640s."[34] Montias observes that the "demand for dealers' services will depend positively both on the degree of the artists' specialization and on the variegation of consumers' tastes (the two variables themselves being interdependent)."[35]

One final factor in the emergence of Dutch art is the increase in demand attributable to the rising per capita incomes of the first half of the seventeenth century. I leave it to last because it is both the most common and most dubious economic explanation for the Dutch cultural flowering. I do not deny that increased disposable income played a role, but by itself it

could not have accounted for more than a small part of the phenomenon. Increased per capita income surely enabled consumers to buy more art, but the explosive growth in the number of painters could only have been sustained if consumers were attracted to new products, or if new products caused their tastes to change.

The second characteristic of Golden Age art needing explanation, the radical confinement of noteworthy art production to the cities of central Holland, poses no great challenge if one accepts the claims made above concerning the importance of organizational innovations. If the creative genius of individual artists had been a direct expression of their nationality, religion, bourgeois background, etc., then we might expect to find such artists in almost any town of the Dutch Republic. If, however, Dutch art depended on the interaction of creative powers with a specific organization of training, production, and sale, then we would expect artists to be attracted to those locations where such structures existed. This is precisely what we find; painters born all over the republic (and the Spanish Netherlands) made their way to the cities clustered between the IJ and the Maas.

The only study of artist mobility known to me, W. Brulez's analysis of 26,529 European artists, shows Netherlandish artists (from both the Northern and Southern Netherlands) to have been more likely to migrate than other nationalities.[36] But what is at issue here is not so much the propensity to migrate as the motivation. Proximity to one's patrons has always been an important factor in the location of artists, and it helps explain the concentration of artists in large, prosperous cities and at active courts. But the Dutch evidence, scant though it may be, describes a broad distribution of painters among a large number of cities rather than a high concentration in the greatest market.[37] Less tied than other artists to patrons or to a narrow customer base, Dutch painters could let production considerations influence their choice of location.

The question of seventeenth-century Dutch art's relationship to the European Baroque I am not competent to address. But the arguments made thus far implicitly accept the orthodox view that Dutch painting represented a novel departure from the European "norm." The privatization and democratization of the market and the organizational transformation of art production described above jointly establish Dutch singularity. But it was not a singularity for all time, which brings us to the final issue.

The Golden Age of Dutch art did not merge into a "gradual dimming

of the golden sunlight as dusk approaches." Our investigation of the num-
ber of painters over time suggests instead an analogy to the sudden pulling
of a curtain. The collapse after 1660 was much more abrupt than had been
the surprising emergence of Dutch art early in the century. The passing
of an era at some point late in the seventeenth century is a commonplace
of Dutch cultural history. Nearly all observers sense that a work such
as Meindert Hobbema's *Avenue at Middelharnis*, 1689 (fig. 1), is what the
Dutch call a *nakomertje* — a surprising late addition to a family thought
already to have been completed. As has been previously noted, the expla-
nations offered for this transition have traditionally been stylistic and eco-
nomic: the "corrupting" influence of French classicism caused Dutch art to
become "dry and derivative,"[38] and the decline of the economy somehow
undermined the uniquely broad market for paintings that had buoyed the
Golden Age.

To the extent that stylistic changes are thought to be autonomous —
originating in the artists' creativity — pronouncements on style are clearly
the prerogative of the art historian. Even when other influences are admit-
ted, it is by no means obvious that the economic historian has anything to
contribute. But this ceases to be the case if style is related to production
methods — if quantity influences quality. Post-1660 Dutch art would seem
to be a good period in which to test such a proposition. As the number of
new painters shriveled, the apprenticeship-based training process declined,
specialization became less pronounced, and young painters were more often
descended from artist families. Municipal guilds became less active, and
surviving guilds changed in character as painters in faience works and later
behangselfabrieken (wallpaper factories) became more numerous. Indeed,
late in the eighteenth century work in a wallpaper factory was the charac-
teristic training ground for painters who in the mid-seventeenth century
would have been trained in the studios of master painters.[39]

A second dimension of the quantity-quality relationship is the tendency
for post-1660 painters to produce a smaller number of more expensive
paintings than had been characteristic of Golden Age painters.[40] Posterity
has withheld admiration from these painters, but their contemporaries
granted both higher social status and higher income to a larger percentage
of eighteenth-century painters than had been granted their more highly
honored predecessors. Clearly, the decline of the number of painters went
hand in hand with a change in the relationship of painters to their mar-

kets. As patrons rose in importance, Dutch art assumed a social function similar to that experienced in the rest of Europe.

These speculations about the causes of stylistic change are predicated on an assumed fall in the demand for paintings. Surely, this influenced the sudden reduction in new painters entering the field in the decades after 1660. What can account for this shrinking of the market? The simple appeal to a reduction in the Dutch Republic's prosperity in the late seventeenth century is insufficient. Economic historians are by no means agreed on the extent of the republic's economic setback in this period. The wars with England and the French invasion of 1672 disrupted Dutch trade and depressed industry, but none of these setbacks proved lasting. As a consequence, some historians speak of a gradual erosion of Dutch economic strength, an erosion that does not assume definitive form until well into the eighteenth century.[41] Such a scenario is inadequate as an economic explanation for the sudden decline in demand for paintings.

In my own view there was, indeed, a substantial decline in Dutch national income in the 1670s and 1680s. Falling commodity prices and constricted foreign trade put a sharp downward pressure on profits and rents, while tumbling industrial production reduced the earnings of urban workers. Space does not allow an extended discussion of this issue here, and no summary statistic adequately conveys the performance of the whole economy.[42] But the trend of rents for upper- and middle-class Amsterdam dwellings certainly supports the view that all was not well with the personal incomes of the social classes that most actively supported the art market (graph 1).

Yet even if we accept that Dutch national income declined absolutely in the 1670s and 1680s, how much of the posited sharp fall in the production of paintings could this account for? An economist's approach would focus on the concept of "elasticity." The measurement of the income elasticity of demand for paintings reveals how much more consumers spend on paintings when their incomes increase by a given amount. For instance, if incomes rise by 1 percent and expenditures on paintings also rise by 1 percent, economists speak of "unitary" elasticity, a situation in which paintings do not change their relative position vis-à-vis other objects of expenditure. If a 1 percent increase in income elicits an additional expenditure for paintings in excess of 1 percent, the elasticity is correspondingly greater than 1, and paintings will come to loom larger in the total expenditure pattern of consumers. In such a situation a *decline* in income will cause the demand

for paintings to fall more than proportionately with the fall in income.

This brief excursion into economics should suffice to establish what is at issue in any argument concerning the impact of a decline in the Dutch economy on the market for paintings. The only estimate known to me of elasticity of demand for paintings based on seventeenth-century Dutch evidence is to be found in Montias's *Artists and Artisans in Delft*.[43] Montias's estimate is based on the probate inventories of deceased citizens, where the notaries often estimated the value of the art collections as well as the total value of the estate. Montias used these observations to explore the relationship of wealth to the value of art collections. Of course, the elasticity which Montias could estimate — "wealth elasticity of art collections" — is not precisely the one that directly interests us here, that is, the income elasticity of demand for paintings. But his findings shed some light on the likely value of the latter elasticity.

Montias calculated an overall elasticity of 1.23. That is, as the wealth of the deceased increased by 1.0 percent, the value of his or her art collection increased by 1.23 percent. This cross-sectional study of the estates of rich and poor does not necessarily reveal how persons of a given income level would respond to a change of income. Indeed, there is reason to believe that the income elasticity of persons with average incomes would differ significantly from that of high-income persons. Montias sought to approximate this difference by calculating separately the wealth elasticity of art collections for estates valued at under 500 *gulden* and for those valued at 500 *gulden* and above. He found that the elasticity for the modest estates approximated unity (0.92) while that for the wealthy was greater (1.235).

Modest estates revealed no tendency to translate greater wealth into the acquisition of more art. Montias hypothesized that such households "bought paintings and prints much as they bought furniture. Walls had to be covered...but there was no need, if one got a little better-off, to spend a greater percentage of one's income...[on] artworks."[44] Matters were different for the well-to-do. Some portion of such persons were collectors of art, and a higher income enabled them to enlarge and improve their collections.

If the wealth elasticities estimated by Montias bear any resemblance to the income elasticities prevailing in seventeenth-century Dutch society, it becomes evident that the fall of income alone can explain only a minor part of the large decline in the number of painters and production of paintings that was proposed earlier in this essay. At the low end of the market, demand

would have fallen no more than proportionately with income, yet it is precisely the cheap, mass-produced paintings that appear to have been hit hardest. At the high end of the market, demand would indeed have fallen more than proportionately with income, but an elasticity of 1.23 could account for the decline of demand only if upper- and middle-incomes plummeted, and even the most confirmed pessimists about the late seventeenth-century Dutch economy stop far short of such a claim.

If the income elasticities of demand can explain only a minor part of the demand for paintings, what other factors might an economic historian invoke? One is suggested by Montias's characterization of the art-buying motivation of non-connoisseurs. If the chief aim is to decorate a finite space, the market could become saturated. That is, the output of modern painters would compete directly with the accumulated stock passed on from earlier generations. By the 1660s the very high production levels of the previous three generations had endowed Dutch society with an enormous stock of paintings. With incomes stagnant or declining, population declining, and a vast stock of paintings "overhanging" the market, the only hope for painters was to innovate – to change tastes by the example of their new products, in the hope of rendering obsolete the existing stock of paintings and speeding their removal to attics and auctions.

The extent to which late seventeenth-century Dutch artists made use of this strategy must be determined by art historians. My own untutored impression is that stylistic innovation was indeed attempted at the uppermost end of the market. It was, to judge from the composition of early eighteenth-century collections (see table 9 of Montias's contribution to this volume, p. 363), only partly successful; artistic innovators in other mediums (porcelain, wallpaper, prints) captured the eighteenth-century market for interior decoration that painters had so completely dominated in the seventeenth century. The option of building upon past achievements was as closed to Dutch painters after the 1660s as it was to Dutch merchants and manufacturers.

I have explored the possibilities of incorporating art into a socioeconomic framework for historical explanation by treating the production of art as an industry more or less like any other. The reader will note that my philistine approach raises questions concerning changes of style, painting technique, and relations of artists to patrons. These are the evident points of contact with the art historian's special knowledge. Perhaps the time will

come when these points of contact will broaden into avenues of intellectual interaction. I do not mean that economic history, political history, and art history should merge. On the contrary, I am a firm believer in specialization. But the classical economists championed specialization for the exploitation of comparative advantage. Their vision included free trade among the specialists. Specialization *and* protectionism does not make sense, whether in international trade or scholarship.

Table 1. The Number of Dutch Painters Reflected in United States and Dutch Museum Collections

	1	2	3	4	5
Period of Birth	Dutch Painters in U.S. Museums	Number of Paintings in U.S. Museums	Paintings per Artist	Dutch Painters in Dutch Museums	U.S./ Netherlands Ratio
<1500	16	60	3.75	24	.67
1500–1549	10	16	1.60	48	.21
1550–1574	13	75	5.77	44	.30
1575–1599	70	399	5.70	190	.41
1600–1619	108	732	6.78	321	.34
1620–1639	121	800	6.61	407	.30
1640–1659	41	101	2.46	96	.43
1660–1679	13	28	2.15	61	.21
1680–1699	8	32	4.00	57	.14
1700–1724	5	7	1.40	78	.06
1725–1749	5	6	1.20	103	.05
1750–1774	10	12	1.20	170	.06
1775–1799	4	9	2.25	162	.02
Total	424	2277	5.37	1761	.24
1575–1639	299	1931	6.46	918	.33
Percent of Total	71	85		52	

Key

Column 1. Number of painters with works in the possession of United States museums, grouped by artist's year of birth. Compiled from Peter C. Sutton, *Dutch Art in America* (Grand Rapids: Wm. B. Eerdmans; Kampen: J. H. Kok, 1986), 331–50.

Column 2. Number of paintings in United States museums that are by painters listed in column 1. Compiled from *Dutch Art in America*. Paintings identified by Sutton as copies or forgeries are excluded.

Column 3. The mean number of paintings per painter in United States collections. The distribution around these means is usually very great.

Column 4. Number of painters with works in the possession of Dutch museums, grouped by artist's year of birth. Compiled from Christopher Wright, *Paintings in Dutch Museums* (London: Sotheby Parke Bernet, 1980). The numbers are estimates based on a tally of one-third of the entries. For 12 percent of the identified painters no specific birth date is available, but most could be assigned to a period of birth on the basis of other information.

Column 5. The ratio of the number of painters in United States museums to those in Dutch museums (column 1/column 4). It is an indicator of the strength of representation of Dutch painters in United States museums.

Table 2. The Number of Dutch Painters Reflected by Probate Inventory Attributions

Period of Birth	1 Painters in Getty-Montias Data Base	2 % of Painters Not Included in Wright and Sutton	3 Total Painters from All Sources	4 Est. Total Using "Capture/ Recapture" Method	5 Est. Painters Active at End of Period, Using Column 4	6 Est. Painters Active at End of Period, Using Museum Data
1550–1574	25	18.2	49	55		24
1575–1599	110	30.4	223	271	55	44
1600–1619	170	19.2	354	398	220	161
1620–1639	199	21.2	451	522	407	317
1640–1659	94	24.2	128	145	591	466
1660–1679	34	37.5	74	99	370	276
1680–1699	23	44.4	67	101	147	94
1700–1724					126	72
1725–1749					[137]	78
1750–1774					[180]	103
1775–1799					[187]	107
Total	655	26.0	1346	1591		

Key

Column 1. Number of painters included in the Getty-Montias data base, based on attributions in probate inventories dating from the period 1620-1713.

Column 2. Painters identified in column 1 who are not included in the sources described in table 1.

Column 3. Painters identified in Sutton, Wright, and the Getty-Montias data base, excluding duplicate cases.

Column 4. Estimated population of painters following procedure described in note 24.

Column 5. The estimated number of painters active at the end of the period. This estimate is based on the data provided in column 4 and the following assumptions: painters began their careers at age 25 and their average period of activity was 25 years. Thus, the estimate for 1679 is based on the number of painters born in the period 1630–1655 [(10 × 26.1) + (15 × 7.25)] = 370. The estimates in brackets are based on the assumption that the recapture probability for 1680–1699 can be applied to the eighteenth century.

Column 6. Same as column 5, except that the estimates are based on the data provided in table 1, column 4.

273

Table 3. Dutch Painters Listed in Getty Provenance Index by Period of Birth and Average Age of Death

Born	Number	Dates of Birth and Death Known	Average Age at Death	Standard Deviation
1550–1574	25	20	61.3	17.3
1575–1599	110	89	57.0	16.0
1600–1619	170	141	58.5	12.7
1620–1639	199	172	56.2	13.3
1640–1659	94	82	58.4	15.1
1660–1679	34	32	63.6	16.2*
1680–1699	23	21	64.9	10.7
Total	655	557		

*One painter died at the age of 103; if he is excluded the mean becomes 62.3 years and the standard deviation 14.8.

Table 4. Life Table for Dutch Painters Born in the Period 1550–1699

Age Interval	Number Living at Beginning of Interval	Proportion Dying	Princeton Model North Life Table Level 5 $e_0 = 28.4$ Proportion Dying	Estimated Missing Deaths**	Revised Number Living at Beginning of Interval	Average Remaining Lifetime at Beginning of Interval (e_x) Original Data	Revised Data
25–29	557	.0126	.0730	34	648	34.01	30.22
30–34	550	.0236	.0806	31	607	29.41	27.10
35–39	537	.0401	.0898	26	563	25.06	24.02
40–44	515	.1029	.1004			21.03	
45–49	462	.1407	.1149			18.11	
50–54	397	.1461	.1362			15.71	
55–59	339	.2094	.1774			12.97	
60–64	268	.2985	.2392			10.75	
65–69	188	.3191	.3312			9.26	
70–74	128	.4375	.4663			7.43	
75–79	72	.4167	.6130			6.26	
80–84	42	.8095	.7312			3.95	
85–89	8	.7500	.8476			5.13	
90 and over	2	1.0000	.9221*			[8.00]	

*age interval 90–94

**assumes that Model Life Table proportion dying actually prevailed: (column 3/column 2) × number dying in interval = total dying in interval.

Graph 1. Index of House Rents in Amsterdam*
Index: 100 = 1575**

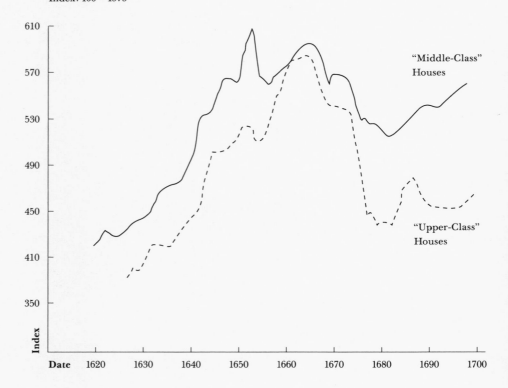

"Middle-Class" Houses

"Upper-Class" Houses

*Based on information in Clé Lesger, *Huur en conjunctuur* (Amsterdam: Amsterdamse Historische Reeks no. 10, 1986), 77–87.

**Rents for each class of housing are set at 100 in 1575; later rents are expressed as a ratio of the rent for that class in 1575. The graph shows how the rents for each class of housing fared relative to the 1575 base.

NOTES

1. This movement is identified with the founders of the French historical journal *Annales E. S. C.*, Lucien Febvre and Marc Bloch, and their successors, now well into the third generation. Independent contributions to the New History were made in other countries, most notably by Wilhelm Abel (*Agrarkrisen und Agrarkonjunktur*, first published in 1935) and B. H. Slicher van Bath (*Een samenleving onder spanning: Geschiedenis van het platteland van Overijssel* [Assen, 1957]). For historiographical and methodological studies of this New History, see Fernand Braudel, J. H. Hexter, and H. R. Trevor Roper, "History with a French Accent," *Journal of Modern History* 44 (1972): 447–539; Trian Stoianovich, *French Historical Method: The Annales Paradigm* (Ithaca: Cornell Univ. Press, 1976); Samuel Kinser, "*Annales* Paradigm? The Geohistorical Structure of Fernand Braudel," *American Historical Review* 89 (1981): 63–105.

2. Ad van der Woude, *Nederland over de schouder gekeken* (Utrecht: Hes Uitgevers, 1986), 14.

3. Fernand Braudel, "Histoire et sciences sociales: La longue durée," *Annales E. S. C.* 13 (1958): 725–53. Quotations are from the English translation: "History and the Social Sciences," in *Economy and Society in Early Modern Europe*, ed. Peter Burke (New York: Harper & Row, 1972), 11.

4. Ibid., 13–14.

5. Ibid., 14.

6. Peter Burke, "Introduction: Concepts of Continuity and Change in History," in *New Cambridge Modern History* (Cambridge: Cambridge Univ. Press, 1979), 13: 1.

7. William Bouwsma, "The Renaissance and the Drama of Western History," *American Historical Review* 84 (1979): 10–11.

8. E. Le Roy Ladurie, "L'histoire immobile," *Annales E. S. C.* 29 (1974): 673–82. Quotations are from the English translation, "Motionless History," *Social Science History* 1 (1977): 122.

9. Ibid., 134.

10. Johan Huizinga, *Nederlandse beschaving in de zeventiende eeuw: Een schets* (Haarlem: H. D. Tjeenk Willink & Zoon, 1941). Quotations are from the English translation *Dutch Civilization in the Seventeenth Century* (London: William Collins & Sons, 1968), 13, 98.

11. Ivo Schöffer, "Did Holland's Golden Age Coincide with a Period of Crisis?" *Acta Historiae Neerlandica* 1 (1966): 107.

12. Simon Schama, *The Embarrassment of Riches: An Interpretation of Dutch Culture of the Golden Age* (New York: Alfred A. Knopf, 1987), 8.

13. Ibid.

14. The most convenient study of this concept remains: Fernand Braudel and Frank Spooner, "Prices in Europe from 1450 to 1750," in *The Cambridge Economic History of Europe*, ed. E. E. Rich and C. H. Wilson (Cambridge: Cambridge Univ. Press, 1967), 4: 374–486. An art-historical

application of this concept can be found in Svetlana Alpers, "Bruegel's Festive Peasants," *Simiolus* 6 (1972–1973): 163–76. Here the suggestion is made that the sixteenth-century rise of food prices helps explain the ambivalent attitude of the urban observer (and the painter) toward the kermis revels of peasants, at once attractively exuberant and disgusting in their crudeness and excess. The conflicting interests of the urban and rural sectors at this time generated a tension that left little room for the pastoral effusions that typified "contraction-phase culture" in the early eighteenth century.

A "secular-trend" perspective may also prove fruitful in interpreting Hobbema's *Avenue at Middelharnis* (fig. 1). This painting is acknowledged as exceptional for being painted in 1689, twenty years after Hobbema had abandoned his career as a painter and the great age of Dutch art had ended. The painting irresistibly beckons the gaze of the economic historian. Everything he expects to find is there: an orchard of fruit trees being pruned or grafted, the *meekrapstoof* (madder drying shed), and the polder land itself with its straight road and field boundaries. It is a remarkable portrayal of a confident, commercial rural prosperity, with one exception. By 1689 the agricultural economy was sunk in severe depression. A break in commodity prices begun in the late 1660s and a rapid rise of taxation and other costs in the 1670s had robbed agriculture of its profitability. Plunging rents and land values, the abandonment of land, depopulation of rural areas, and the complete cessation of land reclamation and other investments were the realities of the time in which Hobbema painted *Avenue at Middelharnis*. Could it be that he sought to recapture a vanished confident prosperity just as the landscape painters of an earlier generation had sought, in the midst of hectic commercial expansion, to capture an ideal of tranquil rusticity? (Concerning landscapes in the mid-seventeenth century, see my speculations in Jan de Vries, "The Dutch Rural Economy and the Landscape: 1590–1650," in *Dutch Landscape: The Early Years, Haarlem and Amsterdam 1590–1650*, ed. Christopher Brown (London: National Gallery Publications, 1986), 85–86.

15. *Histoire totale* was the goal of *Annales* school historians who organized studies of regions and cities that were aimed at systematic analysis of structures, conjunctures, and events. They wished to situate the geographical, economic, political, and — ideally — cultural histories, or *histoires mentalités* of their chosen terrain in those contexts. One of the first of these studies remains the most successful in addressing cultural issues: E. Le Roy Ladurie, *Les paysans de Languedoc*, 2 vols. (Paris: SEVPEN, 1966).

16. For introductions to the seventeenth-century crisis literature, see Trevor Aston, ed., *Crisis in Europe: 1560-1660* (London: Routledge & Kegan Paul, 1965); Theodore K. Rabb, *The Struggle for Stability in Early Modern Europe* (New York: Oxford Univ. Press, 1975); Geoffrey Parker and Lesley M. Smith, eds., *The General Crisis of the Seventeenth Century* (London: Routledge & Kegan Paul, 1978). Rabb's *Struggle for Stability* presents one of the few examples of a modern historian's explicit use of art as evidence in a historical argument. Using the medical

concept of "crisis" as an analogy, Rabb argues that the best evidence of a crisis is the period of resolution that succeeds it (that is, death or recovery). For Rabb art reflects the preoccupations of its times and therefore indicates such resolution. The Baroque, in his view, exuded a confidence that it "never quite captured...the tempestuous grandeur of literature, painting, and sculpture had been an attempt to belie the words of doubt and uncertainty that lay beneath," 100. But after mid-century reason triumphed at the expense of emotion: "The deaths of Rubens, Van Dyck, Velazquez, Poussin, Hals, and Rembrandt, all within less than thirty years between the 1640s and 1660s, mark the passing, not merely of a style, but of an attitude toward the very purposes of art. Henceforth painting was to be pleasing rather than exciting, decorative rather than powerful," 106–7. Rabb's study is furnished with reproductions of paintings that offer evidence of change in the preoccupations of Europe's elites just as literary texts or political correspondence might be used. A recent study sought to link the seventeenth-century social crisis to nothing less than a fundamental shift in the philosophical underpinnings of Western thought. The focus of Stephen Toulmin's *Cosmopolis: The Hidden Agenda of Modernity* (New York: Free Press, 1990) is the philosophy and history of science, but the spirit of the analysis parallels Rabb's.

17. Huizinga (see note 10), 99.

18. Madlyn Millner Kahr, *Dutch Painting in the Seventeenth Century* (New York: Harper & Row, 1978), 299.

19. Huizinga (see note 10), 99.

20. W. Brulez, *Cultuur en getal: Aspecten van de relatie economie-maatschappij-cultuur in Europa tussen 1400 en 1800* (Amsterdam: Nederlandse vereniging tot beoefening van de sociale geschiedenis, 1986), 34–36 and 101–2, n. 97.

21. For an international survey of research see Ad van der Woude and Anton Schuurman, eds., *Probate Inventories: A New Source for the Historical Study of Wealth, Material Culture, and Agricultural Development* (Wageningen: A. A. G. Bijdragen 23, 1980). Among studies based on probate inventories, see Jan de Vries, "Peasant Demand Patterns and Economic Development: Friesland, 1550–1750," in *European Peasants and Their Markets: Essays in Agrarian Economic History*, ed. William N. Parker and Eric L. Jones (Princeton: Princeton Univ. Press, 1975), 205–66; Thera Wijsenbeek-Olthuis, *Achter de gevels van Delft: Bezit en bestaan van rijk en arm in een periode van achteruitgang (1700–1800)* (Hilversum: Verloren, 1987); A. J. Schuurman, *Materiële cultuur en levensstijl* (Wageningen: A. A. G. Bijdragen 30, 1989).

22. John Michael Montias, *Artists and Artisans in Delft: A Socio-Economic Study of the Seventeenth Century* (Princeton: Princeton Univ. Press, 1982), see esp. chap. 8; idem, "Cost and Value in Seventeenth-Century Dutch Art," *Art History* 10 (1987): 455–66; idem, "Art Dealers in the Seventeenth Century Netherlands," *Simiolus* 18 (1988): 244–56; and his contribution to the present volume. It will not escape the reader's notice that my analysis relies heavily on Montias's pioneering and innovative work. I am extremely grateful to him for his generosity and his example.

23. I am grateful to Dr. Burton Fredericksen, director of the Getty Provenance Index, for providing access to the data base of Dutch painters.

24. The method is described in R. M. Cormack, "The Logic of Capture-Recapture Estimates," *Biometrics* 28 (1972): 337–43. In the application of this method found in table 2, I treat the Wright sample and the Getty-Montias sample as having each been drawn independently of the other and randomly from the population of all Dutch painters. The first assumption is valid, but neither sample is strictly random. Then,

N = the total size of the population

where $N = n_i/\hat{P}_i$, and

n_i = the number of individuals captured in sample i

$\hat{P}i$ = the probability that any individual is registered in sample i

where $\hat{P}_i = m_i/M_i$, and

m_i = the number of individuals in sample i that had already been captured.

M_i = the number of individuals that had already been captured.

For example, in the period 1620–1639 the Wright sample had captured 407 painters. The Getty-Montias sample (sample i) captured 199, of which 155 had already been captured: $\hat{P}_i = 155/407 = .38$; $N = 199/.38 = 523$.

25. The simulation model incorporates the following assumptions: The average number of active artists in each 20-year period is estimated as the average of the number active at the beginning and end of the period as recorded in table 2, column 5. Production is estimated at 20 paintings per year per painter, except in the period 1600–1679, when 30 per year is assumed. Paintings are assumed to disappear at the rate of 50 percent per 20-year period for the first three periods after production. The survivors of 60 years are assumed to disappear at the rate of 10 percent per 20-year period. Finally, a beginning stock of 100,000 paintings is assumed for 1580, the initial year of the model. This model produces a stock of paintings for each 20-year period that can be divided between those surviving from the past and those produced within the period. The percentage produced by contemporaries rises to a peak of 70 percent in 1620–1639, declines gradually to 56 percent in 1660–1679, and plunges to 22 percent by 1700–1719.

26. Montias, 1988 (see note 22), offers compelling evidence concerning prolific painters, now unknown to us, whose work was marketed by "supply-augmenting" art dealers. Montias speculates that painters such as "Slort," L. de Laeff, M. Caree, and many others may have been engaged by dealers in *dozijnwerk* (work by the dozen). The work of these painters is not attributed in any probate inventories of private collections yet examined.

27. Montias, 1982 (see note 22), 103–4.

28. John Michael Montias, "Estimates of the Number of Dutch Master Painters: Their

Earnings and Their Output in 1650," *Historisch tijdschrift* 6, no. 3 (1990): 59–74. I am very grateful to the author for allowing me to see this paper in advance of publication.

29. Marten Jan Bok, who is engaged in a study of Utrecht painters, notes that of the 29 painters listed as members of the Saint Lucas guild of Utrecht in 1569, only 13 could be identified in Thieme-Becker. Of the 53 guild painters recorded in 1611–1625, only 31 appear in Thieme-Becker (Marten Jan Bok, "Review of W. Brulez's *Cultuur en getal*," *Simiolus* 18 [1988]: 63–68).

30. The small size of the samples at both the beginning and end of the period surveyed and the higher variance in the observations (see standard deviations) urge caution in drawing conclusions about observed differences among periods.

31. On the calculation of life tables, see Henry S. Shryock, Jacob S. Siegel, et al., *The Methods and Materials of Demography*, 2 vols. (Washington, D. C.: U. S. Dept. of Commerce, 1975), 429–61. On model life tables see A. J. Coale and P. Demeny, *Regional Model Life Tables and Stable Populations* (Princeton: Princeton Univ. Press, 1966).

32. It must be emphasized that the construction of the life table is predicated on the assumption that the painters recorded in the Getty-Montias data base were all "at risk" of dying as practicing artists by the age of 25. The estimate of "unremembered artists" is exaggerated to the extent that people took up the craft at substantially older ages.

33. For a full discussion, see Montias, 1987 (see note 22), 455–59.

34. Montias, 1988 (see note 22), 245.

35. Ibid.

36. Brulez (see note 20), 40–45.

37. If the European norms of patronage had prevailed, the greatest markets would have been Amsterdam (by far the largest city) and The Hague (the seat of court and government). Montias's survey of Saint Lucas guild membership in 1650 shows The Hague to be at the high end of the painters-per-thousand-inhabitants distribution, but this figure (2.1 per 1000) is only marginally higher than most other observations, which range from 1.5 to 2.0 per 1000 (Montias [see note 28], table 1). No comparable data are available for Amsterdam, but Montias has shown in several publications that Amsterdam collectors were much more likely than those in other cities to own the works of painters from other locales. This suggests, if anything, a lower than average painter density in Amsterdam. In the mid-eighteenth century very different conditions prevailed. Johan van Gool claimed that the only viable art centers at that time were Amsterdam and The Hague. My thanks to Lyckle de Vries.

38. Kahr (see note 18), 299. The classic accusation that foreign influence "corrupted" native Dutch artistic style was made by Peter Geyl, the leading Dutch historian of his generation. In his comprehensive history of the Netherlands, *Geschiedenis van de Nederlandsche stam*, 3 vols. (Amsterdam: Wereldbibliotheek, 1948–1958), Geyl wrote: "The art theories that Hoogstraten, Pels, and Lairesse had obtained from France closed the door to all that had been characteristic

of Netherlandish art and that therefore had been of greatest value.... France, whose armies had been blocked by the water barrier, achieved through art the triumph of its spirit in an otherwise undefeated Holland" (2: 713–14, my translation).

39. Earl Roger Mandle, *Dutch Masterpieces from the Eighteenth Century: Paintings and Drawings, 1700–1800* (Minneapolis: Minneapolis Institute of Arts, 1971). The sixty biographical sketches of eighteenth-century painters impress upon the reader the extent to which painting had become an inherited occupation and the importance of *behangselfabrieken* to the economic life of eighteenth-century painters.

40. The evidence for this claim is mainly impressionistic and seems to accord with the high social standing of post-1660 painters relative to their predecessors. The matter is explored further in Lyckle de Vries, *Diamante Gedenkzuilen en leerzaeme voorbeelden: Een bespreking van Johan van Gools Nieuwe Schouburg* (Groningen: Egbert Forsten, 1990). I am the beneficiary of conversations with the author at the Getty Center, California, in 1986–1987 while this study was in preparation.

41. The most comprehensive study of Dutch economic decline remains Johan de Vries, *De economische achteruitgang der Republiek in de achttiende eeuw*, 2nd ed. (Leiden: H. E. Stenfert Kroese, 1968). De Vries speaks of a relative rather than an absolute decline. A recent work is Jonathan I. Israel, *Dutch Primacy in World Trade 1585–1740* (Oxford: Oxford Univ. Press, 1989), 299–300.

42. Readers thirsting for an extended discussion are referred to Jan de Vries, *Barges and Capitalism: Passenger Transportation in the Dutch Economy, 1632–1839* (Utrecht: Hes, 1981), 221–73; Jan de Vries, "The Decline and Rise of the Dutch Economy, 1675–1900," in *Technique, Spirit, and Form in the Making of the Modern Economies: Essays in Honor of William N. Parker*, ed. Gavin Wright and Gary Saxonhouse (Greenwich, Conn.: JAI, 1984), 149–89.

43. Montias, 1982 (see note 22), 263–68.

44. Ibid., 265.

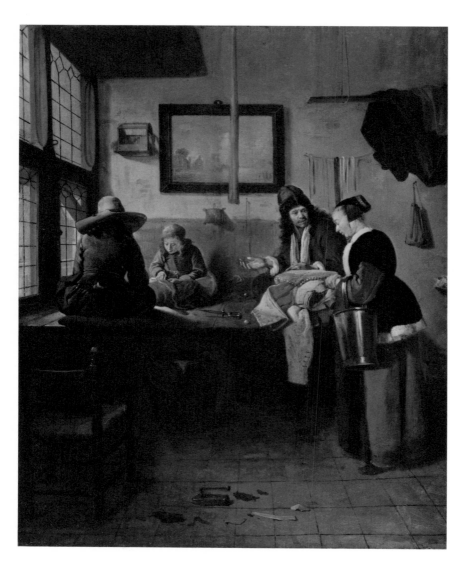

1. Quirijn van Brekelenkam,
 The Tailor's Workshop, 1661,
 oil on canvas, 66 x 63 cm.
 Amsterdam, Rijksmuseum, no. C112.

284

Ad van der Woude

The Volume and Value of Paintings in Holland at the Time of the Dutch Republic

Questions about the number of paintings produced during the time of the Dutch Republic, the productivity of the artists, the monetary value of their works, and the artists' incomes have not as yet achieved a prominent place among the concerns of the art historian. This does not mean that art historians have no interest in these issues; rather, in the tradition of the discipline quantitative problems hold but a marginal position.

Hans Floerke's thesis of 1901 was the only important book on the quantitative aspects of Dutch art for over eighty years.[1] His striking comparison between the market for paintings and that for potatoes reveals the importance that he attached to the integration of the concerns of economic history with those of the history of art and culture. It was not until 1982, with the publication of John Michael Montias's book on Delft artists, that questions of a quantitative nature again formed the core of a major study on Dutch painting.[2] There are, however, signs that Montias's study will not remain the lone voice that Floerke's was, for several scholars have explored quantitative aspects of art history in recent years.[3] In fact, there is a growing awareness in art history of the value of quantitative information, often the product of cross-disciplinary contacts. The remarks, computations, and guesswork presented below were produced in the context of research into the economic history of the Dutch Republic. While a guest of the Getty Center for the History of Art and the Humanities, I came into contact with art historians, and this piqued my curiosity about the economics of art production in the Dutch Republic; thus, this study, which explores questions about the number and kind of paintings, their sizes, and their monetary value, is itself a product of cross-disciplinary encounter.[4]

285

Estimating the Volume of Production

It is generally known that the demand for paintings in the Dutch Republic
was remarkably high; foreigners frequently commented on this. In 1641 the
English visitor John Evelyn noted with astonishment that in Rotterdam he
saw a lively trade in paintings of good quality offered for very low prices.
What struck him was that even farmers could be found among the buyers.[5]
Twenty years later the French schoolmaster Jean Nicolas de Parival, who
lived in Leiden for twenty years and knew Holland well, wrote:

> *Je ne croy point qu'il se trouve tant de bons peintres ailleurs qu'ici ; aussi les
> maisons sont-elles remplies de très beaux tableaux, & n'y a si pauvre bourgeois
> qui n'en veuille être bien pourveu.*[6]

> (I do not believe that so many good painters can be found anywhere else; also
> the houses are filled with very beautiful paintings and no one is so poor as
> not to wish to be well provided with them).

The many regulations governing the guilds of painters also confirm that this
trade was common and widespread.[7] As a group, painters were craftsmen
and were protected by guild regulations; they produced for what was — by
the measure of that time — a mass market. Dutch painters depicted paint-
ings, prints, maps, and mirrors as decorating the interiors of even poor
urban houses (figs. 1–3). Although we may harbor doubts about the abso-
lute fidelity with which artists depicted life, it seems unlikely that they
would have represented the walls of ordinary houses in a way reserved for
the upper strata of society.

Historians have long recognized the ubiquity of paintings in the Dutch
Republic, but this knowledge has been of little value in guiding discussions
of the production of paintings. Scholars content themselves with vague
expressions like "many," "numerous," "a remarkably diffused property," and
so forth. We need to attempt to locate a sturdy fulcrum that will permit the
conversion of these vague expressions into concrete numbers. An idea of
magnitude can be arrived at by trying to determine the number of house-
holds in the Dutch Republic. During most of the seventeenth and the whole
of the eighteenth centuries the number of inhabitants in the province of
Holland oscillated between 825,000 and 900,000. Since Holland's mean

2. Quirijn van Brekelenkam,
 Interior, 1648,
 oil on panel, 57 x 53.5 cm.
 Leiden, Stedelijk Museum de Lakenhal,
 no. 47.

3. Jan Steen,
 Peasant Wedding, 1672,
 oil on panel, 38.5 x 50 cm.
 Amsterdam, Rijksmuseum, no. A388.

287

household size at this time was something under four persons,[8] we know that slightly over 200,000 households existed in Holland at any given time after 1650. Between 1580 and 1650 the number of inhabitants was lower, and the mean household size somewhat larger. If we assume the mean duration of a household's existence in this period to be twenty years, we can calculate the total number of separate households that existed in Holland between 1580 and 1800 at something over two million (table 1). This figure is no more than a rough approximation, of course, but it suffices to make clear that one must think in terms of millions when considering the production of paintings — *provided* that every household possessed on average at least one painting and that every household purchased this work new rather than obtaining it by inheritance. Neither of these assumptions is true: an average of one painting per household seems to be too low and as unrealistic as the total negation of inheritance as a factor in the acquisition of paintings. Our provisional conclusion that the production of paintings in Holland probably exceeded one million does not totally redress the vagueness of expressions like "many" and "a lot," but it does provide a more solid basis for discussion.

We can do better than this, however, by making use of data recently provided in Thera Wijsenbeek-Olthuis's study of eighteenth-century material culture in Delft.[9] Wijsenbeek-Olthuis's work is based on painstaking research into the probate inventories. A burial tax graded into five classes of wealth was levied in Holland in the eighteenth century, and this enabled Wijsenbeek-Olthuis to establish the social position of each testator. The first class comprised those deceased who left an estimated property of at least 12,000 *gulden*, the second those who left property of between 6,000 and 12,000 *gulden*, the third between 2,000 and 6,000 *gulden*, the fourth between 300 and 2,000 *gulden*, and the fifth less than 300 *gulden*. The enormous number of extant probate inventories for every class of the population and the high quality of the description of the material goods present in the households of the deceased make possible meticulous study of the development of all kinds of material goods in the city of Delft during the eighteenth century.

Wijsenbeek-Olthuis focuses on three twenty-five-year periods: 1706–1730, 1738–1762, and 1770–1794. In each period she draws a stratified sample of one hundred probate inventories, twenty from each class. The absolute numbers of the objects found in the probate inventories are given in an appendix. Under the heading "wall decoration" she distinguishes among paintings,

portraits, prints, and drawings, as well as maps and mirrors.[10] From this I computed the mean possession of these objects for each class and each time period. Wijsenbeek-Olthuis's findings are shown in tables 2 ("paintings" excluding portraits), 3 ("portraits"), and 4 (the addition of tables 2 and 3). Note that the data of class 1 in the second period are seriously distorted by the inclusion of the Willem van Berkel collection. Van Berkel was a *burgemeester* with an enormous collection of 911 paintings and portraits. It is prudent, whenever possible, to present two figures; one that omits this collection and one, parenthetically, that includes it. Unless otherwise stated, all references in the text are to the first.

In studying this data, one is immediately struck by the very large numbers, by the large differences between the classes, and by the development over time. Early in the eighteenth century the average number of paintings per household in Delft varied between forty-one for the highest class (taxable property > 12,000 *gulden*) and seven for the lowest class (taxable property < 300 *gulden*). When the portraits are added to these figures, the numbers reach fifty-three and seven, respectively. The regression across the five property classes proved highly regular in all three periods. Also striking is the regular decline in the numbers across the periods. This decline is most noticeable in the two lowest property classes: between 1706–1730 and 1770–1794 the number of paintings diminished by two-thirds in the fourth class and by six-sevenths in the lowest class. In the highest class there was only a 40 percent decrease, while the second property class showed a fall of a little more than 50 percent. Oddly enough the households of the third class (taxable property between 2,000 and 6,000 *gulden*) showed almost no decrease. Is this one of the anomalies of the probate inventory sample, or can a plausible explanation be found?

A decline in the use of hanging wall decoration during the eighteenth century could be expected in light of the increasing habit of decorating walls with painted linen, and this seems to hold true for the two highest classes. They show a decline in the number of both paintings and (hanging) maps. The expensive fashion of using painted linen was far beyond the reach of the two lowest classes. For them fashion moved in a different direction: paintings were replaced by earthenware wall decoration. The decrease in the possession of paintings was accompanied by a total disappearance of maps and by a strong increase in earthenware plaques and *prentborden* (print boards). For those in the third property class, however,

painted linen as a wall covering was probably too expensive, while earthenware would associate them with the lower classes. This middle group held fast to old habits; paintings and maps remained its chief type of wall decoration throughout the century.

Although this knowledge about Delft is interesting enough in itself, our goal is to obtain a reliable estimate of the number of paintings produced in the entire Dutch Republic. The Delft data can help us to achieve this end if we restrict ourselves for the moment to the province of Holland. The data needed for such an estimation to be more than the sheerest guesswork are still lacking for the other provinces, but this is not such a great impediment. Holland was by far the most important part of the republic in wealth and cultural influence. Between 1600 and 1800, 40 percent or more of the total population of the republic was concentrated there. An estimate for Holland will establish a provisional lower boundary for the number of paintings in the republic as a whole.

We can begin with the assumption that the quantities of paintings in the households of Holland resembled on average those found in Delft in the five property classes discussed above. It is then possible to compute the number of paintings provided that two additional facts are known: the number of households in Holland during the period under review and their distribution across the five classes of wealth. A fair estimate of the first can be constructed, and we can assume for the moment that at the time the wealth distribution in Delft was more or less identical to that in Holland as a whole.

Table 1 displays data introduced earlier on population, mean household sizes, and the estimated numbers of households in every twenty-year period from 1580–1599 until 1780–1799.[11] The assumed household life span of twenty years yields a total between 1580 and 1800 of a little over two million. Table 5 provides information on the distribution of the property classes in Delft. It is based on figures for people aged twelve years and older who were buried during this period. The published information does not correspond exactly to the three time periods used in tables 2 through 4 but comes as close as possible. It is noteworthy — and for our purposes convenient — that the distribution of burials across the five classes of wealth differed very little from period to period. I feel justified, therefore, in using a single average figure for the entire period, identified in the column 1716–1794.

To test whether this stability of wealth distribution in Delft can be considered as typical of eighteenth-century Holland, we can consult the only

other published data on this subject — the records of burials in Amsterdam (table 6).[12] It is immediately apparent that the wealth in Amsterdam differed greatly from that in Delft, but these burial tax data cannot be compared without further research because Amsterdam used monetary criteria for the five classes that differed fundamentally from those used in Delft. Moreover, the Amsterdam data included children under the age of twelve. Such children seem not to have been taxed according to the property class of their parents; most were assigned to the lowest class. In one important respect the Delft and Amsterdam data are similar: both show substantial consistency throughout the century in the relative importance of each class.[13] This and the direction of the bias in the Amsterdam burial data suggest that the use of the Delft wealth distribution for all of Holland is not altogether unreasonable.

Table 7 gives the results of this exercise. The further back into the seventeenth century one pushes, the more uncertain is the use of Delft's eighteenth-century distribution of the households over the five classes of wealth. (I have indicated this by inserting question marks on the table.) Assuming that the city of Delft can stand for all of Holland with respect to both the distribution of wealth among households and the average number of paintings held by members of each property class, I calculated the total number of paintings decorating the walls in the households of Holland by combining the data of tables 7 and 4. If the mean household life span is twenty years, there are eleven generations of households between 1580 and 1800. For the 2.16 million households estimated to have existed in this period, I have calculated the presence of nearly 25 million paintings (table 8), or nearly 11.5 paintings per household.

It is certainly not possible to conclude, however, that the total number of paintings produced in Holland can be found in the total column of table 8. The first minor problem is the fact that the periodization used in tables 4 and 7 could not be synchronized. Consequently, on table 8 there are sudden drops in the reconstructed numbers between the generations 1700–1719 and 1720–1739, and again between those of 1760–1779 and 1780–1799. These result from my model of computation. If we accept the results of the generations 1700–1719, 1740–1759, and 1780–1799 with their quantities of about 3.1, 2.0, and 1.2 million paintings as plausible given the assumptions of the model, then we may accept the quantities of 2.5 and 1.6 million as much better estimates for the generations 1720–1739 and 1760–1779, respectively,

than those shown in table 8. Since these corrections cancel each other out, they have no influence on the total for the eighteenth century or the entire period 1580–1800.

A more fundamental problem concerns the extrapolation of the data from the beginning of the eighteenth century back into the seventeenth and late sixteenth centuries. For the last and perhaps even for the penultimate generation of the seventeenth century, this procedure may be acceptable, but the further back one goes, the more dubious this extrapolation becomes. Unfortunately, for the moment we have no better alternative.

One might object, however, to the notion that the situation in Delft can be considered as the norm for Holland as a whole, a key assumption of the model. Delft had been one of the main art centers of Holland, and it would seem reasonable that the average number of paintings in Delft households might have been higher than in many other places. Only protracted research like that done by Wijsenbeek-Olthuis can test this hypothesis. However, in defense of my approach it can be countered that this flowering of the Delft school of painters — Michiel Jansz. van Miereveld, Willem van Vliet, Jacob van Geel, Leonaerd Bramer, Christiaen van Cowenbergh, Anthonie Palamedesz., Gerrit Houckgeest, Emanuel de Witte, Carel Fabritius, Pieter de Hooch, and Johannes Vermeer — occurred long before 1706–1730, the first period in Wijsenbeek-Olthuis's research. Moreover, the walls of normal houses were not decorated with the products of these outstanding artists. It was the works of anonymous rank-and-file painters that could be found everywhere; these many inexpensive pieces form the bulk of the paintings noted in the probate inventories. But again, only systematic research into the probate inventories of other cities can test this argument.

Delft may have been typical of the other cities of Holland, but it would be unreasonable to assume the same for the rural households. Perhaps further research will show that differences in the style of living and housing between the city and the country in Holland were relatively small. But as I have no credible information, it seems prudent to assume that the number of paintings in rural areas was rather less than in the cities. When one arbitrarily sets the rural level at half that found in the cities, the figures in the last column of table 8 have to be reduced by 20 percent, because more than 60 percent of the population of Holland were city dwellers.[14] This would reduce our original calculation of nearly 25 million paintings present in Holland's households to just below 20 million.

We have already considered the representativeness of Delft's distribution of wealth for Holland as a whole. The current state of our knowledge does not permit definite conclusions. Amsterdam, for instance, certainly counted many more very rich burghers than Delft, but it probably also contained many more paupers. A recent study of the average income in Holland's cities in 1742 situated Delft midway between the richest (Amsterdam and Rotterdam) and the poorest (Gouda and Dordrecht).[15] This is a comforting result, but it is also tentative and filled with interpretative problems.

We can be quite certain that the distribution of wealth in the rural districts differed substantially from that found in the cities. There may not have been more poor people in this highly commercialized agricultural society, but there certainly were fewer households that fell in the highest categories of wealth. Here, too, only further research will reveal the true situation, but it seems advisable to subtract from our provisional total to account for the probable difference in distribution of wealth. In Delft the wealthiest 5 percent of households possessed a quarter of all paintings, nearly five times its own quantitative share of the population (table 8). If I provisionally put the size of the richest class (taxable property ≥ 12,000 *gulden*) in rural Holland not at the 5 percent shown in table 5 but at 1 percent of the total number of households, I must reduce the total number of paintings by another 20 percent. This then reduces the total number from 20 to 16 million.

If we now step back for a moment, it is apparent that I have overcompensated for the assumed lower level of rural ownership of paintings: by accounting separately for differences in rural tastes and wealth, I have probably exaggerated the rural/urban gap in the ownership of paintings. At the outset, when I made no distinction between town and country, a total of 25 million paintings was allocated — 60 percent (15 million) to the cities and 40 percent (10 million) to the country. By reducing the total number from 25 to 16 million, only 1 million paintings are left for the countryside. This figure is surely too low in relation to the 15 million ascribed to the cities; by deducting separately for rural "life-style" and for wealth distribution, I have treated separately two interrelated phenomena. Let us bring this exercise to a close by concluding that some 18 million paintings may have been present in Dutch households between 1580 and 1800. (This requires that the last column of table 8 be multiplied by 18/25, or 0.72).

So far we have been discussing "the number of paintings present in

households." That number would have been very different from the number of *new* paintings. If, for example, a picture painted in 1700 was handed down from generation to generation, it would be registered in this model not once but five times. Consequently, the actual number of pictures painted in the Dutch Republic will be but a fraction of the 18 million. We thus need to try to distinguish between the numbers of newly painted pictures and those handed down from one generation to another.

The Wijsenbeek-Olthuis research shows that between the periods 1706–1730 and 1770–1794 the number of paintings present in households declined by about 70 percent (from nearly 3 million to nearly 1 million in table 8). That is, in a period of sixty-four years at least 70 percent of the paintings present in the years 1706–1730 had vanished. In fact, an even larger percentage must have vanished, for it would be ridiculous to assume that not a single new painting was acquired in the intervening years.[16] If we assume for the moment that of the paintings present in the households at the end of the eighteenth century, two-thirds had been produced during that century, then less than one-third of the numbers for the 1790s originated from before 1700. This leads me to conclude that by 1800 more than 90 percent of the paintings existing around 1700 had been lost.

This is believable if we remember the conditions in which those 3 million paintings were introduced. Houses at that time were not built as they are today with air space between the walls. They must have been very damp and water must often have actually dripped from them. This dampness was aggravated by the absence of central heating and by the fact that in simpler dwellings cooking was done in the living quarters, which were inadequately ventilated. Until the end of the eighteenth century cooking and heating always took place on open fires.[17] The resulting smoke, soot, and vapor attached itself to everything not regularly cleaned. This was aggravated by the use of candles (which were expensive and therefore not always of the best quality) and, still worse, of all sorts and qualities of oils employed for lighting. The gout and rheumatism that were facts of life at this time resulted from environments that were also destructive of works of art, which could be safeguarded only with great effort and constant vigilance. For the bulk of common paintings these precautions could not be taken. A survival rate of about 10 percent after a hundred years is not unrealistic under these circumstances. It implies that only about half the stock of paintings were handed down from one generation to the next (i.e., after four changes of

generations: $100 > 50 > 25 > 12\frac{1}{2} > 6\frac{1}{4}$). Things are not really so much better today despite our greatly improved living conditions. For Picassos perhaps they are but not for the less exceptional pieces bought at galleries or exhibitions; otherwise, there would be many more nineteenth-century paintings seen in Dutch houses than there are today.

Accepting a survival rate of 50 percent from one generation of households to the next, we are easily able to distinguish between the number of paintings handed down and the number of new works acquired by each generation. Generation by generation we can translate the total number of paintings estimated in table 8 (reduced by 18/25) into an estimate of the production of paintings for the period 1580–1800. If all of the assumptions and estimates discussed so far are accepted, production for domestic use totaled nearly 9 million paintings (table 9).[18]

The estimates displayed in table 9 show that the share of new paintings in household collections was at its peak between 1600 and 1640, when nearly 60 percent of the total stock consisted of new works. Thereafter the share of new paintings falls, gently at first and more steeply in the eighteenth century. The relative stability of the share of new works in the seventeenth century may bear revision (see, by way of comparison, the share of "contemporary" painters in the collections analyzed by John Michael Montias in table 9 of his article in this volume). In my model the only variable generating change in this estimate is population growth and decline. In the eighteenth century the Wijsenbeek-Olthuis data on changes in the size of collections adds a greater degree of realism to the estimates. As it stands, the model shows that at least two-thirds of the total production was concentrated in the period 1580–1700.

It is likely that the concentration of production in the seventeenth century was even greater than shown in table 9, for the table makes no provision for paintings produced for export, by which I mean those paintings that never hung on walls or reposed in collections in Holland. Unfortunately, we have only a very limited knowledge about export volume. This is partly because there were two kinds of exports: those that were sent to parts of the republic outside of Holland and those that were sent abroad — generally pieces of high quality.

Only scraps of indirect evidence give hints of the possible volume of exported paintings. Consider the statement made at the beginning of this century by Abraham Bredius in which he placed the number of Dutch and

295

Flemish paintings preserved at that time in French provincial museums at 40,000.[19] If this figure is reliable, one might conservatively attribute one-quarter, 10,000, to Dutch origin. It was known that Dutch paintings were also sent to English, Belgian, Spanish, German, and Scandinavian buyers. During the seventeenth century the population of France was nearly as great as that of all the adjoining countries put together. Therefore, let us double the number to 20,000. Floerke gives a figure of at least 9,000 Dutch paintings preserved outside the Netherlands in the outstanding museums in Europe at the end of the nineteenth century.[20] If in 1900, 10,000 Dutch paintings were stored in the best museums of the world, then this would mean about 30,000 pieces in museums outside the Netherlands. These pieces would have been the surviving fragment of a much larger number. The quality of these exported pieces would have been on average higher than those 8 or 9 million that, according to the model, seem to have been produced for the home market. It is prudent to assume that their survival rate was relatively high, perhaps 10 percent,[21] which would suggest a total export of about 300,000. In addition to these museum pieces, there would be paintings still in private hands in 1900, but I have no way of estimating their number.

We are similarly in the dark about the number of paintings produced for other provinces in the Dutch Republic. Of course there were workshops of local painters in many places outside Holland, especially in Utrecht but also in Middelburg, Nijmegen, Zwolle, Groningen, Leeuwarden, and perhaps many more towns. Still, we can be confident that there was a substantial net export from Holland to markets in these regions. Probate inventories for farmers on the island of Walcheren in Zeeland during the second half of the eighteenth century typically seem to record the presence of between 5 and 10 paintings among the furnishings of the deceased. If indeed this was a normal situation, then quite clearly the demand could not have been met by local production from Middelburg alone. In two Frisian districts — Leeuwarderadeel, which included 14 hamlets and Hennaarderadeel, which included 12–41 percent of the farmers with 10 or more milking cows had an average of 3.6 paintings per household in 1646–1654. Farmers with fewer than 10 milking cows owned none at all. In Leeuwarderadeel in the periods 1677–1786 and 1711–1750, 29 percent and 28 percent respectively of the larger farmers possessed paintings with average numbers of 3.0 and 4.8; among the smaller farmers 17 percent and 16 percent owned paintings, with means of 3.5 and 3.7 per household. One should not imagine that these farmers

possessed major works of art: they were often noted as painted on wood and were rarely valued at more than a few *stuivers* each.[22]

At this stage in our research it is impossible to give any reliable figure for the volume of export. But we can cautiously conclude this section of the analysis by noting that the total volume of paintings produced in Holland at the time of the republic (1580–1800) certainly exceeded the 8 million pieces absorbed by the domestic market; it may have reached 10 million. In all of this the reader must not lose sight of the many assumptions standing behind this estimate; it must be accompanied by a large margin of error.

Estimating the Number of Painters

The analysis thus far has been based on evidence, often indirect, of demand — the number of paintings acquired by households at home and abroad. A useful check on the reality of our conclusion that as many as 10 million paintings entered the market is to approach this issue from the supply side: how many painters worked in Holland during the period 1580–1800, and how many paintings did they produce? Here too direct evidence fails us, but it is possible to identify the assumptions necessary to account for a production of 10 million paintings. This can help us decide whether this number should be dismissed as absurd or retained as a viable hypothesis.

We know that painters accounted for 1 percent of the male labor force in the city of Antwerp shortly before it was occupied by the Duke of Parma's Spanish forces in 1585.[23] However, this number includes *kladschilders*, painters of houses, signboards, or other coarse work. Montias, in his book on Delft, reconstructs the numbers of painters (defined by membership in the Saint Lucas guild) for the years 1613, 1640, 1650, 1660, and 1680.[24] These can now be compared with the population figures for Delft provided in Wijsenbeek-Olthuis's study.[25] Under the reasonable assumption that the adult male labor force was about 30 percent of the total population, Montias's figures lead to the conclusion that in Delft painters made up 0.7 percent of the male labor in 1613, 0.7 to 0.8 percent in 1640, 0.6 to 0.7 percent in 1650, and — after the sharp decline of the city as a center of artistic importance in the 1660s — 0.3 to 0.4 percent in 1680. Again, the fact that there were some *kladschilders* in this group complicates things: it means that the estimate of the percentage of workers active as painter-artists must be lowered. I

propose an upper boundary of 0.5 percent and a lower boundary of 0.3 percent, in the expectation that the truth lies somewhere in between.

Since painters, who were generally members of the Saint Lucas guild, lived in the towns, it is important to know the number of urban inhabitants. By about 1600 more than 50 percent of Holland's population lived in cities. By 1622 this had increased to 54 percent or more, and after 1650 it reached about 60 percent, where it remained until the end of the eighteenth century.[26] The number of urban dwellers in 1650 could be put at 480,000, in 1680 at about 525,000, and between 1730 and 1800 again at 480,000. Between 1580 and 1622 this number increased steadily from 200,000 to 365,000. Since the average length of a labor force generation was about twenty-five years,[27] we must reckon with nearly nine generations of painters. After 1650 (six generations) the total urban male labor force was probably at least 160,000. Between 1580 and 1650 this labor force grew from about 70,000 to 160,000. To simplify the calculations, I converted these three pre-1650 generations into two generations as large as those after 1650, which enables me to base my calculation on eight generations each with a labor force of 160,000 urban males. If the proportion of the painter-artists in the generations before 1700 is set at 0.5 percent and that of the four generations after 1700 at 0.3 percent, then the estimated number of painters is:

$$4\frac{(5 \times 160,000)}{1,000} + 4\frac{(3 \times 160,000)}{1,000} = 3,200 + 1,920 = 5,120.$$

This means that in Holland for most of the eighteenth century there would have been about 480 painters at work in any given year. Between 1650 and 1700 this number would have been 800, or even a little more during the last quarter of the century. Between 1580 and 1650 the relative level would have been as high as during the second half of the seventeenth century, but the absolute numbers would have increased at the same rate as the urban population as a whole, from nearly 400 active painters around 1590 to about 800 by 1650. All these numbers are of course the approximations of a theoretical model.

The next question we must consider is whether these 5,000 or more artists, each working for an average of twenty-five years, could have been so productive as to reach a total output of about 10 million paintings. Such a feat implies an average production of 2,000 paintings per painter over an average career of twenty-five years. To achieve this output painters in Holland would have had to finish an average of 1.6 paintings per week. If this

is not realistic, we must try to determine what is wrong with these calculations. The number of artists estimated may be too low, or 10 million pieces may be too high.

Quantitative information on the productivity of individual painters is lacking and comments on the subject in the literature exceptional. But some contemporary statements exist that are worth considering. Samuel van Hoogstraten and Arnold Houbraken both tell of the competition among François Knibbergen, Jan Porcellis, and Jan van Goyen as to who could paint the best picture in the course of a day.[28] Art historian Wolfgang Stechow refers to a contract entered into by Porcellis in 1615 whereby he agreed to deliver forty seascapes in twenty weeks.[29]

Jan van Gool[30] recounts having heard from Matheus Terwesten (1670–1757) that Willem Doudijns (1630–1697), while an apprentice, had to copy portraits of farmers by Adriaen van Ostade. Pupils skilled in this activity could paint two copies per week and sell them for six *gulden* apiece.[31] Van Gool also mentions that the painter Roelof Koets II (1655–1725) could paint six portraits in one day. Van Gool was not inclined to take this piece of information literally, but he does state that people ascribed 5,000 portraits to Koets.[32] Houbraken, however, says that Van Miereveld painted about 5,000 portraits.[33] Van Miereveld lived for seventy-three years and would have practiced his craft for some fifty years, also an average production of two per week.

Van Gool tells yet another story, which takes place in Rome. There seems to have existed a kind of "manufactory," which he calls *een galey* (a galley), in which painters could earn a living by endlessly producing the same kind of picture, most commonly a portrait of a saint. A painter-craftsman could manufacture thousands and thousands of these, which were then sent by the shipload to the Spanish and Portuguese colonies, where they were used to decorate the newly built churches and cloisters.[34]

This story demonstrates, in an exaggerated way, a specialization of labor not totally unknown in the Netherlands. Montias points out that division of labor was a classic way of increasing productivity and reducing costs — in the arts no less than in the manufacture of pins. Rubens was not the only one to refine this production technique in the organization of a workshop by attracting "specialists" whose separate skills in painting animals, landscapes, still lifes, and so on, were applied to the production of integrated compositions. Montias also mentions the example of Bartholomeus van de

Bassen, a painter of church interiors who frequently had Esaias van de Velde paint the figures that animated his works.[35] The growth of market demand called for division of labor and for specialization. Van de Velde and Jan Porcellis moved from "linear depiction and additive composition toward a more painterly technique and a simplified composition integrated by the modulation of color and tone."[36] In the 1640s these new techniques were improved still further by artists like Van Goyen and Pieter Moulijn in landscape; Jacques de Claeuw, Willem Heda, Harmen van Steenwyck, and Evert van Aelst in still life and Van Ostade in low-life genre. Even painters like Frans Hals and Rembrandt could not ignore these technical developments. In the 1640s much less time was needed to produce paintings of comparable size and subject matter to those executed in the 1610s.

One consequence of the diffusion of these innovations must have been a downward pressure on the price level of paintings, especially paintings by rank-and-file workers who could not contribute much "artistic value" to their products — or who could not convince their buyers of it. This last point offers one final chance to obtain an impression of the productivity of painters. The handful of artists who enjoyed renown in their own time often had no problem selling their products for enough money to support a comfortable existence. But even among painters of repute earning a decent living was not always easy. Some combined their work as painters with other, probably more secure, professions, and yet others left the field altogether. Van Gool wrote plainly about artists who could earn no more by their art than common laborers. According to him, even among the masters it was difficult to reach a level of income double that of a carpenter.[37] Van Gool was writing in the middle of the eighteenth century and argued how much better it had been for artists in the Golden Age (the seventeenth century). But was his praise of those bygone days appropriate?

After the middle of the seventeenth century the wage rate for master carpenters in the towns of Holland varied between 28 and 34 *stuivers* per day; in the country this may have been 4 to 6 *stuivers* lower. During the same period the daily summer wage rate for common outdoor labor varied in the towns from 20 to 24 *stuivers*, while in the country it could be as low as 16 to 20 *stuivers*.[38] Van Gool was certainly looking at the urban wage level, and we can conclude that the daily wage rate in the towns of Holland for specialized craftsmen like carpenters was about 1.50 *gulden* per day or 9 *gulden* per week, and for common laborers 1.10 *gulden* per day or 6.50 *gulden*

per week. Changes in the wage level were minimal between 1650 and 1800.

How could a painter hope to make twice the earnings of a master carpenter — 18 *gulden* per week? How many "average" paintings would he have to produce and sell? To answer these questions, we can consult the over 1,700 paintings assigned a monetary value in probate inventories of Amsterdam, mostly in the 1660s and 1670s (table 10). The mean price of these paintings is 31.22 *gulden*. When one excludes the 137 paintings with an estimated value of 100 *gulden* or more (the top 8 percent of this sample), the mean value of the remaining 1,593 paintings averages 15.49 *gulden*. We need to inquire as to whether these approximately 1,600 paintings suggest the typical value of paintings at the time. The selection of this sample could have been biased toward above-average values since the probate inventories have been selected on the basis of the great numbers of paintings contained in them. They are inventories of collectors. On the other hand, the selection might contain some prints recorded by notaries as "paintings." Moreover, it is possible that the many secondhand, anonymous paintings in these collections had lower values on their dates of valuation than when they were sold by the painter.

A mean value of 15 *gulden* for all paintings not belonging to the top 10 percent implies that painters had to produce 1.5 paintings per week to reach a net income twice that of a carpenter (after deduction for cost of materials and the rent of a studio). From this information I am inclined to conclude that for many, if not most, of the Dutch painters during the seventeenth and eighteenth centuries a production of one to two paintings per week was essential to earn a decent living. If this conclusion can be sustained then several millions of paintings must have been produced in Holland during the period 1580–1800. Indeed, 5000 painters × 25 years of productive life × 50 weeks per year × 1.5 paintings per week = 9,375,000 paintings.

The Value of Production

Using the simple formula volume × price = value, it is easy to make a calculation based upon the estimated quantity of paintings and on the prices found in the inventories stored in the Getty-Montias data base. If the existence of 10 million paintings and the average price of 31.22 *gulden* for *all* paintings is realistic, then the total value of the production could have

been about 310 million Dutch *gulden*. If the production amounted to no more than 6 million pieces, the value comes to 190 million *gulden*.[39] Disregarding changes in the volume of production over time, this would give an average yearly value of 1,400,000 *gulden* or 850,000 *gulden*. It is instructive to compare this to other sectors of the economy. Consider the Dutch tobacco crop and the cheese production of North Holland. In the beginning of the eighteenth century the average annual value of North Holland cheese production, at that time one of the most important agricultural export products, was nearly 2 million *gulden*. The value of the total Dutch tobacco crop, also one of the main export products, amounted to 2 million *gulden* at the beginning of the eighteenth century.[40] The price level of agricultural products was a little lower at the beginning of the eighteenth century than in the middle of the seventeenth. Nonetheless, the average yearly value of paintings in Holland could have equaled over half the value of the North Holland cheese production or the total Dutch tobacco crop at its peak.

In practice, however, the situation is likely to have differed from this simple arithmetical exercise for a number of reasons. First of all, the production would not have been equally spread over the years. There must have been periods of high and of relatively low production. Secondly, price data used here are probably biased upward because they were taken from the probate inventories of Amsterdam collectors. Finally, it is important to remember that most of these price valuations come from the 1660s and 1670s, and the price level for paintings changed considerably over time. The eighteenth century remarks of Van Gool already point in this direction. Therefore, it is not realistic to calculate the total value of a production stretching across more than two centuries with a (probably biased) mean price originating from one relatively short period. But for the moment it is all that we have and the result is not meaningless, for it can serve as a point of reference to be altered in the future when more reliable information on quantities *and* on prices becomes available.

Before leaving the issue of the price of paintings, I wish to draw attention to some other features of the prices collected in the Getty-Montias data base. Table 10 presents a survey of data on the prices of 1,127 unattributed and 603 attributed paintings. Table 11 summarizes them in a more manageable way. It is striking that prices cluster around certain round figures. Closer examination reveals that two systems of accounting were in use

simultaneously, the duodecimal and decimal systems. Prices cluster around 3, 6, 12, and their multiples as well as around 5, 10, and their multiples. There was also an enormous difference between unattributed and attributed paintings. As can readily be seen in table 11, nearly 50 percent of the anonymous paintings were assessed at a value of 5 *gulden* or less. But it is perhaps even more astonishing to see that nearly 10 percent of the attributed ones were also valued in this range.

This reveals something about the possible value of oil paintings in Holland. If we suspect that, in general, "paintings" with an assessed price of 2.5 *gulden* or less were actually prints, drawings, and such objects, the number of paintings in this data base would fall by nearly one-quarter (422 of the 1,730 paintings is 24.4 percent), but their total value would be lowered by only 514 *gulden*, from 54,019 to 53,505. The average value of the remaining 1,308 paintings is thereby raised to 40.91 *gulden*. If one accepts that all pieces with a value of less than 5 *gulden* should be considered as drawings, prints, and the like, then the number of pieces accepted as real oil paintings falls to 1,119, or only 65 percent of the pieces described in the inventories. But the value of this 65 percent would only shrink to 52,855 *gulden*, or 97.8 percent of the total value of all 1,730 pieces found in the probate inventories. From this we learn that even an enormous reduction in the number of "paintings" on the grounds that they were misidentified would influence the monetary value of the painted production only marginally.

Subject, Size, and Price

A glance at the valuations in the probate inventories reveals that different types of paintings typically received distinct valuations. Indeed, Floerke drew attention to this fact[41] at the turn of the century, and more recently, Brulez did the same for the Antwerp art market of the seventeenth century.[42] The data from the Getty-Montias data base makes it possible to analyze this issue for Dutch paintings around the mid-seventeenth century. I classified the valuations of the 1,730 paintings found in the Amsterdam probate inventories, following as closely as possible the categories used by Montias with the addition of a category for animals (table 12).[43]

The price differences that emerge from this exercise are substantial and rather well correlated between attributed and unattributed paintings;

this implies that the differences are real and significant. The most valuable paintings in both categories were those depicting allegorical, mythological, biblical, and other religious subjects (with the exception of Old Testament scenes). There was a middle group of paintings with valuations slightly above the overall mean price level (Old Testament scenes, portraits, the anonymous "other histories," and attributed genre paintings). Distinctly lower valuations were given to landscapes, still lifes, animals, anonymous genre paintings, and attributed "other histories." The most valuable group had a price level about 80 to 100 percent higher than the overall average in both categories. The middle group had values of 15 to 25 percent higher than these averages. The lowest group was valued at about 20 to 30 percent below the overall means. The prices of paintings with the most expensive subject matters were more than twice those of the lowest group.

Setting aside for the moment the question of whether the valuations in these Amsterdam probate inventories are representative of the general price level in absolute terms, I believe that these data confirm that subject had a great influence on valuation. This adds interest to the relative importance of each type of painting in the Getty-Montias data base. Table 13 shows the distribution of paintings by subject separately for attributed and unattributed paintings. Also displayed, for comparative purposes, are data provided by Montias in his study on Delft[44] and the distribution by subject for the Rijksmuseum's collection of Dutch paintings that relates to painters born between 1550 and 1649.[45]

The similarity between the data from Delft and the Getty-Montias data base is to be expected. Landscapes were by far the most popular paintings in private collections in the decades around the middle of the seventeenth century. In Delft they numbered more than 31 percent, in the Amsterdam inventories their share was 28 percent (attributed) and 26 percent (unattributed). Portraits take the second place, accounting for 16.5 percent in Delft and 12.9 percent and 18.1 percent in Amsterdam. But the difference in numbers between both subject categories was great. There were twice as many (relatively inexpensive) landscapes as portraits. In Delft scenes from the New Testament and still lifes held a shared third position (nearly 13 percent), but in Amsterdam these subjects were surpassed by genre paintings (more than 9 percent). There were far fewer religious paintings in Amsterdam than in Delft, with a percentage of only 12.6 as against 25.9. Also, still life paintings were less frequently found in Amsterdam (around

6 percent) than in Delft (12.5 percent). But the relative importance of genre painting was exactly the opposite.

Comparison with the Rijksmuseum's collection shows a change in the positions of landscapes and portraits. In the Rijksmuseum the portrait holds first place; religious subjects take a low position, 6.8 percent. On the other hand the prestigious — and in their time most expensive — paintings of mythological and allegorical subjects account for nearly 5 percent of the works in Rijksmuseum's Dutch collection. Genre paintings make a strong showing at 14.4 percent. However, two complications make the comparison across the Delft, Amsterdam, and Rijksmuseum data rather difficult. In the Getty-Montias data base the category of "unknown" subjects accounts for 19.2 percent of the attributed and 16.2 percent of the unattributed paintings. In the Delft and the Rijksmuseum data this group is nonexistent. In the Rijksmuseum collection portraits hold a far more prominent place than portrait paintings would have held in seventeenth-century private collections. This is clearly a product of the history of the collection itself.

One way to overcome these difficulties in the comparison of the four columns in table 13 is simply to remove portraits and unknown subjects from consideration and to examine the remaining paintings. The results are summarized in table 14. Without these two categories, landscapes become the most important subject in all four columns. Moreover, the share of this subject proves to be almost equal in all four cases, oscillating between 37 and 42 percent. In second place now are genre paintings, in three out of the four cases between 12 and 22 percent. Only in Delft does this category assume a subordinate position with under 6 percent. Still life is in third place with a share varying between 9 and 15 percent. Landscape, genre, and still life were, at the time, the least expensive paintings.

Taken together, landscapes, genre paintings, and still lifes represent shares between 58 percent (Delft) and 69 percent (Rijksmuseum). If Houbraken and Van Gool were right in saying that there were portrait painters who produced 5,000 portraits, we can be fairly sure that there were also painters of high productivity in landscapes, genre paintings, and still lifes. Otherwise, the price level of paintings of these three types would probably not have been lower than that of portraits. Portraits would nearly always have been commissioned, and in general the customer would have been critical. Even Rembrandt declared himself prepared to continue his labor on a portrait if neutral critics judged the resemblance to be too poor.[46] Land-

scapes, genre paintings, and still lifes, however, were produced for the mass market. Only in exceptional cases were they commissioned, and the demand for a true likeness would have been much less common or nonexistent.

Labor intensity is an obvious factor influencing the price-level differences revealed in table 12. There may also be another factor that would help explain these differences. A seemingly trivial aspect, the dimensions of the canvases, may have played a role in the determination of the monetary values. Any visitor to galleries of contemporary art can observe some correlation. We need to examine whether this might also have been the case in the seventeenth century.

To the best of my knowledge no systematic research has been done on a possible correlation between subject matter and mean surface area of Dutch paintings.[47] In an effort to fill that gap I turn again to the collection at the Rijksmuseum.[48] Tables 15 and 16 offer the results of my analysis, while graph 1 offers a visual display of the findings. The analysis relates to 2,900 paintings chronologically divided into periods of half centuries, beginning with paintings by painters born before 1500 and ending with the period 1850–1949. The emphasis in the Rijksmuseum collection of Dutch paintings is clearly on the half-century 1600–1649 (1,115 paintings out of the total of 2,900, or 38 percent). The collection of works by painters born during the half-centuries 1650–1699 and 1700–1749 (120 and 280 pieces, respectively) is relatively small.

The regularity in the development of the mean size of paintings over time (table 16) is a striking feature of this investigation. Mean sizes became gradually larger, culminating with paintings by artists born during the second half of the sixteenth century (with most of their working life in the first decades of the seventeenth). From a mean surface area of 86 × 86 cm for paintings by those born before 1500, a peak of 117 × 117 cm is reached for painters born in the second half of the sixteenth century. Thereafter, mean surface area declines gradually to the 70 × 70 cm reached by artists born between 1850 and 1949 (in fact, nearly all of them were born before 1900[49]). This long trend was broken only by a temporary interruption of paintings made by painters born between 1750 and 1799.

Some questions arise from this unexpected finding. Does the regularity reflect the history of the collection or something in the craft of painting itself? Can we discover this by analyzing other collections of Dutch paintings like those in the Mauritshuis and Frans Halsmuseum? And if such

analysis confirms these findings, can we assume that this was not a typically Dutch but an international development? Catalogs of extensive collections should make it possible to answer this question. The temporary interruption found in the works of painters born about 1800 and working during the first half of the nineteenth century was caused by a handful of exceptional pieces.[50] These huge paintings may possibly have been the result of a temporary new development connected with the Romantic style in painting, which was diffused internationally. (One thinks, in this connection, of Théodore Géricault.) In any case, if the Rijksmuseum collection reflects a broader reality, this development of mean sizes over time presents a new aspect of the relation between form and content. Moreover, there is a striking parallel in book publishing, where the folios and quartos were also gradually supplanted and replaced by octavos.

Among the types of paintings only portraits were sufficiently numerous to test whether these trends in surface area were also present *within* types. But here we are confronted by a complication: portraits came in two kinds, individual (almost exclusively found in the probate inventories) and group (usually much larger in size and surely overrepresented in the museum collections). It is advisable to distinguish between the two.

Let us now direct our attention to the general relationship between subject category and size. The last column of table 16 reveals major size differences among different subjects. The largest mean surface in the whole collection belongs to paintings classified as "mythology-allegory" (175×175 cm = $30,658$ cm^2). The smallest is found under genre (61×61 cm = $3,678$ cm^2). Mythology-allegory paintings measured for the whole collection are on average eight times as large as genre paintings.[51] No wonder there were differences in the valuations in the probate inventories. In second and third place but with little difference between them are "Old Testament" and "histories" (mean sizes 138×138 cm and 131×131 cm, respectively). "Portraits" take fourth place (113×113 cm) with practically no difference between them and "New Testament" (111×111 cm); the complication involving portraits should, however, be kept in mind. "Animals" (93×93 cm) take sixth place. The difference in the means between "landscape" and "still life" (78×78 cm and 77×77 cm) is negligible. As already mentioned, "genre" closes the rank order.

These data of averages refer to the whole collection of the Rijksmuseum from the earliest to the latest painting. The monetary valuations from the Getty-Montias data base span the period between 1620 and 1680, although

they are concentrated in the 1660s and 1670s. For a comparison with these price valuations it is more sensible to look at that part of the Rijksmuseum collection devoted to Dutch painters born between 1600 and 1649. Happily enough the quantity of paintings (1,115) in this collection is the most numerous for this period. Nevertheless, we must remove from consideration the "other religious" category because the Rijksmuseum has only two such paintings from this period (table 15). The same obtains for the category "other," with three paintings. Finally, the complication regarding "portraits" makes it advisable to exclude them also from a comparison between sizes and prices, at least for the moment. This leaves eight out of the eleven subject categories (table 17).

There is at least one striking similarity in the rank order. The price valuations of the 683 unattributed paintings in the eight subject categories from the Getty-Montias data base show an almost perfect positive correlation with the average sizes per subject found in the Rijksmuseum collection. The bigger the mean size of a subject in that collection (column 2), the higher the mean price valuation found in the Getty-Montias data base (column 4). There is also a rather less perfect negative correlation between size (and probably also price) and incidence in the probate inventories collected in the Getty-Montias data base: the bigger the size and the higher the price, the lower the share of that subject matter in the private collections of the data base. The smallest are landscapes, genre paintings, and still lifes, and the mean prices for them are the lowest (among the unattributed paintings). Their frequencies, however, are the highest. On the other hand, the subject categories of mythology-allegory, Old Testament, and history paintings have the largest mean sizes in the Rijksmuseum, high mean prices in the data base of unattributed paintings, and a tendency to be present less frequently in the probate inventories.

This last correlation, however, is not perfect. For the moment I am inclined to attribute this to the small sample size in several categories. Only 381 attributed paintings were taken into consideration for prices and frequencies in this rank-order correlation. These had to be distributed across eight subject categories. Given the much better correlations of the 868 paintings from the Rijksmuseum with the 683 unattributed paintings from the Getty-Montias data base there is every reason to believe that the correlations will improve when sample size is increased. This should encourage further research into these aspects of the craft of painting.

Conclusions

Can I say, with any certainty, how many paintings were made in Holland between 1580 and 1800? Not yet, but we have advanced considerably beyond reliance on such vague expressions as "many" and "a lot." Approaching the subject from both supply and demand, I have demonstrated that it is reasonable to locate the production of paintings somewhere between 5 and 10 million. In view of paintings remaining in museums and private collections, this may seem astonishing: it implies that less than 1 percent has survived. All of the good pieces have not been preserved, but most of the pieces that remain belong to the qualitative top of the production.

My estimates of the volume of production were reached by relying on rather crude evidence concerning the number of households, their social distribution, the level of urbanization, and the number of "paintings" found in households of Delft in the eighteenth century. The level of urbanization may be considered solid enough, but the other data are certainly open to discussion. The determination of the number of households was done in an impressionistic and imperfect way; future research may improve on this. The wealth distribution is exclusively based on the data for Delft, but the sources to reconstruct this for cities and the countryside in Holland during the eighteenth century exist in abundance. There is less available for the seventeenth century. But in this, too, future research may improve our knowledge considerably. The most serious deficiency at present concerns the most important information, the mean number of paintings present in houses. At present our information is limited to Delft. It is true that the source from which this information was derived for this city — the probate inventories — is extremely detailed. But such probate inventories exist for many other cities and rural areas in Holland. No fundamental obstacles stand in the way of enlarging our knowledge; it is a matter of time and energy.

The issue of the value of the painters' output does not differ from that of the volume. Still, our knowledge is much too restricted and based on too little information to provide definitive answers. Here again it is a matter of time and energy that must be devoted to broadening our knowledge of prices and of the composition of production. The necessary data exist. From the perspective of academic research this is perhaps the most important result of our endeavors here: a method to gain better insights has been developed, and the necessary data have been shown to exist.

Table 1. The Estimated Number of Inhabitants and Households
in Holland 1580–1799

Period	Population	Mean Household Size	Households
1580–1599	500,000	4.3	115,000
1600–1619	600,000	4.2	140,000
1620–1639	700,000	4.2	165,000
1640–1659	780,000	4.0	195,000
1660–1679	830,000	3.9	215,000
1680–1699	880,000	3.8	230,000
1700–1719	860,000	3.8	225,000
1720–1739	840,000	3.7	225,000
1740–1759	820,000	3.7	220,000
1760–1779	800,000	3.7	215,000
1780–1799	800,000	3.7	215,000
1580–1799			2,160,000

Table 2. The Average Number of Paintings in the Households
of Delft (excluding portraits)

Class	1706–1730	1738–1762	1770–1794
1	41	?/(64)[a]	26
2	34	27	16
3	17	14	13
4	15	9	5
5	7	3	1

Source: Thera Wijsenbeek-Olthuis, *Achter de gevels van Delft: Bezit en bestaan van rijk en arm in een periode van achteruitgang (1700–1800)* (Hilversum: Verloren, 1987).

a = Includes the collection of paintings in possession of Willem van Berkel.

Table 3. The Average Number of Portraits in the Households of Delft

Class	1706–1730	1738–1762	1770–1794
1	12	?/(26)[a]	6
2	4	2	1
3	0,0	–	1
4	0,0	0,0	–
5	–	–	–

Source: Thera Wijsenbeek-Olthuis, *Achter de gevels van Delft: Bezit en bestaan van rijk en arm in een periode van achteruitgang (1700–1800)* (Hilversum: Verloren, 1987).

a = Includes the collection of paintings in possession of Willem van Berkel.

Table 4. The Average Number of All Paintings in the Households of Delft

Class	1706–1730	1738–1762	1770–1794
1	53	52/(90)[a]	32
2	38	29	17
3	17	14	14
4	15	9	5
5	7	3	1

Source: Thera Wijsenbeek-Olthuis, *Achter de gevels van Delft: Bezit en bestaan van rijk en arm in een periode van achteruitgang (1700–1800)* (Hilversum: Verloren, 1987).

a = Includes the collection of paintings in possession of Willem van Berkel.

Table 5. Distribution of the Population in Property Classes for the Burial Tax in Delft (expressed as percents)

Class	1716–1735	1736–1765	1771–1794	1716–1794
1	5	5	7	5.6
2	2	3	4	3.2
3	6	7	8	7.1
4	31	28	31	30.2
5	56	57	50	53.9

Table 6. Distribution of the Population in Property Classes for the Burial Tax in Amsterdam (expressed as percents)

Class	1706–1730	1736–1760	1771–1795	1701–1800
1	2	4	5	3.6
2	1	2	2	1.5
3	2	4	4	3.3
4	8	7	7	7.0
5	87	83	82	84.6

Table 7. The Estimated Number of Households in Holland Distributed by Class Analogous to the Delft Ratio

| | Property Classes | | | | | |
	1	2	3	4	5	
1580–1599	6,440	3,680	8,165	34,730	61,985	?????
1600–1619	7,840	4,440	9,940	42,280	75,460	???
1620–1639	9,240	5,280	11,715	49,830	88,935	???
1640–1659	10,920	6,240	13,845	58,890	105,105	??
1660–1679	12,040	6,880	15,265	64,930	115,885	?
1680–1699	12,880	7,360	16,330	69,460	123,970	
1700–1719	12,600	7,200	15,975	67,950	121,275	
1720–1739	12,600	7,200	15,975	67,950	121,275	
1740–1759	12,320	7,040	15,620	66,440	118,580	
1760–1779	12,040	6,880	15,265	64,930	115,885	
1780–1799	12,040	6,880	15,265	64,930	115,885	

N.B.: Question marks indicate that uncertainty in the use of this data increases as the examination is pursued further back into the seventeenth century.

Table 8. The Estimated Number of Paintings Present in All the Households in Holland According to the Delft Ratios

| | Property Classes | | | | | |
	1	2	3	4	5	Total
1580–1599[a]	341,320	139,840	138,805	520,950	433,895	1,574,810
1600–1619[a]	415,520	168,720	168,980	634,200	528,220	1,915,640
1620–1639[a]	489,720	200,640	199,155	747,450	622,545	2,259,510
1640–1659[a]	578,760	237,120	235,365	883,350	735,735	2,670,330
1660–1679[a]	638,120	261,440	259,505	973,950	811,195	2,944,210
1680–1699[a]	682,640	279,680	277,610	1,041,900	867,790	3,149,620
1700–1719[a]	667,800	273,600	271,575	1,019,250	848,925	3,081,150
1720–1739[b]	655,200	208,800	223,650	611,550	363,825	2,063,025
1740–1759[b]	640,640	204,160	218,680	597,960	355,740	2,017,180
1760–1779[b]	626,080	199,520	213,710	584,370	347,655	1,971,335
1780–1799[c]	385,280	116,960	213,710	324,650	115,885	1,156,485
1580–1799	6,121,080	2,290,480	2,420,745	7,939,580	6,031,410	24,803,295

a = calculated in accordance with period 1706–1730 in Table 4
b = calculated in accordance with period 1738–1762 in Table 4
c = calculated in accordance with period 1770–1794 in Table 4

Table 9. Reconstruction of the Number of Paintings Possibly Made in Holland Between 1580 and 1800 (export excluded)

Generation	1580–1599	1600–1619	1620–1639	1640–1659	1660–1679	1680–1699	1700–1719	1720–1739	1740–1759	1760–1779	1780–1799
New Paintings	680,000	812,707	973,028	1,109,214	1,158,512	1,207,810	1,084,565	736,164	529,681	333,176	302,986
Inherited Stock	453,862	566,931	689,819	813,424	961,319	1,059,916	1,133,863	1,109,214	922,689	726,185	529,680
Total (18/25 × table 8)	1,133,862	1,379,638	1,662,847	1,922,638	2,119,831	2,267,726	2,218,428	1,845,378	1,452,370	1,059,361	832,666
New Paintings (in percents)	60	59	59	58	55	53	49	40	36	31	36
Share in Total Production (in percents)	7.6	9.1	10.9	12.4	13.0	13.5	12.1	8.2	5.9	3.7	3.4
Cumulative Quantity of Production	680,000	1,492,707	2,465,735	3,574,949	4,733,461	5,941,271	7,025,836	7,762,000	8,291,681	8,624,857	8,927,843
Cumulative Quantity (in percents)	7.6	16.7	27.6	40.0	53.0	66.5	78.6	86.8	92.7	96.4	99.8

Table 10. Number and Prices of Dutch Paintings in Getty-Montias Data Base

Prices in Dutch *Gulden*	Anonymous Paintings	Attributed Paintings	Prices in Dutch *Gulden*	Anonymous Paintings	Attributed Paintings
<0.5	66	8	37.50	2	–
0.5	50	5	40	8□	16□
1	102	11	42	1	3
1.5	58	3	45	–	3
2	81	3	48	10◊	16◊
2.5	30	5	50	13□	24□
3	92◊	10◊	52	1	–
3.5	7	4	54	–	2
4	63	9	60	11△	24△
4.5	2	2	70	–	9□
5	61□	11□	72	5◊	13◊
6	95◊	28◊	75	–	12□
7	20	7	76	–	1
8	42	16	78	–	1
9	3	1	80	3□	10□
10	50□	13□	85	–	1
11	–	–	87.50	2	–
12	69◊	31◊	90	4□	3□
13	–	1	100	3□	17□
14	2	2	110	–	2
15	22□	21□	120	6△	10△

Table 10. continued

Prices in Dutch *Gulden*	Anonymous Paintings	Attributed Paintings	Prices in Dutch *Gulden*	Anonymous Paintings	Attributed Paintings
16	2	10	130	–	4
17	–	4	150	5	29□
18	21◊	12◊	175	–	1
19	1	–	180	–	4△
20	27□	17□	190	–	1
21	–	–	200	3	13
22	–	–	225	–	1
23	–	–	250	1	6
24	35◊	17◊	260	–	1
25	4□	10□	270	–	1
26	1	3	280	–	1
27	–	1	300	–	8
28	–	–	315	–	1
29	–	–	350	–	3
30	24△	35△	400	–	7
31	–	1	450	–	1
32	–	3	500	–	4
33	–	1	600	–	2
36	19◊	33◊	800	–	1
37	–	8	1,500	–	1
				1,127	603

◊ = duodecimal system □ = decimal system △ = both

Table 11. The Value of Dutch Paintings in the Getty-Montias Data Base

Prices in Dutch _Gulden_	Number of Paintings		Expressed as Percents	
	Unattributed	Attributed	Unattributed	Attributed
<5	551	60	48.9	9.9
5–9	221	63	19.6	10.4
10–14	121	47	10.7	7.8
15–19	46	47	4.1	7.8
20–24	62	34	5.5	5.6
25–29	5	14	0.4	2.3
30–34	24	40	2.1	6.6
35–39	21	41	1.9	6.8
40–44	9	19	0.8	3.2
45–49	10	19	0.9	3.2
50–99	39	100	3.5	16.6
100–249	17	82	1.5	13.6
250–499	1	29	0.1	4.8
500–999	–	7	–	1.2
>1,000	–	1	–	0.2
	1,127	603	100.0	100.0

	Unattributed	Attributed
Total Value	f 13,466	f 40,553
Mean	f 11.95	f 67.20
Median	f 5	f 32
Interquartile Range	f 2 – f 12	f 12 – f 72

Table 12. Mean Prices in *Gulden* of Dutch Paintings from Amsterdam Probate Inventories in the Getty-Montias Data Base – Classified by Subject

Subject	Prices		Index: Total = 100	
	Attributed	Unattributed	Attributed	Unattributed
1. Old Testament	76.54	14.04	114	117
2. New Testament	130.58	19.75	194	165
3. Other Religious	122.53	22.22	182	186
4. Mythology-Allegory	141.46	22.48	211	188
5. Other History	56.70	14.71	84	123
6. Landscape	53.70	9.73	80	81
7. Genre	77.07	9.33	115	78
8. Still Life	45.41	9.72	68	81
9. Portrait	82.72	13.55	123	113
10. Animals	48.59	5.58	72	47
11. Other Subjects	82.32	13.31	123	111
Subtotal	73.78	12.89	110	108
12. Unknown Subjects	39.83	7.11	59	59
Total	67.20	11.95	100	100

Table 13. Classification of Paintings by Subject (expressed as percents)

Subject	Montias Delft 1610–1679	Getty-Montias Data Base Dutch Paintings Attributed	Getty-Montias Data Base Dutch Paintings Unattributed	Dutch Painters Born 1550–1649 in Collection Rijksmuseum
1. Old Testament	8.9	2.0	3.2	3.0
2. New Testament	12.9	5.1	8.1	3.5
3. Other Religious	4.1	2.5	2.8	0.3
4. Mythology-Allegory	2.7	4.1	3.5	4.9
5. Other History	3.8	2.8	4.0	6.9
6. Landscape	31.1	28.2	26.4	25.6
7. Genre	4.7	11.8	7.9	14.4
8. Still Life	12.5	5.6	6.3	6.1
9. Portrait	16.5	12.9	18.1	32.8
10. Animals	–	3.8	2.4	2.2
11. Other Subjects	2.8	1.8	1.1	0.3
12. Unknown Subjects	–	19.2	16.2	–
Number	9,622	603	1,127	1,448

Table 14. Classification of Paintings by Subject with Omission of the Categories "Portrait" and "Unknown" (expressed as percents)

Subject	Montias Delft 1610–1679	Getty-Montias Data Base Dutch Paintings Attributed	Getty-Montias Data Base Dutch Paintings Unattributed	Dutch Painters Born 1550–1649 in Collection Rijksmuseum
1. Old Testament	10.7	2.9	4.9	4.4
2. New Testament	15.5	7.6	12.9	5.2
3. Other Religious	4.9	3.7	4.2	0.5
4. Mythology-Allegory	3.2	6.1	5.4	7.3
5. Other History	4.6	4.2	6.1	10.3
6. Landscape	37.1	41.5	40.3	38.0
7. Genre	5.7	17.4	12.0	21.5
8. Still Life	15.0	8.3	9.6	9.0
10. Animals	–	5.6	3.6	3.3
11. Other Subjects	3.3	2.7	1.6	0.4
Number	8,037	409	740	973

Table 15. Number of Paintings Produced by Dutch Painters in Collection of the Rijksmuseum Classified by Subject and by Year of Birth of Painter

	1400–1499	1500–1549	1550–1599	1600–1649	1650–1699	1700–1749	1750–1799	1800–1849	1850–1949	Total
1. Old Testament	7		15	28	1			6	5	62
2. New Testament	26	5	21	30	2	1	2	3	3	93
3. Other Religious	6		3	2	5		1	1	3	21
4. Mythology-Allegory	3		21	50	23	5	6		1	109
5. Other History	1	1	36	64	5	6	34	16	14	177
6. Landscape	2	1	55	315	27	21	79	218	123	841
7. Genre	1	1	35	174	32	10	24	62	16	355
8. Still Life		1	13	75	24	3	18	21	10	165
9. Portrait	22	71	133	342	103	70	98	87	50	976
10. Animals				32	2	2	6	15	14	71
11. Other Subjects			1	3	7	2	12	2	3	30
Total	68	80	333	1,115	231	120	280	431	242	2,900

Table 16. Mean Size of Paintings (in cm²) Produced by Dutch Painters in Collection of the Rijksmuseum Classified by Subject and by Year of Birth of the Painter

	1400–1499	1500–1549	1550–1599	1600–1649	1650–1699	1700–1749	1750–1799	1800–1849	1850–1949	Total	Dimensions
1. Old Testament	9936.2		13430.4	30807.0	2336.0			6148.4	2503.3	19118.5	138 × 138
2. New Testament	4777.3	14951.9	17831.2	13619.4	4775.7	4380.0	49472.5	7416.6	11637.9	12389.7	111 × 111
3. Other Religious	7384.5		9324.4	15148.2	3311.0		21630.0	13950.0	2729.8	7757.2	88 × 88
4. Mythology-Allegory	6340.6		6064.4	38837.9	19414.1	41913.8	98532.2		6194.5	30658.3	175 × 175
5. Other History	2196.0	14448.0	11415.2	19767.7	9169.6	3637.9	29489.4	6652.7	11270.2	17103.2	131 × 131
6. Landscape	2970.0	2772.0	4428.2	7689.7	4761.8	2890.7	6286.9	6177.9	3499.9	6109.1	78 × 78
7. Genre	1328.0	4788.0	7672.4	2990.5	1833.7	2402.6	3681.0	4862.0	2385.3	3678.0	61 × 61
8. Still Life		19780.0	5846.5	7515.6	4585.0	5605.3	3440.2	5440.4	1430.9	5920.0	77 × 77
9. Portrait	10366.7	10366.7	21367.9	13529.4	13312.7	10458.3	9172.7	7575.1	5894.4	12698.3	113 × 113
10. Animals				10830.9	3223.0	14979.5	9778.0	2924.0	9548.6	8721.2	93 × 93
11. Other Subjects			11857.5	15797.7	4970.0	9258.0	8279.5	10187.5	19170.8	9659.9	98 × 98
Total	7339.3	10657.4	13766.0	11691.4	9656.1	9315.7	12208.9	6184.0	4911.1	10204.2	101 × 101
Dimensions	86 × 86	103 × 103	117 × 117	108 × 108	98 × 98	97 × 97	110 × 110	79 × 79	70 × 70	101 × 101	

Graphical Presentation of the Mean Sizes of the Paintings in the Dutch Collection of the Rijksmuseum Classified by Period of Birth of the Painter

1400–1499	1500–1549	1550–1599	1600–1649	1650–1699	1700–1749	1750–1799	1800–1849	1850–1949	1400–1949

Graph 1. Presentation of the Mean Sizes of the Paintings in the Dutch Collection of the Rijksmuseum Classified by Subject Matter and Period of Birth of the Painter

323

Table 17. A Comparison of the Rank Order in Sizes, Prices, and Frequencies of Seventeenth-Century Dutch Paintings (data from the Getty-Montias data base and the collection of the Rijksmuseum)

Rank Order	Mean Size[a] (N=868)	Mean Prices[b] Attributed (N=381)	Mean Prices[b] Unattributed (N=683)	Frequencies[b] Attributed (N=381)	Frequencies[b] Unattributed (N=683)
1	4	4	4	6	6
2	1	2	2	7	7
3	5	7	5	8	5
4	2	1	1	2	8
5	10	5	10	4	4
6	6	6	6	10	2
7	8	10	8	5	1
8	7	8	7	1	10

Sources: (a) Collection Rijksmuseum; (b) Getty-Montias Data Base

NOTES

I am indebted to my friends from the Getty Center who inspired this publication: Wim Smit, Jan de Vries, Gary and Loeki Schwartz, Eddy de Jongh, Michael Montias, and Lyckle de Vries. The last two were so kind as to put at my disposal important information on prices and quotations from Jan van Gool's writings.

1. Hans Floerke, *Der niederländische Kunst-Handel im 17. und 18. Jahrhundert* (Inaugural dissertation, Universität, Basel, 1901). Most references are to his *Studien zur niederländischen Kunst- und Kulturgeschichte: Die Formen des Kunsthandels, das Atelier und die Sammler in den Niederlanden vom 15.-18. Jahrhundert* (1905; reprint, Soest: Davaco, 1972).

2. John Michael Montias, *Artists and Artisans in Delft: A Socio-Economic Study of the Seventeenth Century* (Princeton: Princeton Univ. Press, 1982).

3. Å. Bengtsson, *Studies on the Rise of Realistic Landscape Painting in Holland, 1610–1625* (Stockholm: Institute of Art History of Uppsala, 1952); Gisela Thieme, *Der Kunsthandel in den Niederlanden im siebzehnten Jahrhundert* (Cologne: Verlag der Löwe, 1959); J. L. Price, *Culture and Society in the Dutch Republic during the Seventeenth Century* (London: Batsford, 1974); Bob Haak, *Hollandse schilders in de gouden eeuw* (n. p.: Meulenhoff-Landshoff, 1984). Egbert Haverkamp-Begemann recently called to John Michael Montias's attention the forgotten study of S. M. Rozental, "O nekotorych sotsialnych predposylkach gollandskoj i flamandskoj zhivopisi XVII veka: Predvaritelnye materialy k sotsiologicheskomu izucheniu iskusstva" (Concerning several social pre-conditions of Dutch and Flemish art: Contributions to the sociological study of art), *Pamiatniki Gosudarstvennogo Muzeja Izjaschchnych Iskusstv* 5 (1926): 92–109.

4. An important study exploring the relationships between economics and culture in Europe as a whole is W. Brulez, *Cultuur en getal: Aspecten van de relatie economie-maatschappij-cultuur in Europa tussen 1400 en 1800* (Amsterdam: Nederlandse vereniging tot beoefening van de sociale geschiedenis, 1986).

5. Arnold Hauser, *Sozialgeschichte der Kunst und Literatur* (Munich: C. H. Beck, 1953), 1: 503.

6. Jean Nicolas de Parival, *Les délices de la Hollande, avec un traité du gouvernement et un abrégé de ce qui s'est passé de plus mémorable jusques à l'an de grâce 1661* (Leiden: Pierre Didier, 1662), 25.

7. There is considerable literature on the Dutch guild of Saint Lucas (into which painters had been organized). Perhaps the most important text is G. J. Hoogewerff, *De geschiedenis van de St. Lucasgilden in Nederland*, Patria serie XLI (Amsterdam: P. N. van Kampen & Zoon, 1947).

8. Ad van der Woude, "Demografische ontwikkeling van de Noordelijke Nederlanden 1500–1800," *Algemene geschiedenis der Nederlanden* 5 (Haarlem: Unieboek, 1980): 156–68; idem, "Variations in the Size and Structure of the Household in the United Provinces of the Netherlands in the Seventeenth and Eighteenth Centuries," in P. Laslett and R. Wall, *Household and*

Family in Past Time (Cambridge: Cambridge Univ. Press, 1972): 299–318.

9. Thera Wijsenbeek-Olthuis, *Achter de gevels van Delft: Bezit en bestaan van rijk en arm in een periode van achteruitgang (1700–1800)* (Hilversum: Verloren, 1987).

10. Ibid., 455.

11. These data are derived from Van der Woude, 1980 (see note 8), 123–68.

12. S. Hart, *Geschrift en getal*, Hollandse Studiën 9 (Dordrecht: Historische Vereniging Holland, 1976), 191.

13. In a recent study of income and wealth inequality in Amsterdam the author concludes, "Coupled with the findings for 1585 and 1742…this evidence seems to lead to the overall conclusion that relative inequality in Amsterdam changed little from 1585 to 1800" (L. Soltow, "Income and Wealth Inequality in Amsterdam, 1585–1805," *Economisch-en Sociaal-Historisch Jaarboek* 52 [1989]: 72–95).

14. Ad van der Woude, "La ville Néerlandaise," in A. Lottin et al., *Etudes sur les villes en Europe Occidentale* (Paris: SEDES, 1983), 307–85.

15. J. L. van Zanden, "De economie van Holland in de periode 1650–1805, groei of achteruitgang?" *Bijdragen en mededelingen betreffende de geschiedenis der Nederlanden* 102 (1987): 562–609.

16. The scope of eighteenth-century production of paintings is often (implicitly) denigrated. The injustice of this can be read from the specific case of Amsterdam regent portraits; the surviving examples are reproduced in Bob Haak, *Regenten en regentessen, overlieden en chirurgijns: Amsterdamse groepsportretten van 1600 tot 1835*, exh. cat. (Amsterdam: Amsterdams Historisch Museum, 1972), 29.

17. Wijsenbeek-Olthuis (see note 9), 235. In the country the change from open fires to stoves mainly took place after 1830 (A. J. Schuurman, "Het gebruik van vertrekken in de 19e eeuwse Zaanse woningen," in P. M. M. Klep et al., *Wonen in het verleden* [Amsterdam: NEHA, 1987], 231–47).

18. As nothing can be calculated about the number handed over to the first generation (1580–1599), I put the new pictures and the inherited paintings by that generation on the same level as the two that followed, that is at 60 percent of the total stock of new pictures.

19. *Oud-Holland* (1901).

20. Floerke, 1901 (see note 1), 4, subtracting those in the museums in Amsterdam and The Hague.

21. In my numerical model the generation 1780–1799 passed 416,333 pieces to the generation 1800–1819, that is, about 4 percent of the total probable production between 1580 and 1800, while most of the paintings that remained dated from the eighteenth century. About 1 percent of the total production probably still exists.

22. Jan de Vries, "Peasant Demand Patterns and Economic Development: Friesland, 1550–1750," in William N. Parker and Eric L. Jones, *European Peasants and Their Markets: Essays*

in Agrarian Economic History (Princeton: Princeton Univ. Press, 1975), 205–66.

23. J. van Roey, "De Antwerpse schilders in 1584–1585: Poging tot sociaal-religieus onderzoek," *Jaarboek Antwerpen* (1966).

24. Montias (see note 2), 136.

25. Wijsenbeek-Olthuis (see note 9), 27.

26. Ad van der Woude, *Het Noorderkwartier: Een regionaal historisch onderzoek in de demografische en economische geschiedenis van westelijk Nederland van de late middeleeuwen tot het begin van de negentiende eeuw*, A. A. G. Bijdragen 16 (Wageningen: Landbouwhogeschool, 1972; reprint, Utrecht: Hes Uitgevers, 1983), 111; idem (see note 14), 329. The exact level depends on the definition of the concept "town."

27. The reader will recall that I set the mean length of a household generation at twenty years. The years as an active member of the labor force would have been longer, counting the time elapsing between entrance into an occupation and the mean age at marriage (between ages twenty-six and twenty-eight for males).

28. John Michael Montias, "Socio-Economic Aspects of Netherlandish Art," (Paper delivered at the Getty Center for the History of Art and the Humanities, Santa Monica, California, April 1987), 8.

29. Peter C. Sutton, *Masters of Seventeenth-Century Dutch Landscape Painting* (Boston: Museum of Fine Arts, 1987), 3.

30. Concerning the painter-author Jan van Gool, see the instructive essay by Lyckle de Vries, "Jacob Campo Weyerman und Johan van Gool," *Mededelingen van de Stichting Jacob Campo Weyerman* 12, no. 1 (1989) 1, 1–7.

31. *"Ik heb Matheus Terwesten dikwerf horen zeggen, dat Doudyns, in zyn leertyt, Boertjes van Ostade halflyfs geschildert had, die hy zynen Leerlingen te copiëeren gaf; zo dra waeren deze copyën niet klaer, of met dezelve naer de Hofzaal, by eenen Simons, die daer met een Boekwinkel stont, en deze Stukjes voor zes gulden het stuk gretig kocht; die wat vaerdig van penseel waeren, smeerden 'er wel twee ter week af"* (I have often heard Matheus Terwesten say that Doudyns during his apprenticeship painted half-length portraits of Ostade's farmers, which he had given to his pupils to copy; as soon as the copies were ready, they were taken to a man named Simons who had a bookstall in the Hofzaal and who avidly bought these pieces for six *gulden* each; those who were handy with the brush were able to polish off about two in a week). (Jan van Gool, *De Nieuwe Schouburg* [The Hague, 1750; facs. ed., Soest: Davaco, 1971], 1: 359).

32. *"Kunnend hy, zo als men my opgegeven heeft, wel zes Portretten op eenen dag dootverwen, en in die zelve vaerdigheit opschilderen; het geen my echter wat veel voorkomt. Hy is nooit onledig geweest in het schilderen van een oneindig getal portretten; het geen men zegt wel tot 5000 getelt kan worden"* (He could, as has been related to me, prime six portraits in one day and finish painting them with equal dispatch; that seems on the high side to me, however. He has never

been lax in painting an infinite number of portraits; some people say that they number as much as five thousand). (Van Gool [see note 31], 2: 439–440). As Koets II was active as a painter for nearly fifty years, this would mean 2,500 paintings during a twenty-five year period. But this was considered exceptional by Van Gool and implies that an average of 2,000 paintings in twenty-five years is too high.

33. Arnold Houbraken, *De groote schouburgh der Nederlantsche konstschilders en schilderessen*, ed. P. T. A. Swillens (Maastricht: Leiter-Nypels, 1943), 39.

34. *"Want men oeffende de Kunst daer niet met studie, maer slechts uit noot als een ambacht, daer elk om 't zeerst roffelde om maer gedaen te hebben; het geen dus toeging: den Schilder wierd een CHRISTUS, Lieve-Vrouwebeelt, of eenige andere Sant vertoont, daer hy dan zyn keur, om te volgen, uitkoos, en vooraf bedong, tot wat prys hy het naschilderen zou, waer op hy dan aen 't werk viel, en jaren lang niet als Santen en Santinnen, by duizenden in getal, uit zyn penseel liet vloeien"* (Because art was not practiced there studiously, but only for financial reasons as a trade, in which each made great haste to be finished; this is what happened: the painter was shown a painting of Christ, Mary, or a saint, and he would select the one that he liked to copy and he would set a price for copying beforehand; after this he would start to work and for years on end produce saintly men and women by the thousands). (Van Gool [see note 31], 2: 472–74).

35. Montias (see note 28), 4.

36. Ibid., 8.

37. Jan van Gool, *Antwoordt op den zoo genaemden brief aen een vrient* (n.p., circa 1750), 28.

38. Jan de Vries, "An Inquiry into the Behaviour of Wages in the Dutch Republic and the Southern Netherlands, 1580–1800," *Acta Historiae Neerlandica* 10 (1978): 79–97.

39. This is, of course, in prices and values of the middle of the seventeenth century.

40. H. K. Roessingh, *Inlandse tabak: Expansie en contractie van een handelsgewas in de 17e en 18e eeuw*, A. A. G. Bijdragen 20 (Wageningen: Landbouwhogeschool, 1976), 237–38.

41. Floerke, 1905 (see note 1), 181.

42. Brulez (see note 4), 68–70.

43. Montias (see note 2), 238–46.

44. Ibid., 242, table 8.3.

45. *Alle schilderijen van het Rijksmuseum te Amsterdam* (Amsterdam-Haarlem: Unieboek, 1976). The definition of "Dutch painting" in this case is "a painting attributed to a painter born in or immigrated into the Netherlands." According to this definition Vincent van Gogh is considered to be a Dutch painter, as is Gerard de Lairesse, who was born in Liège (1641) but settled in the Netherlands (and died in Amsterdam in 1711).

46. C. Hofstede de Groot, *Die Urkunden über Rembrandt* (The Hague, 1906), 174.

47. An exceptional study is Josua Bruyn, "Een onderzoek naar 17de-eeuwse schilderij-formaten, voornamelijk in Noord-Nederland," *Oud Holland* 93 (1979): 96–115. An elaboration

THE VOLUME AND VALUE OF PAINTINGS

of this subject has been given by Hessel Miedema, "Verder onderzoek naar zeventiende-eeuwse schilderij-formaten in Noord-Nederland," *Oud Holland* 95 (1981): 31–49. But in these studies the subject is the contemporary terminology of the seventeenth century and not the possible correlation between subject and mean size. As far as I know the correlation between subject matter and "format" in the production of books (folio, quarto, octavo, etc.) was studied for the first time in C.-C. van der Woude, *Boekenbezit en boekenconsumptie te Gent en omstreken, 1770–1830*, 2 vols. (Ghent: Licentiaatsverhandeling Rijksuniversiteit Gent, 1986).

48. For the definition of "Dutch painting," see note 45. Only a handful of objects classified in the catalog *Alle schilderijen van het Rijksmuseum* were left out of the analysis because their inclusion might be disputed and because it would have had a disturbing influence on the averages. Examples are: No. RBK 15234 "decorated painter's box" and No. NM 8184 "painted doors for an organ." As the exact year of production of most paintings is not known, the chronological division used in tables 15 and 16 relates to the year of birth of the painter and *not* the date of the painting! For example the paintings of Jan Willem Pieneman, born in 1779, are classified under artists born in the period 1750–1799, but nearly all of his pictures date from the first half of the nineteenth century. One of them is the enormous (576 × 836 cm) *Battle of Waterloo*, painted in 1824. In the same way the pictures by Michiel Jansz. van Miereveld (1567–1641) are classified in the period 1550–1599 and those of Rembrandt (1606–1669) in 1600–1649.

49. The twentieth century witnessed a new revolution in sizes.

50. They are Jan Kamphuijsen (1760–1841), a ceiling painting with scenes from the life of Hercules (630 × 735 cm); Jan Willem Pieneman (1779–1853), *The Battle of Waterloo* (576 × 836 cm); B. Wolff (1758–1825), *The Death of Sophonisba, Queen of Numidia* (270 × 400 cm); idem, *Massinissa, King of Numidia* (265 × 380 cm); J. Schoemaker Doyer (1792–1867), *Kenau Simonsdr. Hasselaer and Her Women's Brigade on the Walls of Haarlem in the Thick of the Spanish Attack, 31 January 1573* (248 × 300 cm); C. Kruseman (1797–1857), *Philip II Accusing William the Silent* (270 × 200 cm); idem, *The Entombment* (330 × 290 cm). When these seven huge paintings are deducted from the total of 280 for that period, the remaining 273 have an average size of 7,477 cm² (87 × 87 cm).

51. We cannot ignore the possibility that the paintings with mythological and religious subjects made for private houses and found in probate inventories would, on average, have been smaller than those on the same subject now in the collections of museums. An important number of this last group would have been painted for institutions.

John Michael Montias

WORKS OF ART IN
SEVENTEENTH-CENTURY AMSTERDAM

An Analysis of Subjects and Attributions

This paper is an exploratory study of seventeenth-century material culture in the Netherlands, centered on the works of art and other decorative objects recorded in the homes of Amsterdam residents. The information drawn from notarized inventories covers a wide range of households, from the very modest to the very rich. However, the distribution of the inventories in the sample that I collected is not, strictly speaking, random. To study the frequency with which artists of the period were cited in those inventories, which citations occurred far more often in the collections of wealthier citizens (those with movable possessions valued at 2,000 *gulden* or more), I had to concentrate on inventories at the upper end of the wealth distribution. In my analysis of the subjects of works of art collected, however, I make at least a limited attempt to show how the collections of more modestly situated households may have differed from those of richer citizens. Because nearly two-thirds of the inventories in my total sample were not assessed, I had to find an indirect measure of wealth to divide my sample between richer and poorer households. For this paper, I chose as a proximate indicator of wealth the presence or absence of at least one attributed work of art in an inventory. (For those inventories in my sample that contain evaluations, the average value of movable goods was approximately twice as large for those inventories containing attributed works of art as for those that did not in both periods under study.)

The subjects of the artworks collected, especially those of a religious and political nature, are not only of interest to art historians; they also shed light on the history of mentalities. The frequency with which artists are cited will, it is hoped, provide a measure — albeit imperfect — of contemporary

reputations. The reader will find that, according to this measure, the contemporary reputation of artists often diverged widely from that which they have today. The division of the frequency lists into two periods —1620–1649 and 1650–1679 — also reveals how tastes evolved in a relatively short time span.

These are the first results of an ongoing investigation. As my sample of inventories collected and analyzed is enlarged in the future, more reliable estimates of the structure of subjects collected and of attributions will become possible. The analysis will also be extended to other characteristics of the available data, including the relation of the value of artworks collected to the total wealth of the collecting households, the relative prices of paintings assessed in inventories (attributed and unattributed, different subjects, etc.), and the place in the home where the objects were located.

The Data Base

The project discussed in this study follows the same general outline as my earlier analysis of collections in Delft.[1] Such progress as I have made resides in the domain of technology: whereas in my earlier study I processed all my inventories manually, this time I fed the data in my Amsterdam inventories into a computer endowed with a rapid search capability.[2] Within the space of a few seconds, this equipment enables the researcher to find the number of times that any work of art — classified by type of object, subject, attribution, evaluation, or location in the owner's home — occurs in the data base. It further allows one to search for the dates when these works of art were recorded in inventories, the religion and occupation of collectors, and so forth. The program also makes it possible to search for any word or combination of words (e.g., "ecce homo" or "Prince Maurits") occurring in the verbatim entries describing the works of art. Finally, it is easy to combine characteristics to carry out more complicated searches, for example, to find the number of instances in which a work of art representing a mythological scene and owned by a Roman Catholic collector was found hung in the front hall of the home.

At present, my data base consists of 362 inventories, dating from 1620 to 1679. These inventories were transcribed by hand from notaries' protocols and from the sales records of the Chamber of Bankruptcy preserved in the

Amsterdam Gemeentearchief. Four of the inventories — those of Lambert Hermansz. Blaeuw (1648), Pieter van Meldert (1653), Matthijs Hals (1662), and Johannes de Renialme (1657) — belonged to art dealers who presumably dealt with the artworks that they owned as their stock in trade. The rest of the inventories documented were privately held collections. Most of these were drawn up after the death of one of the owners (husband or wife), at the request of the heirs, or in view of an impending marriage where the couple wished to keep their assets separate. A few inventories listed the movable goods that a debtor had pledged for security or those that were recorded at the request of his creditors under court supervision. While a majority of the inventories collected are as yet unpublished, many were noted by Abraham Bredius, and a few, including that of the dealer Renialme, were published (with many omissions, particularly of unattributed paintings) in Bredius's *Künstler-inventare*.

The principle of selection that I have followed has been to collect all inventories containing at least one attributed painting. Such inventories, of which there are 258 in my sample, form only a small minority of surviving inventories, probably less than one-twentieth of the whole. As previously noted, Amsterdam burghers who owned attributed paintings were, by and large, fairly prosperous, their movable assets being typically in excess of 2,000 *gulden*. The remaining 104 inventories in my sample, which contain no attributions, were collected more or less randomly from notarial records. They will be used as a basis of comparison with the inventories containing attributions; this comparison will provide a measure of the bias in analyzing subject categories and other sample attributes due to overrepresentation of the richer inventories in the overall sample.[3] There is no reason to believe, in any case, that my sample of inventories containing attributions is a biased sample of all the inventories containing one or more attributions that have been preserved in the Amsterdam archives for the period 1620–1679. If this is so, my analysis of attributions is probably free of serious bias.

In addition to the sample of inventories collected in Amsterdam, I have drawn from two unpublished sources: 21 inventories from the period 1680–1689 collected by Marten Jan Bok, the contents of which have been entered in the Getty Provenance Index Data Base, and 188 inventories from the period 1700–1714, furnished by S. A. C. Dudok van Heel and made available to the Getty Provenance Index. Table 1 summarizes the main characteristics of my data base of April 1989. Inventories with evaluations or prices

made up 38 percent of all those included in the data base. These priced inventories contained precisely the same share (i.e., 38 percent) of all the works of art in the sample. Masters in the Saint Lucas Guild and art dealers evaluated the paintings in 24 inventories. *Schatsers* (sworn assessors) were responsible for appraising 57 of them. It is evident from the table that paintings represented the bulk of the art objects in the inventories selected — 85 percent or more in all decades. Drawings made up about 3 percent of the total, prints 5 percent, and sculptures a little over 1 percent.[4] Some 23 percent of all the paintings and 35 percent of all the drawings in the sample were attributed. Fewer than 1 print out of 20 was identified by an artist's name. If inventories that contain no attributions at all are excluded, 31 percent of the paintings and 40 percent of the drawings were attributed in the remaining inventories.

Subjects Represented in Works of Art

The distribution of the subjects represented in paintings, as recorded in the original inventories, varies appreciably from one collection to the other. One of the important sources of this heterogeneity is the wealth of collectors in each decade, which, as I have already explained, is "proxied" in table 2 by the presence or absence of attributed paintings in collections. I found this method of dividing inventories between relatively wealthy and more modest households to be more reliable than that of using the number of works of art (or just the number of paintings) per household as a proximate measure of wealth.[5]

One significant finding is that landscapes of all kinds in both periods selected were much more frequently represented — their share was at least 50 percent greater — in inventories with than in inventories without attributions. On the other hand, religious paintings represented a much higher percentage of all paintings in inventories without than in inventories with attributions (34.7 percent versus 22.5 percent in the first period, 15.2 percent versus 10.5 percent in the second period). Within the historical group, mythological paintings and classical histories were more commonly found in inventories with attributions than in inventories without them. Together these two subject categories made up 5.5 percent of all paintings in inventories with attributions and 2.2 percent of all paintings in inventories without

attributions in the first period; in the second period they made up 3.5 percent and 2.4 percent respectively. These results are consistent with the hypothesis that wealthier collectors were more educated and had a greater knowledge of the classics than less wealthy ones.

Finally, there is also an enormous disparity between the percentage of pictures *not* described by subject ("two paintings with ebony frames," "four small alabaster panels, etc.") in the two groups. As one might expect, notaries and assessors were much more apt to describe wealthier inventories completely, including the subject matter of the paintings that they recorded.[6] It is important to note, nevertheless, that the trends discussed in greater detail below — the increasing share of landscapes of all kinds and the decreasing share of all "histories" and especially of religious subjects — clearly emerge in each group between the two three-decade periods that have been considered. All these results, both with respect to the effect of wealth on subjects collected and the time periods cited, are congruent with those that I have found in Delft inventories.

As mentioned above, the relative proportions of inventories with and without attributions in my sample are not those that would obtain if my inventories had been rigorously selected at random.[7] To circumvent this problem, I have chosen to limit my analysis of decade-by-decade time trends to inventories containing at least one attribution, the results of which are shown in table 3. I have added the data for the 1680s, collected by Bok, which are also limited to inventories containing attributions. Before analyzing these data, it may be useful to dwell a moment on the meaning of the dates defining the periods in table 3. These are, of course, the dates when the inventories were recorded, not when the art objects were acquired by their owners. Acquisition may have taken place at the time of the owner's marriage; in case of a bequest, when a close relative died; or by purchase at any time. A reasonable guess, given our almost total lack of detailed information about these various possibilities, would be that the works of art in any inventory were acquired at a steady rate between the owner's first marriage and the date of the inventory. This would imply that if there was an interval of x years between the date of first marriage and the date of the inventory, the date of acquisition would proceed the date of the inventory by $x/2$ years. In a sample of 59 inventories, the average difference between the date of the inventory and the date of first marriage was 21.7 years. The works of art in any inventory were then acquired, on average, some 10 or 11 years before the

date of the inventory in which they were recorded. The majority of paintings belonging to inventories dated in the 1660s, for instance, were probably acquired in the 1650s.[8] With this caveat, let us examine the decade-by-decade trends in subject matter collected based upon the inventory dates in table 3.

The general category of landscapes, excluding religious and mythological subjects with landscape backgrounds, which were especially numerous in the early decades (as the difference between the gross and the net numbers reveals), made up 20 percent of the sample in the 1620s, 25 to 28 percent in the period 1630–1659, and about 35 percent in the period 1660–1689.[9] Four subcategories — landscapes proper, seascapes, cityscapes, and battle scenes — made relative gains, whereas the share of "perspectives," which was quite small to begin with, stagnated. (I use quotation marks to denote subjects like "perspectives," "histories," and "kitchens," which are referred to by their Dutch equivalents in the original inventories without further specification.)

The proportion of histories, and especially of religious subjects, declined even faster than the proportion of landscapes increased (as was also found in Delft in the period 1610–1679). If over 4 out of 10 paintings represented a history or a devotional subject in the 1620s, only 1 out of 10 did so in the 1680s. Old Testament subjects declined from 13.6 percent of the total in the 1620s to 1.8 percent in the 1680s; New Testament subjects, from 20.5 percent to 3.3 percent. Interestingly enough, the relative shares of Old and New Testament subjects remained fairly constant throughout the seven decades. The downward trend was about the same for other religious subjects — chiefly saints and religious categories — as it was for Old and New Testament paintings. Even mythological subjects seem to have been considerably less popular after 1650 than before.

The relative number of portraits rose from the 1620s to the 1650s and 1660s and declined thereafter, for no perceptible reason. It is interesting that the share of political portraits — chiefly of the reigning *stadhouder* and princes of the House of Orange — reached a peak in the 1630s and fell rapidly during the period without a *stadhouder*.

The proportion of still life subjects rose from 5 percent in the 1620s to nearly 10 percent in the 1660s and declined thereafter. Genre subjects continued to gain in popularity throughout the period, rising from 3.9 percent of the total in the 1620s to reach 12 percent in the 1680s.[10] The remaining categories are too poorly represented, and the fluctuations to which they are subject too strong, to draw any hard and fast conclusions about trends.

Table 4 shows a breakdown of subject categories for drawings, watercolors, and prints for the periods 1620–1649 and 1650–1679. Only drawings and prints in inventories with attributions have been retained. Of note, fewer drawings and prints than paintings are described by subject: only about half of the drawings can be classified by subject and a little over a third of the prints, as opposed to over 85 percent of the paintings in all decades.

Among the drawings, the most popular subjects were seascapes, portraits of known persons and of political notables, *tronies* (heads), and animals. Their relative frequency, compared to the total number excluding drawings with unknown subjects, is significantly greater than that of paintings. The only subjects of prints that appear with a good deal of frequency (relatively more than among paintings) are portraits of political and religious figures. It is remarkable that even these small samples show a marked tendency for the relative importance of landscapes of all sorts to increase from the period 1620–1649 to the period 1650–1679 at the expense of religious subjects.

The Religions of Collectors and Subjects Collected

I found sufficient information about the religion of 214 of the owners of 362 inventories in my total sample to base a study of differences in subjects collected on the broad distinctions between Reformed (Calvinist) and Roman Catholic households. In many cases the information about the religion of the owner comes from the inventory itself: the books it contained, especially if the collection was small, usually reveal whether a collector was Reformed or Catholic. Jean Calvin's *Institution de la religion chrestienne*, the Catechism of Sleydanus, the Proceedings of the Synod of Dordrecht, or the Geneva Bible are normally found only in Reformed households. If one of these books occurs in conjunction with a portrait print of Triglandius, we can be sure that we are dealing with a Calvinist owner. A book of Catholic sermons or the Catechism of Musius will almost always be owned by a Roman Catholic, who will very frequently have a crucifix hanging above his bedstead and print portraits of Father Musius or Father Ney hanging on his walls. A few Lutheran collectors have been identified by analyzing the confession books that they owned. Where the owner of an inventory is known to have married "in the church" (rather than a civil ceremony), this strongly suggests that he or she was Reformed.

In a few cases Johan Elias's *Vroedschap van Amsterdam* provides information on the religion of the collectors.[11] I did not find a single instance where the various indicators of religion at my disposal gave contradictory signals, and I am satisfied that the errors made by inferring the religion of collectors from these various strands of evidence is small enough to be statistically negligible. It would have been desirable to distinguish strict Calvinists (Counter-Remonstrants) from Arminians or Remonstrants, but I did not feel confident enough of the partial evidence at my disposal to segregate the two groups.

In my data base, I have identified 159 Reformed, 43 Roman Catholic, 9 Lutheran, and 3 Mennonite households. Table 5 shows the breakdown according to selected subject categories of all art objects, including paintings, drawings, prints, and other works of art in Roman Catholic and Reformed households. To avoid the problem arising from inadequate sample size (especially in Roman Catholic inventories), the entire period of sixty years covered by the data has been split into two periods of three decades each. Also, to get around the heterogeneity in the sample due to differences among households of very different wealth, the subject breakdown has been analyzed separately for inventories with and without attributions, which, as noted, are meant to represent wealthy and more modestly situated households respectively.

The pattern of differences between the Roman Catholic and Reformed groups emerges clearly in both periods and for both types of collectors. Religious pictures occurred much more frequently in Roman Catholic households. In Catholic collections New Testament and other religious subjects were more numerous than Old Testament subjects. Throughout the period under study (1620–1679) New Testament subjects represented five times the number of Old Testament subjects in Catholic households (in inventories with and without attributions); in Reformed households Old Testament subjects were more frequently represented than New Testament subjects in both periods. Other religious subjects, including evangelists and saints, religious allegories, and angels were also more frequently encountered in Catholic than in Reformed households. In general more political portraits were found in Reformed than in Roman Catholic households, with the exception of inventories with attributions in the period 1650–1679, where sampling fluctuation may account for the slightly higher percentage in this category in Roman Catholic households. The persons represented in these

338

portraits also differed, with almost no overlap between the members of the religious communities. Reformed households owned portraits of the princes of Orange, while Catholic households owned portraits primarily of Catholic notables (in the period 1650–1679 the counts of Brabant, Charles V, the prince cardinal, and, in one exceptional case, Johan van Oldenbarnevelt). The religious personalities portrayed also differed radically, as one might expect, representing Protestant preachers in one community and Roman Catholic priests and cardinals or the pope in the other. Still lifes were somewhat more prevalent in Reformed than in Roman Catholic households, irrespective of whether or not the inventories contained attributions.

It is remarkable that the broad time trends in subject categories discussed earlier for the sample as a whole — the increased proportion of landscapes of all sorts at the expense of religious subjects — occurred in the inventories of both religious groups, whether or not they contained attributions.

The data available make it possible to examine in greater detail the kinds of religious images found in Reformed and Catholic households. It is well known that the injunctions of Protestant reformers against images were directed against devotional works rather than religious "histories."[12] This distinction, however, is not always obvious. Even though the crucifixion of Christ, for instance, may be thought of as a history, it was probably considered a devotional image by many Reformed collectors, or so I inferred from the relative rarity of the subject in the inventories of Reformed owners (in contrast to the frequent appearance of such imagery in Roman Catholic homes). Tables 6a and 6b show the frequency with which selected religious subjects occur in Catholic and Reformed inventories for the periods 1620–1649 and 1650–1679. The relatively greater frequency of New Testament subjects among religious works in Roman Catholic households compared to Reformed households emerges clearly from the data in these tables, as it did in table 5. There are, however, also differences in the incidence of specific New Testament themes between the two religious communities. The crucifixion, as I have just noted, was relatively rare in Reformed households, but images of the Birth of Christ and the adoration of the magi were common both among Reformed and Catholic collectors in both periods. The Virgin Mary, with and without the Christ child, and the Annunciation — typical Roman Catholic subjects — occurred much more frequently in Catholic inventories,[13] but it is surprising to find that they did crop up in some Reformed households, especially in the period 1650–1679. Among New

Testament subjects, Reformed collectors had a relative preference for episodes in the life of Christ (such as the pilgrims going to Emmaus, the woman at the well, the story of the lepers, etc.), the history of Saint John the Baptist, and the parables. Among the other religious subjects, they preferred the portraits of the evangelists, whereas Roman Catholics tended to collect the post-evangelical saints, including Saint Jerome and medieval saints. In the Old Testament category, Abraham, Hagar, Lot, Jacob, Moses, Adam and Eve, David, and Rebecca were all fairly commonly represented in Reformed households. No Old Testament theme appears to emerge with any frequency in my sample of Roman Catholic inventories for the entire period. (Abraham's sacrifice, the story of Susanna, and Judith and Holofernes are well represented in the first period but hardly at all in the second). As one might expect, the distribution of religious subjects differs significantly in Roman Catholic and Reformed households in both periods (at the 99.9 percent probability level).

Attributions

Table 7 contains an analysis of all the paintings in my sample that are drawn from private inventories bearing some sort of attribution. To arrive at a breakdown by artists active in the most important cities and countries, I have eliminated copies and paintings attributed to unidentified artists. I have classified the paintings that remain as "originals," in the sense that the notary, the assessor, or the member of the Saint Lucas guild who helped appraise the paintings did not specifically describe them as copies although, if we may judge by their low prices, some of them are likely to have been such. These "originals" were further broken down into two groups: paintings by artists who were active in the seventeenth century and by artists who ceased to be active before 1600. This division is to enable us to concentrate on paintings likely to have been painted in or have been imported into Amsterdam not too many years before they entered our inventories. This assumption, of course, becomes increasingly unrealistic as we move toward the end of the period under consideration.

Distributing paintings attributed to artists active in various localities is complicated by the fact that many artists worked in more than one town. This was especially true for artists who lived in Amsterdam, many of whom

moved to the city when it was undergoing rapid expansion. In my sample I found a total of 1,113 paintings (in inventories from the period 1620–1679) ascribed to artists who spent a significant part of their careers in Amsterdam. Of this number, about 15 percent were painted by artists who at some point in their careers also worked in Haarlem; 22 percent by artists also active in Leiden, The Hague, Delft, or Utrecht; and 4 percent by artists also active in Antwerp. Since each painting may be counted several times (once for every locality where an artist had been active), the numbers in the columns of table 7 add up to totals that are greater than the total number of attributions. On the other hand, the choice of any one locality as the artist's "main place of residence" is arbitrary. Perhaps the best solution is to show the percentages of totals corresponding to artists active at any one time in a given city; to artists who worked exclusively in that city; and to artists who also worked in other cities or countries. These three sets of percentages are shown for Amsterdam and other major artistic centers of the Netherlands and for Italy in table 8.

My sample of attributions to identified artists whose place of work can be ascertained is barely adequate to trace time trends in the relative importance of the different localities represented. The apparently ascending trend for Amsterdam (from 43.3 percent in the 1640s to 61.5 percent in the 1670s for our largest decennial samples) may be accounted for as follows. The population of Amsterdam rose from 31 percent of the sum total of the populations of Dutch cities represented in table 7 in 1600 to 43.5 percent of this total in 1650 and 48.7 percent in 1700.[14] (Dordrecht has been excluded from table 8 because it was a relatively unimportant place of origin for artists represented in Amsterdam collections.) It is likely that the number of artists active in Amsterdam gradually caught up with the increase in population of the city. From this it would follow, provided that the average output of paintings per artist remained more or less constant, that the proportion of Amsterdam-based artists in Amsterdam inventories should have increased, as it apparently did. As we have already seen, a great many painters active in Amsterdam had also worked elsewhere; a majority among them were born or trained in Haarlem. By contrast, very few of the Utrecht or Middelburg artists cited also worked in Amsterdam. Considering only those Haarlem artists who did *not* work in Amsterdam (some 15 percent of all attributions to identified artists in the period 1650–1679), the role of this city in supplying Amsterdam with paintings appears to have been

abnormally large (given that its population was only 8 percent of the combined population of the Dutch cities listed in table 7). Considering the costs of importing pictures from out of town, the informational and acquired-taste advantages that local artists must have enjoyed over their "foreign" competitors, and the mild guild restrictions on trade, we would expect — other things being equal — that the percentage of pictures from a center such as Haarlem would have been substantially *lower* than its share of the total population.

Leiden artists, on the other hand, were underrepresented in Amsterdam inventories. Compared to Leiden's 15.5 percent share of the combined populations of the Dutch cities listed on table 7 as of 1650, its share of the attributions, which fluctuated between 4 and 7 percent, seems quite small. The Hague, which is farther removed from Amsterdam, had a higher share of attributions than Leiden with a population that was less than half of its size. One explanation for Leiden's weak representation is that paintings by its artists were expensive and hence less likely to show up in middle-class inventories (the outstanding exception being Jan van Goyen, whose paintings were not as commonly found in Amsterdam as they were in other cities' inventories, including those of Delft). The distance separating Rotterdam, Dordrecht, and Middelburg from Amsterdam accounts in part for the relatively poor showing of these three cities in Amsterdam inventories. But there must have been other factors at work as well. For the period 1620–1679 total attributions to artists active in Antwerp, a city that lay still farther from Amsterdam than did Rotterdam, Middelburg, or Dordrecht, were respectively six, ten, and sixteen times more numerous; yet Antwerp's population was only two to three times as large as that of these cities. The long-established reputation of Antwerp as a major artistic center must have played a role here.

Of the 129 "original" paintings attributed to sixteenth-century masters in privately owned collections, 33 were assigned to artists active in Amsterdam and 51 to artists active in Antwerp. This disparity naturally reflects the relative importance of Antwerp and the relative unimportance of Amsterdam in the sixteenth century. The only notable exception was the prolific Pieter Aertsen, who migrated from Antwerp to Amsterdam. Italian (especially Venetian) and German masters (Albrecht Dürer, Hans Holbein) occurred with some frequency (17 and 15 "original" paintings respectively). Of the other Dutch schools, only Haarlem (1 painting), Leiden (5 paintings), Mid-

delburg (3 paintings), and Utrecht (7 paintings) were represented. These artistic centers achieved distinction in the sixteenth century, when Delft, Dordrecht, and Rotterdam were still in their artistic infancy.

In table 9 I have estimated the number of attributions in each decade to "contemporary artists" and "old masters." I have defined for this purpose a contemporary artist as one still active at the beginning of the decade in which the inventory was recorded (and likely to have been alive when the painting was acquired). I have supplemented my basic sample with 20 inventories collected by Bok from Amsterdam notarial protocols of the 1680s and 108 Amsterdam inventories dating from the early eighteenth century and transmitted to the Getty Provenance Index by Dudok van Heel.

With the exception of the small and perhaps unreliable sample for the decade 1620–1629, there is a steady decline in the percentage share of contemporary masters from 65.7 percent in the 1630s to 41.9 percent in the 1670s. This was followed by such a precipitous decline in the 1680s — to 13.8 percent — that I suspect some unknown source of underestimation in this last decade. There was a moderate increase in the share of contemporary masters in the first fourteen years of the eighteenth century, which still left their share at a relative level less than half of what it had been in the 1670s. In the case of these early eighteenth-century inventories, my calculations indicate that an average of thirty-five years had elapsed between the date of an inventory and the last year of activity of the artist to whom a painting was attributed. That some two-thirds of the artists to whom attributions were made in the 1630s were still active at the time the inventories were drawn up in that decade, whereas less than one out of five were active in the period 1680–1714, is a striking finding. That the share of contemporary masters was so high in the 1630s and 1640s suggests that most collections in those decades were either new or, if formed earlier in the century, had undergone substantial renovation. The sharp drop in the share of contemporary masters in the 1680s is consistent with the hypothesis that fewer new collections were formed or that the older collections remained stagnant in those years. It is very probable that the war with France in the 1670s and the attendant poor economic conditions had something to do with the apparent failure to form new or upgrade old collections in that decade.[15]

I now turn to an analysis of the paintings specifically designated as copies in my sample of inventories. Out of 128 copies in privately held collections dated from 1620 to 1679, 54, or 42 percent, were after Amsterdam

masters; 18, or 14 percent, after Haarlem masters; 7, or 5 percent, after Delft masters; 20, or 16 percent, after Utrecht masters; 21, or 16 percent, after Antwerp masters; and 4, or 3 percent, after Italian masters. There were only 2 copies after a Leiden artist, 1 after a Hague artist, and none after Rotterdam, Dordrecht, or Middelburg artists. The great majority of copies were after seventeenth-century masters. If these samples are representative at all, they clearly indicate that Utrecht and Antwerp were far more important sources of artistic influence than might have been construed from the comparatively low frequency of attributions to artists active in these two centers. That relatively fewer Haarlem masters were copied than were acquired by Amsterdam collectors also suggests that Haarlem artists may have penetrated the Amsterdam market because they were inexpensive rather than because they were highly regarded (with major exceptions such as Cornelis Cornelisz. van Haarlem).

Of 123 attributed drawings or watercolors by artists whose place of origin could be ascertained, 53 were given to Amsterdam and 46 to Haarlem masters. Not a single drawing was attributed to a master who migrated from Haarlem to Amsterdam. All the Haarlem drawings were either by Mannerist artists (Hendrik Goltzius, Jacob Matham, Jan van de Velde) or by Pieter Holsteijn (I or II), who drew insects and other small animals in watercolor. The remaining drawings attributed to seventeenth-century masters were scattered among The Hague (4 by Cryspyn van den Queborn), Utrecht (1 by Roelandt Savery, 1 by Jan or Andreas Both), Middelburg (2 by Balthasar Grebier), and Kampen (5 by Hendrick Avercamp). Curiously enough, only one of the inventories in my sample contained drawings by Rubens and none by any member of his school. There were only 29 attributed prints in my sample of privately owned inventories — 22 in the period 1620–1649 and 7 in the period 1650–1679. In the first period prints by Mannerist artists — Bartholomeus Spranger, Goltzius, and Abraham Bloemaert — predominated. In the second, 4 out of 7 attributions were to Rembrandt.

I now return to the analysis of attributed paintings, this time to focus on the most frequently cited artists. Altogether I was able to identify 469 artist-painters for the entire period 1620–1679. Of these, 78 artists cropped up in the four dealers' inventories but were not represented in any privately owned collections. There were 225 identified artist-painters in the period 1620–1649 and 378 in the period 1650–1679. Of the total number of artists cited, 134 had paintings attributed to them in both periods. The average

number of paintings — not including copies, works "in the manner of," or works by a pupil — was 5.2 per artist for the entire period. In addition there were 110 unidentified artists, including monograms that could not be assigned to an identifiable artist (46 in the first period, 64 in the second). Twelve of the unidentified artists were in dealers' inventories.

If we consider both periods together, the 6 most frequently cited artists in privately held collections were Jan Miense Molenaer (41 paintings), Rembrandt (41 paintings, including 11 copies after the master), Gillis (or Gysbrecht) d'Hondecoeter (37 paintings), Joos de Momper (36 paintings), Jan Porcellis (35 paintings), and Philips Wouwerman (35 paintings). Together these artists accounted for nearly 10 percent of all the paintings attributed in the sample. The greatest number of attributions in the four dealers' inventories (dominated by the large stock of Johannes de Renialme) were to Jan Lievens (21 paintings), Rembrandt (15 paintings), and Molenaer (8 paintings).[16] The most cited painters for the entire period all began their careers a number of years before mid-century.

In tables 10a and 10b all artists to whom at least 7 paintings have been attributed either in the period 1620–1649 or 1650–1679 are listed by frequency of occurrence. Among those whose careers were launched after 1650, the most frequently cited were Elias (or Jan) Vonck (29 paintings), Allart van Everdingen (20 paintings), and Jacob van Ruisdael (18 paintings).

The frequency of attributions to an artist in our sample of inventories is not necessarily a reliable measure of his popularity or attractiveness to contemporary collectors; we must consider that the sample contains a relatively small number of inventories in each period and that many artists are cited in only one or two inventories. In fact, the number of inventories in which an artist appears may be a better indicator of the wide diffusion of his works (or at least of knowledge about him) than the total number of his paintings cited. By this measure, only Molenaer and De Momper from among the six most frequently cited artists still come out on top with 25 inventories cumulated over the entire period from 1620 to 1679. As judged by this criterion, other leaders are Aertsen (23 inventories), Savery (21 inventories), Van Goyen (18 inventories), and Jan Pynas (18 inventories). These artists were clearly recognized by many of the clerks and assessors who drew up inventories.

The popularity of a painter may also depend on the importance of the paintings that he produced and sold. To provide some measure of this "importance," tables 10a and 10b show the arithmetic mean of the prices

at which the paintings by each of the artists listed were valued in the inventories.[17] An alternative measure of popularity may be obtained by weighting the frequency of occurrence of an artist by his average price (on the assumption that this average was representative of both the paintings that were valued in the inventories and those that were not). A new order of relative importance then emerges. The results for the 14 most important artists, based on my limited sample of inventories, are shown in table 11. These two lists may be more congruent with the a priori notions that the reader may have of the relative importance of seventeenth-century artists than those in tables 10a and 10b, although they still leave one obscure painter — Hendrick Cuyper — near the top for the earlier period. It is quite possible that his rank will be lowered once a larger sample of attributions is available for analysis. In the meantime, we may question whether he has been excessively neglected by historians.

To wrap up this survey of the frequency of attributions, we may very briefly deal with attributed drawings and watercolors. By far the most commonly encountered artist in the period 1620–1649 was Goltzius (19 attributions in 9 inventories). Only one of his drawings, however, is cited in the period 1650–1679. Next in the first period is Pieter Holsteijn (7 attributions), followed by Avercamp (5) and Van den Queborn (4). In the second period Pieter Quast is first with 22 attributions in 8 inventories. Next is Hendrick Potuyl with 11 attributions in 6 inventories,[18] then Willem van de Velde the Elder with 9 attributed drawings (4 inventories), Jacob Matham with 7 drawings (5 inventories), and Jan van de Velde with 5 drawings (2 inventories).

Perhaps the most significant finding of this investigation is that Amsterdam collections were similar in their structure and in their time trends to those that I analyzed earlier in Delft, at least as far as the subjects represented. The most striking points of similarity are the following: (1) The importance of religious pictures diminished in the course of time while that of landscapes of all sorts and of genre increased; (2) more modest inventories (containing no attributions) differed from wealthier inventories (containing attributions) mainly in their tendency to lag behind this trend, in the sense that they contained relatively more religious pictures and fewer landscapes and genre pictures (the difference was even more salient in Delft);[19] (3) the subject composition of inventories of art objects owned by Roman Catholics and Reformed collectors differed markedly in both cities and in much the same way, i.e., the incidence of religious pictures was

relatively greater among Roman Catholics than among Reformed collectors, and New Testament subjects were far better represented than Old Testament subjects among the former than among the latter.

Clearly then Delft and Amsterdam inventories were the products of a common culture that was evolving in much the same way and at similar pace toward a more secular orientation. The possibility remains that Amsterdam forged ahead of Delft in establishing these trends, although this cannot be fully substantiated by the present comparison.

The proportion of pictures attributed to local artists was also much the same in Delft and in Amsterdam (50–60 percent in the 1650s), despite the fact that the population of Amsterdam was over seven times that of Delft. This suggests that Amsterdam was a far more open city than Delft with fewer guild and other restrictions on the importation of paintings. It is characteristic of Delft's relatively inward-looking environment that of the eight most frequently encountered artists in its inventories (Hans Jordaens, Leonaerd Bramer, Jacob Vosmaer, Pieter Vroomans, Evert van Aelst, Pieter Stael, Herman Steenwijck, Pieter van Asch), only one (Bramer) achieved any significant fame beyond the borders of his native city. The other seven spent their entire careers in Delft. By contrast, the most frequently encountered artists in Amsterdam inventories were full-fledged "foreigners" (Roelandt Savery, Joos de Momper, Philips Wouwerman, Jan Porcellis), or spent a considerable part of their careers in other cities (Jan Lievens, Jan Molenaer, Jacob van Ruisdael), or attained a fame that manifestly transcended the city's limits (Rembrandt). Only Govert Jansz. and Jan Pynas, whose frequency of appearance declined precipitously from the first to the second half of the century, were exclusively local masters.[20]

The analyses by subjects and by attributions suggest that Amsterdam collections underwent rapid change through time. In the period 1620–1669 new collectors bought fashionable subjects (landscapes and genre) and works by popular contemporary artists. We cannot be sure of the fate of collections after the death of their owners, but it is very likely that their contents were acquired by more modestly situated households, especially in cases where the collections were sold at auction. This at least would account for the more old-fashioned character, judging by subjects, of the works of art owned by less wealthy households. The sharp drop in the relative importance of contemporary masters in collections recorded in the 1670s and 1680s probably reflects a slowdown in the formation of new collections, and in

the expansion and renovation of old collections. Since Amsterdam was such an important outlet for paintings, the shrinking of the Amsterdam market must have had a calamitous effect on the livelihood and prospects of Dutch artists.

Table 1. Characteristics of Data Base

	1620–1629	1630–1639	1640–1649	1650–1659	1660–1669	1670–1679	Total
Number of Inventories	21	58	70	97	68	48	362
with prices	10	22	24	43	24	14	137
with attributions	18	32	54	50	63	41	258
Works of Art	571	2,040	2,462	3,550	2,760	2,186	13,569
Paintings	522	1,760	2,201	3,142	2,413	1,946	11,984
Drawings	9	52	67	101	119	67	415
Prints	13	151	106	202	92	79	643
Maps	2	12	15	24	30	18	101
Sculptures	17	35	52	43	29	25	201
Textiles	1	5	8	1	9	16	40
Other objects	7	25	13	37	68	35	185
Paintings Attributed	107	280	594	596	622	564	2,763
Drawings Attributed	1	27	32	29	46	11	146
Prints Attributed	0	17	6	2	4	1	30
Works Evaluated	193	785	861	1,728	952	620	5,139
Works in Dealers' Inventories	0	0	158	652	116	0	926

Note: Drawings include watercolors; prints exclude maps; sculptures include objects of pietra dura, plaster casts, and crucifixes; textiles include embroidery, needlework tapestries, and pictures made of feathers; other objects include coats of arms, copper plates, calligraphy, and miscellaneous items. Where there is uncertainty about the precise characteristics of a work of art and it may be ascribed to more than one category, it has been counted in the first category listed in descending order (e.g., "a print or drawing" will be classified as a drawing).

349

Table 2. Subject Categories of Paintings in Private Inventories with or without Attributions

	1620–1649				1650–1679			
	Inventories without Attributions	Percent	Inventories with Attributions	Percent	Inventories without Attributions	Percent	Inventories with Attributions	Percent
Histories	333	37.4	985	28.7	238	18.4	783	14.4
Old Testament	105	11.8	278	8.1	74	5.7	197	3.6
New Testament	170	19.1	401	11.7	86	6.6	297	5.5
Other religious	34	3.8	92	2.7	37	2.9	75	1.4
Mythology	17	1.9	145	4.2	26	2.0	146	2.7
Classical history	3	0.3	46	1.3	5	0.4	41	0.8
Modern history	4	0.4	12	0.3	3	0.2	8	0.1
"Histories," n.o.s.	0	0	10	0.3	7	0.5	17	0.3
Literature	0	0	1	0	0	0	2	0
Allegories	14	1.6	48	1.4	7	0.5	61	1.1
Landscapes	134	15.1	854	24.8	278	21.5	1,713	31.4
Seascapes	19	2.1	147	4.3	53	4.1	325	6.0
Cityscapes	11	1.2	35	1.0	9	0.7	81	1.5
Perspectives	5	0.6	19	0.6	5	0.4	38	0.5
Battles	8	0.9	19	0.6	3	0.2	42	0.8
Beach scenes	1	0.1	10	0.3	1	0.1	25	0.5
Horseback riders	0	0	2	0.1	0	0	8	0.1
Landscapes, n.o.s.	90	10.1	622	18.1	207	16.0	1,194	21.9

Portraits	116	13.0	444	12.9	149	11.5	805	14.8
Unknown persons	42	4.7	99	2.9	56	4.3	260	14.8
Known persons	50	5.6	258	7.5	67	5.2	461	8.5
Political	16	1.8	72	2.1	16	1.2	66	1.2
Religious	8	0.9	15	0.4	10	0.8	18	0.3
Still Lifes	54	6.1	267	7.8	87	6.7	483	8.9
"Kitchens"	2	0.2	17	0.5	5	0.4	26	0.5
Barn Scenes	0	0	0	0	0	0	12	0.2
Genre	37	4.2	252	7.3	99	7.6	461	8.5
Nudes, n.o.s.	0	0	13	0.4	5	0.4	55	1.0
Dead Persons, n.o.s.	5	0.6	8	0.2	2	0.2	14	0.3
Heads (*Tronies*)	19	2.1	114	3.3	23	1.8	129	2.4
Children, n.o.s.	0	0	8	0.2	2	0.2	7	0.1
Untitled	176	19.8	427	12.4	401	30.9	899	16.5
Total	890		3,437		1,296		5,448	

n.o.s. = not otherwise specified

Note: Paintings that can be classified in more than one subject group (e.g., "a landscape of the Flight into Egypt") have been assigned to the first appropriate group listed on this table (in the example, New Testament).

351

Table 3. Subject Categories of Paintings in Private Inventories with Attributions

	1620–1629		1630–1639		1640–1649		1650–1659		1660–1669		1670–1679		1680–1689	
	Number of Paintings	Percent	Number of Paintings	Percent	Number of Paintings	Percent	Number of Paintings	Percent	Number of Paintings	Percent	Number of Paintings	Percent	Number of Paintings	Percent
Histories	213	44.0	390	31.3	389	22.5	253	15.2	268	13.5	251	14.0	97	10.0
Old Testament	66	13.6	109	8.7	107	6.2	73	4.4	66	3.3	50	2.8	17	1.8
New Testament	99	20.5	143	11.5	160	9.3	100	6.0	103	5.2	89	5.0	32	3.3
Other religious	17	3.5	30	2.4	45	2.6	19	1.1	24	1.2	29	1.6	11	1.1
Mythology	22	4.5	75	6.0	50	2.9	39	2.3	44	2.2	66	3.7	23	2.4
Classical history	5	1.0	27	2.2	14	0.8	13	0.8	22	1.1	8	0.5	3	0.3
Modern history	2	0.4	4	0.3	6	0.3	4	0.2	1	0.1	3	0.2	2	0.2
"Histories," n.o.s.	2	0.4	2	0.2	6	0.3	4	0.2	7	0.4	6	0.3	2	0.2
Literature	0	0	0	0	1	0	1	0.1	1	0.1	0	0	7	0.7
Allegories	14	2.9	14	1.1	23	1.3	15	0.9	14	0.7	27	1.5	15	1.6
Landscapes	98	20.2	315	25.3	467	27.1	474	28.5	660	33.2	568	32.2	353	36.5
Seascapes	16	3.3	52	4.2	80	4.6	107	6.4	127	6.3	85	4.8	56	5.8
Cityscapes	6	1.2	16	1.3	13	0.8	19	1.1	24	1.2	41	2.3	21	2.2
Perspectives	5	1.0	5	0.4	7	0.4	14	0.8	5	0.3	19	1.1	4	0.4
Battles	4	0.8	5	0.4	14	0.8	5	0.3	20	1.0	17	1.0	14	1.4
Beach scenes	4	0.8	4	0.3	7	0.4	4	0.2	8	0.4	11	0.6	–	–
Horseback riders	0	0	0	0	2	0.1	3	0.2	3	0.2	2	0.1	–	–
Landscapes, n.o.s.	63	13.0	233	18.7	344	19.9	322	19.3	473	23.8	393	22.3	258	26.6

Portraits	55	11.4	144	11.5	245	14.2	262	15.8	305	15.4	233	13.2	87	9.0
Unknown persons	12	2.5	30	2.4	58	3.4	104	6.3	105	5.3	61	3.5	27	2.8
Known persons	33	6.8	77	6.2	147	8.5	125	7.5	168	8.5	156	8.8	51	5.3
Political	9	1.9	27	2.2	36	2.1	26	1.6	27	1.4	10	0.6	8	0.8
Religious	1	0.2	10	0.8	4	0.2	7	0.4	5	0.3	6	0.3	1	0.1
Still Lifes	24	5.0	94	7.5	149	8.6	136	8.2	194	9.8	150	8.5	72	7.4
"Kitchens"	6	1.2	6	0.5	8	0.5	8	0.5	8	0.4	9	0.5	–	–
Barn Scenes	0	0	0	0	3	0.2	4	0.2	3	0.2	3	0.2	5	0.5
Genre, n.o.s.	19	3.9	86	6.9	141	8.2	123	7.4	157	7.9	182	10.3	116	12.0
Nudes, n.o.s.	2	0.4	4	0.3	7	0.4	16	1.0	14	0.7	24	1.4	6	0.6
Dead Persons, n.o.s.	0	0	6	0.5	2	0.1	7	0.4	2	0.1	6	0.3	1	0.1
Heads *(Tronies)*, n.o.s.	18	3.7	49	3.9	47	2.7	64	3.9	31	1.6	35	2.0	11	1.1
Children, n.o.s.	0	0	2	0.2	2	0.1	3	0.2	4	0.2	1	0.1	–	–
Animals, n.o.s.	11	2.3	14	1.1	34	2.0	35	2.1	57	2.9	37	2.1	32	3.3
Untitled	24	5.0	124	9.9	209	12.1	261	15.7	270	13.6	238	13.5	171	17.7
Total	484		1,248		1,726		1,661		1,987		1,764		966	

n.o.s. = not otherwise specified

Note: Paintings that can be classified in more than one subject group (e.g., "a landscape of the Flight into Egypt") have been assigned to the first appropriate group listed on this table (in the example, New Testament).

353

Table 4. Subject Categories of Drawings, Watercolors, and Prints (1620-1679)

	1620–1649				1650–1679			
	Drawings and Watercolors	Percent	Prints	Percent	Drawings and Watercolors	Percent	Prints	Percent
Histories	12	9.4	27	9.6	14	4.9	12	3.1
Old Testament	4	3.1	4	1.4	1	0.3	0	0
New Testament	3	2.4	11	3.9	7	2.4	6	1.6
Other religious	0	0	5	1.8	0	0	1	0.3
Mythology	5	3.9	1	0.4	6	2.1	1	0.3
Classical history	0	0	0	0	0	0	0	0
Modern history	0	0	6	2.1	0	0	4	1.0
Allegory	1	0.8	6	2.1	0	0	6	1.6
Landscapes	14	11.0	5	1.8	65	22.6	16	4.2
Seascapes	6	4.7	1	0.4	47	16.4	4	1.0
Cityscapes	0	0	3	1.1	4	1.4	7	1.8
Perspectives	1	0.8	0	0	0	0	1	0.3
Landscapes, n.o.s.	7	5.5	1	0.4	14	4.9	4	1.0
Portraits	14	11.0	44	15.6	41	14.3	114	29.7
Unknown persons	2	1.6	0	0	2	0.7	8	2.1
Known persons	5	3.9	2	0.7	30	10.5	2	0.5
Political	7	5.5	22	7.8	2	0.7	31	8.1
Religious	0	0	20	7.1	7	2.4	73	19.0
Still Lifes	2	1.6	0	0	2	0.7	0	0
"Kitchens"	0	0	0	0	2	0.7	0	0
Genre	4	3.1	5	1.8	12	4.2	4	1.0
Heads *(Tronies)*	6	4.7	6	2.1	8	2.8	3	0.8
Animals	15	11.8	0	0	8	2.8	3	0.8
Untitled	59	46.5	189	67.0	135	47.0	226	58.9
Total	127		282		287		384	

n.o.s. = not otherwise specified

354

Table 5. Religion and Subject Categories – Art Objects in Inventories without Attributions

	1620–1649				1650–1679			
	Roman Catholic	Percent	Reformed	Percent	Roman Catholic	Percent	Reformed	Percent
Histories	144	51.8	59	31.2	50	28.9	100	15.3
Old Testament	19	6.8	27	14.3	6	3.5	39	6.0
New Testament	101	36.3	14	7.4	27	15.6	33	5.0
Other religious	20	7.2	7	3.7	7	4.0	16	2.4
Mythology	0	0	10	5.3	10	5.8	12	1.8
Allegory	5	1.8	2	1.1	0	0	1	0.2
Landscapes (all)	20	7.2	21	11.1	33	19.1	122	18.7
Portraits	46	16.5	29	15.3	20	11.6	87	13.3
Known and unknown persons	30	10.8	17	9.0	15	6.4	63	9.7
Political	2	0.7	8	4.2	0	0	1	0.1
Religious	14	5.0	4	2.1	5	2.9	23	3.5
Still Lifes	14	5.0	14	7.4	11	6.4	45	6.9
Genre	4	1.4	9	4.8	16	9.2	40	6.1
Other Subjects and Unknowns	45	16.2	55	29.1	43	24.9	259	39.6
Total	278		189		173		654	

Art Objects in Inventories with Attributions

	1620–1649				1650–1679			
	Roman Catholic	Percent	Reformed	Percent	Roman Catholic	Percent	Reformed	Percent
Histories	178	37.0	255	22.0	62	29.4	179	13.0
Old Testament	21	4.4	96	8.3	13	6.2	73	5.3
New Testament	121	25.2	83	7.2	39	18.5	58	4.2
Other religious	25	5.2	20	1.7	6	2.8	16	1.2
Mythology	10	2.1	43	3.7	4	1.9	32	2.3
Allegory	3	0.6	27	2.3	1	0.5	21	1.5
Landscapes (all)	58	12.1	303	26.1	45	21.3	384	27.8
Portraits	63	13.1	203	17.5	47	22.3	179	13.0
Known and unknown persons	57	11.9	142	12.3	38	18.0	156	11.3
Political	3	0.6	50	4.3	4	1.9	21	1.5
Religious	3	0.6	11	0.9	5	2.4	2	0.1
Still Lifes	25	5.2	97	8.4	9	4.3	119	8.6
Genre	32	6.7	79	6.8	13	6.2	110	8.0
Other Subjects and Unknowns	122	25.4	195	16.8	34	16.1	390	28.2
Total	481		1159		211		1382	

Note: Art objects include paintings, drawings, prints, sculptures, images made of textiles, and miscellaneous objects.

Table 6a. Religion of Private Collectors and Religious Subjects (1620–1649) – All Art Objects

	Roman Catholic	Percent of All Religious Subjects	Reformed	Percent of All Religious Subjects
New Testament	**269**	**71.0**	**115**	**42.9**
Crucifixion and Death of Christ[a]	68	17.9	10	3.7
Birth of Christ[b]	35	9.2	18	6.7
Other episodes in the life of Christ	56	14.8	28	10.4
Ecce Homo	5	1.3	2	0.7
Christ or "Salvator"	11	2.9	1	0.3
History of Saint Paul	3	0.8	6	2.2
History of Saint Peter	0	0	6	2.2
History of Saint John the Baptist	8	2.1	7	2.6
Annunciation	6	1.6	4	1.5
Mary and Christ child	8	2.1	1	0.3
The Holy Family	8	2.1	1	0.3
Virgin Mary (all others)	40	10.6	7	2.6
Mary Magdalene	12	3.2	3	1.1
Parables	4	1.1	7	2.6
Others	5	1.3	14	5.2
Other Religious Subjects	**54**	**14.2**	**26**	**9.7**
Last Judgment	1	0.3	1	0.3
Angels	6	1.6	2	0.7
Saints and evangelists	28	7.4	15	5.6
Religious allegory	11	2.9	7	2.6
Others	8	2.1	1	0.3

Table 6a. continued

	Roman Catholic	Percent of All Religious Subjects	Reformed	Percent of All Religious Subjects
Old Testament	56	14.8	127	47.4
Abraham[c]	9	2.4	8	3.0
Hagar, Ishmael	1	0.3	7	2.6
Lot	1	0.3	10	3.7
Jacob	4	1.1	11	4.1
Susanna	5	1.3	9	3.4
Elias	3	0.8	3	1.1
Jepthah	0	0	3	1.1
Moses	0	0	13	4.9
Adam and Eve	5	1.3	4	1.5
Cain and Abel	0	0	2	0.7
David	4	1.1	4	1.5
Esther	0	0	3	1.1
Solomon	2	0.5	5	1.9
Tobias	4	1.1	5	1.9
Rebecca	0	0	6	2.2
Judith and Holofernes	6	1.6	4	1.5
Tower of Babel	1	0.3	5	1.9
Others	11	2.9	25	9.3
Total	379		268	

a. Including the Carrying of the Cross and the Descent from the Cross.
b. Including the adoration of the magi and "Bethlehem."
c. Including the sacrifice of Abraham.

Table 6b. Religion of Private Collectors and Religious Subjects (1650–1679) – All Art Objects

	Roman Catholic	Percent of All Religious Subjects	Reformed	Percent of All Religious Subjects
New Testament	**66**	**67.3**	**122**	**37.9**
Crucifixion and Death of Christ[a]	20	20.4	7	2.2
Birth of Christ[b]	7	7.1	29	9.0
Other episodes in the life of Christ	6	6.1	38	11.8
Ecce Homo	1	1.0	0	0
Christ or "Salvator"	3	3.1	6	1.9
History of Saint Paul	3	3.1	2	0.6
History of Saint Peter	1	1.0	2	0.6
History of Saint John the Baptist	1	1.0	8	2.5
Annunciation	5	5.1	2	0.6
Mary and Christ child	2	2.0	2	0.6
The Holy Family	2	2.0	5	1.6
Virgin Mary (all others)	7	7.1	10	3.1
Mary Magdalene	2	2.0	3	0.9
Parables	1	1.0	6	1.9
Others	5	5.1	2	0.6
Other Religious Subjects	**13**	**13.3**	**45**	**14.0**
Last Judgment	1	1.0	2	0.6
Angels	0	0	5	1.6
Saints and evangelists	9	9.2	24	7.5
Religious allegory	0	0	9	2.8
Others	3	3.1	5	1.6

	Roman Catholic	Percent of All Religious Subjects	Reformed	Percent of All Religious Subjects
Old Testament	**19**	**19.4**	**155**	**48.1**
Abraham	0	0	10	3.1
Hagar, Ishmael	1	1.0	6	1.9
Lot	3	3.1	8	2.5
Jacob	0	0	10	3.1
Susanna	1	1.0	5	1.6
Elias	1	1.0	3	1.0
Jepthah	0	0	11	3.4
Moses[c]	1	1.0	8	2.5
Adam and Eve	1	1.0	5	1.6
David	1	1.0	13	4.0
Esther	0	0	6	1.9
Solomon	1	1.0	6	1.9
Tobias	2	2.0	20[d]	6.2
Rebecca	1	1.0	3	1.0
Judith and Holofernes	0	0	2	1.0
Tamar	1	1.0	4	1.2
Joseph	1	1.0	14	4.3
Others	4	4.0	21	6.5
Total	**98**		**322**	

a. Including the Carrying of the Cross and the Descent from the Cross.
b. Including the adoration of the magi and "Bethlehem."
c. Including the Ten Commandments.
d. Including fourteen small paintings of "Tobias and Judith."

Table 7. Paintings in Private Inventories Attributed to Seventeenth-Century Artists Active in Various Localities (1620–1679)

	1620–1629	1630–1639	1640–1649	1650–1659	1660–1669	1670–1679
Total Attributed	108	323	600	283	623	584
Unidentified	27	14	87	11	57	24
Copies	18	36	28	5	24	19
Originals	63	273	485	267	542	541
"Originals" by Seventeenth-Century Artists Active in:	45	214	427	252	515	519
Amsterdam (all)	24	96	192	155	311	335
Haarlem (all)	9	41	122	73	137	114
Haarlem and Amsterdam	3	16	32	28	38	48
Leiden (all)	0	4	19	7	23	36
Leiden and Amsterdam	0	1	5	1	11	26
The Hague (all)	0	11	22	9	24	49
The Hague and Amsterdam	0	6	2	3	10	28
Delft (all)	2	9	18	4	29	16
Delft and Amsterdam	0	6	4	2	26	14
Rotterdam (all)	0	3	13	1	22	2
Rotterdam and Amsterdam	0	0	3	0	15	2

Table 7. continued

	1620–1629	1630–1639	1640–1649	1650–1659	1660–1669	1670–1679
Dordrecht (all)	0	0	3	2	0	4
Dordrecht and Amsterdam	0	0	0	1	0	4
Middelburg (all)	0	4	12	1	3	2
Middelburg and Amsterdam	0	0	3	0	0	0
Utrecht (all)	6	41	45	19	31	40
Utrecht and Amsterdam	0	0	1	0	9	2
Antwerp (all)	9	34	64	24	43	59
Antwerp and Amsterdam	3	8	6	2	7	20
Antwerp and Haarlem	0	0	7	3	7	19
Antwerp and Leiden	0	2	9	0	5	19
Italy (all)	5	12	6	8	18	18
Italy and Amsterdam	5	1	0	1	11	7
Italy and Haarlem	0	0	0	1	2	3
Italy and Utrecht	0	2	4	4	2	0
Germany or Austria	0	5	10	0	4	0

Table 8. Percentage Breakdown of Attributions According to the Localities Where
Seventeenth-Century Artists Were Active

	Percentage of All Attributed Paintings (originals only)					
	1620–1629	1630–1639	1640–1649	1650–1659	1660–1669	1670–1679
Amsterdam	43.3	43.9	45.0	61.5	60.4	61.5
only in Amsterdam	28.9	29.0	34.0	42.9	37.9	37.0
also in other localities	14.4	14.9	11.0	18.6	22.5	24.5
Haarlem	20.0	19.2	28.6	29.0	26.6	21.5
only in Haarlem	13.3	11.7	17.6	14.3	16.9	10.6
also in other localities	6.7	7.5	11.0	14.7	9.7	10.9
Leiden	0	1.9	4.4	2.8	4.5	6.9
only in Leiden	0	1.4	1.9	2.4	0	1.0
also in other localities	0	0.5	2.5	0.4	4.5	5.9
The Hague	0	5.1	4.9	3.6	4.7	9.4
only in The Hague	0	1.8	3.3	2.0	2.9	2.9
also in other localities	0	3.3	1.6	1.6	1.8	6.5
Delft	4.4	4.2	4.0	1.6	5.6	5.2
only in Delft	4.4	4.2	1.9	1.6	0.6	0.4
also in other localities	0	0	3.1	0	5.0	4.8
Rotterdam	0	1.4	3.0	0.4	3.7	0.4
only in Rotterdam	0	1.4	1.9	0	0.8	0
also in other localities	0	0	1.1	0.4	2.9	0.4
Middelburg	0	1.8	2.8	0.4	0.6	0.4
only in Middelburg	0	0.5	0.2	0.4	0.2	0
also in other localities	0	1.3	2.6	0	0.4	0.4
Utrecht	13.3	19.6	10.5	7.5	6.0	7.7
only in Utrecht	13.3	15.4	6.3	2.6	3.9	5.4
also in other localities	0	4.2	4.2	4.9	2.1	2.3
Antwerp	26.7	15.9	15.0	9.5	8.3	11.4
only in Antwerp	20.0	9.8	9.8	2.0	3.9	6.7
also in other localities	6.7	6.1	5.2	7.5	4.4	4.7
Italy	11.2	5.6	1.4	3.6	3.5	3.4
only in Italy	0	1.9	0.5	0.8	0	0.8
also in other localities	11.2	3.7	0.9	2.8	3.5	2.6

Table 9. Contemporary Artists and "Old Masters" in Amsterdam Inventories 1620–1714

	1620–1629	1630–1639	1640–1649	1650–1659	1660–1669	1670–1679	1680–1689	1700–1714
Number of Attributed Paintings[a]	80	268	511	578	566	540	260	1142
"Contemporary artists"	44	176	300	304	258	226	36	218
(percentage)	55.0	65.7	58.8	52.6	45.6	41.9	13.8	19.1
"Old masters"	36	92	211	274	308	314	224	924
(percentage)	45.0	34.3	41.2	47.4	54.4	58.1	86.2	80.9

a. Identified artists only.

Note: Contemporary artists are those whose last known dates of activity or whose death dates fall within the decades indicated in the column headings.

Sources: Inventories dated 1620–1679 are from the Getty-Montias data base. The inventories dated 1680–1689 were collected and tabulated by Marten Jan Bok. The inventories dated 1700–1714 were provided by S. A. C. Dudok van Heel to the Getty Provenance Index.

Table 10a. Attributions of Paintings Cited in Private Amsterdam Inventories 1620–1649 (artists mentioned seven or more times)

	Total Attributions	Number of Inventories in Which Cited	Number of Copies After	Number of Inventories in Which Copies Were Cited	Number of Paintings Evaluated (excluding copies)	Average Price per Painting (*gulden*)
Momper, Joos de[A]	24	15	0	0	5	18.0
Savery, Roelandt	4	4	0	0	3	43.3
Savery, Roelandt[A]	19	10	3	3	9	52.6
Total	23	14	3	3	12	72.5
Porcellis, Jan	21	10	1	1	8	72.5
Hondecoeter, Gillis d'	4	1	0	0	0	
Hondecoeter, Gillis d'[A]	20	8	0	0	11	30.0
Total	24	9	0	0	11	
Jansz., Govert	18	8	0	0	8	33.4
Pynas, Jan	9	6	0	0	3	36.0
Pynas, Jan[A]	7[a]	6	1	1	3	113.0
Total	16	12	1	1	6	
Peeters, Bonaventura	3	2	0	0	3	9.0
Peeters, Bonaventura[A]	13	1	0	0	13	32.0
Total	16	3	0	0	16	
Aertsen, Pieter	16	13	4	3	2	48.0
Rembrandt	14	5	8	3	2	33.0
Poelenburgh, Cornelis van	14	8	6	3	3	72.0
Molenaer, Jan Miense	14	3	1	1	0	
Bloemaert, Abraham	13	8	3	3	5	64.0

Codde, Pieter	12	7	0	0	5	30.4
Cuyper, Hendrick	11	4	0	0	7	114.6
Quast, Pieter	11	4	1	1	0	
Brouwer, Adriaen	11	4	4	1	1	18.5
Mander, Karel van	11	8	0	0	3	23.1
Cornelisz., Cornelis	10	8	3	2	5	80.4
Floris, Frans	10	6	1	1	2	11.2
Spranger, Bartolomeus	9	3	0	0	4	58.5
Vroom, Hendrik [A]	9	7	1	1	5	39.2
Goyen, Jan van	9	5	0	0	0	
Arentsz., Arent	9	4	0	0	0	
Avercamp, Hendrick	8	4	0	0	3	56.0
Troyen, Rombout van	8	2	0	0	7	18.6
Saftleven, Cornelis	8	3	0	0	2	43.5
Molijn, Pieter de	8	5	0	0	1	50.0
Bosschaert, Ambrosius [A]	7	7	0	0	1	72.0
Bruegel, Jan [A]	7	5	0	0	3	70.0
Heemskerck, Maarten van	7	4	1	1	5	37.0
Vinckeboons, David	7	6	1	1	2	35.0
Ast, Balthasar van der	7	5	0	0	2	39.0
Coninxloo, Gillis van	7	4	4	1	1	96.0
Pynas, Jacob	7	3	0	0	2	34.0
Bles, Harry met de	7	3	0	0	0	

A. Paintings attributed to an artist on the basis of his last name cited in inventory and other evidence (subject, data, etc.).

a. Some of the paintings attributed here to Jan Pynas may actually be by his brother Jacob Pynas.

Note: Inventories of dealers have been excluded from the inventories analyzed in this table.

Table 10b. Attributions of Paintings Cited in Private Amsterdam Inventories 1650–1679 (artists mentioned seven or more times)

	Total Attributions	Number of Inventories in Which Cited	Number of Copies After	Number of Inventories in Which Copies Were Cited	Number of Paintings Evaluated (excluding copies)	Average Price per Painting (gulden)
Molenaer, Jan Miense	37	22	0	0	8	11.0
Wouwerman, Philips	32	16	2	2	11	29.3
Vonck, Elias^A	29	19	0	0	8	4.8
Rembrandt	27	9	3	3	0	–
Lievens, Jan	22	5	1	1	2	78.0
Goyen, Jan van	22	13	0	0	7	12.3
Everdingen, Allart van	20	7	0	0	11	40.0
Ruisdael, Jacob van	18	10	0	0	10	40.9
Vlieger, Simon de	17	6	0	0	13	18.9
Troyen, Rombout van	16	11	2	1	7	16.4
Wyck, Thomas	15	8	0	0	5	16.2
Porcellis, Jan	15	8	0	0	8	24.1
Goor, Steven van	14	3	0	0	11	24.1
Koninck, Philips de	14	4	0	0	0	–
Camphuysen, Govert^A	14	6	0	0	10	9.9
Velde, Adriaen van de^A	13	7	0	0	4	58.5
Moucheron, Frederick de	13	7	0	0	6	20.6
Witte, Emanuel de	13	6	0	0	8	46.1
Colyn, David	13	7	0	0	6	29.6
Aertsen, Pieter	13	10	1	1	4	33.0

Hondecoeter, Gillis d'	1	7	0	0	0	–
Hondecoeter, Gillis d'A	12	7	0	0	7	32.9
Total	13	8	0	0	7	
Hondecoeter, Melchior	2	2	0	0	2	7.0
Hondecoeter, Melchior A	11	5	0	0	0	–
Total	13	7	0	0	2	
Lundens, Gerrit	12	6	0	0	2	25.0
Brouwer, Adriaen	12	6	1	1	5	6.0
Momper, Joos de A	12	10	0	0	9	16.7
Molijn, Pieter de	12	6	0	0	8	5.3
Lingelbach, Johannes	11	6	0	0	8	28.4
Hals, Dirck	10	2	0	0	1	5.0
Hooch, Carel de	10	3	0	0	3	19.7
Snyders, Frans	10	7	0	0	5	109.8
Beerstraten, Jan A	10	6	0	0	6	31.0
Wet, Jacob de	2	1	0	0	0	–
Wet, Jacob de A	8	3	0	0	0	–
Total	10	4	0	0	0	
Berchem, Nicolaes	9	7	0	0	1	36.0
Coninxloo, Gillis van	9	3	0	0	8	23.3
Poelenburgh, Cornelis van	9	4	2	2	1	8.0
Pynas, Jan	6	3	0	0	0	–
Pynas, Jan A	3	3	0	0	2	5.0
Total	9	6	0	0	2	

continues on next page

Table 10b. continued

	Total Attributions	Number of Inventories in Which Cited	Number of Copies After	Number of Inventories in Which Copies Were Cited	Number of Paintings Evaluated (excluding copies)	Average Price per Painting (*gulden*)
Savery, Roelandt	2	2	0	0	1	18.0
Savery, Roelandt[A]	7	5	0	0	2	31.1
Total	9	7	0	0	3	
Velde, Willem van de	3	3	0	0	2	22.5
Velde, Willem van de[A]	6	3	0	0	1	18.0
Total	9	6	0	0	3	
Schellings, Willem	8	7	0	0	1	18.0
Vinckeboons, David	8	5	0	0	2	36.0
Metsu, Gabriel	8	4	0	0	1	50.0
Neer, Aert van der	8	7	0	0	4	11.0
Rubens, Peter Paul	8	5	1	1	4	62.5
Ostade, Adriaen van[A]	8	3	0	0	5	3.8
Bruegel, Jan[A]	7	6	0	0	2	40.0
Bloemaert, Abraham	7	6	0	0	3	12.7
Goltzius, Hendrik	7	6	0	0	2	25.5
Uyttenbroeck, Moses van	7	5	1	1	1	60.0
Vertangen, Daniel	7	3	0	0	2	5.0
Weenix, Jan Baptist	7	4	0	0	0	–

A. Paintings attributed to an artist on the basis of his last name cited
 in inventory and other evidence (subject, data, etc.).

Table 11. Price-Weighted Frequency of Attributed Paintings in Private Collections (fourteen most important artists)

1620–1649		1650–1679	
Artist	Price-Weighted Frequency (gulden)	Artist	Price-Weighted Frequency (gulden)
Porcellis, Jan	1523	Rembrandt[a]	2387
Cuyper, Hendrick	1261	Lievens, Jan	1716
Savery, Roelandt	1173	Snyders, Frans	1098
Pynas, Jan	1115	Wouwerman, Philips	938
Poelenburgh, Cornelis van	1008	Everdingen, Allart van	800
Bloemaert, Abraham	832	Velde, Adriaen van de	761
Cornelisz., Cornelis	804	Ruisdael, Jacob van	736
Aertsen, Pieter	768	Witte, Emanuel de	599
Coninxloo, Gillis van	672	Rubens, Peter Paul	500
Jansz., Govert	601	Hondecoeter, Gillis d'	428
Spranger, Bartolomeus	527	Colyn, David	385
Bosschaert, Ambrosius	504	Porcellis, Jan	362
Bruegel, Jan	490	Pynas, Jan	351
Rembrandt	462	Goor, Steven van	337

a. There were no assessed paintings attributed to Rembrandt in the sample of inventories dated 1650–1679. The average value of paintings attributed to Rembrandt in other privately owned inventories recorded in Walter L. Strauss and Marjon van der Meulen's *The Rembrandt Documents* (New York: Abaris Books, 1979) was 88.4 *gulden*. This average was multiplied by 27, the number of attributions in our sample, to arrive at the figure in the table.

NOTES

1. John Michael Montias, *Artists and Artisans in Delft: A Socio-Economic Study of the Seventeenth Century* (Princeton: Princeton Univ. Press, 1982), 220–71.

2. I am grateful to Dr. Burton Fredericksen and to the staff of the Getty Provenance Index for technical assistance in resolving numerous problems that arose during the course of this project. William Stalls kindly assisted me with the statistical calculations in this paper.

3. One way of figuring the bias due to overrepresentation of richer inventories is to compare the prices of paintings in these inventories and in inventories containing at least one attribution. Twenty-seven priced inventories without any attribution were collected as part of the overall sample for the 1630s and 1640s. Prices for paintings in this subsample of 323 paintings averaged 4.6 *gulden*. In the subsample of inventories containing one or more attributions, the anonymous paintings were evaluated at an average of 13.8 *gulden* (757 paintings), the attributed paintings at an average of 47 *gulden* (275 paintings). The average for all paintings was 22.7 *gulden*. Inventories with one or more attributions contained many more works of art than those that did not. There were on average 43.5 works of art per inventory in the former and only 17.4 in the latter. This difference reflects a significant disparity in wealth between the owners of the two types of inventories.

4. The share of paintings is probably overstated and the shares of other objects understated because early on in this project I omitted recording a certain number of prints without titles, as well as maps and sculptures.

5. The correlation between the number of paintings in an inventory and the total value of movable assets for a subsample of 28 inventories (for which I had data on both these variables that I considered reliable) was only 0.46 with an estimated standard error of 0.15. An important reason for this relatively low correlation is that wealthier households, which devoted more of their wealth to the acquisition of works of art, spent a good deal more per work of art (see note 3). Many modest households owned a fairly large number of inexpensive *bortjes* (little panels), so that a mere count of the works of art in these inventories may give an inflated idea of their contents. The difference in value of the movable goods owned by households with and without attributed works of art, in a sample of 59 inventories for the period 1620–1649 and 51 inventories for the period 1650–1679, was significant at a very high level of probability. In particular it may be noted that in the first period nearly 60 percent of the inventories with attributions were valued at over 2,000 *gulden*, whereas about three-quarters of those without attributions were valued at less than this sum. In the second period three-quarters of the inventories in the sample were valued at over 2,000 *gulden* and 63 percent of those without attributions at less than this sum. This sample was constructed in part from inventories that have not been included in my computerized data bank. It should be noted that in all the comparisons of relative frequencies

made here and elsewhere in this paper, chi-square tests were carried out to assess the significance of these differences. Only results that are significant at the 95 percent probability level or higher have been reported. (Chi-square tests are designed to ascertain whether the distribution by categories [such as the subjects of paintings] in two samples differing in some characteristic [such as inventories with and without attributions] differs significantly.)

6. It is tempting to assume that the pictures left undescribed by subject were in fact distributed by subject categories more or less in the same proportions as those that were described. But the interesting possibility arises that notaries and assessors were more inclined to describe certain pictures than others, for example, biblical pictures as opposed to landscapes. If so, the overrepresentation of religious pictures and the underrepresentation of landscapes in inventories without attributions ("proxying" poorer inventories) would be partly due to this factor. But it is doubtful whether this possible bias in recording could offset more than a fraction of the total disparity between the two groups of inventories in these two broad subject categories. The reader should note, in any case, that only about 10 percent of the very high chi-square in the first period (significant at the 99 percent probability level) was contributed by the category of untitled works of art (along with some other smaller groups). In the second period this residual category contributed about half of the total chi-square (significant at the 99 percent level).

7. Note that such a random selection could not easily be carried out by using random numbers to pick inventories from each notary. Because notaries had substantially different clienteles (rich and poor, Roman Catholic and Reformed), every inventory of every notary would have to be assigned a number, and a random sample would have to be selected from this complete set of numbers. Given that researchers are only allowed access to microfilm in the Amsterdam archives and that it takes considerable time to locate inventories in the "protocols" of notaries, which do not segregate inventories from other documents, such a procedure would be extraordinarily expensive and time-consuming. It would clearly be beyond the resources of a single researcher.

8. Ideally, one would like to estimate the average date of acquisition for each collector on the basis of his or her first marriage date and then calculate the distribution of works of art by subject using these dates for the periodization. I would guess that the time trends in subject categories would be even more pronounced if the periods were based on these estimated dates of acquisition rather than on the dates of the inventories (because inventory dates were used as a "proxy," or surrogate, for acquisition dates, when in actuality the interval between the two sets of dates varies among individual owners, which has the effect of blurring the underlying trend).

9. It is noteworthy that the proportion of histories and landscapes remained approximately constant from the 1660s to the 1670s. This tends to support my hypothesis, developed in the latter part of this paper, that there were relatively few new collections formed or substantial additions made to existing collections in the 1670s.

10. The upward trend in the genre category was much more pronounced than that which I observed in my sample of Delft inventories.

11. Johan E. Elias, *De Vroedschap van Amsterdam 1578–1795*, 2 vols. (Amsterdam: N. Israel, 1963).

12. Jean Calvin, *Institutes of the Christian Religion*, ed. John T. McNeill, 2 vols. (Philadelphia: Westminster Press, 1961), vol. 1, bk. 1, chap. 11, sect. 12.

13. Note, however, that the frequency of individual subjects in Catholic inventories in the period 1650–1679 may not be reliable, owing to the relatively small size of the sample.

14. Computed from data in Jan de Vries, *European Urbanization 1500–1800* (Cambridge, Mass.: Harvard Univ. Press, 1984), 271–72.

15. The causes of this decline are discussed in greater detail in John Michael Montias, "Cost and Value in Seventeenth-Century Dutch Art," *Art History* 10, no. 4 (December 1987): 455–66.

16. For a detailed comparison of attributions in dealers' and privately owned inventories, see John Michael Montias, "Art Dealers in Seventeenth-Century Netherlands," *Simiolus* 19, no. 2 (1989).

17. Starting from the hypothesis that the incidence of an artist's works might be inversely related to the prices that he obtained for them, I regressed the average price for each artist on the number of paintings attributed to him in each period. The slope of the regression was very slightly negative in the first period (–0.22) and positive in the second (+0.085), but in neither case did it differ significantly from zero. There is no statistical confirmation for the hypothesis in my sample of inventories.

18. Neither the dates nor the place of the activity of Hendrick Potuyl are known.

19. For Delft, I used either a measure of the total value of the inventory of movable goods — less than 500 *gulden* for the "poor" and more than 2,000 *gulden* for "rich" inventories — or, as a "proxy," the number of paintings in the inventory — less than 10 paintings in "poor" and more than 40 paintings in "rich" inventories (John Michael Montias, "Collectors' Preferences in Seventeenth-Century Delft: Evidence for Inventories" [Unpublished paper, New Haven, Conn., 1985], 3–4). I ran the same statistical tests as in the present paper and found the differences in the structure of subjects between "rich" and "poor" inventories highly significant.

20. Some of the paintings attributed here to Jan Pynas may actually be by his brother Jacob Pynas, who spent most of his career in other cities.

CONCLUSION

Fig. 1. Maria Sibylla Merian,
Preparatory study for *Metamorphosis
Insectorum Surinamensium*
(Amsterdam, 1705),
watercolor on vellum, 35.8 x 27.7 cm.
Windsor, Windsor Castle, Royal Library.
Photo: Reproduced by permission of Her
Majesty the Queen.

David Freedberg

Science, Commerce, and Art:

Neglected Topics at the Junction of History and Art History

Ever since my youth I have been engaged in the examination of insects. I
began with silkworms in my native city of Frankfurt, but then, noticing that
much more beautiful butterflies, both nocturnal and diurnal, emerged from
caterpillars, I was moved to gather together all the caterpillars I could find
and to make observations of their metamorphoses. For this reason I set aside
my social life and devoted all my time to these observations and to improving
my abilities in the art of painting, so that I could both draw individual
specimens and paint them in lively colors. The result was that I was able to
gather together, quite beautifully painted by me on sheets of vellum, all the
insects that I found, first in Frankfurt and then in Nuremberg [fig. 2]. When a
number of amateurs later happened to see these, they strongly encouraged
me to publish my observations of insects, in order to satisfy both their
demands and those of other conscientious natural historians. And so, moved
by their urgings, I had the figures engraved and published, the first part in
quarto in 1679 and the second part in 1683.[1] I then moved to Friesland and to
Holland. Naturally, I continued in my examination of insects, especially in
Friesland, since in Holland there was less opportunity than elsewhere, particu-
larly for investigating those kinds of insects found on heath and moorland.
But very often the skills of other amateur naturalists helped fill this lacuna,
and they brought me caterpillars in order to study the metamorphoses of
these animals still more deeply: to such a degree that I was able to gather
together a large enough number of observations to make a further addition to
the two previous volumes.[2] When I was in Holland I saw with wonderment
the many kinds of animals being brought back from both the West and the
East Indies — especially when I had the honor of visiting the distinguished

Fig. 2. Maria Sibylla Merian,
Preparatory study for *Der Raupen
wunderbare Verwandelung, und sonderbare
Blumen-Nahrung* (Nuremberg, Leipzig,
and Frankfurt, 1679),
watercolor on vellum, 19.8 x 25.6 cm.
London, British Museum.

museum of the most noble and distinguished burgomaster of Amsterdam and director of the East India Company, Nicolaas Witsen, and the most noble Jonas Witsen, secretary of the same town. Afterward, I saw the museum of the distinguished Frederick Ruisch, medical doctor and professor of anatomy and botany, as well as that of Levinus Vincent and of many others. Here I saw these and innumerable other insects, but I did not see their origin and generation, nor how the caterpillars became chrysalises and how they were further transformed. Inspired by just this, I made a long and expensive journey, sailing in June 1699 to Surinam in America (a hot and humid region whence the above mentioned gentlemen had obtained the insects), in order to make a more accurate investigation of the same subject and to pursue my study further. There I remained until June 1701, when I sailed back again to the Netherlands, returning there on 23 September. In Surinam I painted these sixty figures with the greatest diligence on pieces of parchment, all life-size, as well as my observations of them [figs. 1, 3]. They can be seen at my house, along with some small dried specimens. But I did not really find the opportunity I had hoped for of examining the insects, since the climate of the place was very hot, and the heat did not agree with me. For this reason I was forced to return home sooner than I had planned.

After I returned to Holland and a number of amateurs of such things saw my paintings, they began to urge me to commit them to the press and to publish my findings, since they thought that they were the most superior and most beautiful of all the works ever painted in America. At the beginning, the expense of bringing this book to completion deterred me, but finally, since the burden had already been undertaken, I began to work on the project.

This book, therefore, consists of sixty copper plates, on which are displayed ninety studies of caterpillars, worms, and maggots, how they change their pristine color and form once they have shed their skins and are finally transformed into butterflies, moths, beetles, bees, and flies. All these animals I have placed on the plants, flowers and fruits that provide their respective nourishment [figs. 1, 3].[3] To them I have added the development of the spiders of the West Indies, ants, snakes, lizards, and the rare toads and frogs, all observed by me in America and drawn from life, with only a few exceptions, which I have added based on the oral testimony of the Indians.

In putting together this book, I have not sought to make money. I was simply content to cover my costs. Nor have I spared any expense to bring the work to completion. I have taken care to have the plates engraved by the

Fig. 3. Maria Sibylla Merian,
Preparatory study for *Metamorphosis
Insectorum Surinamensium*
(Amsterdam, 1705),
watercolor on vellum, 36 x 29.5 cm.
Windsor, Windsor Castle, Royal Library.
Photo: Reproduced by permission of Her
Majesty the Queen.

most skilled artists,[4] and to this end I have also sought out the very best paper; so that I might respond not only to those who are knowledgeable about art but to all students of insects and plants. And if I find that I have achieved this goal and have satisfied and not displeased such readers, then I will indeed rejoice.[5]

This is the justly proud letter to the reader with which Maria Sibylla Merian begins her great book on the insects of Surinam, published in Amsterdam in 1705. It is at once modest and exalted, the testimony to a single-minded and heroic achievement, and it yields much to the historian and art historian prepared to take the long view of the course of Dutch art from the end of the sixteenth century until the middle of the eighteenth century. The book itself is entitled *Metamorphosis Insectorum Surinamensium*, "in which the worms and caterpillars of Surinam are drawn from life, along with their transformations, and placed on the plants, flowers, and fruits on which they are found"[6] (and not, it should be noted, just any wildflowers, but specifically those of some economic interest and value). It is the apotheosis of those lowly animalcules celebrated not only by natural historians but by every emblem writer and poet who saw in them yet further evidence of the divine and splendid intricacies of God's creation. But it is also, as the title suggests and the text makes magnificently clear, the great fulfillment of the implications of a term — *metamorphosis* — which dominated the complex relations between mythology, art, and nature for more than a century.

The tradition of metamorphosis had always combined science and fable and offered the basic parallel for the transformations of nature by art: hence the importance for Dutch painting of Karel van Mander's seemingly old-fashioned reworking of the genre of moralized metamorphoses in his *Wtleggingh op den Metamorphosis* appended to the *Schilder-boeck*; hence the persistence of this genre long after its apparent extinction at the end of the fifteenth century; and hence the republication of just this part of the *Schilder-boeck* as late as 1660 and again in Nuremberg in 1679. But with Merian metamorphosis was finally stripped of fable altogether. In earlier books there might have been long discussions of whether rightly to call a *Lacerta* a *Stellio* (after Ovid's boy-lizard), as in Johannes Faber's vast dissertation on Mexican animals first published in 1628,[7] but Merian shows no such indecisiveness, no such taxonomic anxiety. With insects, worms, and caterpillars, one might expect to find lessons about the greatness of God

being evinced in these smallest and lowliest of creatures, as Jacob Cats and Constantijn Huygens and many others found heaven in a grain of sand; and one might have anticipated something explicit about the grand complexity of God's designs, about his magnanimity in thus investing such insignificant beings, or even about his humility in so endowing them with reflections of the divine. But no — missing even is the more obvious insistence on metamorphosis as a figure for the resurrection of the soul.

The most extensively illustrated earlier work on insects was that of Johannes Goedaert, a painter from Middelburg,[8] whose many practical experiments with insects were translated and edited for publication by his Middelburg acquaintances Doctor Johannes de Mey (for the first volume) and Paulus Veezaerdt, minister from Wolfaartsdijk and formerly chaplain of Michiel de Ruyter (for the second). From the very outset of Goedaert's book — significantly entitled *Metamorphosis Naturalis* (1662 and 1667), as if to make clear the distinction from the metamorphoses of mythology and fable — notions about the divine are still wholly present. "Although these animalcules are generally despised by men, on account of their slight size... it is clear that by observing the visible works of God we are able in our minds to reach those things in God otherwise invisible in themselves," he says in his first volume. "There is nothing in the universe and in nature more divine than man himself; yet insects too are divine. They are miracles of nature to be admired, the irrefragable testimony of infinite wisdom and power. From the outside they seem to be disgusting and abject, but if you look at them more closely, you soon discover they are very different," it is asserted in volume two.[9]

There is none of this in Merian — even though we might expect it, given the refuge she took among the devout Labadists of Friesland. It was here, as she makes clear in her letter to the reader, that she began the studies that led to the book on the insects of Surinam. And although the depictions of the insects in Goedaert are good enough, Merian raises the portrayal of insects to great art. If this applies to her earlier books on the insects of Frankfurt and Nuremberg (the title pages specifically state that they were intended not only for lovers of insects and plants but also for painters),[10] it is even more strongly the case with the studies produced during and following her visit to the Indies (figs. 1–3).

Between Goedaert and Merian came one of the great entomologists of all time, Jan Swammerdam, who was also one of the leading anatomists of

the century. Swammerdam was able to rectify at a stroke some of the more egregious of Goedaert's mistakes (most notably by setting forth the stages of the transformation from worm to moth and thereby confuting Goedaert's misguided views about the spontaneous generation of insects). But Swammerdam's book, *Historia Insectorum Generalis*, for all its importance in the history of systematic entomology and the classification of insects, and despite his pioneering use of the magnifying glass and the beautifully and densely etched plates, is not nearly as pretty a production as Goedaert's or as sumptuous as Merian's — nor is it as extensively illustrated.[11] It thus makes less of a contribution to the history of systematic visual documentation and to the broader history of art.

Swammerdam himself, who fell under the influence of Antoinette Bourignon, ended his days attempting to provide his scientific interpretations with lengthy pietist glosses. It was left to Hermannus Boerhaave to take up Swammerdam's role in the next century with the 1737–1738 edition of *Bybel der Natuure of Historie der Insecten*, in which he published a famous essay proving the sex of the queen bee. But here the illustrations were altogether different. Self-consciously artistic aims were almost entirely relinquished in favor of new, more scientific forms emphasizing detailed visual analysis of parts and the whole of the anatomy; the detail was so careful and so dense that representation crowded out much of the available space on the page. There was often so much visual information on a single sheet that the earlier attention to the decorative and ornamental yielded to the new epistemological pressures.

Merian's Surinamese book thus stands at the apex of a tradition of scientific examination that had been growing for just over a century, and it was intimately bound up with the mental habits underlying the great seventeenth-century museums.[12] The book is unimaginable outside the context of the extraordinary investigative excitement aroused by the adventures of the two companies of the Indies, East and West; and it binds together the fruits of high artistic skill with intense and minute observation in the interests of both science and art. It forces upon us awareness of the perils of neglecting a strain in Dutch culture that has been almost completely passed over by historians of Dutch art. This strain cannot be understood without considering the ways in which the historic and economic motivations for Dutch trade overseas reached far more deeply into Dutch art than is generally acknowledged and without emphatically recalling the ways in which

such motivations spurred the progress of science. The basic historical and economic context is now available in the excellent works of scholars like Charles R. Boxer and Jonathan Israel.[13] Art historians have failed to take sufficient cognizance of such studies, but in this neglected tradition history and art history come together with the development of natural history in ways that may stand as a paradigm for the fruitful meeting of these disciplines. But such paradigms can only be perceived by taking a longer view than usual.

Consider the long history of botanical illustration in the Netherlands. In assessing the significance not only of the descriptive element in Dutch art but of the relation between description and fantasy and between the earthly visible and the divine invisible, we cannot afford to overlook the strain that runs from the herbals of Rembert Dodoens (Dodonaeus), Matthias de L'Obel (Lobelius), and Charles de L'Ecluse (Clusius) to Hendrik Adriaan van Reede tot Drakenstein's stupendous *Hortus Malabaricus* — issued in twelve large volumes (with over six hundred plates) between 1673 and 1703[14] — and then to Linnaeus's epochal *Hortus Cliffortianus* of 1737[15] and the final publication of the *Amboinsche Kruid-Boeck* by the "Pliny of the Indies," Georg Rumphius, in 1741–1755.[16] The strain has not gone wholly unremarked, it is true, but has never been referred to more than cursorily. It calls for interrogation, and questions arise from both the historical and art historical implications of its production. When we look at this full strain, we note how the foreigners — from Lobelius to Merian, Rumphius, and Linnaeus — either come to the Netherlands themselves or have their work published there, first by Plantin in Antwerp, then by Raphelengius in Leiden, and finally by the great publishers of Amsterdam and The Hague. We ponder the relations between the development of close graphic description (in the early stages in the florilegia by Adriaen Collaert, Jan Theodoor de Bry, Emanuel Sweerts, and the De Passes) and the close attention to objects demanded by fetishizing gardeners and museum founders (consider, in the early stages, the relation between Joris Hoefnagel and Rudolf II).[17] We discern the significance of the bond not simply between mapmaking and description but — most pronouncedly in the beginning — between calligraphy and descriptive illustration, as in the manuscripts of Hoefnagel and Georg Bocskay. And we see the impetus offered by Dutch overseas trade to art, museums, and science. In short, we begin to detect much of what the more regular histories of Dutch art miss in their concentration, on the one

384

hand, on the work of art itself and, on the other, on its looser contexts. And when we survey this particular history, a wrongly other history, we start to discern the larger patterns as well.

Two great decades for the illustration of flora and fauna stand out, from 1647 to 1658 (the decade plus one year marked by the publications resulting from Johan Maurits of Nassau-Siegen's expedition to Brazil), and the *decennium mirabilius* from 1695 to 1705. These years saw the publication not only of the final volumes of the Van Reede tot Drakenstein's *Hortus Malabaricus* but of the book by Jan and Caspar Commelin (uncle and nephew) on the rare plants of the Amsterdam Hortus,[18] of Maria Sibylla Merian's book on Surinamese insects, and of Georg Rumphius's *Amboinsche Rariteitkamer*. This last book showed the contents of the cabinet (but the word is too modest for his collections) of Rumphius, the blind German doctor resident in Amboina (see fig. 9), and is notable above all for its stunning illustrations of crustaceans (see fig. 6), which the illustrations in the author's posthumous *Kruid-Boek* do not approach in quality.[19] If one considers painting alone, the Golden Age may be said to end in 1669; but if one considers art in its better and larger sense, the Golden Age is still at its height at the turn of the century. Natural history flourishes as never before and so does still life. We need no longer be puzzled by — or be obliged to overlook — the abundance of great flower pictures executed well into the eighteenth century. Or should one take a slightly different view in which, almost with the death of Rembrandt, artistic energy may be seen to have drained from painting, only to pass into book production and the illustration of natural history?

The heroes of the story include the figures around Johan Maurits, from Caspar van Baerle to the medical doctors Georg Marcgraf, Willem Piso, and the versatile Johannes de Laet, the last neglected for all but his history of the West Indies Company;[20] they also include Nicolaes Tulp, always in the shadows, Swammerdam, the Commelins, and Rumphius himself. The great heroine is Maria Sibylla Merian, relegated by patriarchal histories to the role of illustrator or only mentioned in passing. Merian stands at the apex of the tradition that I am emphasizing, chronologically and in terms of skill, but as with the lesser figures Gesina ter Borch (whose sketchbooks have only now been published),[21] Judith Leyster (whose tulip books deserve further study), and Rachel Ruysch, the inability to place Merian within the grand progress of art is wholly symptomatic of the patriarchal view. And her case is further bedeviled by the low view of illustration in general

and the dismissal of natural history drawing as a predominantly female activity. Women are omitted from the histories, as are natural histories. Yet no one who has seen the books themselves, or Merian's preparatory drawings made on the purest vellum and preserved in the British Museum and at Windsor Castle (see figs. 1–3), the Leningrad sketchbooks, or even those copies of the book colored under her supervision could doubt her status and the magnitude of her contribution to the recording and classification of the natural world. It is here, not earlier, that description and art finally come together in perfect concord. When it comes to picture making, art historians may argue about the relative claims of description — "reality," say — and art, of faithful recording on the one hand and the pressures of imagination and intellect on the other. In Merian such relativizing anxieties fall by the wayside.

Let us return briefly to the implications of Merian's letter to her readers. It is informed by the same independence of spirit that saw to the publication of her earlier books on insects, led her and her daughter to the loneliness of the sectaries at Castle Waltha at Wieuwerd in Friesland (the place to which Anna Maria Schuurman had also retired and died), enabled her to refuse the repeated and pressing implorations of her husband to return to Nuremberg with him, made her see that her studies in the safe museums of Ruysch and Vincent would be incomplete without a personal visit to the rain forests of America, and compelled her to take the risk of subsidizing the publication of her great book herself (when the Commelins published their volumes on the exotic plants of the Amsterdam Hortus in 1697 and 1701, they received a full subsidy from the city council). Merian rigorously records from life — here too is the ultimate fulfillment of the phrase *naer het leven* — under appalling difficulties but cannot do so without setting herself the highest artistic standards. And whom does she address in this foreword? The powerful museum owners: Witsen, mayor of Amsterdam, director of the East Indies Company, and author of an authoritative book on shipbuilding as well as a treatise on Siberia, a part of the world inaccessible to ships; Witsen's promising but prematurely deceased brother Jonas, secretary of the city; Frederik Ruysch, father of Rachel, doctor, and professor at the Amsterdam Hortus; and finally Levinus Vincent, owner of perhaps the most famous museum at the time. The bond between trade, exoticism, collecting, and the fetishization of objects could hardly be clearer; and the role of art in making the kinds of objects that are traded, transported,

and enshrined in museums available to the eyes of all is spelled out.

The whole nexus between trade, America, art, and the advancement of natural history deserves deeper investigation than it has received so far. At the center of the relationship between the museums of seventeenth-century Holland and pictorial production lies a whole set of problems — economic, psychological, and art historical — pertaining to the fetishization of objects. It is perhaps worth remembering, as R. W. Scheller reminded his readers in a pathfinding article on Rembrandt and the encyclopedic *kunstkamer*, that even some of the greatest picture collections — such as that of Gerard and Jan Reynst — were only part of museums that also contained natural expressions of God's creation alongside objects artificially made or adapted by man.[22] Conversely, many of the greatest *kunstkamers* had very few oil paintings in them, and the works of art they contained were of a kind not today regarded as especially high — pictures made of stones or birds' feathers, for example. When the brothers Reynst wanted a museum, they took over a Venetian collection lock, stock, and barrel;[23] and we may note the irony that their father, one of the founders of the East Indies Company, was governor-general of the East Indies from 1613 until his death in Djakarta two years later. From mid-century on, however, there was no need for such importation. The *naturalia* could come directly from America and to a lesser extent, at least to begin with, from the East Indies. So it was with Rembrandt, with Jan Swammerdam the Elder (whose entomologist son prepared the inventory of his museum), and above all with the great and versatile director of the West Indies Company, Witsen, and the well-traveled virtuoso Vincent.

Before considering some of the further artistic and scientific implications of the Dutch expeditions to the Indies and their relation to cultural production, a few preliminary remarks about the historical precedents may be in order. Central to this history is the work of Charles de L'Ecluse of Arras (Clusius), who was brought from the Imperial Gardens in Vienna in 1593 to head the botanical garden at Leiden and to take up the professorship of botany there. Clusius systematized the more random approaches of the earlier herbalists and was even more determined in his search for exotic specimens and in his careful descriptions of them. It was he, as is well known, who introduced the tulip to England and was responsible for the first growth of the Dutch bulb trade, which led to the rise and fall of speculation in tulips and tulip bulbs.[24] Yet art history has barely risen above superficial

comments on the relationship between the economic weight of tulips and the penchant for depicting them. How little we know about the effects of developments in the classification and taxonomy of such plants on their representation in some of the most materially precious and meticulously crafted pictures of both centuries! What was the substitutional value of such representations, and what was their epistemological significance? These are matters that have yet to be clearly set out.

But first a great deal of basic work remains to be done on Clusius's remarkable and wide-ranging correspondence, which, aside from anything else, offers powerful testimony to his energetic and authoritative search for the rare and the exotic. One consequence of the newer academic divisions between studies of the Netherlands and those of Italy has been the failure to discern the close and unexpected ties that bind the investigators of nature in both countries. Yet just as the gardeners of Amsterdam corresponded with those of Florence from the beginning of the sixteenth century, so the gardeners of Florence and Montpellier learned from Clusius and he from them. The botanists' methods of compiling the visual evidence of nature were interlocked and mutually stimulating. The brilliant Fabio Colonna was greatly encouraged by Clusius, with whom he corresponded; a few years later books such as those on the Farnese Gardens by Pietro Castelli[25] were illustrated in a sophisticated manner that far exceeded the finest garden books of the De Passes or the florilegia of De Bry and Sweerts.[26]

But it is not simply a matter of the connections and comparisons to Italy. Among Clusius's pioneering activities was his work in Hungary where, under the patronage of Baron Balthasar de Bathyány, he hired an artist to paint the mushrooms of Pannonia. These drawings, most of which still survive in Leiden, formed the basis of his late book on the subject.[27] This in turn provided the spur for the greatest mycological endeavors of the first half of the century, those of Federico Cesi and his fellow Linceans, and formed the foundation of modern mycology. It all reminds us how wide the net must be cast.

To speak of Eastern Europe is to recall the role of that extraordinary personality Rudolf II, whose garden in Vienna had been founded by Clusius. His patronage of both art and science and his museology have recently been the subject of exhibitions and scholarly study.[28] But let us not forget that the tradition that bore such fine fruit in the work of Swammerdam and Merian may be said to begin with Hoefnagel, Rudolf II's favorite miniaturist. In a

treatise now almost forgotten, Outger Cluyt describes a scene in which Hoefnagel sits by the banks of the Dijle outside Mechelen, drawing the insects flitting above the river.[29] It is entirely characteristic of the lacunae that I am attempting to address that the source of this charming and important vignette should be the practically unknown Amsterdam doctor Cluyt (Cloet, Clutius), himself the son of one of Clusius's friends and correspondents, Theodorus Cluyt (Dirk Outgersz.), founder of the Botanical Garden in Leiden but not yet a significant figure in the literature. In addition to his entomological studies, the younger Cluyt wrote treatises on the transport of bulbs, on nephrites and other stones, and on the double coconut of the Maldive Islands (with frequent references to the collections of Rudolf II).[30] These count amongst the earliest Dutch works of their kind and are much less thorough than the almost contemporary researches into similar subjects by the Lincei, who knew of Cluyt's work and tried to obtain copies of his writings on nephrites. Cluyt's book on the insect he called a *hemerobion* (the insect observed by Hoefnagel) was dedicated to none other than Nicolaes Tulp, to whom Swammerdam was in turn to dedicate his spectacular anatomy of a testicle and the male genital system some thirty-seven years later[31] — one year before he dedicated his perhaps even more famous engravings of the female genital system to the Royal Society of London. The story of the medical doctors in the development of science and their importance as patrons and encouragers of the arts is a heroic one and has yet to be told in all its fullness.

Once we grasp the extent of the lacunae, we begin to appreciate the merit of the long view. We will continue to see the story of Dutch art as ending around 1670 as long as we continue to overlook the implications of the colonial experience and colonial trade for the study of Dutch art. It is symptomatic of the current state of the field that the only large-scale monographs on Frans Post are inadequate and that with the outstanding exception of Rüdiger Joppien, art historians have barely begun to mine the excellent material brought to the fore by the exhibitions of 1979 on Johan Maurits of Nassau-Siegen, Governor of Brazil between 1636 and 1644.[32] In his establishment of a briefly secure settlement and administration there, in his scientific entourage, and in the extraordinary publications that he sponsored, his importance can hardly be overestimated. His library provides testimony to the range of his interests in art and science. The celebrated and well-con-

nected poet Caspar van Baerle (who had recently written the well-known epigrams on Tulp's anatomy theater in Amsterdam and the splendidly illustrated volume on the entry of Marie de Médicis into Amsterdam, the *Medicea Hospes* of 1638, and who was a long-standing friend of Constantijn Huygens) inaugurated a series of publications hitherto unparalleled in the history of chorographic and scientific literature: the account of Johan Maurits's rule in Brazil, its establishments, battles, and achievements, the *Rerum per Octennium in Brasilia et alibi nuper gestarum, sub praefectura Illustrissimi Comitis Iohannis Mauritii Nassoviae &C. comitis* of 1647.[33]

In this huge volume, one of the most sumptuously illustrated works of the Golden Age, mapmaking and picture making come closer than ever before. But would that the equation were that simple! Further elements must be added. The parallel (rather than equation, perhaps) does not simply hang on the matter of description.[34] The book, illustrated with scenes by Frans Post, consists of two classes of imagery: maps showing the settlements, battles, and campaigns and great foldout prints with views of inland and coastal settlements as well as portrayals of sea battles with the Portuguese. In the maps description is intensely bound up with the conveying of atmosphere and a sense of pastoral idyll (even in scenes of sieges); a good proportion contain finely etched vignettes of the houses, animals, and daily activities of the primitive and youthful denizens of that land. In these vignettes — placed with graceful nonchalance on the side of maps of sieges, troop movements, and beleaguered settlements — pure description yields to invention, the invention of new idylls in that hard land. We see this even on maps such as that of Seregipe, where the vignettes are of tapirs, jaguars, and cacti.

The link between science (in the form of topographic or faunal and floral description) and pastoral idyll emerges even more clearly in the foldouts of interior and coastal scenes. Here topography gives way to pure effect, to vast and airy scenes, arguably the airiest in all Dutch art. Houses and people are even less significant — visually speaking — than in contemporary mainland prints, where skies and large expanses of water were also dominant. We might have expected this watery airiness, it is true, in the scenes of battles at sea, but the enormous four-fold depiction of Johan Maurits's capital, Mauritiopolis, seems *all* sea and air (fig. 4). Descriptive representation of the capital goes by the board, as Frans Post yields to the spell of a spaciousness: a spaciousness that the sea journey itself must have called forth, and then a land a hundredfold larger than Holland itself.

Fig. 4. After Frans Post,
 View of Mauritiopolis, engraving from
 Caspar van Baerle, *Rerum per Octennium in
 Brasilia et alibi nuper gestarum*
 (Amsterdam: Ioannis Blaeu, 1647).
 Santa Monica, The Getty Center for the
 History of Art and the Humanities.

The etcher of several of Post's scenes was Johannes Brosterhuisen, later professor of Greek and botany at Breda. Brosterhuisen, who went on to produce some of the lightest, most delicate, and most finely detailed landscape prints of the seventeenth century, is still too little known. How much truth there is in the report that he worked on his prints at the Amersfoort country estate of that most classical of artists Jacob van Campen — where he also worked on his Dutch translation of Vitruvius — we do not know; but in his biography and personality Brosterhuisen encapsulates just those elements of the pastoral and the scientific, the classical and the descriptive, that seem to be separate in much Dutch art but go together far more often than it is now fashionable to think. It seems futile, when we look at works like Van Baerle's (and, for that matter, Merian's) to insist on too strenuous a distinction between the descriptive and the classical, the realist and the pastoral. If Dutch culture *is* to be endowed with distinctiveness, then it would be best to allow it one of its great graces: the marriage of classical culture with its realist, scientific, and descriptive strain. One has only to remember that the Mauritshuis itself was built by Post's brother, Pieter, according to designs by Van Campen, and that Pieter, the second great classicist architect of the Netherlands, not only did the interior decoration of Johan Maurits's new home in The Hague but was also responsible for the planning and layout of Olinda and Pernambuco in Brazil.

Van Baerle's book was followed less than a year later by a work of signal importance for the natural history and ethnography of South America and thereby for the history of Dutch art, the *Historia Naturalis Brasiliae*. Johan Maurits funded both the research for and publication of this volume. Three men were responsible for its contents: Georg Marcgraf, who came from Germany but studied in Leiden; Johannes de Laet, who edited Marcgraf's contribution and added comments of his own; and Johan Maurits's doctor, Willem Piso.[35] Piso's contribution consisted of four extensive discussions. The first was on the air, water, and topography of Brazil, the second on its endemic diseases, the third on poisons and their remedies, and the fourth on its medicinal plants. Marcgraf, like the artists Post and Albert Eckhout, joined Johan Maurits's personal entourage and was directly paid by him (unlike Piso, who was paid by the West Indies Company); he was responsible for the immensely careful and valuable sections on plants, fishes, birds, quadrupeds, snakes, and insects.[36] Marcgraf's nomenclature was adopted to a substantial degree by Linnaeus in his classification of Brazilian fauna

and has thus passed into modern scientific terminology. To these impor-
tant sections Marcgraf added precise astronomical observations, as well as
short discussions of several of the native tribes of Brazil and Chile and brief
glossaries of two of their languages.

This book represents the first complete natural history of South America,
preceding by just one year the final form of the great Lincean compilation
on the subject, published by the Mascardi firm in Rome, 1649–1651.[37] It is
true that Johannes Faber, the German doctor and close friend of the foun-
der of the Accademia dei Lincei, Federico Cesi (and also of Rubens and
Adam Elsheimer), had published his own section on "Mexican" animals in
1628, and the Linceans had long been working on the subject (and on the
American notes of Phillip II's physician, Francisco Hernandez), often with
the generous practical support of the polymathic Cassiano dal Pozzo; but it
was only with the subvention of the Spanish ambassador that the almost
complete version of the Lincean studies could finally appear.[38] Since the
so-called *Tesoro Messicano* concentrates on natural history, it contains even
less in the way of ethnographic material than the volume subsidized by
Johan Maurits. In fact, it is a tribute to Johan Maurits's artistic and scien-
tific patronage that Marcgraf and Piso's work should have appeared so soon
after the expedition to Brazil and that its illustrations should be so con-
siderably superior to those of the Lincean publication.

No one looking through the many hundreds of pages in the immensely
complex and diffuse Lincean book could fail to be impressed by the num-
ber of illustrations, especially of plants but also of animals — from fish
to snakes, from the much-discussed civets to the toothed and untoothed
Onocrotalus mexicanus. The book as a whole represents a landmark in the
history of visual documentation. But how impressed the remaining Lincei
must have been when they saw the superiority of the illustrations in the
books sponsored by Johan Maurits. It was not just a matter of their greater
attractiveness and refinement but above all their accuracy and detail. The
Lincean images had always to be supplemented by textual modification, as
is abundantly clear from the expansive notes by Nardo Antonio Recchi,
Johannes Faber, Johannes Schreck (Terrentius), and Fabio Colonna. But in
Piso and Marcgraf's history such verbal modification is far less necessary.
Furthermore, not only are the engravings much superior to the admittedly
earlier woodcuts of the *Tesoro Messicano*, in many copies they are colored
with extraordinary exquisiteness and accuracy, just as they were later in

both of Merian's works on insects. The illustrations in the best copies of these Dutch books give the impression of being individual paintings and not colored prints. The coloring was often carried out under the direct supervision of the original authors and artists, or with reference to the original colored drawings, or both. The whole question of hand coloring is one of the neglected topics of art history, and no one who has seen the coloring of the tropical fishes in Marcgraf's section on the subject in the best copies of the *Historia Naturalis Brasiliae* could doubt its potential interest.

One further difference between the illustration of the Lincean work and that of Piso, Marcgraf, and De Laet is the presence in the latter of ethnographic illustrations. (These are to be supplemented by Albert Eckhout's remarkable paintings of Indians now in the Nationalmuseet, Copenhagen.) But they are not simply ethnographic, since several of the illustrations, as with the maps and views of Van Baerle's *Rerum per Octennium*, show the agricultural and industrial activities of the Indians, most notably those relating to the production of sugar and manioc. Thus the reader is alerted to the entrepreneurial basis of the colonial venture as a whole and of the natural historical explorations in particular, just as economic usefulness was later to be a key factor in the plants that Merian chose to show as the environment for her Surinamese insects. That such factors should be largely absent from the illustrations commissioned by the Lincei — unworldly, aristocratic, clerical, sometimes libertine — in a Rome that had no colonial aspirations is not surprising.

Embodied in the lives and activities of the men involved in the production of the Brazilian book are the chief elements in the nexus that binds together medicine and exotica, trade, art, and natural history. Piso, who in 1638 at age twenty-seven joined Johan Maurits in Brazil and remained there for the rest of his governorship, was a protégé of Tulp and became inspector of the Amsterdam Collegium Medicum in 1655. He was probably Joost van den Vondel's personal doctor as well. Marcgraf had come from Germany to study botany, astronomy, and mathematics in Leiden in 1636, where he soon attracted the attention of Johannes de Laet. Marcgraf returned from Brazil in 1644, soon set off for Africa, and died in August of the same year in Luanda before he could bring his Brazilian notes to order for publication. He was thirty-three years old. Fortunately for posterity, however, the notes were edited and supplied with a commentary by De Laet, one of the most important figures in the development of Dutch natural history.

394

De Laet, who until the end of his life identified himself as *Antverpianus*, was a member of the Synod of Dordrecht, a friend of Franciscus Gomarus, and the author of a treatise on Pelagianism published in Harderwijk in 1617.[39] In 1621 he was elected a director of the new West Indies Company. It is in this connection that he is best known, since his *Nieuwe Wereldt ofte Beschryvinge van West Indië* (Leiden, 1625; reprinted in Dutch, 1630; in Latin, 1633; and in French, 1640) and especially his *Historie ofte Jaerlijck Verhael van de Verrichtinghe der Geoctroyeerde West-Indische Compagnie sedert haer begin tot het einde van het jaar 1636* (Leiden, 1644), all published by the Elzeviers, remain the primary sources for the history of the company. But while historians of Dutch overseas expansion — and Dutch historians generally — have used these works, they, like historians of art and natural history, have passed by his work in the field of natural history in almost complete silence. Charles R. Boxer noted the praise bestowed on De Laet's book of 1631 on the empire of the Great Mogul, *De Imperio Magni Mogolis*, but this is only one of a series that De Laet wrote or edited between 1629 and 1642 for the well-known Elzevier "Republics" series. All of these books testify to his skills and range as a geographer. Furthermore, in addition to his extensive work on the *Historia Naturalis Brasiliae* (note that his editing of Marcgraf's notes is described on the title page: *"Joannes de Laet in ordinem digessit & annotationes addit, & varia ab auctore omnia supplevit & illustravit"*), he also engaged in a serious debate with Hugo Grotius about the original inhabitants of Americas, a debate which, as has sometimes been remarked, does not reveal Grotius in the best light.[40] De Laet was well prepared for the Brazilian book both by his professional and commercial involvement in the West Indies and by the work in natural history to which he devoted himself, especially after his retirement from the directorship of the West Indies Company in 1636. He had already published an edition of Pliny's *Natural History* in 1635, as if in preparation for his later work on Marcgraf's texts, while in the same year in which the Brazilian book appeared (1648), he published a mineralogical work and his edition and translation of Theophrastus's book on stones. Both formed an invaluable supplement to Adriaan Tollius's reedition of the book on gems and other geological specimens by Rudolf II's doctor, Anselm Boetius (De Boodt) of Bruges.[41] These endeavors are worthy of being set beside the efforts of the great Lincean students of fossils, Cesi and his devoted friend Francesco Stelluti; but they are altogether more professional. De Laet's work demonstrates the

extraordinary strides made in this area, as in so many others, in the short period since the publication of works such as Cluyt's book of 1627 on nephrites and his later tracts on the double coconut and the *nux medica*.[42]

Finally, De Laet's multifarious output also provides one of the best examples of the reciprocal nourishment of art history and natural history. This we discover not under the sign of realism or descriptiveness alone, but by acknowledging, again, the degree of humanist involvement with the classical past. In Holland such involvement was more direct and less self-conscious than elsewhere, and despite the implications of approaches such as Svetlana Alpers's *The Art of Describing*, it remains a fundamental element of seventeenth-century Dutch society. To oppose intellectualism and realism is to miss the boat, to have to ignore not only the chief affections of Constantijn Huygens, but also to overlook the fact that De Laet could move with such ease — and with such evident enthusiasm — from natural history to classicism or, rather, from theology to commerce to natural history to classicism. In the last year of his life, De Laet's attractive and useful edition of Vitruvius was published with its notes assembled from Daniele Barbaro, Guillaume Philander, and Claude Saumaise, its long extracts from Pomponius Gauricus on sculpture, its edition of Leon Battista Alberti's *De Pictura*, and (prefacing the whole book) a Latin translation of none other than Sir Henry Wotton's *Elements of Architecture*.[43] It is as well to remember that this is twelve years after Amsterdam saw the first publication — in Latin — of Franciscus Junius's *De Pictura Veterum*. And it is clear from Dal Pozzo's all too little studied *Memoriale* of the late 1640s (and from his unpublished correspondence) that the Vitruvius was eagerly awaited in Rome and that De Laet kept abreast of all the latest classical discoveries in that city.

But let us return to the Indies and to art in the service of natural history more generally. In 1658 a new version of the *Historia Naturalis Brasiliae* appeared in the form of fourteen books on the natural and medical history of both the Indies, the *De Indiae utriusque re naturali et medica libri quatuordecim*. This time Piso's name — and his exclusively — appears on a title page which is not much changed, in visual terms, from the earlier one.[44] But his contribution is less easy to define and has been the subject of some debate. While his own medical observations and researches as they appeared in the 1648 book are here only slightly revised and modified, Piso now ascribes to himself the work on the flora and fauna that had earlier rightly been credited to Marcgraf. It is true that Piso adapted and supple-

mented Marcgraf's text, but the scientific observations and conclusions are basically the latter's; so too are the illustrations (for example, fig. 7). The puzzle, however, cannot be resolved here. In the new book Marcgraf is only fully credited with the authorship of the topographical and meteorological treatise — with its excellent observations on solar eclipses — and with a report on the Brazilian and Chilean natives. Key additions to the work as a whole are the extensive medical discussions of the doctor of Batavia, Willem Bontius, son of Professor Gerard Bontius and a 1614 graduate in medicine from Leiden. To Bontius we also owe the important description of the animals and plants of the East Indies (*"quibus sparsim inseruit G. Piso annotationes & additiones"*!). It is not surprising to discover that Bontius's section on the "medical methods to be used in the East Indies for the purpose of curing the endemic and everyday diseases there" should simply be dedicated to the body of directors of the East Indies Company. His excellent section on animals and the commentaries edited by Piso also deserve more attention.[45]

By the time that Piso's book appeared, the Brazilian adventure had failed, and the main stimulus and encouragement to publish on the East Indian and South African settlements came from Amsterdam itself. The Amsterdam Hortus was set up in 1682, and its directors, Jan and Caspar Commelin, were responsible for or assisted in the chief publications in this area for the rest of the century. It could be argued that they and their garden played a role in the development of the study of exotic plants similar to that which Clusius and his Leiden garden had played a century before. Although the Leiden professor of botany Arnoldus Syen had provided the notes and commentary to the first volume of Van Reede tot Drakenstein's epic work, the *Hortus Malabaricus*,[46] this task and that of editing the illustrations by native artists and the text by the Cochin minister Johannes Casearius fell to the Commelins for all subsequent volumes from 1679 to 1703. By the time Jan Commelin had begun to work closely on the project of the extraordinarily dynamic and widely traveled former governor of Malabar, he had already published a remarkable book on citrus fruit entitled *De Nederlantze Hesperides*.[47] This was a kind of Dutch version of the work on the subject by the Jesuit priest Giovanni Battista Ferrari, to which it was heavily indebted in terms of both text and illustrations.[48]

Oranges in the Netherlands! Here is a subject to conjure with. It is worth reflecting both on the growth of private gardens in the Netherlands and on

the role of citrus cultivation and orangeries in them. Citrus fruit in still lifes (lemons above all) may have all manner of symbolic significance, but only when we consider the range of the contents of books like Commelin's and Ferrari's[49] with their excellent discussions of the origins and uses of oranges and lemons — their medicinal purposes, their uses as cures, perfumes, pastilles, the basis for sherberts, and so on — that we begin to grasp the cultural freight of the presence of citrus fruit in pictures: the more exotic the better. They become food for the eyes, even when wormed or wilted. At the same time, as with the most exotic of the plants, it is worth observing the comparative absence in the pictures of oranges, granadillas, and tiger lilies. The Netherlands would never produce a Bartolomeo Bimbi.

But Commelin had more important work to do. His treatise on citrus fruit simply marks the first flowering of an interest in exotic plants that was soon to find much fuller expression. For the rest of his life he devoted his energies to the garden under his care and to the culminating botanical projects of the century: the description and representation of the exotic and rare plants of the Amsterdam Hortus[50] and the continuation of the work on Van Reede tot Drakenstein's *Hortus Malabaricus*.[51] Commelin was not to see the completion of either project. It was left to Frederik Ruysch to translate the first volume of the *Rariorum Plantarum Horti Medici Amstelodamensis* into Latin and to edit it properly, while Commelin's nephew Caspar (an encourager of Merian's who provided the Surinamese book with botanical notes) put together the second volume and (with Abraham van Poot) saw the *Hortus Malabaricus* through its final stages.

The volumes on the Amsterdam garden, as has been noted, were published at the expense of the Amsterdam Town Council. Their dedications are to the great magnates and patrons of the garden, among them Witsen, Johan Hudde, Cornelis Valkenier, and Dirk Bas in volume one and Hudde, Jan Corver, Francois de Vicq, Theodoor Munter, Franciscus de Vroede, Johan Huydecoper, and Gerbrand Pancras in volume two (the last three men were also curators of the garden and responsible for the publication of the first volume). The volumes are the summation of the knowledge of plants assembled in countless trips to the Indies. The second volume also contains a proportionately large number of African plants, mostly sent from the Cape by governors Simon van der Stel and his son Willem Adriaen. The rich floral kingdom of the Cape seems, initially at least, to have stimulated rather less research and publication than the flora of the Indies (although

Fig. 5. Hendrik Adriaan van Reede tot Drakenstein,
*Hortus Indicus Malabaricus, continens Regni
Malabarici apud Indos celeberrimi omnis
generis plantas rariores* (Amsterdam,
1673–1703), vol. 10 (1690), pl. 50.
Photo: Courtesy History and Special
Collections Division, Louise M. Darling
Biomedical Library, University of California,
Los Angeles.

399

this may have had much to do with the fact that the serious recording of American plants had gone on for almost a century longer than that of Southern African plants). Once again, many of the copies of the volumes on the Amsterdam garden were beautifully colored with the meticulously accurate watercolors made richer and more permanent by the addition of varnish. The engravings themselves were the work of Johan and Maria Moninckx. To possess such volumes was to combine the preciousness of painting and the rarity of the *kunstkamer*, with a substantial addition to scientific knowledge, in the form of one of the prouder achievements of the capitalist enterprises in the Indies.

The plates of the *Hortus Malabaricus* are even larger, more ambitious, and more useful taxonomically than those in the Amsterdam book. They are almost all life-size, as the title page proudly notes, and by the best native artists, *"naturali magnitudine a peritissimis pictoribus delineatas, & ad vivum exhibitas."* The marriage of art and science is perfectly consummated, and the old tensions between precision and fantasy are resolved. The former governor of Malabar thus celebrated his long, brave, and prosperous years in the uppermost echelons of the company's servants in a publication of a local flora that was never again to be equaled in sumptuousness or in careful and minute visual detail and specification. And the great double-page plates are inscribed with the names of plants, first in a Latin version of their local form and then in Arabic and Malayalam (fig. 5).

The twelfth and final volume of the *Hortus Malabaricus*, dated 1703, came two years after the second volume of the *Hortus Amstelodamensis*. If botanical illustration could reach no greater heights of skill or ambition, at least two other areas of natural history remained where the summit of illustration had yet to be achieved. But this was reached swiftly enough, just two years later in 1705. That year saw the publication not only of Merian's book on Surinamese insects but also the appearance of Rumphius's *Amboinsche Rariteitkamer*. If Merian's plates represent the pinnacle of entomological illustration (figs. 1–3), equal to the finest insects in oil of Jan Bruegel or Jan van Kessel or to any of the worms that spoil the fruit and flowers and the butterflies that hover above them in the great still lifes of the century, then the lobsters of Jan Davidsz. de Heem, Willem Kalf, and Abraham van Beijeren find their scientific equivalents in the illustrations of the specimens in Rumphius's museum. It is impossible to imagine finer or grander illustrations of crustaceans than those by Jan Lamsveld and J. van Buisen

Fig. 6. Georg Eberhard Rumphius,
De Amboinsche Rariteitkamer
(Amsterdam, 1705), fol. 10.
Photo: Courtesy History and Special
Collections Division, Louise M. Darling
Biomedical Library, University of California,
Los Angeles.

Fig. 7. Willem Piso [et al.],
De Indiae utriusque re naturali et medica
(Amsterdam, 1658), fol. 77.
Photo: Courtesy History and Special
Collections Division, Louise M. Darling
Biomedical Library, University of California,
Los Angeles.

Fig. 8. Georg Eberhard Rumphius,
De Amboinsche Rariteitkamer
(Amsterdam, 1705), fol. 32.
Photo: Courtesy History and Special
Collections Division, Louise M. Darling
Biomedical Library, University of California,
Los Angeles.

in the *Amboinsche Rariteitkamer* (fig. 6), even though Marcgraf's example might have seemed hard to match (fig. 7).

The prints of sponges, fossils, and shells that follow the crustaceans are not as striking (fig. 8), but the shells mark an important juncture in the long history of conchology in the Netherlands. This is not a subject to dwell on at any length here, but of all the tokens of the Indies that could be acquired by the owners of *kunstkamers* or represented in art, shells were perhaps the easiest to come by and to preserve adequately. When we search for the place of the exotic in Dutch culture, shells play one of the earliest roles in still lifes, in shell studies (most famously in Rembrandt's etching of a single *Conus marmoreus*), and in portraits of their owners. In considering Rumphius, it is as well to record Goltzius's famous portrait of Jan Govertsen of 1603, or Jacques de Gheyn's picture of *Neptune and Amphitrite* in Cologne (to say nothing of his obsession with them in many of his graphic works), or the paintings by Jan Davidsz. de Heem, Adriaen Coorte, Jacques Linard, and many others with shells from the Caribbean, the Pacific, and Indonesia; and, finally, to think forward to the other end of the tradition, the conchological clubs that flourished in the eighteenth century. None of these matters have gone unremarked, and the whole still life tradition has been finely discussed by Sam Segal, most recently and notably in his catalog for the exhibition of the sumptuous still life (which he termed the *pronk* still life).[52] But there are issues that remain, and Rumphius's work and his collection bring them to the fore.

It is all very well to interpret the shells in pictures as *vanitas* symbols or to see in them the visible evidence of the glory and intricacy of God's creation: but for every Philibert van Borsselen walking along the local beach and picking up shells or describing the shell collection of his brother-in-law with such thoughts in mind,[53] there is a Cluyt, De Laet, or Rumphius, not on some beach in Zeeland but in a remote castle in Amboina. God the technologist swiftly recedes from their works to give way to man the all-resourceful investigator. Shells may be a miraculous testimony to God as the supreme technologist of nature, but in the years between Goltzius's portrait of Govertsen and the poem by Van Borsselen, the supposedly Dutch invention of the microscope was being absorbed by Galileo and by the Lincei around him, to be used in the analysis of bees and other insects by the beginning of the next decade. With the development of the microscope, God the great artificer gives way to man the great investigator for whom no mystery

is too dark or too impenetrable, no phenomenon of nature beyond his cool analytic reach. With the microscope the eye acquired new and unheard-of powers. Nothing in nature remained beyond the capabilities of visual reproduction. It is no surprise that in the years of the first flowering of Dutch still life, the Lincei should have set out to document the whole of nature by reproducing its every aspect, and by employing artists to do so. By the time Rumphius had the contents of his museum reproduced on paper, man the artist was capable of reproducing nature as perfectly and as artistically as God made the originals.

To the objects, then, themselves. They are not just or only the tokens of the divine Other. They are much more than that, whether in still life or any other form of Dutch picture making. They are tokens of real and material value. They are of this world — the more exotic, the more precious; the more beautiful, the more precious. We linger over them with our eyes because we need to use them, handle them, and exchange them for other rarer, stranger, and more valuable objects. They are realistic precisely because they are of this earth; they cannot be too much of the spirit, since they would then neither be amenable to investigation and analysis nor capable of verification. If the all-powerful eye cannot see them, then they must be handled. Touch too becomes a criterion for representation. The more real, the better — but real because one cannot fetishize what is only present to the mind.

Caecus habens oculos tam gnavae mentis acutos,
Ut nemo melius detegat aut videat:
RUMPHIUS hic vultu est Germanus origine, totus
Belga fide et calamo: caetera dicit opus.

Thus runs the inscription beneath P. A. Rumphius's portrait of his father, the Pliny of the Indies (fig. 9), "Though blind, the sharp eyes of his vigorous mind see and uncover things better than anyone else. Rumphius may be German by origin, but in faith and in his writings he is wholly Dutch. The work tells all the rest."

The importance of this inscription is twofold. First, it makes clear the Dutchness of the German-born doctor's inspiration, commitment, and contribution; second, it emphasizes that despite his blindness, Rumphius sees — and discovers — better than anyone. And he does so, as the print so

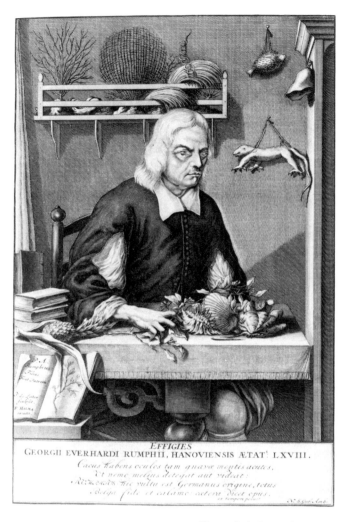

Fig. 9. J. de Later after P. A. Rumphius,
Portrait of Georg Eberhard Rumphius in
Georg Eberhard Rumphius, *De Amboinsche
Rariteitkamer* (Amsterdam, 1705),
frontispiece, 21 x 34 cm.
London, British Museum.

plainly shows, with his hands. He clutches at, and thereby discovers, the rare plants and shells on the table before him. The manual component of blind Rumphius's insight thus stands for the physical and sensual impulse that accompanies all looking.

The conference that gave rise to this paper and the others in this volume was based on the view that the twin disciplines of history and art history might fruitfully illuminate each other. This view was not novel, but it seemed time to take stock of the *potential* of history for art history and vice versa. Recognition of the mutually beneficial possibilities of the two fields has almost always been a basic assumption of art history (except, perhaps, in those areas involving the purer forms of connoisseurship and the more rarefied regions of formalism and style criticism). History, on the whole, has been rather slower to see the value of art historical methods and procedures, despite an increasing use of visual evidence by some historians. But in recent years the situation has changed considerably in both disciplines.

It could be argued that for art historians to say anything at all about a work of art, they have, to a greater or lesser degree, to act as historians, as Gary Schwartz may seem to suggest in his essay in this volume; and there have been few art historians, in the Dutch field in particular, who have not exercised more or less traditional historical skills in pursuit of their subjects. Recently, however, it has become fashionable in all fields of art history to claim that art historians have not been historical *enough* and that the social history of art, or the new art history, as it has come popularly to be known, should replace the older varieties. Although the use of social history to provide a context for works of art in the hope of illuminating them more directly is among the oldest procedures of art history, the proclamations of novelty are loud. But the raison d'être of the whole enterprise is forgotten. A significant and revealing shortcoming of the new social history of art is that while context is often richly provided, the work remains somehow isolated from that context, with its peculiarity and individuality as a work of art unilluminated. This is the chief burden of J. W. Smit's essay in this volume. Certainly, one of the great projects for the history of art remains the adequate integration of art as cultural production into the society that gives rise to it. The will has been there for some time, but the results have been meager. It would be difficult to claim any significant methodological

breakthrough in this area since Max Dvorak, and he is rightly no longer a model to be followed closely.

In history the situation is different. Many historians, especially in recent years, have turned to the evidence of pictures and prints; and increasing numbers of historical monographs are illustrated by works of art and by more everyday forms of representation. But an old allegation often made by art historians still holds. It is that the way historians use visual material does not go much further than the rather simplistic illustration of argument, and the pictures themselves play no role at all. Historians, so the allegations run, lack the art historian's skills in distinguishing genres, in iconographic interpretation, in correctly assessing internal histories of style and other internal pressures on the genesis of works of art, and so on. It is true that gross errors continue to be made, as in the case — to turn to the Netherlands specifically — of the frequent use of inappropriate visual material from the Southern Netherlands to illustrate works and arguments about the United Provinces. A glittering exception, of course, is Simon Schama's *The Embarrassment of Riches*.[54] Here a knowledge not only of the images themselves but of the most recent art historical developments results in a brilliant integration of art history with history, in which images play a crucial role in the unfolding of both the historical arguments and the ethnographical set pieces. No historian has yet devoted such full attention to the methods and findings of art history nor shown so deep an understanding of them.

If Schama uses art history for the benefit of history, the work of John Michael Montias provides the chief example of the way in which historical and economic research may enrich art history. His archival studies of Vermeer[55] and his more recent analyses of inventories, as exemplified by the essay in this volume, point to large areas of research yet to be exploited by those many scholars concerned with the place of works of art in seventeenth- and eighteenth-century Dutch society. Research of the kind undertaken by the economic historians writing in this volume gives art historians far more precise economic and statistical contexts than those with which they are accustomed to work. Heretofore, it has only been possible to make intuitive and sometimes gross generalizations about such contexts, often at considerable cost to chronological and iconographic accuracy. Richard W. Unger and Willem A. Brandenburg, on the other hand, provide taxonomic data normally passed over or left roughly grained by art historians. Their

data, just as the statistical material provided by Jan de Vries and Ad van der Woude, are of a kind that bears directly on the objects of art historical research but that could not have been generated by art historical methods. Such information arises from methods and skills peculiar to special areas of historical investigation. Here, then, is an excellent case where one discipline (art history) may benefit from another (whether economic, agricultural, or naval history) but where in the end — even with the work of Montias — there is little real integration of disciplines. The methods and findings of one discipline are simply brought to bear on the objects of another. Schama's project is fundamentally more ambitious, but while it provides inspiration for all those who would integrate the disciplines, it offers no real model, since its success depends on expository brilliance rather than on integrative method. And its ethnography, in all its picturesqueness, is unrepeatable.

What is called for is a much more closely interactive endeavor in which it becomes impossible to declare "here I act as a historian" and "here I act as an art historian." The disciplines, having taken from the best of each other, must look forward to becoming more wholly integrated. In this respect one might be inclined to argue — against the position set out by Jan de Vries in his introduction — that art historians in general have learned more from historians. Yet anyone who looks at the field of Dutch art history now would be hard put to claim even this with great conviction, despite the progress of recent years.

Let us consider five areas of research. With those studies that fall into the category of what its practitioners call the "new social history of art," rich contexts are provided, but the work itself often remains strangely unilluminated. A fine web is spun, the work of art is more precisely located, yet it remains incidental to the analysis. The work becomes a pretext for more or less random clusters of information relating to its production and consumption. While no one would deny that before T. J. Clark's recent impetus to the old social-historical modes best exemplified by Frederick Antal, art historians were too inattentive to modes of production and consumption and to the determining role of social structures and fundamental socioeconomic pressures, the majority of the new studies are rather hit-and-miss affairs. They do not have the courage of their convictions. They lack the rigor that would be provided by a strict Marxian or Gramscian view of the relations between base and superstructure or by more schematic Althusserian models

of the relations between works of art and ideological state apparatuses. Nor do they explore the potential of a strict working out of the kinds of inferential modes suggested by Michael Baxandall.[56] Indeed, considerably greater progress could be made by clearly recognizing the particular requirements of art history and the skills that it entails, without necessarily espousing its soft and retardataire forms. Too often the practitioners of the new art history attempt to do what straightforward historians do better and are better trained to do, and they forget that their training as analysts of art and of visual culture enables them to go beyond the provision of a context that either fitfully illuminates the work or is largely irrelevant to it. Take only one example from the Dutch field: how much might have been built on the now comparatively old work of Konrad Renger on peasant representation (for all its orientation toward symbolic readings) or the more recent work of students like Hans-Joachim Raupp![57] But even if one were to claim that there is no preordained reason why the primary aim of the art historian should be to illuminate the work of art, the efforts of most current social historians of art leave readers with the feeling that the work itself plays no role in the analysis and illumination of context. In the dialectics of the new art history, the work is rendered doubly passive. It neither casts light nor has much light cast upon it. It stands some distance away from a vague target peppered with whatever buckshot happens to be available. The work does not even suffer, because it is absent.

The second recent development has been the revivification (and perhaps apotheosis) of connoisseurship in the Rembrandt Research Project. Here the old forms and principles of connoisseurship meet new scientific techniques; but while the project's value in refining the Rembrandt corpus is great, it is so unremittingly positivist that it needs no further discussion in the present interdisciplinary arena.

The great iconographic studies of E. de Jongh[58] have provided the basis for one of the most richly worked areas in the field, but one that has also turned out, a little surprisingly, to be perhaps the most rawly positivist, clinging to texts and seeking direct equivalents between word and image or between emblem and oil painting. Large numbers of iconographic investigations turned out to be little more than the seeking of literary equivalents — moralizing, spiritual, didactic — for pictures or parts of pictures. A number of cautionary articles have appeared, including those by Peter Hecht (urging common sense), Jan Baptist Bedaux (applying severe but salutary

strictures on excessive interpretative specificity), and Jochen Becker (in the present volume). But none of these has managed to arrest the positivist flow.[59] The high-water mark of the narrow lexicographic approach to the supposedly disguised symbolism of Dutch pictures was the introductory essay by Josua Bruyn in the catalog of the Dutch Landscape exhibition held in Boston and Amsterdam in 1986–1987.[60] Since there has already been a certain amount of auto-critique of the excessive or inappropriate use of emblems in the interpretation of pictures, since Eric J. Sluijter's piece in the present volume provides a magisterial overview and criticism of developments in this subfield,[61] and since the subfield as a whole is reasonably well represented and subject to critique in this volume, it does not need further analysis here. And while it represents an area in which the disciplines of art history and literature come together, it is also one in which more purely historical concerns and principles have often been strangely absent — often to the detriment of the particular arguments. One of the more regrettable methodological developments in the field has been the uncritical and anachronistic use of texts to illuminate pictures that were produced long before the texts themselves, such as the use of seventeenth-century texts and emblems to illustrate sixteenth-century pictures, or late seventeenth-, or even eighteenth-century texts for early seventeenth-century pictures.

A fourth field in which one might have expected history and art history most logically to come together is that of political representation (whether in painting, sculpture, or prints) in both senses: representations with political subjects and representation for overtly political purposes. Propaganda in sixteenth- and seventeenth-century Dutch art has been comparatively little studied, and the challenge of Henri van de Waal's monumental *Drie eeuwen vaderlandsche geschieduitbeelding, 1500–1800*, and of Katherine Fremantle's book on the Amsterdam Town Hall, both published over thirty years ago, has largely gone unmet.[62] Aside from the important work of Albert Blankert on the Amsterdam Town Hall and the revealing exhibition *Gods, Saints, and Heroes* (the title conveys rather more than the slightly cryptic Dutch version *God en de goden*),[63] little progress has been made. Recent recognition of the potential of this area is provided by Elisabeth Onians-de Bièvre's study of Dutch town halls and Perry Chapman's work on Philips Angel.[64] Alison McNeil Kettering's book on the Dutch Arcadia[65] has an important analysis of the complex interrelation between pastoral

and power, a relationship so much studied, for example, with regard to Britain in the seventeenth century.

The fifth field was pioneered by Alpers in *The Art of Describing*. Here, the author threw down an epistemological gauntlet to Dutch art history as a whole. Readers will have recognized the ways in which many of the remarks in this essay have been influenced by Alpers's book. In the face of a fast-growing tendency to hunt for the disguised symbolism of pictures, Alpers insisted on the importance in Dutch art of observation and description. While some scholars object to the stridency of her assault on the practitioners of an iconography too closely tied to the emblem books, her strictures on symbolism in the narrow iconographic sense developed by Panofsky were timely, and it is as a result of her work that the lines of debate between the iconographers and those who hold that the claims of description are greater than those of symbolism are now clearly drawn. But to its own detriment the mainstream in the field has failed to take full cognizance of the implications of her dense and often difficult arguments and has opted instead for varieties of the new positivism to which I have already alluded.

In the first part of this essay I pointed to the visual and artistic material produced as a direct result of the activities of the two great companies of the Indies. I did so not simply because this large body of material has been so neglected by historians of art or because it stands so clearly on the borders of a large number of disciplines — history, economics, natural history, art history, even psychology. I did so because it obliges the student to gauge the relations between description and art, to consider the links between artistic and scientific activity, and to assess the place of the representation of nature and mapmaking in the larger context of Dutch image making and art. All these issues are writ large in Alpers, even though she chooses to pass over the natural historical material discussed here in an explicitly cursory way. But there can be no doubt of the potential fruitfulness of her insistence not only on the role of this-worldly descriptiveness over other-worldly symbol and allegory but also on the relations between seventeenth-century Dutch science and art and on the parallels, in the descriptive treatment of surface, with mapmaking.

But Alpers seems to have pushed this last analogy too far, and in emphasizing the importance of the practical and scientific modes as constitutive

of Dutch art in general, she grossly overlooked the role of other modes, most notably the classical and pastoral traditions, usually but not always intertwined in Dutch culture. The traditions merge with the scientific, this-worldly, practical, and descriptive in works such as the *Historia Naturalis Brasiliae* and in the books by De Laet. There is no place in Alpers's account for the evidence offered by a figure like Anthonie Thysius, who in the fore-word to his edition of Guillaume Postel's treatise on the government of the Greeks (published just one year after Thysius himself delivered the gratu-latory oration on the return of Johan Maurits from Brazil) waxes lyrical on the outdoor delights of his cousin's estate. As the cousins wander through the garden comparing Greek and Roman legal systems, they cannot restrain themselves from praising its sylvan pleasures. The garden may have antique statues in it, but the ponds bursting to capacity with fish catch Thysius's eye and call forth his lyrical pen, as do the fountains, the portico with its rustications, the view toward the wide meadows beyond it, the gardens, the trees groaning with fruit (*"arbores sub ponderibus fructuum gementes"*), the maze of cherry trees, the tulips and other flowers, the hills that fend off the inclement winds, and, finally, the nearby sea with the boats bobbing up and down.[66] *This* is the context that Thysius provides for his conversation about ancient administration, bureaucracy, and law, and it is one, yet again, in which the works of man give way to the gentler amenities of nature, how-ever tamed they may be — and however cliché-ridden the description. In a paper devoted to sketching interdisciplinary prospects, it is hard not to reflect on the way in which the most fruitful recent developments in gar-den history have been almost entirely ignored by historians of art.

Such are the difficulties that arise from the pursuit of a chimera — the essential nature of Dutch art — and from the need to establish something called realism as constitutive of Dutch art as a whole. The real shortcoming of *The Art of Describing* lies in the too-strenuous efforts in this direction and the consequent neglect of the importance of the *Italian* observational and descriptive traditions in the very years of the first burgeoning in Holland of an art that might be called realistic. Aside from the great sixteenth-century tradition of natural illustration in Italy — as can be seen in the work of men like Jacopo Ligozzi, Gherardo Cibo, and Fabio Colonna (all without equal in the North) — the illustrations in works such as Pietro Castelli's description of 1625 of the Farnese Gardens in Rome (written under the name of the Farnese gardener Tobia Aldini) and Giovanni Battista Ferrari's *De*

Florum Cultura of 1633 are at least as refined, sophisticated, and accurate as those in the contemporary Dutch and Flemish florilegia. They are also more valuable in accurately conveying useful botanical information for the purposes of analysis, classification, and taxonomy. Scientific and analytic descriptiveness come together with art at least as powerfully, for example, in the extraordinary body of material produced on behalf of the apparently conflicting claims of those who were first supposed to have cultivated the passion fruit in Italy; and considered in the light of the great illustrations and broadsheets that arose from this controversy in the 1620s, the work of the Dutch florists seems either too fussy or too visually evasive at the crucial analytic places. The illustrations in the works of someone like Cluyt appear amateurish beside even the most amateur of the illustrated works published by the Lincei around Galileo.

None of the early Dutch attempts at scientific description can match the marvelous prints showing microscopic studies of bees by Cesi and Stelluti; while their sense of excitement in the use of the new instrument is well conveyed by the accompanying texts and tables. It is worth remembering that Stelluti's pioneering illustrations of bees and wasps under the microscope were published in his edition and translation of the difficult poems of Persius. In this work too, which issued from the Mascardi presses in Rome in 1631, the classical was made vernacular and pressed into the service of furthering both literature and the practical advance of science. These first efforts with the microscope were made, as is well known, in the immediate wake of Galileo's development and use of the telescope. No one who reads the scientific literature of the second and third decades of the seventeenth century can escape the sense of excitement that accompanied the first great utilization of an instrument that arose from Dutch discoveries in the use of lenses for magnification but was perfected by Galileo. It was he, after all, who first recognized and publicized the cosmological significance of the close observation enabled by the telescope; and his contemporaries, especially Cesi and his fellow Lincei (the lynxes, those keen-witted and sharp-eyed animals who served as the emblem of the first modern scientific academy), immediately saw the profound significance of his discoveries for the exploration of the world of natural things. It is not surprising that the Lincei should have produced the first great body of visual recordings of nature — often commissioned from reputable artists — and that it was Dal Pozzo, antiquarian and scientist, who saved them for posterity.[67]

Which brings one back, once again, to South America and to the Indies in general. Just as the great compilations made and assembled by the Spanish doctor of the Indies Francisco Hernandez in the course of his expedition to America between 1571 and 1577 provided renewed stimulus to the Lincean studies from 1625 on, so too the course of Dutch picturing was changed by the findings and publications that arose from Maurits's governorship of Brazil and his sponsorship of the medical and naturalist researches of both his and the West Indies Company's employees there. From this time on, and especially after the publication of the two books on the natural history of Brazil in 1648 and 1658, the Dutch far outstripped all other nations of Europe — and certainly Italy — in the artistic and scientific value of their illustrations of nature. How vastly superior, how much more scientifically useful, how much more closely descriptive are the fine engravings in the *Historia Naturalis Brasiliae* than the rough woodcuts in the *Rerum Medicarum Novae Hispaniae Thesaurus*. There could be no clearer indication of the great strides made by Dutch art and science than the difference between the books produced by Cluyt on the one hand and Marcgraf and Piso on the other. All, let it not be forgotten, were medical doctors.

For all this, however, and for all Alpers's neglect of the Italian observational and descriptive tradition, there is little doubt that this tradition hardly entered mainstream picture making in Italy as it did in the Netherlands. The great merit of *The Art of Describing* is to have raised the appropriate epistemological issues to account for such distinctions — for the issues are indeed epistemological.

One would have thought, after Foucault, that the meanings of representation would have been more deeply scrutinized when it comes to Dutch pictures. Alpers made a beginning, it is true, with an inquiry almost negligently shirked by others, but we still need to know more about the *kinds* of knowledge embodied in Dutch pictures, prints, and book illustrations. We need to be clearer about the value — both use value and exchange value — that they *and what is represented in them* entail. Artistic criteria enter into consideration here, but so do the pressures, exigencies, and requirements of scientific investigation. So too does the status of objects within the trade economy, both local and international. All this, in turn, imposes a further task. It is all very well to insist on the importance of considering the full range of Dutch visual culture, but what remains to be identified is the relationship that

may or not exist between particular kinds of knowledge on the one hand and individual representational genres on the other. We need to move toward a closer determination of the degree to which a genre may be more fitted to the embodiment of one form of knowledge than another. The pressures may be epistemological, or social and economic, or a combination of these factors; yet we are far from possessing the necessary data to identify them adequately. The practical requirement is simply one of further research into the kinds of areas I have suggested here. The theoretical issues have to do both with the general shape of knowledge and with particular knowledge, as well as with the relationship of such knowledge to representation.

One thing, however, should be made clear. In speaking of the freight of pictures and of the objects they show, I do not speak only of their cultural baggage or even of *how* they are fraught culturally. This is precisely the form of information that may be obtained from a writer like Schama, however selective or random such information may be alleged to be. The information may also seem to be embodied in emblems, but we cannot put the evidence of emblems to full and appropriate use until we know better how to locate allegorical knowledge on the epistemological map. The difficulties are clear, the investigative requirements plain. And the questions that arise are ones that art historians may most fittingly address, rather than the kinds of tasks (chiefly social and historical) that under the pressure of fashion they have usurped from regular historians. It is precisely in the area of the relationship between epistemology and visual representation that the art historian has a distinctive contribution to make. Here is at least one area where the skepticism about the art historian's taste expressed by Jan de Vries in his introduction to this volume is unjustified.

But, as De Vries also noted, it is clear that the barriers between disciplines must still come down — not that one field should usurp another but that each may benefit from the findings of the other. For example, only by considering the status of objects within the overseas trade may we begin to assess their status within representation in the Netherlands. The status of objects at home, after all, is directly affected by the perception and value of objects from abroad. If we cannot yet arrive at an adequate psychological theory of the fetishization of objects or — even more complexly — of the fetishization of representational forms, we can at least begin to examine the turning of exotic and imported objects into fetishes or into things bound to be fetishized.

415

In the Netherlands we see perhaps more clearly than anywhere else the connections between fetishism and exoticism on the one hand and trade and finance and investment in art on the other — investment in art and investment in the broader sense. Every European *kunstkamer* contained objects from the East (they were of its essence, its sine qua non), but in seventeenth-century Holland the *kunstkamer* was rooted in the commercial world of the two companies of the Indies. Once we consider this commerce (and I have shirked the task of detailing it here; this must remain for the historians), we may begin to consider its importance for science and for representation — whether descriptive, analytic, allegorical, or narrowly subject to the rules of art and intellect. It will never be possible to capture the excitement of the Dutch discovery of the Indies again or of the flora and fauna brought back from there. But if we start with the kinds of books and events that I have described, we might at least focus on an area where the meeting of academic disciplines may for once unequivocally clarify the status of an area of cultural productivity.

The aim of this essay has been simple. I have attempted to assess the potential of certain kinds of natural historical research — chiefly botanical, entomological, and zoological — for the interdisciplinary study of history and art history. I have not taken explicit account of a number of works, often as ambitious as the ones discussed here, that also grew out of the overseas experience of the Dutch Republic but are of less interest for the development of natural history. Thus I have omitted books such as those written or edited in the second half of the seventeenth century by Olfert Dapper on north and south Africa, the Indies, Iran, China, and so forth, and eighteenth-century projects such as François Valentijn's huge *Oud en Nieuwe Indien* published in Dordrecht in 1724–1746. Not every illustrated work on natural history that appeared in the most fruitful periods has been discussed here, and only tacit account has been taken of works that emerged as a result of travel to places like Japan.[68] The whole field of cartography, obviously relevant to many of the issues raised in this paper, has of necessity been alluded to only briefly. But the potential interest of *all* such works for those exploring these still unmarked borders will be plain.

Along with the shells, sponges, minerals, the lions' hides, costumes, and boxes from the Indies, and the seventy-three weapons from such places that Rembrandt kept in his *kunstkamer*, he also had a bird of paradise, which he

Fig. 10. Rembrandt Harmensz. van Rijn,
Two Studies of a Bird of Paradise, ca. 1640,
pen and ink, heightened with white, on
paper, 181 x 154 cm.
Photo: Courtesy Giraudon/Art Resource,
N. Y., no. 14191.

kept in a drawer together with six fans. Johannes Faber, the friend of Cesi, Rubens, and Elsheimer, reproduced a drawing of the bird of paradise in his *Animalia Mexicana*, and related birds appear in the *Historia Naturalis Brasiliae*. In each case the animal is presented in all its parts, ready for study, analysis, description, and classification. Yet Rembrandt's own drawing,[69] taken from a dead specimen kept in a drawer in his *kunstkamer*, makes it look as if it were sufficiently lively to fly off the page — something the other beast could never do, despite the presence of all the parts that enable flight (fig. 10). It is analytic (roughly), it is descriptive — but it is to Rembrandt that we turn, again and again, for the essence of the animal. All this may be just what we expect from Rembrandt, but until we cross into the less familiar territories represented by the exotic objects in his *kunstkamer*, we will never discover what makes his art — and that bird — doubly marvelous, marvelous beyond all description.

NOTES

As will be evident from the notes that follow, this essay depends largely on material derived from seventeenth- and eighteenth-century texts whose titles are often extremely unwieldy and resistant to citation in any kind of consistent form. I have therefore taken the liberty of citing the full texts of titles only where absolutely necessary; for the rest I have simply given the main title (where more than one title exists for a single work) or the chief elements of the more cumbersome titles. To have done anything else would have been to burden a piece already too long with even bulkier notes. In general I have included the names of publishers and passed over the printers in silence; but, given the frequently overlapping roles of these professions in the seventeenth and eighteenth centuries, I have not always been consistent. To those who find the inconsistencies troubling, I can only plead that in many instances the usual forms of citation are even less informative than the ones that I offer here. All translations are my own.

1. Maria Sibylla Merian, *Der Raupen wunderbare Verwandelung, und sonderbare Blumen-Nahrung, worinnen durch eine ganz-neue Erfindung der Raupen, Würmer, Sommer-Vögelein, Motten, Fliegen, und anderer dergleichen Thierlein, Ursprung, Speisen, und Veränderungen, samt ihrer Zeit, Ort und Eigenschaften, den naturkündigen, Kunstmahlern, und Gartenliebhabern zu Dienst, fleissig untersucht, kurtzlich beschrieben, nach dem Leben abgemahlt, ins Kupfer gestochen, und selbst verlegt von Maria Sibylla Graffinn, Matthai Merians, des Eltern, seel. Tochter* (Nuremberg: Johann Andreas Graffen, Mahlern; Frankfurt & Leipzig: David Funken, 1679–1683). Every element in this extraordinary title deserves attention, from the specification of the

prospective users of the book to the stipulation about the *ad vivum* representation of the insects, the last use of the author's married name, and the proud announcement of her personal responsibility for the publication. All these recur in one form or another in her subsequent publications; see notes 2 and 5.

2. As evinced in the Dutch version of the text cited in note 1, *Der Rupsen Begin, Voedzel en wonderbare Verandering, Waar in de Oorspronk, Spys en Gestaltverwissling: als ook de tyd, Plaats en Eigenschappen der Rupsen, Wormen, Kapellen, Uiltjes, Vliegen, en andere diergelyke bloedelooze Beesjes vertoond word; Ten dienst van alle Liefhebbers der Insecten, Kruiden, Bloemen, en Gewassen: ook Schilders, Borduurders &c. Naauwkeurig onderzogt, na't leven geschildert, in print gebragt, in in't kort beschreven door Maria Sibilla Merian* (Amsterdam: the author and Gerard Valk, 1683–1717). Observe here that the work was destined for lovers not only of insects but of herbs, flowers, and shrubs. Although Merian refers to her works in such a way as to make the reader think of them as purely entomological, nothing could be more misleading. The chief focus of attention in every plate is arguably the flower or plant on which the insects are shown. Indeed, the text itself reinforces one's sense that the work is almost more about flowers than insects. Note also the use of diminutives in the title, and see the discussion of this practice in note 11.

3. This is most important. Like Merian's earlier work on insects, the book is at least as valuable as a study of plants as it is a study of insects. Cf. note 2.

4. Most of the plates were engraved by Jan Sluijter and Jozef Mulder.

5. Maria Sibylla Merian, "Ad Lectorem," in *Metamorphosis Insectorum Surinamensium, In qua Erucae ac Vermes Surinamenses, cum omnibus suis Transformationibus, ad vivum delineantur & describuntur, singulis eorum in Plantas, Flores & Fructus collocatis, in quibus reperta sunt; tum etiam Generatio Ranarum, Bubonum rariorum, Lacertarum, Serpentum, Araneorum & Formicarum exhibetur; omnia in America ad vivum naturali magnitudine picta atque descripta* (Amsterdam: Sumptibus Auctoris, 1705). A Dutch version appeared in the same year. The original Latin text for the quoted passage is as follows:

> *Insectis jam ab ipsa juventute mea examinandis occupata, primum de bombyce Francofurti ad Moenum in patria civitate feci initium; dein vero, Papiliones multo pulchriores & diurnos & nocturnos ex aliis produci erucis, animadverso, ut omnes, quas invenire licuit, erucas congregarem, earumque metamorphoses notarem, commota sum. Quamobrem humana plane deserens consortia, unice his vacavi observationibus, quo me in arte pictoria magis exercere, & ad vivum singulas tum adumbrare, tum vivis coloribus exprimere possem. Ita factum est, ut cuncta, quae initio Francofurti & postea Noribergae reperi Insecta, in Pergamenis mihi pulchre admodum picta congregarem. Haec ubi postmodum casu in quorundam curiosorum inciderunt conspectum, maxime illi, ut hasce de Insectis observationes meas publico darem,*

atque sic industriis naturae examinatoribus eorumque expectationi satisfacerem, tum temporis cohortati sunt. Permota tandem persuasionibus, figuris mea manu aeri incisis, easdem edidi, Partem Primam in Quarto, Anno 1679. Secundam Anno 1683. In Frisiam deinde ac Belgium profecta, porro in examine Insectorum continuavi, praesertim in Frisia, cum in Belgio magis quam alibi deesset occasio, illis praecipue investigandis, quae in ericetis ac locis caesposis reperiuntur. Aliorum tamen curiosorum solertia istum saepissime supplevit defectum, qui erucas mihi attulerunt, ad explorandas ulterius earum metamorphoses: quemadmodum plures ejusmodi collectas mecum servo observationes, mihi praecedentibus binis Partibus alias adhuc addendi ansam suppeditantes. Verum in Belgio, quot animalium genera ex utraque India & Orientali & Occidentali advehi curarentur, cum admiratione perspexi, maxime cum egregium dignata fuissem perlustrare thesaurum Nobilissimi & Amplissimi Viri, Nicolai Witsen, in Urbe Amstelodamensi Consulis & in Societate Orientalis Indiae Assessoris meritissimi, &c. ut & Nobilissimi Viri Jonae Witsen, eidem civitati à secretis. Vidi etiam postea thesaurum Clariss. Friderici Ruischii, M.D. Anatomiae & Botanices Professoris, *nec non Livini Vincent, & aliorum quamplurimos, ubi haec atque alia numero innumera conspexi Insecta, ita tamen, ut in illis tum origo, tum generatio deficeret, qua ratione scilicet ex erucis fierent aureliae, & quomodo ulterius transformarentur. Hoc ipso incitata, longinquum & sumtuosum iter tentavi, atque in terram Surinamensem in America, (regionem calidem & humidam, unde Viri praedicti ista acceperunt Insecta,) mense Junio anni 1699. transnavigavi, ut accuratius eadem indagarem, & in studio meo pergerem, ad mensem Junii anno 1701. ibidem commorata: tum autem Belgium versus iterum vela feci, atque insequente mense Septembris die 23. ibi rursus appuli. Sexaginta has figuras cum illarum observationibus isthuc loci in Pergamenis naturali magnitudine summo cum studio pinxi; veluti apud me una cum animalculis siccatis cerni possunt. Quam vero animo conceperam, in regione illa opportunitatem Insecta examinandi non inveni, quippe cum ejusdem clima sit calidissimum, atque hic aestus naturae meae adversetur: qua de re coacta domum citius reverti, ac mihi antea propositum erat. Posteaquam in Belgio essem redux, picturasque meas nonnulli cernerent rerum amantes, hi prelo easdem committerem & publici juris facerem, valde à me contendere coeperunt, primum hoc & pulcherrimum ex Operibus unquam in America pictis esse, arbitrati. Verum initio sumtus, ad perficiendum librum impendendi, me ab eo deterruerunt, donec tandem hoc quoque onere suscepto, illi manus admoverem.*

Consistit itaque hoc Opus ex figuris aeneis sexaginta, quibus ultra nonaginta Observationes de Erucis, Vermibus & Acaris exhibentur, quomodo illa cum exuviis pristinum mutent colorem & formam, & tandem in Papiliones, Phalaenas, Scarabaeos, Apes & Muscas transfigurentur. Omnia haec animalcula iisdem quaeque apposui plantis, floribus ac

420

fructibus, quae singulis escam praebuerunt: illisque adhuc addita est generatio Araneorum Indiae Occidentalis, Formicarum, Serpentum, Lacertarum, rariorum Bufonum atque Ranarum; omnia in America à me observata & ad vivum delineata, paucis solum exceptis, quae ex ore Indorum percepta junxi.

Quaestum in Opere hoc conficiendo non quaesivi, modo adhibitos mihi reddat sumtus, contenta: neque enim his ad perficiendum illud peperci, sed a peritissimis artificum tabulas aeneas incidi, atque optimam huic scopo chartam eligi curavi; ut ita artis non solum gnaris, verum etiam cunctis Insectorum & Plantarum studiosis, rem facerem jucundam eorumque expectationi responderem. Quod si illum me consecutam esse finem, atque simul & satisfecisse, & non displicuisse, animadvertero, non parum gaudebo.

6. See the text of the title in note 5.

7. Johannes Faber, *Animalia Mexicana* (Rome: Iacobum Mascardum, 1628). For the terminological discussion, see 746–48 of the 1651 edition of this work, which is incorporated in the work cited in note 37.

8. On Goedaert as a painter, see Laurens J. Bol, "Johannes Goedaert, schilder-entomoloog," *Tableau* 7, no. 4 (1985): 48–54.

9. Johannes Goedaert, *Metamorphosis Naturalis/Metamorphosis et Historia Naturalis cum Commentariis D. Ioannis de Mey Ecclesiastis Medioburgensis ac Doct. Med & duplici eiusdem appendice una de Hemerobiis, altera de Natura Cometarum & varia ex iis divinationibus* (Middelburg: Jacob Fierens, 1662), sig. 2v: "*Et quamuis animalcula haec ab omnibus fere hominibus, ob exilitatem suam contemni soleant.... Reliquum tamen in nobis est lumen aliquod naturae quo diligenti observatione, creaturarumque attenta consideratione, ex visibilibus Dei operibus, ea percipere atque assequi mente possumus quae alioquin in Deo per se invisibilia sunt*"; "Interpretis praefatio ad lectores," in idem, *Metamorphoseos et Historiae Naturalis Pars Secunda. De Insectis ... latinitate donata, commentariis & notis, textui insertis, illustrata & auctuario notarum sive Appendice locupletata. De Insectorum origine utilitate & usu a Paulo Veezaerdt, Ecclesiaste in Insula Wolfphardi Zelandorum* (Middelburg: Jacob Fierens & Johannes Martinus, 1667): "*Nihil in universa rerum, quae sub coelo sunt, Naturae, Homine divinius. Divina tamen etiam sunt Insecta.... Admiranda sunt Naturae miracula, indubitata Infiniti sapientiae, & Potentiae testimonia. Exteriore licet adspectu faeda, & abjecta esse videantur, si tamen propius ea intueamini, multo secus apparebunt.*"

10. The original German edition has garden lovers on this list of possible customers for the book, while the Dutch title page specifically includes embroiderers. See the full titles cited in notes 1 and 2.

11. Jan Swammerdam, *Historia Insectorum Generalis, ofte Algemeen Verhandeling van de*

Bloedelooze Dierkens, waar in de waaragtige Gronde haare langsaame aangroeingen in ledemaaten,
klaarelijk werden voorgestelt, kragtiglijk van de gemeene dwaaling der vervorming, anders Meta-
morphosis genoemt, gesuivert: ende beknoptelijk in vier onderscheide Orderen van Veranderingen,
ofte natuurelijke uytbottingen in leeden, begreepen (Utrecht: Meinardus van Dreunen, ordinarius
drucker van d'Academie, 1669). The characteristic and evidently affectionate use of the diminu-
tive to describe the objects of the entomologist's study (*dierkens, beesjes, animalcula,* etc.) should
be noted not only in this title but in Merian's (see note 2) and in the recommendations to the
reader by Goedaert's editors, as cited in note 9. See also Laurens J. Bol, *Bekoring van het kleine*
(Amsterdam: Stichting Openbaar Kunstbezit, 1963), and, most recently, idem, *Goede onbeken-*
den: Hedendaagse herkenning en waardering van verscholen, voorbijgezien en onderschat talent
(Utrecht: Tableau, 1982), for material on the painters of insects.

12. The deservedly well-known article by R. W. Scheller, "Rembrandt en de encyclopedische
kunstkamer," *Oud-Holland* 84 (1969): 81–147, provides a rich body of material that is still too
little considered in its full ramifications.

13. Charles R. Boxer, *The Dutch in Brazil, 1624-1654* (Oxford: Oxford Univ. Press, 1957);
idem, *The Dutch Seaborne Empire, 1600-1800* (London: Hutchinson, 1965); Jonathan I. Israel,
Dutch Primacy in World Trade, 1585-1740 (Oxford: Oxford Univ. Press, 1989).

14. Hendrik Adriaan van Reede tot Drakenstein, *Hortus Indicus Malabaricus, continens*
Regni Malabarici apud Indos celeberrimi omnis generis plantas rariores, 12 vols. (Amsterdam:
Theodori Boom, 1673–1703).

15. Carl von Linnaeus, *Hortus Cliffortianus plantas exhibens quas in hortis tam vivis quam*
siccis, Hartecampi in Hollandia coluit Georgius Clifford (Amsterdam: Lehre, J. Cramer, 1737).

16. Georg Eberhard Rumphius, (*Herbarium Amboiense*), *Het Amboinsche Kruid-Boek,* 12
vols. (Amsterdam; The Hague; Utrecht: François Changuion, 1741–1755).

17. See E. Kris, "Georg Hoefnagel und der wissentschaftliche Naturalismus," in *Festschrift*
Julius Schlosser zum 60. Geburtstage, ed. Arpad Weixlgärtner and Leo Planiscig (Zurich: Amal-
thea Verlag, 1927), 243–53; and Th. Wilberg Vignau-Schuurman, *Die emblematischen Elemente*
im Werke Joris Hoefnagels (Leiden: Universitaire Pers, 1969). See also the valuable catalogs of
the 1988–1989 exhibitions on Rudolf's patronage and collections, Kunsthistorisches Museum
Vienna, *Prag um 1600: Kunst und Kultur am Hofe Rudolfs II,* exh. cat., 2 vols. (Freren: Luca
Verlag, 1988); *Rudolf II and his Court,* Leids Kunsthistorisch Jaarboek 1 (Delft: Delftsche
Uitgevers Maatschappij, 1982); and T. DaCosta Kaufmann, *The School of Prague: Painting at*
the Court of Rudolf II (Chicago: Univ. of Chicago Press, 1988).

18. Jan and Caspar Commelin, *Rariorum Plantarum Horti Medici Amstelodamensis Descrip-*
tio et Icones (Amsterdam: P. & J. Blaeu & Abraham a Someren, 1697 and 1701). Each volume has
four separate title pages; the first volume, published by the Blaeus and Abraham van Someren,
is credited to Jan Commelin; the second (which contains African and East Indian plants in

addition to the West Indian varieties of the first volume) was published by the Blaeus and the widow of Abraham van Someren and is credited to Caspar Commelin. The first volume by Jan Commelin was posthumously published but was translated and edited by Frederik Ruysch and François Kiggelaar.

19. Georg Eberhard Rumphius, *De Amboinsche Rariteitkamer* (Amsterdam: François Halma, 1705).

20. Johannes de Laet, *Nieuwe Wereldt ofte Beschrijvinge van West-Indien* (Leiden: Isaack Elzevier, 1625; reprint in Dutch, Leiden: Elzeviers, 1630; in Latin, Leiden: Elzeviers, 1633; and in French, Leiden: Elzeviers, 1640); idem, *Historie ofte jaerlijck verhael van de verrichtinghen der Geoctroyeerde West-Indische Compagnie zedert haer begin tot het eynde van het jaer 1636* (Leiden: Elzeviers, 1644).

21. Alison McNeil Kettering, *Drawings from the Ter Borch Studio Estate in the Rijksmuseum*, 2 vols. (The Hague: Staatsuitgeverij, 1988).

22. For Scheller, see note 12. On the Reynsts' collection, see the work by Logan cited in note 23.

23. Anne-Marie S. Logan, *The "Cabinet" of the Brothers Gerard and Jan Reynst*, Verhandelingen Afdeling Letterkunde: Koninklijke Nederlandse Akademie van Wetenschappen, n. s., vol. 99 (Amsterdam and New York: North-Holland, 1979).

24. See the excellent discussion in Simon Schama, *The Embarrassment of Riches: An Interpretation of Dutch Culture in the Golden Age* (New York: Alfred A. Knopf, 1987), 151–66. P. Biesboer, " 'Tulipa Turcarum': Über die 'Tulipomania' in Europa," in *Europa und der Orient 800–1900*, ed. G. Sievernich and H. Budde, exh. cat. (Berlin: Berliner Festspiele, 1989), regrettably adds very little to this subject, nor do the sections on the Netherlands in the catalog: a missed opportunity.

25. T. Aldini (*recte et iuste* P. Castelli), *Exactissima Descriptio Rariorum Quarundam Plantarum, Quae continentur Romae in Horto Farnesiano* (Rome: Jacobus Mascardi, 1625).

26. J. T. de Bry, *Florilegium Novum* (Frankfurt, 1612); E. Sweerts, *Florilegium tractans de variis floribus et aliis Indicis plantis* (Frankfurt, 1612); C. de Passe (with C. de Passe II and W. de Passe), *Hortus Floridus* (Arnhem, 1614).

27. Charles Clusius, *Fungorum in Pannoniis Observatorum Brevis Historia*, appended to the *Rariorum Plantarum Historia* (Antwerp: Johannes Moretus, 1601).

28. See note 17.

29. A. Clutius, *Opuscula Duo Singularia, I De Nuce Medica; II De hemerobio sive Ephemero Insecto, & Majali Verme* (Amsterdam: Typis Jacobi Charpentier, 1634), sigla ***2v and ****2v.

30. Outger Cluyt, *Memorie der Vreemder Blom-bollen, Wortelen, Kruyden, Planten, Zaden ende Vruchten: Hoe men die sal wel gheconditioneert bewaren ende overseynden* (Amsterdam: Paulus Aertsz. van Ravesteyn, 1631); A. Clutius (see note 29); idem, *De Cocco Maldivensi*

(generally bound together with the preceding). The numeration and pagination of these works are a bibliographical nightmare; I have not yet attempted to deal with these issues thoroughly. The work on nephrites is generally appended to G. Lauremberg, *Historica descriptio Aetitis seu Lapidis Aquilae.... Cui adjunctus est eijusdem Tractatus de Lapide Calsuve, nec non Methodus conficiendi Herbaria Viva* (Rostock: A. Ferber, 1627), since it was Lauremberg who edited the text by Cluyt, A[ugerius] Clutius, *Calsuee, sive Dissertatio, Lapidis Nephritici, seu Jaspidis viridis, in quaedam callois dicti, naturam, proprietates & operationes exhibens, quam sermone latino recenset M. Gulielmus, Gulielmi F. Lauremberg* (Rostock: Joachim Pedanus, 1626 or 1627).

31. [Jan Swammerdam], *Exquisita Demonstratio Vasorum Spermaticorum, Testium sive Ovarii, Tubarum seu Cornuum, &c. Uteri Humani, in aedibus Anatomici praestantissmi D. van Horne A. 1667 21 Januar. primo adumbrata* (n. p., 1671).

32. Guido de Werd, ed., *Soweit der Erdkreis reicht: Johann Moritz von Nassau-Siegen, 1604-1679*, exh. cat. (Kleve: Stadt Kleve, 1979); and E. van den Boogart et al., eds., *Zo wijd de wereld strekt: Tentoonstelling naar aanleiding van de 300ste sterfdag van Johan Maurits van Nassau-Siegen op 20 december 1679* (The Hague: Stichting Johan Maurits van Nassau, 1979–1980). An extremely valuable collection of essays that appeared in the same year as these exhibitions and should be consulted in considering the topics discussed here is E. van den Boogart, ed., in collaboration with H. R. Hoetink and P. J. P. Whitehead, *Johan Maurits van Nassau Siegen, 1604-1679: A Humanist Prince in Europe and Brazil. Essays on the Occasion of the Tercentenary of His Death* (The Hague: Johan Maurits van Nassau Stichting, 1979). Rüdiger Joppien's article is entitled "The Dutch Vision of Brazil: Johan Maurits and His Artists," 296–376. For a useful, brief catalog of pictures, see J. de Sousa Leão, *Os Pintores de Mauricio de Nassau* (Rio de Janeiro: Museu de Arte Moderna, 1968).

33. Published by Johannes Blaeu. The plates were reused in the same year to illustrate the epic poem by Franciscus Plante (Brugensis), *Mauritiados Libri XII. Hoc est rerum ab illustrissimo Heroe Joanne Mauritio Comite Nassawiae & c. In Occidentali India Gestarum* (Leiden: Johannes Maire, 1647).

34. As readers of Svetlana Alpers, *The Art of Describing: Dutch Art in the Seventeenth Century* (Chicago: Univ. of Chicago Press, 1983), might be inclined to conclude.

35. [W. Piso, G. Marcgraf, and J. de Laet], *Historia Naturalis Brasiliae, Auspicio et Beneficio Illustrissimi I. Mauritii...In qua non tantum Plantae et Animalia sed et Indigenarum morbi, ingenia et mores describuntur et iconibus supra quingentas illustrantur* (Leiden: Franciscus Hack; Amsterdam: Ludovicus Elzevir, 1648). For the role of these figures in the making of this book and the *De Indiae utriusque re naturali et medica libri quatuordecim* (Amsterdam: Ludovicus & Danielis Elzevir, 1658), as well as their mutual relations, see D. de Moulin, "Medizinische und naturwissenschaftliche Aspekte der Regierungszeit des Grafen Johann Moritz von Nassau als Gouverneur in Brasilien 1637–1644," in Städtisches Museum Haus Koekkoek Kleve, *Soweit der*

Erdkreis reicht: Johann Moritz von Nassau-Siegen, 1604–1679 (Kleve: Der Stadt Kleve, 1979), 33–46. P. J. P. Whitehead, "Georg Markgraf and Brazilian Zoology" and F. Guerra, "Medicine in Dutch Brazil" in Van den Boogaart (see note 32), 424–93, now stand as the fundamental studies of Marcgraf's zoological contribution and of the significance and context of Piso's work in Brazil.

36. On Marcgraf, see the articles cited in note 35. On the work of Post and Eckhout, see the outstanding survey by Joppien cited in note 32. Joppien's article also provides many other invaluable insights into the topics discussed in this essay.

37. *Rerum Medicarum Novae Hispaniae Thesaurus seu Plantarum Animalium Mineralium Mexicanorum Historia. Ex Francisci Hernandez Novi Orbis Medici Primarij relationibus in ipsa Mexicana Urbe conscriptis. A Nardo Antonio Reccho…Iussu Phillippi II…collecta ac in ordinem digesta. A Ioanne Terrentio Lynceo Notis illustrata. Nunc primum in naturalium rerum studiosorum gratia lucubrationibus Lynceorum publici iuris facta* (Rome: Vitalis Mascardi, 1649 and 1651). A further title was added in 1651 as follows: *Nova Plantarum Animalium et Mineralium Mexicanorum Historia a Francisco Hernandez Medico in Indijs praestantissimo primum compilata, dein a Nardo Antonio Reccho in volumen digesta a Io. Terentio, Io. Fabro, et Fabio Columna Lynceis, Notis, & additionibus longe doctissimis illustrata, Cui demum accessere Aliquot ex Principis Federici Caesii Frontispiciis Theatri Naturalis Phytosophicae Tabulae.* These titles alone give a sense of the ambition and scale of this majestic collaborative undertaking. To give an exact date for the publication of the definitive version of the *Rerum medicarum* is not easy. Clearly the printer and the guiding force, Francesco Stelluti, were eager to get it out as soon as possible, but it seems that matters were never quite ready, so that several versions appeared before the "definitive" one of 1651. Most copies carry this date. The problem was complicated by the complex position of the recently disgraced Barberini family (Francesco Barberini was one of the chief original sponsors of the project). Publication was held up, I believe, by indecision about the dedication of the book and references to the family within the text: whether to omit or tactfully rephrase them. But this is not the place to resolve such matters. See note 38 for further references.

38. The basic article on the publication of the Lincean work is G. Gabrieli, "Il cosidetto 'Tesoro Messicano' edito dai primi Lincei," *Rendiconti della Accademia dei Lincei: Classe di scienze morali, storiche e filologiche*, 7th ser., 1 (1940): 110–21. See also the important collection of articles on Cesi and the *Tesoro Messicano* that appeared as *Atti dei Convegni Lincei, 78: Convegno celebrativo del IV centenario della nascita di Federico Cesi (Acquasparta, 7–9 ottobre 1985)* (Rome: Accademia Nazionale dei Lincei, 1986). For a summary of Cassiano's role, see David Freedberg, "Cassiano, Natural Historian," *Quaderni Puteani* 1 (1989): 10–15.

39. Johannes de Laet, *Commentarius de Pelagianis et Semi-Pelagianis* (Harderwijk, 1617).

40. Johannes de Laet, *Notae ad dissertationem Hugonis Grotii de origine gentium Americanarum et observationes aliquot ad meliorem indaginem difficillima illius quastionis* (Amsterdam:

Ludovicum Elsevirium, 1642 and 1643); Hugo Grotius, *Dissertatio de origine gentium Americanarum adversus obtrectatorem opaca bonum quem facit barba* ([Paris?: n. p.], 1642); Johannes de Laet, *Responsio ad dissertationem secundam Hugonis Grotii* (Amsterdam: Ludovicum Elsevirium, 1643, 1644, and 1646).

41. *Gemmarum et Lapidum Historia, quam olim edidit Anselmus Boetius de Boot Brugensis, Rudolphi II Imperatoris Medicus. Postea Adrianus Tollius…recensuit; figuris melioribus & commentariis pluribus illustravit…tertia edition longe purgatissima. Cui accedunt Ioannis de Laet Antverpiani De Gemmis & Lapidibus Libri II. Et Theophrasti Liber de Lapidibus, Gr. & Lat. cum brevibus notis* (Leiden: Joannes Maire, 1647). On De Boodt, see M. C. Maselis, A. Balis, and A. Marijnissen, *De Albums van Anselmus de Boodt, 1552-1632: Geschilderde natuurobservatie aan het Hof van Rudolf II te Praag* (Tielt: Lannoo, 1989), reproducing over one hundred of the colored natural history drawings painted and commissioned by De Boodt, which survive in eleven volumes in the Soenens collection in Belgium.

42. See note 30.

43. *M. Vitruvii Pollionis De Architectura Libri Decem…. Cum variis indiciis copiosissimis. Omnia in unum collecta, digesta & illustrata a Ioanne de Laet Antwerpiano* (Amsterdam: Ludovicus Elzevir, 1649).

44. Guilielmi Pisonis Medici Amstelaedamensis, *De Indiae utriusque re naturali et medica libri quatuordecim* (Amsterdam: Ludovicus & Danielis Elzevir, 1658).

45. *Iacobi Bontii Bataviae in majore Java novae Medici Orinarii I De conservanda valetudine. II Methodus medendi. III Observationes in cadaveribus. IV Notae in Garciam ab Orta. V Historia Animalium. VI Historia Plantarum*, in the work cited in the preceding note.

46. See note 14.

47. Jan Commelin, *De Nederlantze Hesperides, dat is, Oeffening en gebruik van de limoen- en oranje-boomen, gestelt na den aardt, en climaat der Nederlanden* (Amsterdam: Marcus Doornik, 1676).

48. Giovanni Battista Ferrari, *Hesperides sive de Malorum Aureorum Cultura et usu Libri Quatuor* (Rome: Herman Scheus, 1646). On the work and circle of Ferrari, see David Freedberg, "From Hebrew and Gardens to Oranges and Lemons: Giovanni Battista Ferrari and Cassiano dal Pozzo," in Cassiano dal Pozzo, *Atti del Seminario Internazionale di Studi su Cassiano dal Pozzo: Napoli 18-19 dicembre 1987*, ed. F. Solinas (Rome: De Luca, 1989): 37-72; and David Freedberg, "Cassiano dal Pozzo's Drawings of Citrus Fruits," *Quaderni Puteani* 1 (1989): 16-36.

49. I shall have more to say about the fame and influence of Ferrari (whose 1633 *De Florum Cultura* was republished by Jan Janssen in Amsterdam in 1646) in my forthcoming biography.

50. See note 18.

51. See note 14. Jan Commelin's participation is recorded from volume 2 onward, even after his death.

52. S. Segal, *A Prosperous Past: The Sumptuous Still Life in the Netherlands, 1600–1700*, ed. W. B. Jordan (The Hague: SDU Publishers, 1988).

53. P. V. B. [Philibert van Borsselen], *Strande, oft Ghedichte van de Schelpen, Kinkhornen ende andere wonderlijcke zee- schepselen, tot lof van de Schepper aller Dinghen* (Amsterdam: Doen Pietersz., 1614). His brother-in-law was Cornelis van Blyenburgh.

54. See note 24.

55. Now brought together in John Michael Montias, *Vermeer and His Milieu: A Web of Social History* (Princeton: Princeton Univ. Press, 1989); see also idem, *Artists and Artisans in Delft: A Socio-Economic Study of the Seventeenth Century* (Princeton: Princeton Univ. Press, 1982).

56. Set forth schematically in "The Language of Art History," *New Literary History* 10 (1979): 453–65; but brilliantly and innovatively exemplified in Michael Baxandall, *Painting and Experience in Fifteenth-Century Italy: A Primer in the Social History of Style* (Oxford: Oxford Univ. Press, 1972); and idem, *The Limewood Sculptors of Renaissance Germany* (New Haven and London: Yale Univ. Press, 1980).

57. See, among several possible examples, Konrad Renger, *Lockere Gesellschaft: Zur Ikonographie des verlorenen Sohnes und von Wirtshausszenen in der niederländischen Malerei* (Berlin: Gebr. Mann Verlag, 1970); and Hans-Joachim Raupp, *Bauernsatiren: Entstehung und Entwicklung des bäuerlichen Genres in der deutschen und niederländischen Kunst ca. 1470–1570* (Niederzier: Lukassen, 1986).

58. The groundbreaking early pieces were E. de Jongh, "Erotica in vogelperspectief: De dubbelzinnigheid van een reeks 17de -eeuwse genrevoorstellingen," *Simiolus* 3 (1968–1969): 22–74; E. de Jongh, *Zinne- en minnebeelden in de schilderkunst van de zeventiende eeuw* (Amsterdam: Nederlandse Stichting Openbaar Kunstbezit en Openbaar Kunstbezit in Vlaanderen, 1967); E. de Jongh, "Realisme en schijnrealisme in de Hollandse schilderkunst van de zeventiende eeuw," in Paleis voor Schone Kunsten, *Rembrandt en zijn tijd*, exh. cat. (Brussels: La Connaissance, Europalia, 1971); and *Tot lering en vermaak: Betekenissen van Hollandse genrevoorstellingen uit de zeventiende eeuw*, exh. cat. (Amsterdam: Rijksmuseum, 1976). These were followed by a succession of articles and catalogs that, while containing much in the way of new iconographic material, exemplified the method set out in these earlier works rather than significantly modifying it. These catalogs include E. de Jongh, *Still Life in the Age of Rembrandt*, exh. cat. (Auckland: Auckland City Art Gallery, 1982); and idem, *Portretten van echt en trouw: Huwelijk en gezin in de Nederlandse kunst van de zeventiende eeuw*, exh. cat. (Haarlem: Frans Halsmuseum; Zwolle: Waanders, 1986).

59. Peter Hecht, "The Debate on Symbol and Meaning in Dutch Seventeenth-Century Art: An Appeal to Common Sense," *Simiolus* 16 (1986): 173–87; Jan Baptist Bedaux, "Fruit and Fertility: Fruit Symbolism in Netherlandish Portraiture of the Sixteenth and Seventeenth Centuries," *Simiolus* 17 (1987): 150–68.

60. Josua Bruyn, "Toward a Scriptural Reading of Seventeenth-Century Dutch Landscape Paintings," in *Masters of Seventeenth-Century Dutch Landscape Painting*, ed. Peter C. Sutton, exh. cat. (Boston: Museum of Fine Arts, 1987): 84–103. See the more complex variant of Bruyn's general position in the earlier thesis by R. L. Falkenburg, "Joachim Patinir: Het landschap als beeld van de levenspelgrimage" (Ph.D. diss, Nijmegen, 1985); as well as the interesting modifications recently proposed by Falkenburg in "De betekenis van het geschilderde Hollandse landschap van de zeventiende eeuw: Een beschouwing naar aanleiding van enkele recente interpretaties," *Theoretische geschiedenis*, 16 (1989): 131–54.

61. It first appeared as "Belering en verhulling? Enkele 17de-eeuwse teksten over de schilderkunst en de iconologische benadering van Noordnederlandse schilderijen uit die periode," *De zeventiende eeuw* 4 (1988): 2–28.

62. Henri van de Waal, *Drie eeuwen vaderlandsche geschied-uitbeelding, 1500–1800: Een iconologische studie*, 2 vols. (The Hague: Martinus Nijhoff, 1952); Katherine Fremantle, *The Baroque Town Hall of Amsterdam* (Utrecht: Haentjens, Dekker & Gumbert, 1959).

63. Albert Blankert, *Kunst als regeringszaak in Amsterdam in de 17de eeuw: Rondom schilderijen van Ferdinand Bol*, exh. cat. (Amsterdam: Historisch Museum, 1975); Albert Blankert et al., *Gods, Saints and Heroes: Dutch Painting in the Age of Rembrandt*, exh. cat. (Washington D.C.: National Gallery of Art, 1980).

64. Perry Chapman, "A *Hollandse Pictura*: Observations on the Title Page of Philips Angel's *Lof der schilder-konst*," *Simiolus* 16 (1986): 233–48; Elisabeth Onians-de Bièvre, "Violence and Virtue: History and Art in the City of Haarlem," *Art History* 11 (1988): 303–34. Chapman has recently announced a study of the impact of political history, most notably the struggle for independence and the national self-consciousness it engendered, on Dutch painting between 1609 and 1648.

65. Alison McNeil Kettering, *The Dutch Arcadia: Pastoral Art and Its Audience in the Golden Age* (Montclair, N. J.: Allanheld & Schram, 1983).

66. Guillaume Postel, *De Republica, seu Magistratibus Atheniensium Liber. Ex Museo Joan. Balesdens.... Accessit Antonii Thysii IC Discursus Politicus et eadem materia collatio Atticarum & Romanorum Legum* (Leiden: Ioannis Maire, 1645), 2–3v.

67. See note 38. For a summary of the neglected activities of Cassiano as a natural historian, see the article by Freedberg cited in note.

68. In both respects readers will want to consult the excellent survey by D. O. Wijnants, "Hortus Auriaci: The Gardens of Orange and Their Place in Late Seventeenth-Century Botany and Horticulture," *Garden History* 8 (1988), nos. 2 and 3 (special double number), J. Dixon Hunt and E. de Jong, eds., *The Anglo-Dutch Garden in the Age of William and Mary*, 61–86, which also offers an invaluable supplement to many of the other topics I discuss here.

69. O. Benesch, *The Drawings of Rembrandt, Complete Edition Enlarged and Edited by E. Benesch* (London: Phaidon, 1973), no. 456, Louvre, Cabinet des Dessins, Inv. RF 4687.

Biographical Notes
on the Authors

Jochen Becker focuses his research on the interrelation of art and literature, iconology, art theory, and emblematics. Among his recent publications are articles on seventeenth-century Dutch painting, Erasmus of Rotterdam, Goethe, Aby Warburg, and Walter Benjamin. He teaches iconology and art theory at the Rijksuniversiteit, Utrecht.

Willem A. Brandenburg studies the backgrounds of cultivated plants and their mechanisms of domestication. His biological research often necessitates the consultation of a wide variety of documentary sources, including paintings. He pursues his research as a plant systematist at the Centre for Variety Research and Seed Technology (CRZ), Wageningen.

David Freedberg focuses his research on art theory and the history of Dutch, Flemish, and Italian art. His publications include *Dutch Landscape Prints of the Seventeenth Century* (1980), *Rubens: The Life of Christ after the Passion* (1984), *Iconoclasts and Their Motives* (1985), *Iconoclasm and Painting in the Revolt of the Netherlands, 1566–1609* (1987), *The Power of Images: Studies in the History and Theory of Response* (1989), and *The Prints of Pieter Bruegel the Elder (*1989). He is a professor of art history at Columbia University, New York City.

E. de Jongh specializes in iconology and art theory. He is a co-founder of the journal *Simiolus: Netherlands Quarterly for the History of Art*, and his publications include *Zinne- en minnebeelden in de schilderkunst van de zeventiende eeuw* (1967), *Tot lering en vermaak: Betekenissen van Hollandse genrevoorstellingen uit de zeventiende eeuw* (1976), *Still-life in the Age of Rembrandt* (1982), and *Portretten van echt en trouw: Huwelijk en gezin in de Nederlandse kunst van de zeventiende eeuw* (1986). From 1976 until his retirement in 1990, he was a professor of art history at the Rijksuniversiteit, Utrecht.

John Michael Montias engages in research ranging from trade in art goods in seventeenth-century Holland to industrial policy in contemporary Eastern Europe. His publications include *The Structure of Economic Systems* (1976), *Artists and Artisans in Delft: A Socio-Economic Study of the Seventeenth Century* (1982), and *Vermeer and His Milieu: A Web of Social History* (1989). He is a professor of economics at Yale University, New Haven.

Gary Schwartz focuses his studies on Dutch art history. His publications include *Rembrandt, His Life, His Paintings: A New Biography* (1985; Dutch edition, 1984), *The Dutch World of Painting* (1986), and *Pieter Saenredam:*

The Painter and His Time (with Marten Jan
Bok, 1990; Dutch edition, 1989). He is the
publisher of Gary Schwartz/SDU, an imprint
of SDU, the former Dutch Government
Publishing Office.

Eric J. Sluijter specializes in Dutch art his-
tory. His publications include *De "heydensche
fabulen" in de Noordnederlandse schilder-
kunst, circa 1590-1670: Een proeve van
beschrijving en interpretatie van verhalende
onderwerpen uit de klassieke mythologie* (1986)
as well as numerous articles and reviews.
He is an associate professor at the
Rijksuniversiteit, Leiden.

J. W. Smit studies the social structure and
cultural history of the Dutch Republic. His
publications include *Fruin en de partijen
tijdens de Republiek* (1958) and contributions
to *Preconditions of Revolution in Early
Modern Europe* (1971), *Failed Transitions to
Modern Industrial Society* (1974), and *Reader
uitgegeven door het Instituut voor Geschie-
denis der Rijksuniversiteit te Utrecht*, vols. 2
and 3 (1976 and 1977). He is Queen Wilhelmina
Professor of History and Literature of the
Low Countries at Columbia University,
New York City.

Linda Stone-Ferrier focuses her research on
Dutch art history. Her publications include
*Dutch Prints of Daily Life: Mirrors of Life or
Masks of Morals?* (1983) and *Images of Tex-
tiles: The Weave of Seventeenth-Century Dutch
Art and Society* (1985). She is an associate
professor of art history at the University of
Kansas, Lawrence.

Richard W. Unger studies marine history.
His publications include *Dutch Shipbuilding
before 1800: Ships and Guilds* (1978), *The
Ship in the Medieval Economy, 600-1600* (1980),
and *The Art of Medieval Technology: Images
of Noah the Shipbuilder* (forthcoming). He
is a professor of history at the University of
British Columbia, Vancouver.

Jan de Vries studies European pre-indus-
trial economies and the historical process of
Europe's urbanization. Among his most recent
publications are *Urbanization and Migration
in Historical Demography* (1990) and "The
Decline and Rise of the Dutch Economy,
1675-1900" (1990). He is a professor of his-
tory and economics at the University of
California, Berkeley.

Lyckle de Vries researches problems of
periodization and classification in Dutch art.
He has published studies of Jan Steen, Gerard
Houckgeest, Wybrand de Geest, Jan van der
Heyden, and Johan van Gool. He teaches art
history at the Rijksuniversiteit, Groningen.

John Walsh specializes in the study of seven-
teenth-century Dutch painting. His publica-
tions include *The Painter's Light* (1971),
*A Mirror of Nature: Dutch Paintings from the
Collection of Mr. and Mrs. Edward William
Carter* (with Cynthia P. Schneider, 1981), and
numerous other exhibition catalogs and arti-
cles. He is the director of the J. Paul Getty
Museum, Malibu.

Ad van der Woude researches issues in
Dutch economic history. His publications
include *Het Noorderkwartier: Een regionaal
historisch onderzoek in de demografische en
economische geschiedenis van westelijk Neder-
land van de late middeleeuwen tot het begin
van de negentiende eeuw* (1972), *Probate
Inventories: A New Source for the Historical
Study of Wealth, Material Culture, and
Agricultural Development* (with Anton
Schuurman, 1980), and *Nederland over de
schouder gekeken* (1986). Recently, he edited
*Urbanization in History: A Process of Dynamic
Interactions* (with Akira Hayami and Jan de
Vries, 1990). He is a professor in the
Department of Rural History at Wageningen
Agricultural University.

Index

Page numbers in italics indicate an illustration.

Flutes, 167n.20

Folk and peasant paintings: Alpers on, 21; characteristics of, 229, 243n.62, 277n.14; and *naer het leven*, 220, 222; and periodization, 234; reactions to, 277n.14; realism of, 222

Folk sermons, 217

Folk songs, 214–15

Fools, 146

Fossils, 395

France, 267, 268, 295–96

Frankfurt, 377

Fremantle, Katherine, 410

Friesland, 377, 382, 386

Froidment, Libertus, 106

Fromentin, Eugène, 175

Fruits, 60, 62, 122, 206n.82, 242n.57, 398

Fuchs, Leonhard, 60

Fustel de Coulanges, Numa-Denis, 18

Galilei, Galileo, 403, 413

Gardens, 44, 384, 398, 412

Geesteranus, Johannes Evertsz., 188

"Geistliche Hausmagd" (broadsheet), 164n.14

General crisis concept, 253, 254, 278n.16

Genre paintings: Alpers on, 15n.21, 175; and archaeology, 212; background of, 215–16, 228; Białostocki on, 175; daily life and commonplace in, 213, 219; deception of the eye in, 204n.74; didacticism and moralization in, 121, 176, 185, 189, 216, 217, 218, 220, 230; emblems in, 139–40, 206n.82; eroticism and sexuality in, 219, 238n.20; exempla in, 217, 230; Fromentin on, 175; Gombrich on, 123; Hecht on, 12, 15n.21; Hegel on, 8, 9, 15n.21; and history paintings, 228–29; humor in, 201n.55, 220, 231, 243n.62; iconography and iconology in, 139, 157, 175, 214, 225, 229; influences on, 215, 219, 240n.40; De Jongh on, 11, 175; kitchen maids in, 163n.10; De Lairesse on, 241n.48; and literature, 212, 215; love in, 189, 238n.20; motifs in, 140, 142; number of, 304, 305–6, 308, 320–21, 324, 336, 346, 347, 351, 353–55; and periodization, 233; picturesqueness in, 224; and poetry, 240n.40; prices of, 304, 305, 308, 319, 324; primacy of, 123; as product innovations, 265; purposes of, 175; Raupp on, 122, 201n.55; reactions to, 228; realism of, 8, 211, 217, 220, 223, 225, 228, 231, 233, 239n.30, 241n.46; revolt against Spain in, 7; and riddles, 158; sizes of, 307, 308, 322–23, 324; specificity of, 216; style of, 231; symbolism and disguised symbolism in, 121, 139, 157, 176, 185; transience in, 189; Weyerman on, 212; youth in, 189. *See also* specific types of genre paintings

Germany, 9, 215, 296, 361

Gesprächsspiele, 158, 171n.33

Getty Art History Information Program, 259

Getty Center for the History of Art and the Humanities, 4, 6n.9, 18

Getty Provenance Index, 259, 263, 333

Geyl, Pieter, 234, 281n.38

Glauber, Johannes, 212

Gods, Saints and Heroes (exhibition), 199n.46, 211–12, 410

Goedaert, Johannes, 382, 383

Gogh, Theo van, 125

Gogh, Vincent van, 125, *126*, 127

Goltzius, Hendrik: and classicism, 234; and clouds, 106; genre paintings by, 233; landscape paintings by, 232; and *naer het leven*, 232–33; and personification, 233; reactions to, 346, 368; and realism, 232, 233; unequal couples by, 146, *147*, 148

Gombrich, E. H., 123

Gool, Johan van: on manufactories, 299, 328n.34; on painters, 212, 281n.37, 299, 300–301, 327nn.31, 32

Goyen, Jan van: number of paintings by, 299; reactions to, 345, 365, 366; as realist, 209; river landscapes by, 128

Grebber, Pieter de, 211–12

Greuze, Jean-Baptiste, 151, *152*

Groen, Jan van den, 44

Groot, C. Hofstede de, 96

Grotius, Hugo, 395

Guicciardini, Lodovico, 42

Guilds. *See* Municipal guilds; Saint Lucas guilds

444